WITHDRAWN

ZEN

Painting & Calligraphy

An exhibition of works of art lent by temples, private collectors, and public and private museums in Japan, organized in collaboration with the Agency for Cultural Affairs of the Japanese Government.

JAN FONTEIN & MONEY L. HICKMAN

Museum of Fine Arts, Boston

Distributed by New York Graphic Society, Greenwich, Connecticut

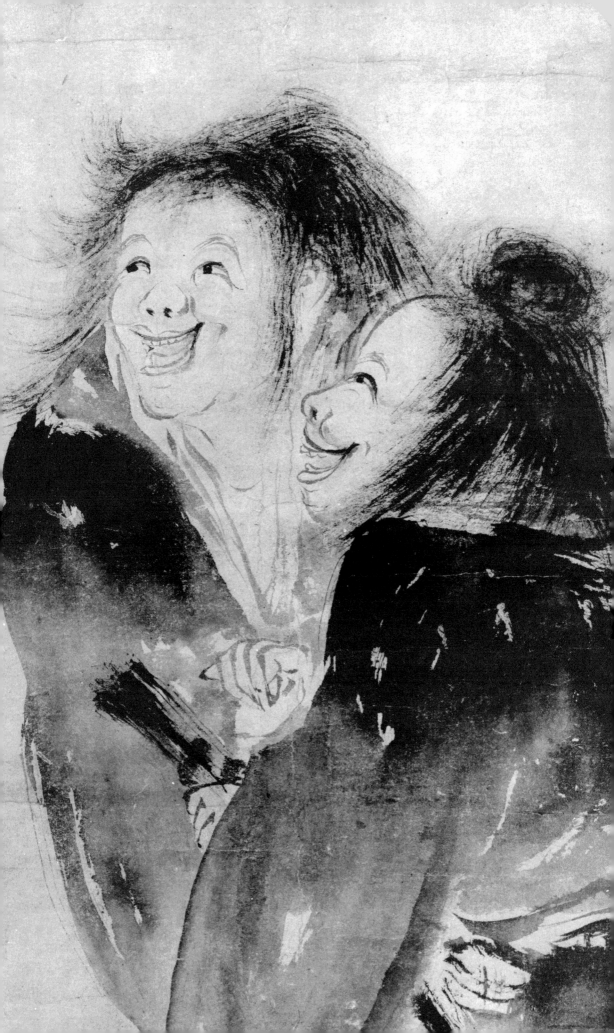

Copyright © 1970
by Museum of Fine Arts, Boston, Massachusetts
All rights reserved
ISBN 0-87846-000-4
Library of Congress Catalogue Card No. 76-127853
Typeset in Linofilm Palatino by
Wrightson Typographers, Boston
Printed by The Meriden Gravure Co.,
Meriden, Conn.
Designed by Carl F. Zahn

Dates of the Exhibition:
November 5–December 20, 1970

Jacket illustration:
20. *"Red-Robed" Bodhidharma,* artist unknown,
ca. 1271
Title page illustration:
48. *Kanzan and Jittoku,* traditionally attributed to
Shūbun (active second quarter of 15th century) (detail)

Contents

Foreword

I should first like to offer my warmest congratulations to the Museum of Fine Arts, Boston, on the occasion of its hundredth anniversary.

From the time of its founding, the Museum's relationship with Japan has been of an extremely close nature. Ernest Fenollosa, who first came to Japan in 1878 and later developed a boundless appreciation for Japanese art, and his friend and follower Okakura Tenshin, the ardent advocate of the beauty of Far Eastern art, were both energetic men who held important positions in the Asiatic Department of the Museum of Fine Arts. These men performed a role of great importance in stimulating interest in Japan and in Japanese art among many segments of the public in America, and the deeper understanding that they brought about represents one of the brightest achievements in the history of cultural exchange between our two countries. In the following decades, the Museum diligently continued to collect and exhibit pieces of Asiatic art, and it has maintained to the present day its reputation of having the foremost collection in this field in Europe and America.

This exhibition of Zen art, held in honor of the Museum's centennial year and in collaboration with the Agency for Cultural Affairs, is particularly appropriate in light of the Museum's unique history of association with Asiatic art. The Agency for Cultural Affairs looks on this enterprise with particular enthusiasm and takes great pleasure in being able to send these seventy-one superlative items, which have been assembled through the kind cooperation of temples and private collectors as well as public and private museums. The selection has been carried out in full consultation with specialists from the Museum of Fine Arts. To show the broad scope and distinctive characteristics of Ch'an art in China and Zen art in Japan, and to permit the viewer to increase his appreciation and knowledge of this unique body of Asiatic art, every effort has been made to bring together a wide range of works dating from the Sung and Yüan periods in China and the Kamakura, Muromachi, and later periods in Japan, including *chinsō* portraits; paintings of patriarchs and eccentrics, of landscapes, birds, animals, and plants; and calligraphy by eminent monks.

We hope that the many people who will see this exhibition will not only gain insight into the profound meaning of Zen forms but will also be moved by the lofty spiritual content of these pieces. We trust also that the exhibition, which is wholly fitting for the commemoration of the Museum's one hundredth anniversary, will be an outstanding success.

HIDEMI KOHN
Commissioner of the Agency for Cultural Affairs Tokyo

Preface

Zen — who has not responded to that word with bafflement, or with curiosity, or with enough insight into the infinity of the subject it connotes to wish to explore it further? The ancient philosophy of Zen Buddhism, which had its roots in India and traveled to China and Korea and thence to Japan in the twelfth and thirteenth centuries, has so deeply penetrated the life of the Far East that it has affected many expressions of its culture. This is especially true of the traditional culture of Japan, where perhaps the most intimate and personal of these expressions are Zen-inspired painting and calligraphy.

In recent years an appreciation of Zen principles has spread throughout the United States, so that the meaning of the word *Zen* is now widely understood in our country. A generation ago this would not have been the case. Yet, in spite of this interest, this is the first exhibition of Zen painting and calligraphy to be held in the Western world. Two very distinguished men who figure prominently in the Museum's history would have been deeply pleased, I believe, by this event, held in honor of our one hundredth anniversary. These were Okakura Kakuzō, second curator of the Asiatic Department, and William Sturgis Bigelow, "a follower of the Buddha, a lover and collector of the fine arts of Japan, a recipient of the Order of the Rising Sun," as his gravestone near Kyoto is inscribed. Both men were greatly interested in Zen. Okakura translated an ancient Chinese text on the subject of meditation, that characteristic feature of Zen discipline, and ten years later, in 1923, it was published in the *Harvard Theological Review* with a prefatory note by Dr. Bigelow. This work, entitled "On the Method of Practising Concentration and Contemplation," was probably the earliest scholarly translation dealing with this subject.

Among the masterpieces of Zen painting and calligraphy in Japan are a number of precious early works of Chinese origin. Twenty-seven of these are included in the exhibition and are shown for the first time outside Japan. For this unprecedented loan of works of art, including two national treasures and thirty-eight "Important Cultural Properties," I should like to express on behalf of our trustees sincerest thanks. First, we are profoundly grateful to the lenders: the national and private museums of Japan, the monasteries, and the private collectors who have parted temporarily with cherished works. We also acknowledge our debt to Mr. Hidemi Kohn, Commissioner, Agency for Cultural Affairs (Bunkachō), who received me with great courtesy in Tokyo, and the Deputy Commissioner, Mr. Kenji Adachi, who came to Boston to arrange the details of the exhibition, and Mr. Jo Okada, Counsellor, Cultural Properties Protection Department. Their friendly response and cooperative spirit throughout our preparations continue an ancient tradition of cordial relations, now nearly one hundred years old, between Japan and the Boston Museum. It is this bond that we also celebrate on our Centennial.

PERRY TOWNSEND RATHBONE
Director
Museum of Fine Arts, Boston

Acknowledgments

The idea of an exhibition of Ch'an and Zen art was conceived with the optimism of the ignorant, and its final realization has brought the organizers more humility than knowledge. If we have achieved anything at all, it is thanks to the many Japanese scholars whose studies of the works of art exhibited here were an invaluable source of information and inspiration. But, even though we have relied heavily upon their opinions, this should not make them in any way responsible for the opinions and statements made in the catalogue.

In one respect, however, we were left to our own devices. In writing the descriptions of the paintings, we could not, like our Japanese colleagues, reprint without comment the text of the colophons and encomiums, which often grace these paintings. We faced the sobering choice of ignoring, paraphrasing, or translating them. By choosing the last course in almost all cases, we have compounded our own dilemma, for these inscriptions frequently entail very thorny problems of interpretation. We have derived some solace and comfort from a remark made by the Japanese diarist Gidō Shūshin (1325-1366) concerning the colophons by Bompō: "His old-style verse is abstruse and rough; he uses many strange characters, which frequently makes his poems undecipherable." We can only hope that our feeble efforts at translating these cryptic texts will provide the interested viewer with a more complete understanding of these works of art and of the atmosphere in which they were painted, inscribed, and admired.

We wish to thank Professor Tanaka Ichimatsu, without whose erudite publications on the subject of Zen and ink-monochrome painting this catalogue could not have been written, not only for his generous advice but also for his encouragement and support of our efforts from the inception of the project. Mr. Watanabe Akiyoshi and Mr. Zaitsu Nagatsugi of the Agency for Cultural Affairs of the Japanese government kindly assisted us in the selection of pieces for the exhibition. They also provided us with photographs, measurements, and readings of the colophons, which were indispensable in preparing the catalogue. We are indebted to Mr. Kurata Bunsaku, Head of the Curatorial Department of the Tokyo National Museum, for his valuable assistance in the preparatory stages of planning.

Many aspects of the paintings would have remained obscure without the help of Professor Shūjirō Shimada of Princeton University; Dr. Hellmut Brinker, of the Rietberg Museum, Zurich, thoughtfully made available to us his notes on Professor Shimada's Japanese painting seminar held at Princeton, and these have been the source of substantial information. Professor John M. Rosenfield, of Harvard University, kindly consented to read our manuscript and suggested many improvements.

Mr. Chimyo Horioka and Mr. Yasuhiro Iguchi of the Department of Asiatic Art have contributed to the exhibition and to this catalogue in a multitude of ways. They have given us the benefit of their wide knowledge and experience, and we are deeply indebted to them for their help in deciphering difficult inscriptions. The entire staff of the Department of Asiatic Art participated in the preparation of the catalogue. Juliana Boyd and Pat Shen made valuable contributions to the preparation of the text, which was patiently typed by Francesca Eastman, Susan Erskine, and Tsering Yangdon.

JAN FONTEIN MONEY L. HICKMAN

Chinese and Japanese Chronology

CHINA		JAPAN	
Six Dynasties	220-589		
(Southern Liang, 502-557)			
Northern Wei Dynasty	386-535		
Sui Dynasty	581-618		
T'ang Dynasty	618-906	Nara Period	710-794
Five Dynasties	907-960	Heian Period	794-1185
Northern Sung Dynasty	960-1127		
Southern Sung Dynasty	1127-1279	Kamakura Period	1185-1333
Yüan Dynasty	1279-1368	Muromachi Period	1336-1573
Ming Dynasty	1368-1644	Momoyama Period	1573-1615
Ch'ing Dynasty	1644-1912	Edo Period	1615-1868

Introduction

The Beginnings of Ch'an Buddhism

The practice of contemplation or meditation (Sanskrit: *Dhyāna;* Chinese: *Ch'an;* Japanese: *Zen*) as a means of attaining Enlightenment is an ancient Indian tradition. The precedent established by Gautama Buddha, who attained Enlightenment under the Bodhi-tree through this practice, made contemplative practices an integral, vital part of Buddhism. Meditation was first introduced into China when the Buddhist Law reached that country from India. This happened sometime in the early centuries of our era, but for a considerable time while various sects of Indian Buddhism were transplanted to China and became firmly established there, meditation played a role of only minor importance. It was only after Buddhism had become thoroughly sinicized that meditation as a special, separate, and direct path leading towards Enlightenment came to be propagated.

Some monks, like the great Chih-i (538-597), retired to remote mountains to practice contemplation. Others, instead of seeking the seclusion of life in the mountains, mixed among the adherents of the orthodox Buddhist sects who repeated holy formulas for the acquisition of merit or studied the *sūtras* and their commentaries or placed their faith in the performance of esoteric rituals. Those who adhered to contemplative practices sometimes formed small enclaves within larger monastic communities of the orthodox sects. Perhaps the later stories about the eccentrics Han-shan and Shih-tê (see below, page XXIX and cat. no. 14) were reminiscences of a period when monks given to contemplation lived the life of semi-outcasts among the adherents of other sects.

Towards the end of the seventh century meditating monks had formed a monastic community at the East Mountain in Hupei. They were led by the monk Hung-jên (601-674), who later became known as the Fifth Patriarch of the Ch'an sect. From this mountain retreat the meditating monks gradually spread their practices all over the country, attaching themselves to existing monastic communities, especially those of the Lü or Vinaya sect, or setting up communities of their own.

As Ch'an Buddhism (as it later came to be known) gradually evolved into an independent Buddhist sect, the necessity for an established historical foundation grew. In China, new ideas often had gained acceptance by being presented

as the product of ancient tradition. Moreover, competition with such sects as the T'ien-t'ai, which claimed the ancient Indian philosopher Nāgārjuna as its spiritual ancestor, made it necessary for the Contemplative Sect to trace its image back to India. In order to support their religious claims to a status above all other sects of Buddhism, the Ch'an Buddhists projected their meditative practices back into the remote past and zealously reconstructed their own "ancient history." Ch'an, they claimed, was the essence of the Buddhist Truth, and had been transmitted from Śākyamuni down to the present, in unbroken sequence from teacher to pupil, without ever having been reduced to writing. The Ch'an sect thereby questioned the validity and authenticity of the *sūtras,* which were believed by all the other sects to contain the true words of the Buddha. Rejecting the written word, the Ch'an adepts laid claim to an unwritten doctrine, transmitted from mind to mind, pointing directly at the heart of man, who, by seeing into his own nature, might attain Buddhahood.

Their doctrine, the Ch'an adepts claimed, had been transmitted by an uninterrupted succession of twenty-eight Indian patriarchs, from Mahākāśyapa, the disciple of the Buddha, to Bodhidharma, the Indian sage who brought the doctrine to China. There the doctrine had been handed down from Bodhidharma to Hui-k'o, and from him through four other Chinese patriarchs to Hui-nêng (639-716). The process by which the Ch'an sect created its own history can be partially reconstructed by an analysis of various collections of biographies of Ch'an monks, which give us an idea of the methods which were employed in rewriting. Monks, most of whom were hardly more than isolated names, were rescued from the limbo of historical obscurity and posthumously elevated to the ranks of the patriarchs in order to supply missing links in the line of succession. In due course, the meager information on their lives was expanded and elaborated into biographies which abound in colorful and picturesque detail. The standard history of the Ch'an sect, as we know it now, and as it was accepted during practically the entire period covered by this exhibition, is the final result of a protracted and complicated process of continuous accretion and deliberate elimination, which took place between the seventh and thirteenth centuries.

Of special interest is the evolution of the legends which surround the alleged founder of Ch'an Buddhism in China, the Indian Bodhidharma (Japanese: Bodaidaruma, usually shortened to Daruma). The historicity of this figure is still a controversial problem, despite the efforts of various scholars. Bodhidharma, the legend tells us, was a South Indian prince, who came to China during the early part of the sixth century after long peregrinations. In an audience with the Southern Chinese Emperor Liang Wu-ti (502-550), a noted patron of Buddhism, he pointed out the uselessness of founding temples, copying *sūtras* and supporting monks (see cat. no. 7). According to late accounts, he crossed the Yangtze on a reed, and spent nine years in meditation in front of a rock wall at the Shao-lin-ssŭ, a monastery at Mount Sung in the state of Northern Wei.

Bodhidharma finally transmitted the "Seal of Mind" to the monk Hui-k'o, who had cut off his arm to express the deep sincerity of his religious resolve. Hui-k'o became the Second Patriarch (see cat. nos. 1 and 55). The end of Bodhidharma's life is as shrouded in mystery as is its beginning. Some stories say that he returned to India by land, or crossed over to Japan, while others state that he died in China at 150 years of age. A passage in the sixth-century *Lo-yang Ch'ieh-lan-chi* casually speaks of a Persian monk named Bodhidharma, who lived at the Yung-ning-ssŭ, and who claimed to be 150 years old. This statement is sometimes thought to be the historical grain of truth from which the later Ch'an legend grew. Bodhidharma's transformation in legend from a Persian into an Indian monk would seem to be in perfect keeping with what may be called the Indian mystique of Ch'an Buddhism.

Chinese and Indian Thought in Ch'an Buddhism

The reason why we speak of an Indian mystique is that in spite of all Ch'an protestations, there is no clear prototype or established precursor for the Ch'an among the Buddhist sects of India. Ch'an Buddhism is, as we shall see, a typical product of Chinese soil, a native Chinese reaction to the impact of Indian metaphysics on their culture. Although it is generally thought that Ch'an Buddhism was largely a product of the Chinese mind, and not directly inherited from India, it is nevertheless apparent that there are contributions from both sides. However, by the time the Ch'an sect was established and its

ideas formulated, Buddhism already had flourished for more than four hundred years, and to dissect such a movement into its Chinese and Indian components is not always possible. All we can do, therefore, is to suggest possible origins for some of the ideas which were incorporated into the doctrine of the Ch'an sect.

The literary descriptions of the search for Enlightenment by Ch'an masters are as fascinating as they are puzzling. The atmosphere they evoke is quaint and exotic. Thus, grumpy, strong-willed old teachers, who "stride around like oxen," reply to what would seem to be perfectly legitimate and sensible questions concerning the Buddha-nature or Bodhidharma's meditation with inarticulate exclamations such as *kuan!* or *ho!* or crudities mixed with paradox, or seemingly unconnected replies such as "Go, wash the bowls" or "When I was staying in Ching-chou I made a hemp robe which weighed seven catties." Teachers surprised their pupils with all kinds of bizarre tricks, shocking them into sudden realization of the Truth by means such as twisting their noses, beating them about the head, or crushing their feet in doors. Enlightenment was thus a dramatic, sudden event, which came unannounced, without forewarning, often under the most unusual circumstances.

A doctrine which so resolutely rejects the written traditions of Buddhism, which considers the veneration of icons useless and absurd, and which preaches highly unorthodox and paradoxical methods to attain Enlightenment, would seem to be as far removed from the mainstream of Buddhist tradition as is possible. Yet, upon closer scrutiny, there are many things which Ch'an and other forms of Mahāyāna Buddhism have in common.

As the schools of the Greater Vehicle (Mahāyāna) developed, the founder of the Buddhist Law, the Buddha Śākyamuni, receded gradually into religious obscurity. His renunciation of the world, his final attainment of Enlightenment were no longer considered to be unique events. Śākyamuni became incorporated in an infinite chain of Buddhas, the appearance of whom was thought to extend over an eternity of innumerable *kalpas* in the remote past as well as in the distant future. His identity as a person became abstracted, as he gradually came to be identified with the Truth which he himself had first proclaimed. Thus he became the visible manifestation of the Absolute Truth which is omnipresent in the universal "Buddha-nature."

The Ch'an Buddhists revived this remote figure and restored him to his original as an enlightened human being. In the story of his life, in his personal struggle for Enlightenment, which he attained through his own willpower and exertions, the Ch'an Buddhists found an inspiring example. In some respects this development represents a return to the wellsprings of primitive Buddhism. The Enlightenment of Śākyamuni is the central message of Buddhism, and in focusing again on this event in their direct, human way, the Ch'an Buddhists brought him back to life again.

The rejection of textual traditions by the Ch'an sect can easily be exaggerated. As its opponents pointed out with glee, even Ch'an adherents sometimes reluctantly admitted to the belief that Bodhidharma had transmitted a copy of the *Lankāvatāra-sūtra* to his disciple Hui-k'o. Although this would seem to be inconsistent with their claim of a "transmission outside the scriptures," the ideas of the Ch'an Buddhists do indeed have much in common with the doctrine of subjective idealism embodied in this *sūtra*. They, too, recognize that the phenomenal world is a mirage, a reflection of our impure minds, and that inner realization lies at the core of all higher knowledge. For a considerable time the Ch'an Buddhists seem to have formed a kind of Lankāvatāra sect mainly devoted to the study of this *sūtra*.

It was only when Hui-nêng, the Sixth Patriarch, appeared on the scene that the emphasis shifted to another text. Hui-nêng, his biographies tell us, made the resolve to follow the path to Enlightenment when he overheard a monk reciting the *Vajracchedikā-sūtra,* and it was during his patriarchate that the difficult and abstruse *Lankāvatāra-sūtra* gradually began to lose ground to the much more easily understandable *Vajracchedikā-sūtra.*

With the *Vajracchedikā-sūtra,* which is part of the *Prajñāpāramitā* literature, the concept of transcendent comprehension (*Prajñā*) as a source of Enlightenment became part of the Ch'an doctrine. This text also introduced the idea of *śūnyatā* or "vacuity," i.e., the relativity or irreality of things, the idea that on the highest philosophical plane reality is uncognizable and non-plural, that everything is identical, and intangible.

These ideas, which Ch'an adopted from the mainstream of Buddhist philosophy, are all

traceable to the Mādhyamika and Yogācāra schools of thought in India. Although Ch'an Buddhism may sometimes have twisted relativity in a somewhat negativistic direction, the ideas are all thoroughly Buddhist in character. One of the reasons they found such ready acceptance in Ch'an circles was that they corresponded in many ways to the older, more familiar Chinese concepts of Taoism. The idea of a transcendental principle (*Tao*), which manifests itself in Nature and is inherent in everything, approaches the concept of the universal, omnipresent Buddha-nature. Both Ch'an adepts and Taoists use the paradox to describe its action and practice contemplative methods in order to become part of it or to gain insight into this principle. Furthermore the Taoists shared with the Ch'an Buddhists an ingrained distrust of the human intellect, and the words it produces. The Taoists were the first to use the expression "a doctrine without words," which was later applied to Ch'an Buddhism.

The Northern and Southern Schools

The line of patriarchal succession, which, according to pious legend, had lasted through twenty-eight Indian and five Chinese patriarchates, suffered its first schism when Hui-nêng (638-716) was appointed Sixth Patriarch. The so-called Northern School formed by his opponent Shên-hsiu (died 706) lasted only a few generations, and most of our knowledge of the schism is based on rather one-sided information supplied by the victorious followers of Hui-nêng. The reasons for this schism undoubtedly are more fundamental than the mere rivalry between the two main proponents. The Northern School was ideologically closest to orthodox Buddhist ideas and inclined toward a quietistic approach, whereas the Southern School of Hui-nêng was more extreme in its propagation of the concept of Sudden Enlightenment. As a result the Northern School continued the study and exegesis of the *sūtras*, while the Southern School advocated the rejection of the written word. However, the controversy also had political overtones, for Shên-hsiu was backed by the notorious Empress Wu, whereas Hui-nêng and his followers received the support of the Confucianists.

In the end, the views of the Southern School prevailed and flourished; new subsects appeared and new lines of succession were established, each with its own center of activity and methodological variations. Most of the subsects developed into a complex pattern of patriarchal genealogies and shared the fate of the Northern School. Three schools of Ch'an Buddhism survived, and this only because they were transplanted to Japan. The most important of these are the ancient Lin-chi (Rinzai) School (see cat. no. 62), exported to Japan in 1191, and the Ts'ao-tung School (Sōtō), exported in 1228. Much later, in 1654 the Chinese priest Yin-yüan Lung-chi (1592-1673) of the Wan-fu-ssŭ near Foochow came to Japan. In 1661 he founded the so-called Huang-po (Ōbaku) branch, the third and last Ch'an school to be transplanted to Japan (see cat. no. 68).

The Earliest Form of Ch'an Art

Reliance primarily on a non-scriptural transmission made the question of the lineal authenticity of the succession from teacher to pupil a matter of crucial importance in the Ch'an sect. This deep concern for the authentic transmission of the "Seal of the Mind" stimulated the growth of the hagiographical literature of the Ch'an sect during the eighth, ninth, and tenth centuries, a movement which culminated in the compilation of *The Record of the Transmission of the Lamp*, a large collection of biographies, towards the end of the tenth century. The common motive in all of these biographical works is first and foremost to establish legitimate lines of transmission of the doctrine. Thus, they quote extensively from the conversations between teachers and pupils, in which the former display profound Ch'an wisdom by their "strange words and extraordinary behavior," and in which the latter earn their teacher's official sign of approval (Chinese: *yin-k'o*; Japanese: *inga*) by their enlightened answers or astute reactions.

The preoccupation with patriarchal genealogies, so evident in the early Ch'an literature, has its parallel in the earliest recognizable forms of Ch'an art: the theme of the Six Patriarchs Transmitting the Law and the Robe. The earliest reference to a painting of this type occurs in the opening paragraphs of Hui-nêng's *Platform Sūtra*, which gives a detailed and highly partisan account of the circumstances under which Hui-nêng became the Sixth Patriarch: "In this corridor they intended to have scenes from the *Lankāvatāra-sūtra* painted as an act of devotion. They also wanted paintings of the Five Patriarchs Transmitting the Robe [of Bodhi-

dharma] and the Law in order to spread knowledge about them and as a record for later generations. The painter Lu Chên had already inspected the walls and was planning to start the next day." Perhaps it illustrates the relative importance accorded to certain words in the Ch'an sect, in contrast to images, that this wall painting was never realized. That very night the empty space on the wall was taken up by the first of a series of competing couplets, composed by the monks Shên-hsiu and Hui-nêng. Their competition resulted shortly afterwards in the latter's confirmation as the Sixth Patriarch of the sect. Judging from the literary sources, paintings representing either the Sixth Patriarch or Six Patriarchs — unfortunately, the Chinese language does not draw a distinction between the two — were painted by a number of well-known artists, among them the T'ang artists Lu Lêng-chia and Ch'ên Hung. The Northern Sung painter Li Kung-lin painted *The Patriarchs Transmitting the Robe and the Law*. This work was kept in the collection of the Emperor Hui-tsung (reigned 1101-1126), but is now lost.

During the eleventh century, illustrated books with pictures of the Six Chinese Patriarchs or the Twenty-eight Indian Patriarchs were printed in Ch'an monasteries in Soochow and Foochow in Southern China. In 1072 the traveling Japanese monk Jōjin personally made a copy of such prints to send to Japan. Monk-painters eagerly copied these continental models. The drawing of *The Six Patriarchs of the Bodhidharma Sect* (cat. no. 1) is an example of such a Japanese copy. In spite of its modest size, it still conveys a vivid impression of a now almost completely vanished iconographic theme, which may well have been the oldest of all Ch'an themes in painting.

The Consolidation and Expansion of the Ch'an Sect

During the T'ang period (618-906) the monasteries of most sects of Buddhism became powerful and prosperous. About the middle of the ninth century, however, the impoverished and weakened central government, no longer able to afford the drain of wealth from the national economy which resulted from these huge tax-exempt institutions, reacted with a secularization program that resulted in a virtually complete destruction of the Buddhist monasteries in the metropolitan area and in those regions where the central government could still enforce the law. In regions farther removed from the capital and no longer in the hands of rulers loyal to the central government, monasteries often escaped the fate of the central provinces. Even so, most Buddhist sects never recovered from this crippling blow dealt to their economic position, continued to decline, and began to disappear altogether in the period of civil wars which came in the aftermath of the T'ang dynasty.

The period of the Five Dynasties (906-960), a time of steep decline for most of the sects of Buddhism, saw the Ch'an sect prosper, spread, and gain a foothold in the area which was to remain its stronghold during the next few centuries, the region in and around Hang-chou (Chêkiang Province). During this period most of present-day Chêkiang was part of the Kingdom of Wu-Yüeh. Under the patronage of the ruling Ch'ien family, Buddhism, especially the T'ien-t'ai school, went through a period of revival, stimulated in part by the recovery, from Korea and Japan, of Buddhist texts which had been lost in China.

The reasons for the survival and the resilience of the Ch'an sect cannot occupy us in detail, but need to be briefly sketched here. By the time the persecutions began, the Northern Branch of Ch'an, descended from Shên-hsiu, had already disappeared. The Southern Branch and its offshoots emerged from the period of the persecutions relatively unscathed. To some extent the sect may have owed its perpetuation to the organizational reforms which had been instituted by the great monk Po-chang Huai-hai (720-814) fifty years earlier. Up to that time, Ch'an monks had often lived in monasteries of the Lü sect and were obliged to obey its special monastic rules. Huai-hai established a new set of rules of conduct, different from those of the other sects and more in keeping with the Ch'an ideals of simplicity and austerity. In the newly founded monasteries, which were even admired by the Confucianists for their atmosphere of frugality, Huai-hai began to put these new regulations into practice. By doing so, he must have drawn his following away from the large and affluent institutions, which were soon to bear the brunt of the persecutions. By propagating his motto "Cling to nothing" he discouraged the accumulation of great wealth, and by enforcing the rule "One day without work, one day without food," he effectively reduced the native Chinese antipathy toward the

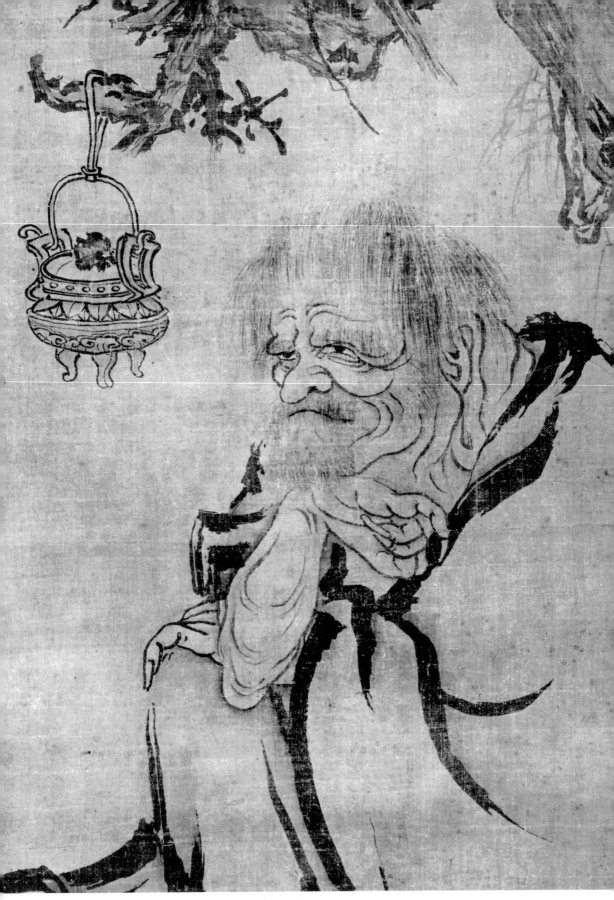

2. *Arhat reidentified as Shih-tê,* in the style of Kuan-hsiu,
ca. 14th century (detail)

non-productivity of the Buddhist clergy. Planting trees and growing tea or vegetables, the adherents of the Ch'an sect escaped from the odium of living by alms, which had been propagated by the Indian *vinaya*. From that time on, begging by the Ch'an monks was strictly regularized.

Kuan-hsiu (832-912): The Birth of Ch'an Art

It was in Chêkiang that the first great artist emerged from the Ch'an milieu, the monk, painter, calligrapher, and poet Kuan-hsiu (832-912). His *Three Arhats* (cat. no. 2), although undoubtedly copies several hands removed from originals by the master, illustrate some of the typical characteristics of Ch'an art, which were to remain its hallmarks throughout its entire history.

During the middle of the T'ang period certain artists appeared who distinguished themselves by their nonconformist methods of painting. One of them is Wang Mo ("Ink Wang") who painted landscapes starting from configurations of ink splashes, spattered freely on the silk, which he then elaborated in a composition. Supposedly painting only when he was drunk, Wang Mo was in the habit of stamping upon his pictures with his feet and of smearing them with his hands. Nevertheless, these unorthodox ways were recognized as having their own artistic merit.

The art critics consequently established a separate category for the practitioners of such techniques, whose work did not conform to the "basic methods of painting" — the *i-p'in* or "untrammeled" class.

The artists of this category usually worked in ink-monochrome. Their brush methods were unrestrained, coarse, and "deficient in bone structure," according to their critics. They painted simplified, sketchy shapes, which they indicated with a few strokes of the brush. The use of these unorthodox methods of painting gradually spread during the Five Dynasties and Sung periods. That they gained increasing acceptance among the art critics is clearly indicated by the fact that the "untrammeled" class — a classification implying judgment of quality as well as describing style — began to be placed at the head of the traditional threefold classification of painters according to their artistic ability. It was among the artists of the western Chinese state of Shu (present-day Szechwan) that the untrammeled methods of painting gained con-

siderable popularity. While unrest and civil war engulfed the rest of the country, this secluded and peaceful area became a haven of refuge for artists from other regions. When Kuan-hsiu became implicated in political intrigue, he too headed west for the state of Shu, where he was warmly received because his fame as a poet and painter had already preceded him there. Thus it happened that the first great artist with a Ch'an background came into contact with the artists of the untrammeled class.

The fact that the rise in popularity of the untrammeled styles of painting coincided with the appearance of the first real Ch'an artists, could be a mere accident of history. Although practically nothing is known about the evolution of Kuan-hsiu's style, he may well have been painting in an unconventional manner before he came to Shu. How strongly he was influenced by the *i-p'in* artists is not clear. It is quite conceivable, however, that a Ch'an artist, reared in an atmosphere where the authority of the canonical texts of Buddhism was emphatically rejected, would adopt a method of painting which deliberately deviated from the classical precept of "fidelity to the object in portraying form." Although some of the existing works attributed to Kuan-hsiu are painted in colors, the paintings in this exhibition are in ink-monochrome, a technique which is specifically mentioned in literary sources as one in which Kuan-hsiu excelled. This in itself is not surprising, for Kuan-hsiu had a great reputation as a calligrapher and was compared with the "mad" monk Huai-su (725-785), who practiced the "unrestrained cursive style." Thus we may assume that Kuan-hsiu's methods of painting and writing were equally unorthodox. To work in ink-monochrome rather than in colors would seem to be in keeping with the Ch'an spirit of simplicity, and to reduce the many colors of the phenomenal world to values of gray and black was a method which certainly had an essential affinity with Ch'an ideas. If it was merely an accident of history which brought Kuan-hsiu into the group of the *i-p'in* and ink-monochrome practitioners, it certainly was a momentous occurrence. For it is clear that from the time Kuan-hsiu first painted his Arhats, there has been a close affinity between unorthodox brushwork in ink-monochrome and themes or subjects favored in Ch'an circles.

It is also of importance to note that Kuan-hsiu's behavior typifies the attitude and way of

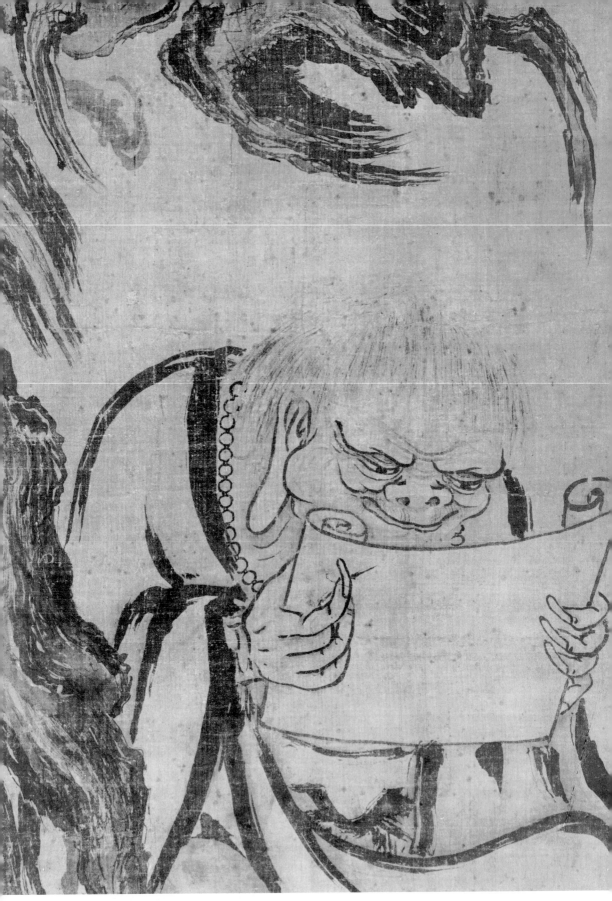

2. *Arhat reidentified as Han-shan,* in the style of Kuan-hsiu, ca. 14th century (detail)

life characteristic of many later Ch'an artists. Renowned for his poetry and calligraphy, Kuan-hsiu maintained numerous contacts with the intelligentsia of his generation. Especially during the Sung and Yüan periods this tradition of intellectual accessibility, often leading to exposure to politics, was to be an important factor in the mutually productive cultural exchange between Buddhism and Neo-Confucianism. Because of their secular contacts, the Ch'an artists were able to find inspiration in thoughts and forms which would have remained outside their range of vision if they had stayed entirely within the monastic confines of their Ch'an institutions. Conversely, many concepts of the Ch'an Buddhists, in art as well as in literature, penetrated into literati circles and even influenced certain of the academic artists.

The predictable result of this interaction is that there are paintings which represent typical Ch'an themes executed by artists who were not themselves Ch'an priests. In this exhibition the two paintings attributed to Ma Yüan (cat. no. 4) and *Two Patriarchs Harmonizing Their Minds* (cat. no. 3) by Shih K'o are the works of artists who were never part of the Ch'an sect. Conversely, there are paintings by Ch'an priests that are strictly secular in artistic origin and have no overt connection, symbolic or otherwise, with Ch'an ideas. That *Two Patriarchs Harmonizing Their Minds,* which belongs to the earliest period of the development of ink-monochrome painting in China, should happen to deal with a Ch'an theme, is an interesting phenomenon in the history of Chinese painting but should not create the misconception that Ch'an is necessarily ink painting or, conversely, that ink painting is Ch'an, nor that *i-p'in* and Ch'an are identical modes of expression.

Ch'an Literature and Kōan

The T'ang period has often been called the "Golden Age of Ch'an Buddhism." The Japanese have called it the "Epoch of Zen Activity" (*Zenki no Jidai*), the word "activity" here being used in the sense of creative ability or originality of thought. By giving it this name, they have stressed one of the most striking features of the activity of the great Ch'an masters of the T'ang period: their singularly unpredictable originality and liveliness of spirit. Their determined, singleminded quest for Enlightenment and their unrelenting efforts to shake and shock their pupils into realization of the Truth are full of

eccentric originality and have a spirited vitality. It was only natural that this movement should one day spend its energy and start to slow down.

That seems to be what happened during the Sung period, and many of those who were living at that time realized the inexorable process which was taking place. As time passed, the path to Enlightenment, which the great Ch'an masters of the T'ang period had found in a direct, immediate, intuitive fashion, and not as the result of an involved process of cogitation, gradually was lost. Dōgen, the monk who introduced Sōtō Zen into Japan in 1228, lamented that the T'ang period had been the great epoch of Ch'an and that by Southern Sung times it had lost all of its "purity." In their search for this purity, spontaneity and vitality, which had carried earlier generations of Ch'an priests to the realization of Truth, later Ch'an adepts turned to the "strange deeds and extraordinary behavior" of the ancient masters. Searching for clues to what was basically an incommunicable experience, they began to commit to writing the many puzzling stories which they found either in the biographical literature or oral traditions transmitted to them from the past. One visionary (or perhaps reactionary?) monk tried to destroy the manuscript of the *Green Cliff Record* (early twelfth century), a collection of one hundred strange Ch'an stories which are accompanied by equally abstruse commentary and verse. He feared that by reducing Ch'an lore to writing its spontaneity would be lost forever. One must admit that this is what eventually happened. Dōgen, however, who deplored the loss of T'ang "purity," was not free from literary inclinations. He is reputed to have spent the night before he sailed home from China in a determined effort to copy the entire *Green Cliff Record.* The result of his labors still exists and is known as the *Ichiya-bon,* the "One-Night Book."

By committing the acts of the ancient patriarchs to writing, the Ch'an monks fixed and codified the stories about their distant predecessors, calling them "precedents" or "cases" (*kung-an*; Japanese: *kōan*), a term borrowed from legal terminology.

The *kōan* became the subject of intense study, especially in those subsects which continued to adhere to the doctrine of "Sudden" Enlightenment. The students were required to cogitate on them, to "solve" them, in the hope that this would help them recapture the spirit of the classical period of Ch'an. But of even more

importance, the primary aim of this method of teaching was to provide the pupils with a tool with which they could attain Enlightenment themselves.

The T'ang masters had created and lived *kōan*, while the Sung masters contemplated and studied them. With the benefit of hindsight, we can explain this change in Ch'an mood and method as the inevitable result of institutionalization. The growth of a voluminous literature, created by a sect which claimed "transmission outside the scriptures" as one of the fundamentals of its creed, is an indication of change, but can hardly be viewed as a symptom of decline. By some of the Ch'an and Zen monks who actually took part in these developments — Dōgen is a typical example — these changes were viewed as an omen of the inexorable decline of the religious momentum.

Even though we may find Dōgen's harsh judgment too romantic and onesided, one cannot entirely escape from the impression that the artistic élan of the Ch'an sect reached its peak a considerable time after the original religious spontaneity and philosophical creativity had begun to decline. Whether a direct correlation exists between these two phenomena is difficult to judge. The creativity of the Ch'an sect is not simply explained as an accumulation of creative energy which, in accordance with some law of nature, had to find an outlet, be it in original doctrinal speculation or in art. It has been taken for granted too often that the search for Enlightenment and the desire for artistic expression can be equated, and that the attainment of Enlightenment and artistic inspiration are experiences of a similar kind.

In considering these points two important facts have to be taken into account. The first is that the nostalgia for the "Epoch of Zen Activity" was one of the primary motivations behind the growth of Ch'an literature and that, as we shall presently see, a very important part of Ch'an art was based in turn upon the writings which this longing for the "creative" past had produced. The second is that it is almost as difficult to determine when the philosophical creativity abated as it is to establish when Ch'an art began to develop. Perhaps enough literature has been transmitted to gain insight into the progress of philosophy. Our vision of early Ch'an art, however, is bound to remain unclear, for we can only base our judgment on the few isolated works of art which chance has preserved for us.

Ch'an Art during the Northern Sung Period (960-1126)

The Northern Sung period was a time when there were only sporadic contacts between China and Japan. The few Japanese who made the crossing usually went on pilgrimages to the revered sites of T'ien-t'ai Buddhism. This was the original motivation for the journey of Eisai, through whose efforts Zen was finally introduced into Japan.

After the firm establishment of Ch'an Buddhism in Japan, monks began to go to China to "seek the Law," i.e., to sit at the feet of the great Ch'an masters on the continent. As we have already seen, the monk Jōjin sent home a drawing of the Six Patriarchs, but this still was an isolated instance during the Northern Sung period. It was not until later, after the move of the seat of the Chinese Government to Hangchou (1126), that Japanese monks began to collect the artistic materials on which our entire knowledge of Ch'an art is based. The infrequency of previous contacts and the preoccupation of the early pilgrims with other sects of Buddhism probably account in large part for the fact that so little Ch'an art of the Northern Sung period has survived.

The literary sources of the Southern Sung period give us no inkling of the sudden development of artistic talent, which is attested to by the actual Ch'an paintings preserved in Japanese collections. The few, isolated remarks on Ch'an art in Northern Sung records cannot be taken, therefore, as an indication that the production of Ch'an art was necessarily small in quantity at the time. Some impression of the artistic production, vague though it is, may be gained from the small number of rare illustrated Chinese books, and the scattered literary references which throw some dim light on the religious and artistic movement which produced these books.

During the middle of the eleventh century, Ch'an monks and Buddhist laymen began to compose poetry of an allegorical type, in which man's grasp of the Ch'an doctrine was likened to a tenfold parable of the ox and its herdsman (see cat. no. 49). At least a dozen of such sets of "songs" are known to have been composed, and it would appear that it became a literary fashion to write sets of *Ten Oxherding Songs* and publish them in illustrated books. This vogue was part of a larger movement to reduce the contents of large *sūtras,* such as the *Gandavyūha,* to a series

of fifty-three poems, devoted to the Good Teachers, whom the boy Sudhana visited in his legendary search for Enlightenment. These poems were also published in illustrated books, and at least two authors, a Ch'an priest and a layman, tried their hand at both themes. To illustrate these books required artistic talent, and several of the authors supplied their own illustrations, as they were amateur painters. Whereas all early Chinese copies of the *Ten Oxherding Songs* have disappeared, a few Sung copies of the illustrated *Gandavyūha* texts have been preserved.

At least one of the artists involved in composing and illustrating such poetry was an artist whom we may safely place in the untrammeled class. This was Yang Chieh, whose description says: "He excelled in painting demons and spirits. Each time he put his brush to the paper he would first paint the hands and feet, then he would finish the whole figure in two or three strokes." This description fits almost perfectly such pictures as Shih K'o's *Two Patriarchs Harmonizing Their Minds* (cat. no. 3). One of the painters and poets of *Gandavyūha* illustrations, the Ch'an Master Chung, is said to have painted in a style comparable to that of the great Northern Sung artist Li Kung-lin (1040-1106), and the work of the Ch'an monk Fo-kuo, another Ch'an illustrator, shows the unmistakable influence of the line-drawing technique for which Li Kung-lin was famous. This shows that the Ch'an artists were not working in some sort of artistic vacuum, but were cognizant of the main artistic trends of contemporary art and responded to these according to their own inclinations.

Ch'an Monks and Literati

There would be no special reason to dwell here at any length on the work of one group of early Ch'an artists whose entire oeuvre has been lost, if it were not for the fact that the circumstances which led to the publication of the *Ten Oxherding Songs* and the rhymed abstracts of the *Gandavyūha* reveal some interesting facts about the relations between literati and Ch'an monks during the Northern Sung period. A tradition of cordial relations had already been established by the time Kuan-hsiu roamed the country. He was a famous poet and calligrapher, and must have found it easy to associate with people of similar interests. The information we have about the obscure artists who were involved in

writing and illustrating these books clearly shows, however, that even Ch'an monks of lesser fame were on congenial terms with the famous literati of their time. Well before the effects of the lively interaction of these two groups may be seen in actual works of art, members of the literati group and Ch'an monks often met and established close bonds of friendship.

The most famous coterie of Northern Sung literati consisted of the great writer, poet, and calligrapher Su Shih, his brother Su Ch'ê, the calligrapher and poet Huang T'ing-chien, the painter Li Kung-lin, and Mi Fu, an amateur painter who was primarily known as a calligrapher and art collector. Su Shih, Huang T'ing-chien and their close friend the Ch'an monk Fo-yin later made their appearance in Ch'an painting as the Three Vinegar Tasters.

It was among these intellectuals and artists that the basic ideas first began to be formulated which led to the rise of the literati school of painting. By shifting the emphasis from the subject-matter of painting to its formal elements, and thereby extending concepts and ideas which had first been developed in poetry and calligraphy into the realm of painting, the literati asserted that a work of art expresses and communicates to its viewer the personal character of the artist, and the mood in which he created his work.

Although an examination of the theories of the literati school would lead us too far away from the topic at hand, certain close parallels between the ideas of literati and Ch'an monks should be mentioned. Thus there is the common idea that the painting reveals the character of the artist, and that there is no need to stress skill and technique. The idea of "deliberate awkwardness," which the literati propagated, also must have been agreeable to the Ch'an artists. Furthermore, because of their familiarity with the concept of "by Mind transmit to Mind," the idea of transmitting the spirit of the artist by non-descriptive, "abstract" means must also have been perfectly acceptable to the Ch'an monks. However, even though many of the ideas of the literati may have touched a responsive chord among Ch'an priests, it cannot be denied that there are clear differences between them. Most important, perhaps, was the Confucian mood of loftiness and restraint, or nobility of spirit, which was not part of the traditions of the Ch'an monks, even though each group in

its own way expressed an aversion to the over-attachment to things.

Nevertheless, there was enough common ground to allow a lively exchange of ideas. The profound influence of Buddhism on the rising Neo-Confucian school is well known and need not be treated here. It not only extended into such forms of literature as the "Recorded Sayings" and into a form of meditation practiced by the Neo-Confucianists, but penetrated deep into the highest spheres of philosophical speculation. The influence of Sung Confucianism on Ch'an is less clear, but in Ch'an art the impact of the literati is omnipresent. In fact, the parallels become so numerous that James Cahill has written: "It may be questioned whether a valid division [between literati and Ch'an schools] can in fact be made, whether they should not be regarded as a single school of amateur artists. In styles they overlap; perhaps they should be distinguished, if at all, on the basis of attitude: the more intellectual approach of the Confucian literature as against the intuitive one of the Ch'an monks" (Chinese Painting, Geneva, 1960, p. 96).

The Repertoire of Ch'an Themes

In view of the frequent contacts between literati and Ch'an monks, it is only natural that the styles of painting of these two groups overlap, and that the lines of distinction often become blurred. Themes dealing with Nature, whether it be landscape, animal or plant, can be seen from the Ch'an point of view by pointing out that the Ch'an painter was aware of "a single reality underlying the phenomena of nature." But who is to draw a clear distinction in art between the reality of the "Buddha-nature" of the Ch'an monks or the "mind" which the Neo-Confucianists consider the fundamental principle behind all phenomena?

The most obvious criterion for establishing what Ch'an art is lies in its subject matter, and the evolution of Ch'an art can best be followed through the gradual development of this repertoire of typical Ch'an themes.

Claiming to transmit a doctrine outside the scriptures which could not be expressed in words, the Ch'an sect rejected the authority of most of the sūtras which the orthodox Buddhists believe to contain the teachings of the Buddha. By doing so they turned their backs on the vast corpus of canonical literature which provided a source of inspiration for more orthodox Bud-

dhist artists. The rejection of the written word by the Ch'an sect is graphically expressed in Liang K'ai's The Sixth Patriarch Tearing up a Sūtra (cat. no. 6), and the lack of respect for icons could not have been more appropriately and brilliantly illustrated than in The Monk from Tan-hsia Burning the Wooden Image of the Buddha (cat. no. 13). Yet, although both masterpieces are typical creations of the Ch'an sect, their message should not be taken literally. After all, the "doctrine without words" had produced a large volume of religious literature, and the occasional outbreaks of anti-scriptural protests seem to have been directed not so much against the beliefs of the orthodox sects as against certain literary tendencies within the Ch'an school itself. The artistic counterpart of the anti-scriptural tendencies is iconoclasm. Except for such cases as the monk from Tan-hsia, there is no evidence of this kind of fanaticism in Ch'an or Zen. However, there is no indication that Ch'an Buddhism succumbed to the cult of icons which played such a prominent role in other Buddhist sects.

The Buddha and Figures from the Buddhist Pantheon

The general rejection of the sūtras automatically eliminated, at least in theory, a vast number of orthodox Buddhist themes. Moreover, whenever themes concerning orthodox Buddhist concepts were represented at all, a certain aloofness from exact iconographical representation and a deliberate effort to make the work of art look different from an orthodox icon are clearly noticeable. All schools, orthodox as well as Ch'an, accept the first part of the life of the Historical Buddha, leading up to his Supreme Enlightenment. As we have already seen, the Ch'an sect returned to a more humanistic, less abstract concept of the Buddha, and saw him in the first place as the supreme example of an Enlightened Being. In keeping with this concept, the Ch'an artist usually represented the Buddha not as a stylized remote Tathāgata-type, but as an Indian monk. In a way, he was regarded as the First of all the Arhats. The Arhats (Chinese: Lohan; Japanese: Rakan) represented the class of beings who have attained Enlightenment by themselves, but are unconcerned about the Enlightenment of others. Vague figures from Indian Buddhist antiquity, about whose lives almost nothing is known, the Arhats fitted well into the Indian mystique of the Ch'an sect, and the

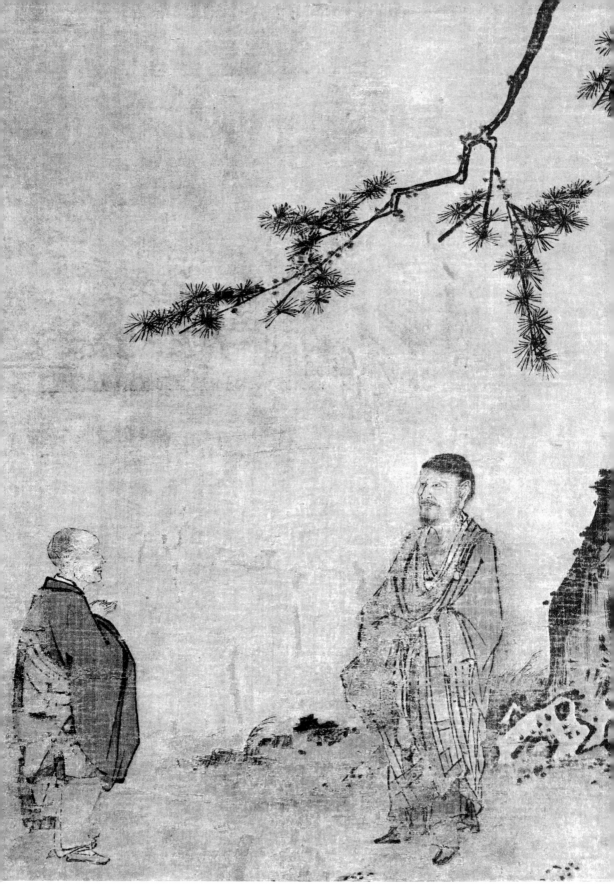

4. *Fa-yen Wên-i and His Teacher Lo-han Kuei-ch'ên,*
attributed to Ma Yüan (ca. 1150-1230) (detail)

artist, relatively free in the way he wished to represent them, often created fantastic, almost grotesque "Indian" figures (cat. no. 2).

In their selection of the moments from the life of the Buddha which they represented in art, the Ch'an painters made a choice which deviates from that of the traditional sects. Obviously, a school which claimed to have received the wordless doctrine from the Buddha himself had little interest in his later activities as a preacher. Surprisingly, however, the theme of the actual moment of Supreme Enlightenment, though not lacking in Ch'an art, is uncommon. Perhaps there was some reluctance to represent not only the Buddha's Supreme Enlightenment, but also the actual moment of *Satori* of Zen priests. Instead we find representations of the Buddha undergoing austerities (cat. no. 53) and, most frequently, his return from the mountains after he had relinquished asceticism as a path leading toward Enlightenment (cat. no. 28). Although Reisai and Minchō have painted the scene of the Death of the Buddha (*Parinirvāna*), it would seem that this reflects the widespread popularity of this theme in orthodox Buddhist circles and should not be taken as part of the typical Ch'an repertoire.

The selection of other Buddhist figures from the vast traditional pantheon is perhaps somewhat more easily understood than the choice of the events from the life of the Buddha. The White-Robed Kuan-yin was perhaps the most informal, the most secular, and the least Bodhisattva-like figure of the entire Buddhist pantheon. The theme of Śākyamuni Returning from the Mountains as well as the White-Robed Kuan-yin (cat. nos. 19, 33, and 35) may have both come into the Ch'an repertoire through the work of the much-admired Northern Sung literati painter Li Kung-lin (died 1106). The only other traditional Buddhist deity to be included in the Ch'an pantheon is the Bodhisattva Mañjuśrî (cat. no. 32). This Bodhisattva embodies the idea of transcendental knowledge (*Prajñā*) and came closest to the Ch'an concept of the Ideal Teacher as the Bodhisattva who guides the faithful on their way to Enlightenment.

The deities adopted by the Ch'an sect from orthodox Buddhism were depicted in accordance with the descriptions of these figures in the *sūtras*. During the eleventh and twelfth centuries, when Ch'an literature had become fully developed, the artists of the Ch'an school began to draw upon their own Ch'an literature for artistic inspiration. Naturally, one of the most important figures they selected was the First Patriarch, Bodhidharma. Even within the limited framework of this exhibition, we can follow the evolution of this theme through several of its most important stages. The Founder of Ch'an is shown as an ordinary monk in *The Six Patriarchs of the Bodhidharma Sect* (cat. no. 1). During the Southern Sung period (cat. no. 7), however, he had already acquired most of the facial features which would serve as a prototype for the later Japanese Bodhidharma representations (cat. no. 57). The *"Red-Robed"* Bodhidharma of the Kōganji (cat. no. 20) represents a different Chinese tradition. More portrait-like than any other representation of Bodhidharma, this masterwork comes as close to a real icon as is possible in the Ch'an sect. Such representations as *Bodhidharma Crossing the Yangtze on a Reed* (cat. no. 22) and *Bodhidharma Contemplating a Wall* (cat. no. 55) illustrate events from the life of the First Patriarch which are later additions and embellishments of his biography.

Zenkiga

The cryptic discussions and confrontations between Ch'an teachers and pupils, which make up such an important part of the biographical literature, found their way into art through a category of Ch'an painting which the Japanese have called *zenkiga*, i.e. paintings of Zen "activities" (see above, p. xxi). Just like the literature they illustrate, these paintings may suggest paths leading to Enlightenment. Although written *kōans* were used for instruction, there appears to be no evidence that the visual representations of these same stories served the purpose of training Ch'an adepts. The only exceptions are the illustrations of the *Ten Oxherding Songs*, but these were an integral part of the scroll or book in which text and illustration were reproduced together.

Zenkiga is a generic term, and it is possible to subdivide the large body of painting belonging to this group into several categories. A large group consists of representations of visits, dialogues, and encounters. These can be meetings between teachers and pupils, a type of painting represented in this exhibition by two works by Ma Yüan (cat. no. 4). This type of representation is sometimes referred to as a "Patriarch Meeting" (Chinese: *tsu-hui-t'u*) or as

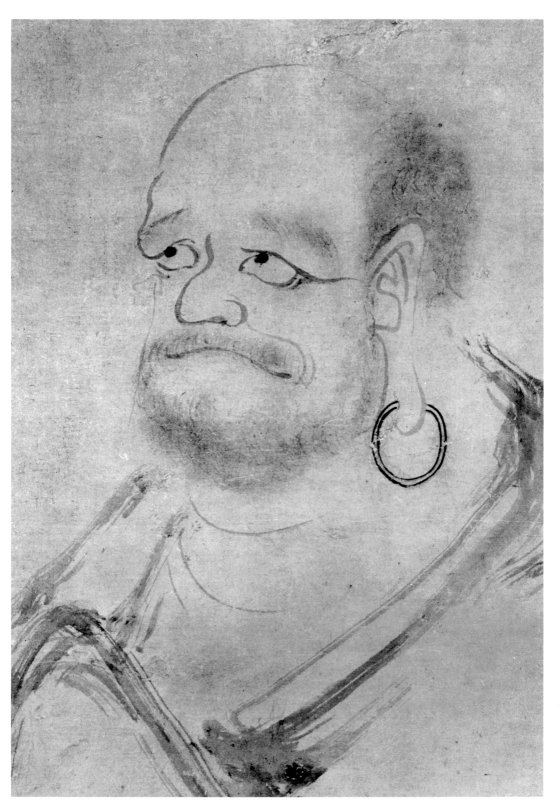

7. *Bodhidharma,* artist unknown, 13th century (detail)

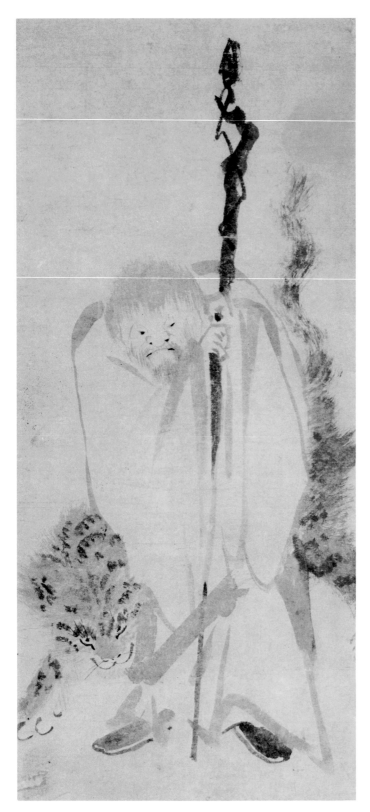

7. *Fêng-kan,* by Li Ch'üeh, 13th century (detail)

a "Ch'an Visit" (ts'an-ch'an), a term still used among Zen adepts for the private interview between teacher and pupil at stated times. Other categories of meetings represented in these paintings take place between Ch'an monks and persons who are either ignorant of Ch'an or committed to other ways of life. The conversation between the Monk from Tan-hsia and the abbot of the temple whose image he burned (cat. no. 13), or the visit of Ma-tsu to the recluse P'ang (cat. no. 17) both seem to fall into this category, which is known as "Ch'an meetings" (Chinese: Ch'an-hui; Japanese: Zen-e). Often, the titles of such paintings mention the words "question and answer," i.e., dialogue (Chinese: wên-ta; Japanese: mondo). This is a very descriptive form of art, sometimes not far removed from historical figure painting. It is not surprising, therefore, that it attracted artists who are not known for their connections with Ch'an Buddhism. The pair of hanging scrolls from the Tenryūji (cat. no. 4) is a perfect example of Ch'an art created by an artist of the Academy with a professional painter's background.

A special category of zenkiga, which often poses difficult problems of interpretation, is that of pictures which supposedly represent a Ch'an monk in the act of attaining Enlightenment. The unusual circumstances under which certain Ch'an monks attain Enlightenment, such as hearing the sound of a stone against bamboo or seeing his own face reflected in the water when fording a stream, are described in biographical Ch'an literature. Chinese representations of Ch'an monks attaining Enlightenment are almost nonexistent. According to an old tradition, The Sixth Patriarch Chopping Bamboo (cat. no. 5) represents Hui-nêng at the moment when hearing the sound of bamboo being chopped brought him Enlightenment. However, this Japanese tradition has no support in literary sources, and this is also true of many other paintings belonging to this category. The possibility that the interpretation of these paintings is a later Japanese elaboration, which occurred after the original meaning of the painting had been lost, should therefore not be altogether excluded.

The Ch'an Eccentrics in Art

The next category of subjects, though still typically Ch'an in character, is of a somewhat different nature. The encounters and confrontations with persons such as P'ang Yün (cat. no.

17) almost invariably represent personages of a definitely historical character, even if their brilliant sallies and clever repartee may have been embellished by later chroniclers. Another group, however, consists of a number of weird figures, whose historical authenticity is less clear. There are several features in their biographies which makes it doubtful that these waggish additions to the Ch'an pantheon of eccentrics really ever existed. First of all, they do not seem to appear in any of the pedigrees which record the lines of transmission of the doctrine. Although their bizarre unworldliness bears testimony to their advanced stage of Ch'an perception, and although the names of their teachers are sometimes mentioned, these figures never seem to have founded lines of their own. Secondly, their place of birth and secular name — biographical data which are available for almost all prominent Ch'an monks — are generally unknown. Instead we find a long list of strange, occasionally even facetious names, highly contradictory dates, and a dearth of any solid biographical information.

The first and by far the most famous Ch'an eccentrics who belong to this category are Han-shan ("Cold Mountain"; Japanese: Kanzan) and Shih-tê ("Foundling"; Japanese: Jittoku). The origin of the legends of Han-shan and his inseparable companion Shih-tê can be traced to a collection of about three hundred T'ang poems, known as the Collected Poems of Han-shan. The suggested dates for Han-shan, the alleged poet of these verses, range from 577 to 871. The numerous chronological discrepancies in the earliest accounts strongly suggest that Han-shan, Shih-tê, and Fêng-kan, a Ch'an priest who befriended them, are all legendary personages, whose elaborate fictional biographies were constructed upon a few lines of poetry and the preface of the Collected Poems.

According to this preface, Han-shan was a recluse and poet who lived on Mount T'ien-t'ai (Chêkiang, a place renowned for its hermits, both Taoist and Buddhist). He was a friend of the monks Fêng-kan and Shih-tê of the Kuo-ch'ing-ssŭ, a monastery near his hermitage. Shih-tê, who had been found as a child by Fêng-kan, and who had been brought up in the monastery, worked in the dining hall and kitchen. He supplied his hermit friend with leftovers. Sometimes, the legend says, Han-shan would stroll for hours in the corridors of the monastery, occasionally letting out a cheerful cry, or laughing or talking to himself. When taken to task or

driven away by the monks, he would stand still afterwards, laugh, clap his hands, and then disappear. Judging from his poems, which abound with references to the *Tao-tê-ching* and *Chuang-tzŭ,* the Taoist classics, Han-shan was actually more of a Taoist recluse than a Ch'an monk, and most of the Buddhist references in his poems are taken from the *Mahāparinirvāna-sūtra*, a work not highly regarded in Ch'an circles. Later, Han-shan and Shih-tê came to be regarded as avatars of Bodhisattvas (Mañjuśrī and Samantabhadra) and took their place in the Ch'an pantheon.

The Ch'an painters often represented these two eccentrics at work, an artistic tradition which had its beginning in the Sung period. It is quite possible, however, that their companion Fêng-kan, always escorted by his pet tiger, gained earlier recognition as a figure worthy of inclusion in the repertoire of Ch'an painters. If the copy after Shih K'o (cat. no. 3) accurately reflects a work of this master, Fêng-kan Sleeping on His Tiger is a Ch'an theme which antedates the earliest Han-shan and Shih-tê pictures by a considerable period of time.

Another Ch'an eccentric is the potbellied Pu-tai, the only personage of this group who became a popular deity in Chinese folk religion. The biographical works list him under the monk's name Ch'i-tz'ŭ, a weird name meaning "Congruent with This." His name Pu-tai is a facetious, punning nickname, for it can mean "cloth bag" or "glutton." Pu-tai carried a cloth bag on a stick over his shoulder. Wandering around the country, he begged for food and alms, and whatever he received he promptly put into his bag.

This potbellied, bald, and wrinkled figure, sometimes cheerful, sometimes crude, and always taciturn when confronted with Ch'an riddles, was believed to be an avatar of Maitreya, mainly on the strength of some cryptic statements which he had made himself. Some maintain that he died in 916 or 917, which is in conflict with descriptions of his alleged exploits twenty years later. Whatever the exact date of his death may have been, all accounts agree that it became fashionable to paint portraits of Pu-tai, if not already during his lifetime, then at least shortly after his death. The *Sung Kao-sêng-chuan,* compiled ca. 988, says that his portrait was frequently painted by the people of the Yang-tzu and Chêkiang regions.

This pageant of eccentrics of dubious historical authenticity becomes complete with Hsien-tzŭ ("Clam") and his companion Chu-t'ou ("Pig's Head"), two unrelated figures, whose eccentricity consisted of non-vegetarian habits.

Chinsō: The Portraits of Ch'an Masters

The Ch'an themes which have been described in the preceding pages can often be recognized immediately by their bizarre figures. The real core of Ch'an art, however, which reveals the essence of Ch'an more directly than any other type of painting, is portraiture: seemingly conventional paintings representing monks seated in high chairs, usually holding one of various Ch'an implements in their hands.

Ch'an portraiture is a highly personal form of art, as intimately connected with the idea of the orthodoxy of transmission as the ancient theme of the Six Patriarchs Transmitting the Robe and the Law. In the Ch'an sect, it was customary that each disciple who had achieved Enlightenment was given a portrait of his teacher. In recognition of the advanced stage of the disciple's perception, the teacher would inscribe his portrait with a personal dedication or eulogy. It is unclear just when the practice of presenting pupils with portraits began, and there is almost no evidence left in China that the artistic tradition ever existed at all. If it were not for the many Japanese monks who proudly returned to their homeland carrying the portraits of their beloved teachers, we would probably never have known anything about this form of Ch'an art.

It would be wrong to think, however, that the Ch'an portrait, usually referred to by its Japanese name *chinsō*, was nothing but a diploma or certificate, intended simply to testify to the fact that the pupil had attained *Satori* and that he had therefore taken his place in the line of succession. Much to the contrary, the Ch'an portrait is the tangible artistic expression of the deeply personal relationship between teacher and pupil which is one of the fundamental characteristics of the Ch'an sect. By having the portrait of his teacher ever with him, the pupil could always maintain the indivisible spiritual bond with his teacher through this symbolic presence of the painting, drawing from it the inspiration and the psychological comfort which he would need on his way through life.

Naturally, this high ideal was not maintained in every case, and certain portraits seem to have

been made to satisfy more general, ceremonial purposes. The *Butsunichi-an Kubutsu Mokuroku,* an inventory of works of art in the Engakuji in Kamakura dating from 1365, lists thirty-nine portraits of Chinese Ch'an monks. About half of these bear inscriptions by the sitter (Japanese: *jisan*), suggesting that they may have been given to pupils. The other half consists of portraits inscribed by other monks, usually contemporaries. All of these portraits represent well-known Ch'an monks, worthy of being included in a collection of portraits of the spiritual ancestors of the school.

Certain prominent Ch'an teachers, who were particularly respected by the Japanese, had large followings, with the result that several of their portraits survive. Chung-fêng Ming-pên, whose portrait is shown in this exhibition (see cat. no. 15), must have given away a large number of portraits, to judge from surviving examples. Although several of Ming-pên's portraits, including the example shown here, are of distinguished artistic quality, it is not surprising, considering the circumstances, that a few of them are somewhat perfunctory in execution. But even if we disregard the mere souvenir and the imitation among the *chinsō* portraits which came to Japan, there still remains a group of portrait painting of a very special type.

First of all, the intimate personal relationship between the sitter and the recipient required that these portraits meet a high standard of physical likeness. In addition, however, the artist was obliged to penetrate beyond the surface of mere physical resemblance in order to capture some essential aspect of the psychology of his subject. Although it is difficult to establish with certainty just how successful the artists were in achieving this objective, there can be no question that the best portraits of Ch'an priests extant today surpass all of the existing secular Chinese portraits in quality of observation and execution.

In view of the dearth of secular portraits — the few existing examples are small figure paintings, not real portraits — it is difficult to judge whether the Ch'an portraitist created an art form which consistently surpassed the secular works. Certainly, Sung and Yüan portraiture should not be judged by the fossilized art of Ming and Ch'ing ancestral portraits. On the other hand, the Yüan treatise by Wang I, *The Secrets of Portrait Painting,* reveals no remarkable psychological insight, and seems to be mainly preoccupied with the mechanics of portraiture. It opposes the uncultured portraitists "who ask their models to sit stiffly erect with their garments in orderly array." Yet this is exactly what the Ch'an portraitists seem to have done without any detrimental effect.

Almost nothing is known about the identity of the portraitists. One portrait of Ming-pên is signed by a monk-painter, and it is probable that other, anonymous *chinsō* were also painted by monks. Japanese examples substantiate this idea. The monk-painter may have known the sitter personally and was naturally familiar with the specific requirements for a Ch'an portrait. Although he may have been influenced on occasion by the idealizing inclination of the historical portrait painters, his primary purpose was nevertheless to penetrate through the external appearance and into the heart of the subject. At the same time, however, he exercised all his powers of visual observation and portrayed the smallest details, omitting no stray hair or wart.

The final step was the addition of the teacher's encomium in order to seal the bond of transmission of the doctrine, which is "by Mind to transmit Mind." And the pupil, by looking at the portrait, and by reading the inscription, would look straight into his teacher's heart. There is perhaps no other form of Chinese and Japanese art in which painting and calligraphy are so intimately connected in their purpose and meaning.

Landscapes, Animals, and Plants

All the different categories of painting treated above have in common a clearly demonstrable connection with Ch'an doctrine and Ch'an literature. In paintings representing landscapes, animals, or plants, however, a connection with Ch'an is inherently less obvious and thus often cannot be established with the degree of certainty that may be possible with figure paintings. The "secular" paintings shown in this exhibition are most likely all works of Ch'an or Zen monks, and may therefore be classified as Ch'an or Zen art simply because of the religious affiliation of the artist. Even though the artist is a Ch'an monk, however, it does not follow that his paintings will necessarily have a symbolic or allegorical Ch'an content.

There are, of course, subjects with obvious symbolic connotations. A number of these are

familiar and well established, since they were derived by painters from the repertoire of the literati painters. As the poems written on the paintings by Ch'an and Zen priests indicate, bamboo, plum blossoms, and orchids stood for the same lofty ideals in Ch'an as among the literati. A striking example of the adoption of literati symbols is to be found in the *Ten Oxherding Pictures* traditionally attributed to Shūbun (cat. no. 49). The ninth stage, dealing with the purity of one who has attained Enlightenment, is visually represented by the Three Pure Ones—rock, plum blossom, and bamboo.

The frequent appearance of herons as a subject in Ch'an painting (cat. nos. 34 and 61) suggests that the artists were inspired by more than simple delight in the elegance of these birds. Ch'an and Zen artists painting oxen must have borne in mind the parable of the *Ten Oxherding Songs* (cat. no. 49). Sparrows, represented in this exhibition in a painting attributed to Mu-ch'i (cat. no. 11), are mentioned in Ch'an and other Buddhist literature with a regularity which makes us suspect that this simple bird may have acquired some special symbolic connotation. Although sparrows first appear in paintings of the Northern Sung Academy, the Ch'an artists soon adopted and developed this motif, possibly for symbolic reasons. The deep attachment of the great Ch'an monk Ikkyū to a bird of this type is expressed in the *document humain* embodied in the calligraphy of this artist (see cat. no. 52).

The symbolic meanings of birds, animals, plants, and fruit in Ch'an painting should be considered in terms of several levels of possible meanings. First of all, there are the documented and traditional symbolic subjects already mentioned. Future research in depth in the literature of the Sung and Yüan periods, especially in Ch'an texts and in poetry, may reveal more cases of such intentional, directly interpretable symbolism.

In the *Ts'ai-kên-t'an* ("Turnip Talk") by Hung Tzǔ-ch'êng (ca. 1600), an author whose syncretic ideas show a strong influence of Ch'an Buddhism, and whose work was much admired by Zen Buddhists in Japan, the following passage occurs: "The fishes swim in water, but they are oblivious to it; birds mount the wind to fly, but they do not know that there is wind. If we understand this, we can rise above the fetters of the phenomenal world and we can rejoice in our destiny."

Although this was written long after sparrows and herons had become common subjects in Zen painting, this passage reveals the less direct, more diffuse levels of symbolism which may account for the inclusion of birds in the Ch'an repertoire of subjects. In this group of paintings the artists express the spontaneous and natural movement of a bird or a fish in its own habitat— by analogy, the condition of the enlightened human being in this world. Paintings in this category may appear to be works of art in which no meaning—no purpose beyond that of pictorial representation—can be established at all. One cannot escape the impression, however, that the philosophical content of Ch'an painting increases as the symbolism becomes less specific, particularly near the indistinct borderline between religious and secular painting.

Ch'an artists who achieved Enlightenment viewed the world around them with new and different eyes. It was not, of course, the world that had changed; the change was within themselves. They had acquired an intuitive awareness of the transcendental principle which unites man and mountain, animal and plant. Of this state of mind it is said: "Only when you have no thing in your mind and no mind in things are you vacant and spiritual, empty and marvelous." This frame of mind implies an extraordinary blending of aloofness and non-attachment on one hand and a sympathetic feeling of total participation and complete understanding on the other. Such a *Weltanschauung* must have enhanced the individual character and flavor of Ch'an landscape painting which distinguish it, despite its numerous and obvious connections, from the landscapes of the literati.

Ch'an Monks and Literati in the Southern Sung and Yüan Periods

For us to reconstruct the breadth of the differences between literati and Ch'an landscapes is a difficult undertaking. One wonders, indeed, to what extent these differences were already felt by the contemporaries of the artists. It may not be coincidence at all that the frequent and intimate personal contact between literati and Ch'an artists and the appreciation of Ch'an paintings by the intelligentsia of the secular world seem to have diminished at the time when Ch'an painting brought forth its greatest artists: Liang K'ai and Mu-ch'i.

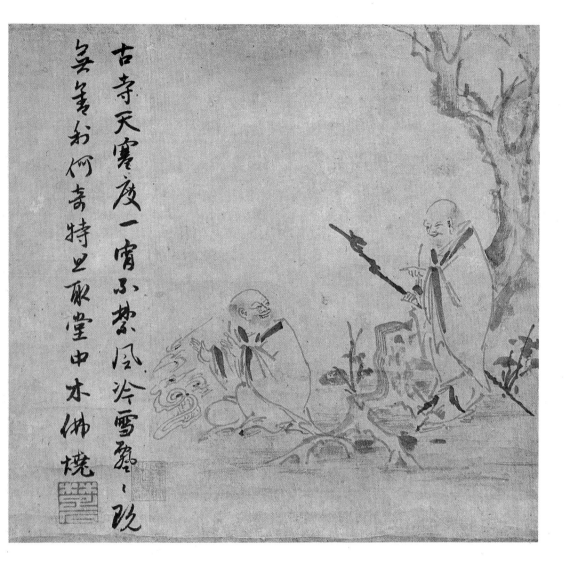

古寺天寒度一宵不禁風冷雪聲々晩

無柴和何寺特上取堂中木佛燒

13. *The Monk from Tan-hsia Burning a Wooden Image of the Buddha,* by Yin-t'o-lo (13th-14th century)

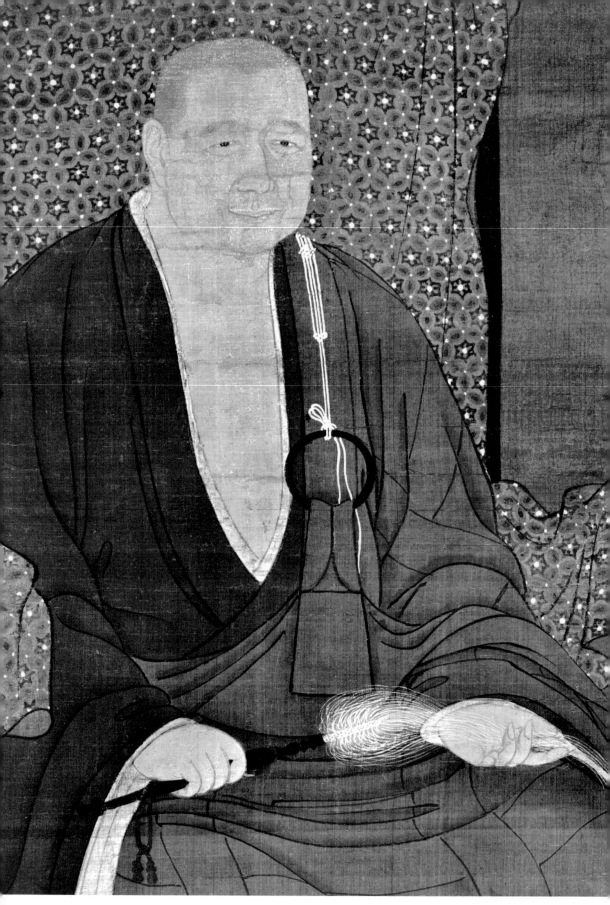

15. *Portrait of the Ch'an Priest Chung-fêng Ming-pên*
(before 1325) (detail)

Liang K'ai, represented here with two of his finest figure paintings (cat. nos. 5 and 6), blends the impetuousity of the untrammeled artists with the line drawing of Li Kung-lin and the discipline of a former academician. His association with Ch'an monks left an indelible mark on his work. Although he was not a Ch'an monk himself, he treats Ch'an themes with genuine Ch'an feeling. From the moment he left his Golden Belt (an imperial decoration) hanging in the Academy, the literary sources of the Sung period seem to have lost sight of him. It is only on the strength of his former association with the Academy that his name appears in later collections of artists' biographies, and we may even wonder whether the positive judgment accorded his work is not simply the result of ignorance of his later style. The near-contemporary and somewhat later comments by Chinese art critics on the work of Mu-ch'i are almost invariably of a derogatory nature. Perhaps the most "noncommittal" statement, tinged with a *dédain* that in itself is most revealing, is the remark, addressed to him and other painters, that their work is "good only for display in monks' quarters." However, at least two Ch'an artists achieved great fame during their lifetimes. The reputation of the calligrapher Chang Chi-chih (cat. no. 9) is said to have spread to the Chin Empire which occupied northern China. Perhaps of merely local character was the great fame of the painter of orchids Hsüeh-ch'uang (also known as P'u-ming). According to contemporary accounts, paintings from his hand seem to have hung in every house in Soochow, where he lived. Perhaps it is a measure of his fame that he is the only Ch'an artist whose name was ever mentioned in something as popular as a Yüan novel.

Contrary to traditional pattern, which had been established several generations earlier, several Ch'an monks of the Southern Sung and Yüan periods repudiated the life of monastic seclusion, which was devoted to withdrawal from the turmoil of the world and to association only with kindred spirits. Hsü-t'ang Chih-yü (1185-1269), a superb calligrapher, and the teacher of Nampo Jōmyō (see cat. no. 26), was closely connected with the imperial court. As the abbot of the Ch'an monastery at Mount A-yü-wang, he engaged in a conflict with the government and was forced to resign from the abbotship. Mu-ch'i, the great painter (cat. nos. 10-11), had to flee to Yüeh and go into hiding because

he had insulted the prime minister, Chia Ssŭ-tao. Others enjoyed the secular world in the company of poets and calligraphers without getting involved in politics. Chung-fêng Ming-pên (cat. no. 15) is an example of a monk who entertained the closest contacts with the secular and artistic world around him without ever being drawn into controversial politics.

When we compare the list of monks who wrote colophons on the paintings of Liang K'ai with that of the poets who inscribed the paintings of Mu-ch'i, we discover that many of the names are identical. If we try to unravel, with the help of such Ch'an sources as the "Recorded Sayings" of prominent Ch'an monks, the complicated fabric of mutual friendships, provincial loyalties, and casual acquaintances of the Ch'an monks involved, we receive the impression that the Ch'an art of the Southern Sung and Yüan periods was produced, inscribed, and admired by a relatively small coterie. To some extent this impression may be deceptive, and attributable to the semi-nomadic habits of Ch'an priests, who often moved from one temple to another every few years. The rotating system of abbot-ships, which gave the more accomplished eligible monks a chance to be the head of a monastery at least for a few years, and the search for teachers with whom the adept could establish the personal rapport which is a prerequisite of Enlightenment, contributed to the frequent communication between principal monasteries of Ch'an Buddhism in or near the metropolitan area of Hang-chou. Naturally, artists and monks with an interest in art tended to gravitate to the same centers, which may be one of the reasons why the student of Ch'an art is confronted again and again with the same names of monasteries, temples, artists, and monks writing colophons.

Although it is hazardous to make generalizations, it would seem that the contacts between Ch'an monks and literati during the Southern Sung period were neither as frequent nor as intimate as they were during the Northern Sung. One of the reasons the Northern Sung intelligentsia had praised the work of minor Ch'an artists, albeit in a somewhat condescending way, was that their work resembled that of their friend and *confrère* Li Kung-lin. This attitude on the part of the intelligentsia seems to have changed during the later periods. With the exception of Chang Chi-chih, who was not a Ch'an monk, even calligraphers, who revered and emulated the same masters that the literati

did, do not seem to have enjoyed the respect and appreciation of the establishment. Chung-fêng Ming-pên's contacts with Fêng Tzŭ-chên and Chao Mêng-fu (see cat. nos. 15 and 16) were certainly not based on their good opinion of his calligraphy, which even his admirers considered clumsy. It appears that Ch'an art, after being encouraged by the literati in its formative stage, and after absorbing the influence of the literati styles, shapes, and ideas, evolved into something which the literati found difficult to understand and to appreciate. As a result, the Ch'an artists may have gradually turned inward, losing contact with the artistic movements which were developing in the circles of the literati. With the triumph of landscape painting as developed by the Four Great Masters of the Yüan period, Ch'an art gradually receded into the background.

The End of Ch'an Art in China

Ch'an as a vital doctrine did not end with the Ming restoration. On the contrary, it made a significant contribution to the philosophy of Wang Yang-ming, who revitalized Confucianism. Ch'an Buddhism was even viable enough to resume, at the fall of the Ming, its missionary activities in Japan. Tung Ch'i-ch'ang's references to Ch'an, and the artistic activity of the "mad" painter Hsü Wei (1521-1593), who is reported to have painted a now lost picture of Han-shan and Shih-tê in his wild, impetuous ink-monochrome style, are isolated instances of the survival of Ch'an elements in art. The artists of the thirteenth and fourteenth centuries did not establish a Ch'an tradition. The great collectors of the Ming period did not collect the works of these obscure Ch'an painters, who, if mentioned at all in biographical reference works, were given no words of praise. That any part of the Ch'an oeuvre has been preserved at all and handed down to the present day is due only to the activities of a small group of dedicated Japanese monks who penetrated into the coterie of Ch'an artists. With a genuine desire to attain Enlightenment, they had come from across the sea to sit at the feet of the great Ch'an masters. Deeply imbued with the philosophy of Ch'an, they were perhaps in a better position to appreciate Ch'an art than their Chinese secular contemporaries. Their acquisitive instinct, their desire to transplant the real Ch'an to Japan, saved the oeuvre of some of China's most fascinating artists.

Zen: Its Establishment in Japan

The first reliable information on meditative practices in Japan goes back to the middle of the seventh century. Dōshō, who was responsible for the founding of the Hossō (Yogācāra) sect in Japan, went to China in 653 and became a disciple of Hsüan-tsang, the redoubtable pilgrim who had journeyed all the way to India in order to study the Dharma in its birthplace. As a result of Hsüan-tsang's influence, Dōshō took an interest in Ch'an, which had become a vital, flourishing movement at the hands of Hui-k'o's successors; and when he returned home, he had the first Japanese meditation hall built within the precincts of the newly founded Hossō headquarters.

The first Ch'an priest to make the voyage to Japan, Tao-hsüan, arrived almost a century later. A member of the northern line of Shên-hsiu, he came to Japan at the invitation of Japanese Buddhist monks, and is credited with influential religious activities during the Tempyō period. He taught Ch'an meditation to Gyōkyō, the teacher of Saichō (767-822), the founder of the Tendai sect in Japan, who seems to have been a part-time practitioner himself, and although meditation was a part of the routine in the Chinese parent sect (T'ien-t'ai), Saichō's approval of these practices accounts for the inclusion and continuance of the contemplative tradition in the Japanese branch in later centuries.

During the second quarter of the ninth century, a Chinese monk of the Lin-chi sect, I-k'ung, who had been invited by the wife of the Emperor Saga, made the long journey to Japan. He lectured on Ch'an at the Imperial Court and also founded the Danrinji, which the Empress built for him, and gave instruction in meditative practices there. He seems, however, to have been unable to generate the religious momentum necessary for establishing the sect permanently in Japan, and he returned disappointed to China.

Thus, all these early attempts to plant the roots of Ch'an in Japanese soil proved ineffectual, and it was only after a hiatus of more than three centuries that this task was finally accomplished. There seems to be no evidence of the importation of Ch'an art in connection with any of these abortive efforts to bring the sect to Japan, or of artistic efforts during the short-lived activities of these missionaries there.

16. *Dedicatory Encomium for Hōgyū Kōrin* by Fêng
Tzŭ-chên (1257-post-1327) (detail)

The effective transplantation of Ch'an to Japan took place initially at the hands of the two native masters, Eisai (1141-1215) and Dōgen (1200-1253), who are much revered for their pioneering efforts in transmitting the Lin-chi (Japanese: Rinzai) and Ts'ao-t'ung (Japanese: Sōtō) sects. As Eisai was active somewhat earlier, however, he is commonly honored as the actual founder of Japanese Zen. Eisai received his first training at the great Tendai monastery on Mount Hiei, and when he made his first trip to China in 1168, he followed the established pilgrimage route, visiting the great centers of his sect. However, he seems to have been strongly attracted to the doctrines and spirit of Ch'an, which was by then the most vital school in Chinese Buddhism. In 1187 he made the voyage to China again, inspired this time by a zealous ambition to retrace Buddhism to its spiritual source in India. Bad weather and uncooperative authorities forced him to give up this plan, but he focused his efforts on the study of Ch'an, and subsequently received the seal of Enlightenment from a branch of the Lin-chi line, which he propagated with great determination and vigor on his return to Japan, hoping that Ch'an teachings would revitalize Japanese Buddhism. In 1191 he founded the Shōfukuji, the first center of the Rinzai school in Japan, at Hakata, the customary terminus for voyages from the continent.

In 1202, the Kenninji was completed in Kyoto, and Eisai, who received the support of the Shōgun Yoriie, was appointed to head this new establishment, the first large-scale Zen monastery in Japan. However, there was concerted opposition to Zen by the older sects, especially the Tendai, who viewed it as a dangerous competitor, particularly because of the Kenninji's location, in the midst of the area of traditional Tendai control and also unfortunately close to the long-standing sources of Tendai temporal support in the court. Eisai's proclamations emphasizing the superiority of Zen over Tendai did little to ease the problem. Despite Eisai's diligent efforts to propagate the faith and to gain recognition for it as an independent school, he was nevertheless forced to make certain pragmatic concessions to the older, entrenched Kyoto sects, Tendai and Shingon. Thus, the original architectural layout of the Kenninji had a heterodox quality about it which clearly exhibited doctrinal compromise: in addition to the most essential Zen facility, the meditation hall, there were also buildings for both Tendai and Shingon rites, and although the pressures which caused this syncretic accommodation disappeared with the passing of time, a residual Tendai ceremony is still performed there at the present day. In general plan, the Chinese monastery on Mount Po-chang is said to have served as the prototype for the Kenninji. Shortly before his death, Eisai was invited to Kamakura, where the Shōgun had established his governmental headquarters, and there he superintended the construction of the Jūfukuji, which was not only the third Zen temple in Japan, but more importantly, the first Zen establishment in this city, which was soon to become the greatest bastion of the faith in eastern Japan.

Zen flourished during the Kamakura period (1185-1333) not only in the two main centers of influence and culture, Kyoto, the ancient capital, and Kamakura, the city which gives the period its name, but also in the provinces, where great monasteries like the Eiheiji, the headquarters of the Sōtō sect, were established. While the ardent efforts of a large group of distinguished monks, some Chinese, the majority Japanese, provided the energy for this progress, Zen was also fortunate in acquiring the patronage of the Bakufu, and this support was of primary importance in the construction of the great monastery complexes where the faith was propagated.

Many of the Hōjō family, the de facto rulers during the period, became devout followers and diligently sought the company of distinguished prelates. Other influential members of the military class followed their example and were converted to the Zen doctrine, which seems to have struck a particularly responsive chord among the warriors, who were drawn naturally to its direct, simple tenets, which stressed self-discipline and the realization of truth through introspection rather than tedious reference to scriptures or tendentious metaphysics. The Hōjō Regent Tokiyori (1227-1263) was a devoted protagonist of Zen, whose interest began with the arrival of the Chinese prelate Lan-ch'i Tao-lung (Rankei Dōryū) (cat. nos. 20, 21) at Kamakura. Tokiyori recognized the religious eminence of Tao-lung and installed him as the first abbot of the newly built Kenchōji, a magnificent monastery completed in 1253, where Zen was practiced in the unadulterated Chinese fashion for the first time. Tokiyori achieved *Satori* as a result of instruction from another emigré Chinese priest, Wu-an, and died in 1263 dressed

in Buddhist robes and sitting motionless in *zazen,* the meditating posture.

Zen Monks in China during Late Kamakura Times

The completion during the third quarter of the thirteenth century of two great monasteries, the Tōfukuji (cat. no. 59) in Kyoto, and the Ken-chōji (see cat. no. 21) in Kamakura, ushered in a vigorous new era in the development of the Zen church. With the establishment of these and other great centers, Zen grew rapidly in influence and numbers. Japanese monks traveled with ever-increasing frequency to China, where they dutifully followed the well-trodden paths from one celebrated Ch'an institution to the next, studying industriously under Chinese masters in their singleminded search for Enlightenment.

The most influential prelate in China during the first half of the century was Wu-chun Shih-fan (see cat. no. 8), and the efforts of his students, both Chinese and Japanese, were of particular importance in the evolution of Zen as a dynamic force in Japan in the latter half of the century. Disciples came to him from various regions of China, and sixteen Japanese monks are known to have studied under him. Thus, it is not surprising that the founders of both the Tōfukuji (the Japanese monk Ben'en Enni) and the Ken-chōji (Lan-ch'i Tao-lung, the noted Chinese monk) were recipients of the "Seal of Mind" from Wu-chun Shih-fan.

During Southern Sung times, the most important Ch'an temples were organized into a hierarchical system known as the "Five Mountains and Ten Monasteries," a system which was later to be utilized in a modified form in Japan. Of the fifteen institutions, eleven were situated in Chêkiang, the province where the capital was located, three in Kiangsu, and one further south in Fukien. It is clear from this geographical distribution that the main Ch'an centers were localized in a fairly small area. This concentration simplified the traveling problems of Japanese monks, who do not generally seem to have gone very far from the chief monasteries in Chêkiang. There are no accurate figures on how many Zen monks crossed the sea to study at these Ch'an centers during Sung times, but about one hundred names are attested to in literary sources. During the succeeding dynasty, the Yüan, more than

fifty Zen monks traveled to the continent from about the time of the Mongol invasion attempts (1274, 1281; see cat. no. 30) to the end of the Kamakura period (1333), and ten Chinese monks made the voyage to Japan during the same period.

It was only natural that the earnest Japanese pilgrims returned from their continental sojourns with greater religious insight, but they also brought back, as more tangible evidence of their protracted journeys, the prescribed memorabilia and keepsakes acquired during their studies. In doing so, they were simply continuing a tradition dating back centuries to the earliest days of Buddhism in Japan. The iconographical sketch depicting *The Six Patriarchs of the Bodhidharma Sect* (cat. no. 1), probably the oldest subject depicted in Ch'an art, may be based on a sketch done originally by one of the earlier Japanese monks who traveled to the continent, Jōjin, who never returned to Japan himself, but is known to have sent back drawings of this subject.

The unique importance of the master-disciple relationship, together with the perennial preoccupation with authenticity in the transmission of doctrinal lines in Ch'an-Zen, resulted in the production of art forms which reflected these concerns: the *chinsō* portrait of the master, with an inscription by him above (usually attesting to the religious achievements of the student, and often with explanations of methods for seeking Enlightenment), and certain types of calligraphic documents, such as *suiji* (which are often similar to the inscriptions over *chinsō*), instructions on procedures designed to help the student in his quest for *Satori,* or *inkajo* certifying that the student had mastered all the necessary disciplines and had attained an advanced degree of religious accomplishment. These art forms were the objects of the highest veneration, for they symbolized the true and authentic transmission of the particular branch of Zen which inspired them. Consequently, it is not surprising that Zen pilgrims attached the greatest importance to acquiring such works, and solicitously transported them back to their homeland, where they were reverently protected.

Both Eisai and Dōgen returned with *chinsō,* setting the precedent for later travelers. The finest Chinese *chinsō* in existence, the full-length portrait of Wu-chun Shih-fan in the Tōfukuji, was given to Ben'en Enni (see cat. nos. 8, 59) by the sitter in 1238, and brought back

to Japan in 1241. It is of unique importance, for it demonstrates the high degree of artistic excellence and psychological insight achieved by Ch'an monk-portraitists, a superlative tradition which soon declined in its homeland, and is known today only as a result of the care and veneration accorded such paintings over the centuries in Japan. Among the other early dated Chinese *chinsō* in Japan are an apocryphal portrait of Hui-nêng in the Kōshōji in Fukuoka (dated 1198), a portrait of Yün-an P'u-yen, with his own colophon, in the Daitokuji (dated 1218), and a representation of his student Hsü-t'ang Chih-yü with a colophon in his own hand (dated 1241). Japanese monks continued to diligently collect *chinsō* in China over the next century and a half, although their own native monk-painters had become so proficient in this genre that they had drawn abreast of and passed the Chinese by the end of the Yüan period (third quarter of the fourteenth century). However, the portrait of Chung-fêng Ming-pên (cat. no. 15) shows that the artistic level of the Chinese portraits was still high at the beginning of the century.

With the establishment and rapid growth of Zen monasteries during the twelfth century, it was only natural that Japanese artists should have turned their attention to the *chinsō*, not only because works imported from the continent could not meet the demand, but also because Chinese masters were active in Japan and Japanese priests such as Ben'en Enni had achieved high esteem and established their own lines.

Japanese Chinsō

It is not clear when the first Japanese *chinsō* were produced by Zen artists, but it may have been as early as the third quarter of the thirteenth century. Initially, Zen institutions lacked the established atelier traditions and nucleus of trained artists to produce such works, and they were forced to utilize the services of specialists from other sects, as we know from the fine portrait of Wu-an P'u-ning in the Shōdenji in Kyoto, painted in 1265 by Takuma Chōga, a specialist in Esoteric Buddhist subjects from the Daigoji, a temple of the Shingon sect close to Kyoto. Whether the famous portrait of Lan-ch'i Tao-lung in the Kenchōji, dated 1271, and its companion piece the *"Red-Robed" Bodhidharma* (cat. no. 20) were indeed painted by a Japanese artist (rather than by an emigré Chinese special-

ist) is impossible to determine at the present state of our knowledge, although Japanese scholarly opinion is strongly inclined in this direction. Another superb painting by an anonymous artist which falls into the same category is the *chinsō* of Shōichi Kokushi, who died in 1280, which has a colophon by the sitter and is preserved in the Manjuji in Kyoto.

Where Ch'an monks are portrayed in *chinsō* it is often difficult to determine whether the work was actually produced in China or whether it is a Japanese imitation, for the high esteem accorded imported portraits in Japan resulted in the production of very meticulous copies. In some cases the identity of the writer of the colophon or the date may help clarify the problem. Although there is not enough evidence to generalize, it appears that Chinese Ch'an specialists in *chinsō* did not sign their works during Sung times, and it is possible that the earliest Japanese Zen portrait painters also followed this precedent. Perhaps the earliest signed *chinsō* done by a Zen artist is a portrait of the priest Shinchi Kakushin (Emmyō Kokushi), which is dated 1315 and bears a signature which reads "Kakukei," a name presumed to be that of a Zen monk. By the second quarter of the fourteenth century, however, it is clear that Japanese artists were capable of producing *chinsō* of the highest artistic quality, a fact which is demonstrated by the superb portrait of Musō Soseki (cat. no. 24) done by his disciple Mutō Shūi in 1349, and carefully signed in the lower right-hand corner in small characters. Eight portraits of Soseki are attributed to Shūi, and among these there is an earlier dated work, produced in 1340. Another superb work of this period is the *chinsō* of Shūhō Myōchō (Daitō Kokushi, cat. no. 26) in the Daitokuji, dated 1334, which is unsigned but reveals the influence of the traditional Yamato-e style of painting in its execution.

Once the standard of artistic excellence had been established by Mutō Shūi, other Zen painter-priests developed who maintained this superb tradition. Generally, they were men like Minchō (see cat. no. 42) who worked at ateliers in the largest monasteries, either in Kyoto or Kamakura. Minchō, like Shūi before him, was a master of great versatility who produced a large variety of paintings. However, his posthumous portrait of Ben'en Enni (Shōichi Kokushi), preserved in the Tōfukuji, shows that he must have been very carefully trained in the painting of *chinsō*. That the high artistic level of

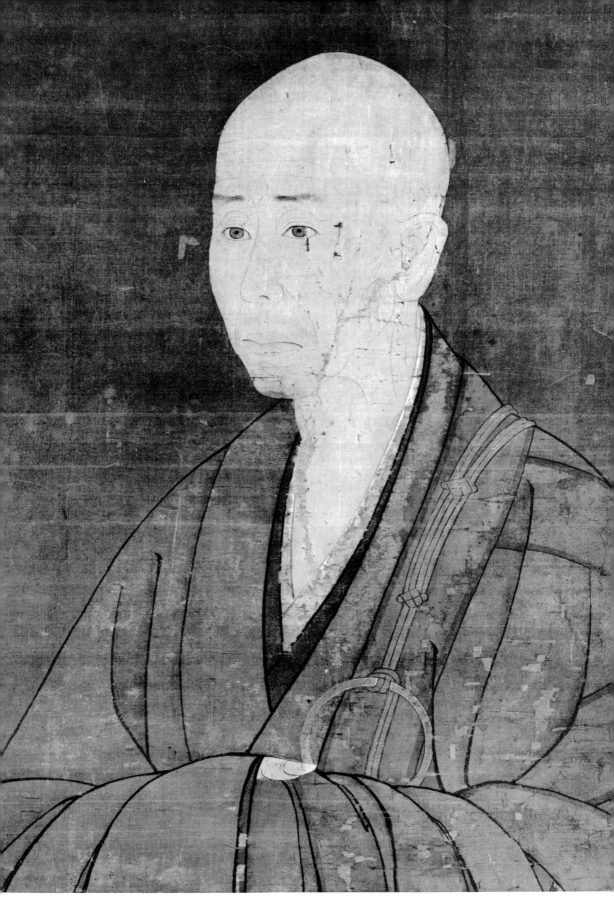

24. *Chinsō Portrait of Musō Soseki* by Mutō Shūi (active
first half of 14th century) (detail)

Japanese Zen portraiture was still being energetically maintained as late as the middle of the fifteenth century is apparent in the *chinsō* of Ikkyū Sōjun (cat. no. 51). Fine *chinsō* continued to be produced until the end of the Muromachi period, and the tradition exercised a strong influence on secular portraiture during the sixteenth century.

Although there are interesting *chinsō* depicting masters of the Ōbaku sect which were produced in the seventeenth and eighteenth centuries, the tradition of Zen portraiture had generally lost its vigor by this time, and there are few examples that show any artistic inspiration or originality.

Chinsō are used in Zen monasteries on a variety of ceremonial occasions, generally in connection with memorial services of one type or another, such as founding dates, anniversaries of deaths of eminent monks or patriarchs, or services connected with certain dates revered in Buddhism. Certain of the events are celebrated in a formal, prescribed manner, often with large numbers of monks in attendance. On such occasions *chinsō* are generally hung in the Dharma Hall or the second story of the huge *Sammon* gate. One of the most solemn occasions is the funeral service held for a venerated priest, when a portrait representing the departed personage is installed in a portable pavilion-like structure known as a *shintei*, equipped with curtains. This is carried in procession and installed on a funeral altar, and rites are performed before it. *Chinsō* are also used in more informal, private ceremonies, as well, such as the occasion when the Shōgun Yoshimitsu received the tonsure (see cat. no. 24) while sitting in front of a portrait of Musō Soseki.

As a result of the close connections between the military class and the Zen church from middle Kamakura times on, an interesting hybrid form of *chinsō* evolved. Along with the other features of etiquette and daily behavior which were adapted from Zen by the military class, certain aspects of the funeral observances followed by Zen monks were also taken over by the warriors, and this included the use of portraits of the deceased which were, to all intents and purposes, *chinsō*. The portraits of four generations of the Hōjō family in the Kanazawa Bunko Collection are representative of this derivative genre. Although the religious affiliations of these men varied, the artistic influence of the *chinsō* tradition is readily apparent in the treatment of the faces, which are rendered in a carefully observed, realistic manner. Perhaps the finest example of this type of portrait is the *chinsō* of Nanso-e Koji with a colophon, dating it to 1330, by Minki Soshun, who came from China and served as abbot of the Nanzenji.

Bokuseki:
The Calligraphy of Ch'an and Zen Monks

It may well seem paradoxical that a sect which attached so much importance to the concept of a "special transmission outside the scriptures," with "no dependence upon words and letters," should have produced a monumental amount of written materials during the course of its development. Included among the prolific output of its Chinese and Japanese monk-writers and chroniclers are sermons, tracts, hymns, the "Recorded Sayings" of a large number of patriarchs and eminent ecclesiastics, compendious biographies, and *kōan* collections, as well as an impressive quantity of writings in seemingly secular forms of literature, such as diaries and poetry. It must be noted, however, that this history of literary accomplishment did not develop without occasional antiscriptural activities. Liang K'ai's painting of a patriarch tearing up a *sūtra* (cat. no. 6) provides graphic evidence of this sentiment, which seems to have developed from time to time among certain monks who feared that the spiritual vitality of the sect would decline if the revered sermons, sayings, or apothegms of the masters were set down in written form. This type of concern probably accounts for the action of Ta-hui, who suppressed and burned the famous collection of *kōan* known as the *Green Cliff Record (Pi-yen-lu)*, a composite work of Hsüeh-t'ou Chung-hsien (980-1052) and Ta-hui's highly respected teacher, Yüan-wu K'o-ch'in (1063-1135). Yüan-wu had lectured to his students on the one hundred "cases" of Hsüeh-t'ou which are included in this work. He seems to have had no intention of compiling his lectures, but the monks wrote them down and they were later published as commentaries to the one hundred cases. Ta-hui may even have felt that he was actually carrying out the master's wishes in destroying the work. Good fortune prevailed, however, for the work existed in other copies, and it became one of the most frequently used *kōan* compilations in later times. The case of Tê-shan (780-865), famous for his rough treatment of students, provides another example of this antiscriptural tendency.

He devoted himself diligently to the study of the *Diamond Sūtra*, but when he attained *Satori*, he burned all his patiently accumulated notes and commentaries on the *sūtra*, proclaiming that all philosophical speculation was meaningless.

Despite these destructive aberrations, however, which seem to be characteristic of the Chinese parent sect rather than the Japanese offspring, the amount of written material that has been preserved, both in book form and in handwritten documents, is nothing short of prodigious. The corpus of printed editions of Ch'an religious literature that has been transmitted down to the present in both China and Japan is impressive in its variety and size, but actual specimens of the writings of Ch'an priests can only be seen today in Japan.

The calligraphy of Ch'an and Zen monks is generally referred to in Japan as *bokuseki*, an elegant term which, translated literally, means "ink traces" or "ink vestiges." In China the term (pronounced mo-chi) seems to have been used as early as the Six Dynasties period, but it did not become a popular term until Sung times, when it seems to have been only one of several synonyms for "calligraphy." Japanese Zen monks who traveled to China during Sung times adopted the term and applied it in a more specific, restricted sense to the handwritten documents or calligraphy of Ch'an or Zen monks. The term is already used in this sense in the *Butsunichi-an Kubutsu Mokuroku*, the catalogue of calligraphy and paintings of the Butsunichi-an, a sub-temple of the Engakuji in Kamakura, compiled in 1365.

As we have mentioned, the unique master-student relationship in Ch'an-Zen is an outgrowth of the central preoccupation of the sect, the direct, personal transmission of certain intuitively comprehended truths from the teacher to his successor or follower. The tradition that Bodhidharma's bowl and robe were handed down in succession to the patriarchs who followed him represents the symbolic expression of this arcane, perhaps on occasion ineffable, transmission. When the sect had become considerably larger and more institutionalized in later times, the desire for some tangible evidence of this transmission resulted in the practice, described above, of the master's presenting a *chinsō* of himself (usually with an inscription by him above) to the zealous student in recognition of both his advanced stage of religious accomplishment and his acceptance in the master's line. Alternatively, the master might write out a document in his distinctive calligraphic style and give it to the disciple, accomplishing the same purpose. In either case, the essential requirement was that the object of certification, whether painted or written, was received directly and personally from the master's own hand.

While the greatest reverence was focused on the particular calligraphic documents which attested to the religious accomplishments of the student and confirmed his position in the authentic line of the master, it is also clear that there was a deep sense of respect, if not awe, for all of the writings of eminent church figures, contemporary as well as past. This feeling of veneration was twofold, for it applied not only to the religious content of the writings, but also to the calligraphy itself, the direct product of the master's personality, with its individuality, strength, and profundity of expression. Believed to express the total personality of the writer, the art of calligraphy acquired a kind of mystique, inspired in part by religious circumstance, but more largely as a result of its high level of aesthetic accomplishment.

The oldest piece of calligraphy from the hand of a Ch'an monk preserved in Japan is a letter written by Tao-ch'ien, a man who was awarded a high ecclesiastical title by the Sung Emperor Chê-tsung (reigned 1086-1101), and who seems to have associated with many of the scholars and literati of the period, including Su Tung-p'o. He achieved fame for his talents in composing poetry, but it is also apparent that he was a superlative calligrapher. His style owes something to that of Wang Hsi-chih (see cat. no. 40) but he seems to have been influenced by Su Tung-p'o's manner in his later years.

However, the Ch'an calligraphy that has been most admired in Japan is not of the orthodox type represented by Tao-ch'ien's example, but belongs rather to more personal, unconventional types like the famous example by Yüan-wu (1063-1135) in the Tokyo National Museum. Yüan-wu belonged to the Yang-chi branch of the Lin-chi (Japanese: Rinzai) school of Ch'an, which became the dominant branch in Japan, and exercised the strongest influence on the evolution of calligraphy in later times. The works of Yüan-wu's pupils such as Sung-yüan and Ta-hui (who destroyed the *Pi-yen-lu*) are highly respected and continue the master's stylistic tradition.

In China, where the weight of established tradition in calligraphic expression was quite strong, the unconventional, highly personal calligraphy of Ch'an monks does not often seem to have been well received very far beyond their own religious circles, and it eventually declined. In Japan, however, where Zen exercised a dominating influence on the evolution of culture during much of the "medieval" period, the calligraphy of Zen monks established the standard for excellence, and was extensively emulated in secular society.

There is some evidence, however, that the attitudes of Ch'an monks, and perhaps even something of their calligraphic style, exercised a degree of influence on certain of the literati who associated with Ch'an monks during the Northern Sung period. Thus Su Tung-p'o, who studied Ch'an under two noted masters, seems to express the individualized spirit of the Ch'an practitioners in his statement: "While it cannot be said that my calligraphy is very accomplished, I have produced my own new ideas, and the fact that I am not treading in the footsteps of men of the past is the most pleasant thing of all to me!" Again, the pronouncement of his close friend Huang T'ing-chien (who was a diligent devotee of Ch'an practices): "In my calligraphy there is no basic method!" reflects the original, eccentric quality of Ch'an.

There are many fine specimens of *bokuseki* in private and public collections in Japan, but the largest number of pieces are preserved in Zen temples, particularly in Kyoto, where the main headquarters of the Rinzai school are located. The Tōfukuji (see cat. no. 59) has a superlative group of early examples, particularly those from the hand of the great Ch'an prelate Wu-chun Shih-fan (see cat. no. 8) which were brought back personally from China by Ben'en Enni in 1241, or sent to him slightly later in honor of the founding of the Jōtenji in Hakata. Wu-chun's style, although vigorous and dynamic, is rather more orthodox than that of most Sung monks, and shows a strong inclination to emulate the style of his somewhat younger contemporary Chang Chi-chih (cat. no. 9). Lan-ch'i Tao-lung, the founder of the Kenchōji in Kamakura (see cat. nos. 20, 21), and Fêng Tzŭ-chên (cat. no. 16) also exhibit an indebtedness to Chang's influential style in their writing.

The *bokuseki* collection in the Daitokuji in Kyoto is one of the finest in existence. Not only is it extensive in numbers and high in quality,

but is also includes a variety of pieces which span a considerable period of time, and a general idea of the main currents, styles, and developments of Ch'an-Zen calligraphy from early Southern Sung times up to the Edo period can be acquired through a study of this collection alone. The oldest example is from the hand of Mi-an Hsien-chieh (1107-1186), one of the most influential prelates of the first half of the Southern Sung dynasty, whose later line includes names such as Sung-yüan, Hsü-t'ang, Wu-chun, Tao-lung and I-shan. It is not surprising that the Daitokuji has the most important corpus of calligraphy by its founder, Daitō Kokushi (Shūhō Myōchō, 1282-1337) or examples of works of his teacher Nampo Jōmyō (1235-1309), who studied in China under Hsü-t'ang Chih-yü (1185-1269) and returned to Japan with works by his master. Daitō's style represents the fusion of his own strength of expression with the calligraphic manner of Huang T'ing-chien, one of the most widely emulated masters of the Northern Sung period. T'ing-chien's characters have an incisive though elegant quality which is reproduced in Daitō's works; but with the addition of a slightly eccentric flavor. Daitō reached the height of his career during his fifties, when he devoted himself to educating and advising his many disciples. He wrote a large number of *hōgo* (essays or tracts interpreting the teachings of the Buddha, often with advice on methods for attaining Enlightenment) during this period, which he presented to his students. The manner in which he expressed his opinions through sermons and explanatory discourses and tried to elucidate the methods and means for achieving *Satori* show a clear resemblance to certain practices followed by the Ch'an master Chung-fêng Ming-pên (cat. no. 15), who had a number of Japanese students. Daitō revered Chung-fêng and must have been familiar with his "Recorded Sayings," which were brought back to Japan.

Several of the abbots who succeeded Daitō at the Daitokuji, such as Tettō and Kasō, were also accomplished calligraphers, but the most dynamic hand in this line during the middle of the Muromachi period belonged to Ikkyū Sōjun (1394-1481, cat. nos. 51, 52, 53). The larger part of Ikkyū's life was devoted to combating the religious shortcomings of Zen during this period—a growing spiritual debilitation, complacency, and worldly ostentation. His great strength of character and sense of conviction

stand out in his calligraphy, which is renowned for its uniqueness and vitality.

The Daitokuji produced few calligraphers of note during the last century of the Muromachi period, a time marked by wars and instability. During the Momoyama period, however, there was a renewed interest in calligraphy. This development took place in large part as a result of the rapid growth of interest in the Tea Ceremony, in which hanging scrolls with appropriate phrases played an essential part. The Daitokuji was the chief monastic center for the Tea Ceremony during Momoyama times, and Sen no Rikyū, who established the main canons for the ceremony which are still followed, was closely associated with the temple and is buried there. Thus there was considerable demand for the calligraphy of Daitokuji monks such as Shun'oku Sōen and Kokei Sōchin, who produced small works with the characters written in a precise, spare manner.

During the second quarter of the seventeenth century, Daitokuji masters such as Kōgetsu Sōkan (cat. no. 65) and Takuan Sōhō (cat. no. 66) returned to a larger, more dynamic mode of calligraphic expression in an attempt to realize more fully the aesthetic potentialities of the hanging scroll format. Both men favored short, direct phrases which could be rendered in a single line, often consisting of only two or three characters, and usually containing some reference to Zen. Kōgetsu's association with the Tea Ceremony was of a very intimate nature, for his father had been a Tea Master, and Kōgetsu studied with Kobori Enshū, the famous garden designer and arbiter of taste, who was also a fellow student at the Daitokuji. The Daitokuji continued to provide support and inspiration for the Tea Ceremony and related calligraphic forms of expression during the following centuries, and it remains a center for these activities at the present day.

The Gozan Monasteries and Their Literary School

As we have noted, during the Sung period the most important Ch'an institutions were organized into a hierarchical system known as the "Five Mountains and Ten Monasteries." The majority of these institutions were located in Chêkiang, at varying distances from the capital, Hang-chou, while the others were situated nearby in the adjoining provinces of Kiangsu and Fukien.

This system was introduced to Japan during the latter part of the Kamakura period. The greatest monasteries of Kyoto and Kamakura were included under the title Gozan ("Five Mountains"), while lesser temples, some of which were located away from the two cities, were assigned to the Jissatsu ("Ten Monasteries") category. With the establishment of the Tenryūji by the Shōgun Ashikaga Takauji in 1339, the monasteries were given a hierarchical ranking, in which the Kenchōji (in Kamakura) and Nanzenji (in Kyoto) were equated at the top of their respective groups. In 1386 the institutions in Kyoto and Kamakura were divided into two independent groups of Five Mountains with their own individual rankings and with the Nanzenji placed in a superior position above both. Below this were the "Ten Monasteries," some of which were located in the provinces. Thus the system went through a series of evolutionary shifts determined not only by occasional changes in the balance of power within the Zen church, but more often as a result of the fluctuating temporal sources of support, for religion and politics became very closely intertwined during Muromachi times. It should be noted that the term "Five Mountains" was not always interpreted in a strict numerical sense, but was simply used to refer to the greatest Zen monasteries of the period.

It was at these great institutions, which exercised a pervasive influence on the development of Japanese culture during Muromachi times, that a literary movement known as Gozan Bungaku ("Literature of the Five Mountains") developed early in the fourteenth century. Although the initial stimulus for the school's development came from emigré Ch'an teachers, like I-shan I-ning (1247-1317; cat. no. 23), it was soon taken over by Japanese monks, such as Sesson Yūbai (1290-1346, cat. no. 30), who had studied for more than two decades on the continent, and Kokan Shiren (1278-1346; cat. no. 31), one of the most industrious and talented scholar-monks of the period. These men aspired to write poetry that was so thoroughly "Chinese" that it would be mistaken for the work of Chinese poets themselves. Although they were not always successful in this difficult task, they undoubtedly produced a higher level of competent "Chinese" verse than the nobles of the Heian period. At the hands of some of the most talented practitioners of the school, however, verse which approached, if it did not equal,

the quality of the Chinese works was un-doubtedly produced on occasion. There are references in Japanese sources to certain members of the school who are said to have achieved such excellence in their works that they even surprised the Chinese, although the words of compliment in these sources should not be taken at face value. Yūbai, who spent twenty-three years in China and was obviously gifted, may have produced some of the best poetry in the school. Chinese men of letters are reputed to have said that his verse was even better than their own, but the traditional Chinese ethic of self-denigration may well explain such compliments. Among Yūbai's successors in the Gozan literary movement are Zekkai Chūshin (1336-1405; see cat. no. 38) who is said to have been esteemed in China as a poet, and Gidō Shūshin (1324-1388), both of whom were pupils of Musō Soseki (see cat. no. 24). Both were highly esteemed in contemporary literary circles, and Gidō was a trusted adviser to the Shōgun Yoshi-mitsu, whose fascination with things Chinese is indicated by his pleasure in wearing Chinese dress and being carried about in a Chinese palanquin. The taste for Chinese verse gradually declined in Japan, however, and by the end of the century the chief attentions of the members of the Gozan literary school had turned toward philosophy (chiefly in Neo-Confucian ideas) and historical research.

Many of the monks associated with the movement were superb calligraphers. I-shan I-ning, the nominal founder, specialized in the "cursive" or "grass" style, drawing his inspiration from the great T'ang practitioners of this style, the "mad monk" Huai-su and Chang Hsü. The influence of I-shan's style was widespread in Japan, and is apparent in the hand of his student Musō Soseki (see cat. nos. 22, 24). By contrast the hand of Sesson Yūbai shows a degree of indebtedness to the influential style of Huang T'ing-chien. Although the styles of the Chinese literati calligraphers Chang Chi-chih (cat. no. 9), Su Tung-p'o, and Chao Mêng-fu all may be discerned in Japanese examples of the late Kamakura and Muromachi periods, that of Huang T'ing-chien is certainly one of the most pronounced strains. The most successful practitioner of Huang's style in Japan is Kokan Shiren, whose superb "Dankei" (cat. no. 31) with its strong sense of form, calligraphic ingenuity, and rhythmic vitality is a fitting tribute to the style of the Chinese master.

Ōsen Keisan (cat. no. 54) is one of the representative figures of the Gozan literary movement during the fifteenth century. In addition to his success in the church, he was also respected as a scholar and writer. By Keisan's period, however, the interests of the school had become largely academic, and the calligraphy of its practitioners shows a tendency toward accommodation with native Japanese schools of writing.

Zen Suiboku Painting: Origins and Evolution

The Zen monks who made the long journey to Ch'an monasteries in Southern China during the thirteenth century encountered paintings of a type that was unfamiliar to them, paintings executed in a provocative style which not only caught their imaginations but also roused their acquisitive instincts. These were (to use the Japanese term) *suiboku* paintings, monochrome works executed in washes and lines of pure ink, a form of expression which already had a tradition several centuries old in China but was still unknown in Japan. As we have noted earlier, the origins of this type of painting are not clear, but it seems to have developed in large part among the "untrammeled" artists who appeared during late T'ang times and flourished during the Five Dynasties period. While the Ch'an painters who worked in the ink-monochrome medium had no monopoly on this form of expression during Sung times, they nevertheless contributed significantly to its development. We have mentioned the close association between certain literati and Ch'an priests during the Northern Sung, and the mutual importance of this congenial intercourse in the evolution of calligraphy. The case was much the same with painting, where the free exchange of ideas and aesthetic concepts resulted in the development of composite styles which do not lend themselves to easy division.

At any rate, it is clear that calligraphy and painting flourished and reached a remarkable degree of development at Ch'an monasteries. The reason may lie partly in the traditional role of the monastery as a retreat from the troubles of the secular world. Men of good education who did not fare well in the examination system probably became monks with some regularity; and it would appear that Jih-kuan was one of a number who joined the Ch'an fraternity to escape the oppression of the Mongol conquerors.

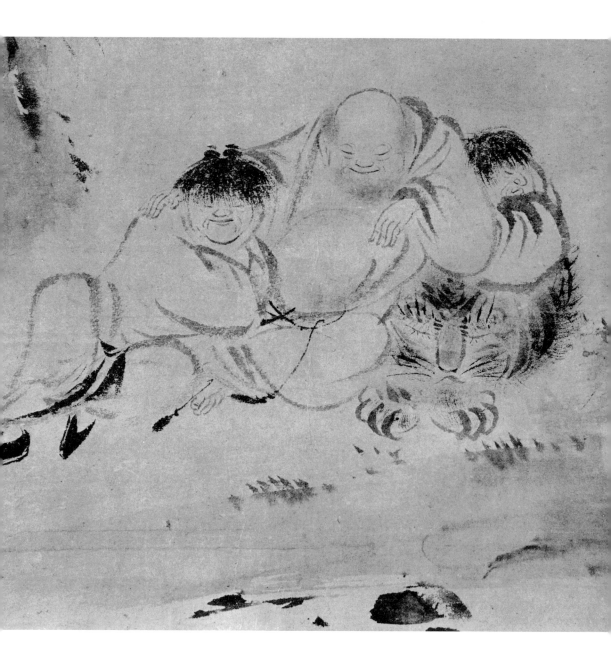

29. *The Four Sleepers* by Mokuan Reien (active first half of 14th century) (detail)

The Zen monks, like the pious clergy of any church who make pilgrimages to the religious centers of their faith, were anxious to acquire not only instruction and Enlightenment, but also the more tangible manifestations of their sect, the religious objects and paraphernalia which could be used to propagate the faith on their return. Chinsō and calligraphy undoubtedly headed the list, but the number of early monochrome paintings brought back to Japan in the Kamakura and early Muromachi periods indicates that such works were also highly prized.

Japanese monks probably visited all the main Ch'an monasteries where ink-monochrome specialists were active, and they not only acquired the works of the better-known masters such as Liang K'ai (cat. nos. 5, 6) and Mu-ch'i (cat. nos. 10, 11), but also the paintings of men such as Yin-t'o-lo (cat. nos. 13, 14) whose names have not even been preserved in the Chinese literary sources dealing with painting. Ben'en Enni (see cat. no. 8) is credited with returning to Japan in 1241 with Mu-ch'i's famous White-Robed Kuan-yin, Monkeys, and Crane, which were later combined into a triptych. Mu-ch'i is said to have been a student under Wu-chun Shih-fan, Enni's teacher, and perhaps this association led to Enni's acquisition of these great works, now preserved in the Daitokuji. Although ink-monochrome works brought from the continent were installed in Zen temples initially, the subsequent collecting activities of the shōguns brought many of these masterpieces into the shōgunal collections. The catalogue Kundaikan Sōchōki, which was probably compiled at the end of the fifteenth century by the noted painters Nōami and Sōami, contains comments on various Chinese painters, and classifies them on the basis of their artistic level, according to traditional Chinese precedent. The Gyomotsu On-e Mokuroku, an inventory of the shōgunal collection compiled at about the same time, lists 103 paintings by Mu-ch'i, twenty-seven by Liang K'ai, and thirteen by the Academic painter Ma Yüan (cat. no. 4). Not all of these pieces need necessarily have been of the highest quality, or even authentic, for paintings acquired through successive owners may sometimes have carried spurious seals or untenable attributions. On the whole, however, the Zen monks acquired a corpus of Chinese ink-monochrome works which was discriminating in its quality and representative in its breadth.

Suiboku painting was introduced into Japan as early as the end of the thirteenth century. In the Rikkyokuan, a sub-temple of the Tōfukuji, there is a triptych depicting Śākyamuni Returning from the Mountains (the same subject as cat. no. 26) flanked by works showing plum branches in bloom. The central painting is by a different hand than the flanking pieces, and their combination into a triptych represents a practice which was common in Japan (see cat. no. 7). All three have colophons by Haku'un Egyō (1223-1297), who visited China in 1266, served as abbot of the Tōfukuji in his later years, and retired afterwards to the Rikkyokuan. It has not been determined whether these paintings were executed by a Chinese or a Japanese artist, but the paper used in the two flanking pieces has a wax-dyed pattern of plum blossoms and is probably of Chinese manufacture. Perhaps the oldest extant Zen figure painting is the piece in the Masaki Collection (Osaka) showing Hui-nêng arriving at the gate of the Fifth Patriarch and requesting to be taken on as a disciple. Above the painting is an inscription by Mugaku Sōgen, written while he was in residence at the Engakuji in Kamakura, between 1282 and 1286. It appears to be the work of an artist trained in traditional Buddhist subjects who had had the opportunity to study Chinese works. The earliest Japanese ink-monochrome landscape in existence is probably the piece in the Satomi Collection (Kyoto) which bears a seal reading "Shikan," thought to be that of the artist. It shows one of the scenes from the traditional set of subjects depicting the Eight Views at the Confluence of the Hsiao and Hsiang Rivers, and has a colophon above by I-shan I-ning, who arrived in Japan in 1299 and died there in 1317. The varied brushwork utilized in the rocks, trees, and mountains, together with the accomplished sense of spatial depth, indicates the artist's familiarity with the landscape canons of the late Sung and early Yüan dynasties.

During the fourteenth century, a vigorous native tradition of ink-monochrome painting evolved at the hands of Zen monks such as Mokuan Reien (first half of the fourteenth century; cat. no. 29), Kaō Ninga (mid-fourteenth century), Ryōzen (active mid-fourteenth century; cat. nos. 33, 34), and Ue Gukei (active 1361-1375; cat. nos. 35, 36). Generally, the suiboku practitioners of the fourteenth century seem to have tried their hands at a wide variety of subjects, whereas the fifteenth-century

Facing page:
47. The Ten-Thousand-Mile Bridge, School of Shūbun, 1467

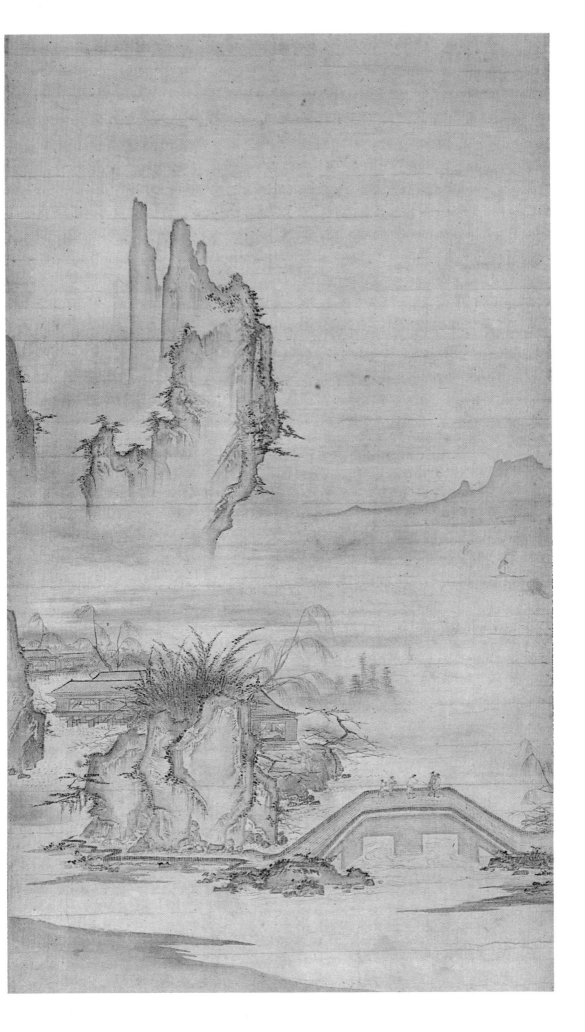

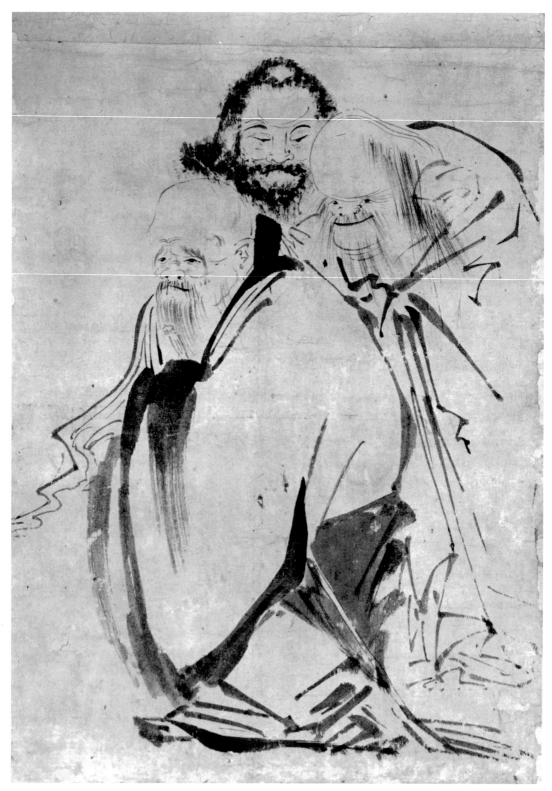

39. *The Three Doctrines,* attributed to Josetsu (active
early 15th century)

painters are characterized by an increasing tendency towards specialization. Certain of the earlier painters, such as Ryōzen, were strongly influenced by traditional, orthodox methods of Buddhist painting, while others, like Kaō and Gukei, show a freer, more spontaneous approach, which is more artistically congenial to the ink-monochrome medium.

Because of its intimate connection with Chinese literature, the Gozan literary movement produced a group of men known as *Bunjin-sō* ("literati-monks") whose highest aspirations were to produce poetry in Chinese which would be indistinguishable from that of their continental models. One of the outgrowths of this attitude was the appearance of Zen artists such as Tesshū Tokusai (died 1366), and Gyokuen Bompō (1344-ca. 1420; cat. no. 41) who dealt with subjects such as orchids, bamboo and eroded rocks, and viewed their painting as an amateur activity, an adjunct of their scholarly pursuits. This attitude, as well as the restricted choice of subjects, had originated much earlier among Chinese literati, but had been adopted by Ch'an painters such as Hsüeh-ch'uang P'u-ming, and eventually became integrated into the repertoire of Ch'an-Zen subjects. Poems are almost invariably written on such paintings, and this intimate bond between art and literature is often explained in the famous phrases—a poem is "a painting with a voice"; a painting is "a voiceless poem."

Mutō Shūi (cat. no. 24) is the first Zen painter-monk who can be identified with any degree of confidence as a true specialist in painting. He qualifies not only on the basis of the variety of his subjects, but also because his skill and artistic vision are simply too refined to be that of a part-time painter. It is not until the end of the fourteenth or the early fifteenth century, however, that there is reliable evidence of the establishment of ateliers in Zen monasteries.

The Tōfukuji seems to have been the site of an atelier at least as early as the time of Minchō (cat. no. 42). The religious importance, largeness of scale, and material well-being of the Tōfukuji are all logical reasons why a group of artists were able to find a continuous outlet for their efforts there. Reisai (cat. no. 44) and Sekkyakushi (cat. no. 45) are only two of a group of artists who seem to have been pupils of Minchō. Ryōzen (cat. nos. 33, 34), who worked half a century earlier, has also traditionally been associated with the Tōfukuji, and it is even possible that an atelier existed at the temple as early as his period of activity there. Ryōzen, Minchō and Reisai all seem to belong to a transitional school of Zen painting—indebted to earlier, more orthodox traditions of polychrome Buddhist painting, but also painting with great skill in the new ink-monochrome medium. The small ink landscape in the Konchiin known as the *Kei'in-Shōchiku-zu* ("Small Studio Facing North by a Stream") is traditionally attributed to Minchō. Above it are seven inscriptions of a congratulatory nature, one of which includes the date 1413. The Nan-zenji monk Junshiboku built a small studio named the Kei'in ("Facing North by a Stream"). He seems to have hoped that even though he lived in the vulgar world, his heart would remain as clear as a mountain stream. In recognition of this ideal, seven of his friends had this painting executed and wrote felicitous passages above. This is one of the oldest examples of a type of Japanese painting known as *Shiga-jiku*, a "poetry and painting scroll" (see cat. nos. 46, 47). This unique combination of literary and visual art became one of the chief art forms in Japan from the fifteenth century on, and developed mainly at the hands of Zen monks.

Another Zen atelier of great importance in the history of Japanese painting was organized at the Shōkokuji in Kyoto, a temple built by the Ashikaga Shōgun Yoshimitsu. It produced its own school of painters, including Josetsu (cat. nos. 39, 40) and his student Shūbun (cat. nos. 46, 47, 48, 49), who established a new compositional scheme which was to dominate landscape painting for the next century. Sesshū (cat. no. 55) was one of Shūbun's students, and men such as Oguri Sōtan and the painters of the Ami family were deeply influenced by him.

The Daitokuji was the center for another group of artists whose fountainhead was Soga Jasoku (cat. no. 53), a man who seems to have been connected in some manner with Ikkyū Sōjun. Jasoku and his followers make up the Soga line of painters, which continues up well into the Edo period.

Another school of painters developed in Kamakura, probably at the Kenchōji. Although certain of the earliest *suiboku* practitioners, such as Mokuan and Gukei, seem to have been associated with this locality, the connections seem tenuous, and the formation of a true school does not seem plausible until the time of Chūan Shinkō (cat. no. 56). With Kenkō Shōkei (cat. no. 57), however, the line is firmly established,

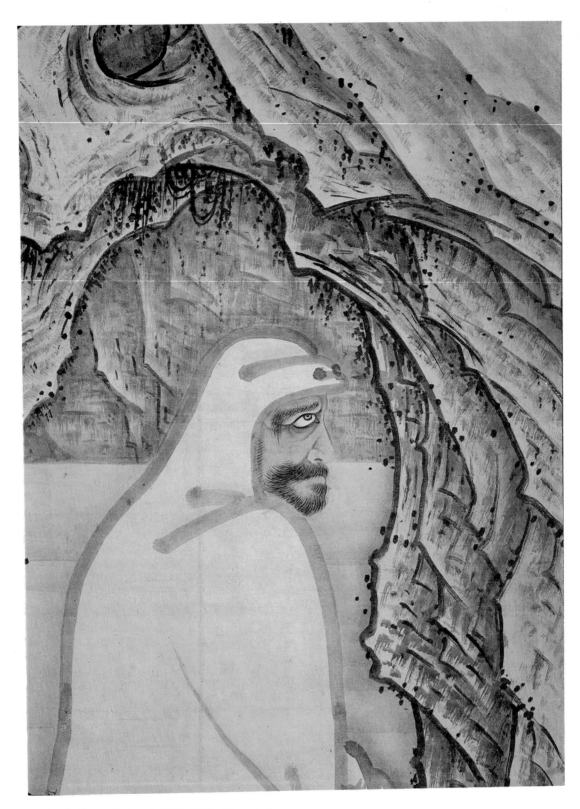

55. Bodhidharma Facing the Wall, detail of the painting
Hui-k'o Showing His Severed Arm to Bodhidharma, by
Sesshū Tōyō (1420-1506)

and the names of a number of his students are known.

With the appearance of ateliers in the fifteenth century, Zen painting entered a new phase, when many of the best artists were specialists who devoted all their time to producing works of art for the church. In Zen temples the monks were generally divided into "eastern" and "western" groups, divisions which distinguished those who performed administrative or maintenance functions from those who practiced the disciplines leading to Enlightenment. Several of the best-known painters of the Muromachi period had titles which indicate they belonged to the former. Minchō is also known as Chō-*densu,* a title roughly equivalent to "building custodian." Shūbun's title was *tsusu,* an office whose duties appear to have involved general accounting, while Shōkei was also known as Kei-*shoki,* a title that indicates he performed secretarial duties.

During the sixteenth century, Zen painters continued to produce paintings in great numbers, generally in monochrome but occasionally also with some additions of color, taking their subjects from the standardized inventory of Zen themes (see cat. no. 62). Moreover, the influence of Zen had by this time become so pervasive and deep-seated in Japanese culture that Zen themes and artistic techniques were common even in the works of secular painters such as Tan'an Chiden (cat. no. 61) and masters of the Kano school such as Motonobu (cat. no. 63). This tendency continued to grow in the Edo period, where it may be seen in the paintings of some of the finest monochrome masters of the period, of whom Miyamoto Musashi (cat. no. 67) is representative.

Zen Art in the Edo Period

The Zen church exerted a profound influence on the course of Japanese culture over a period of about three and a half centuries. It dominated intellectual and artistic activities, made notable contributions to popular as well as higher education, and provided religious and moral direction in an age marked by recurrent violence and disorder. During the sixteenth century, however, spiritual stagnation set in and the great Gozan monasteries began to decline. Under the authoritarian regime of the Tokugawa shōguns (1615-1867) the vitality of the church ebbed still further, and its religious activities grew increasingly ceremonial. This is not to say that Zen did not continue to produce talented, vigorous masters, devoted to learning and the arts. But they faced the additional difficulty of realizing these virtues within a church afflicted with an enervating malaise that was common to all branches of Japanese Buddhism.

Among the outstanding figures of the early seventeenth century are Kōgetsu Sōkan (cat. no. 65) and Takuan Sōhō (cat. no. 66), two men who received their training at the Daitokuji in Kyoto, one of the few monasteries where the traditional vigor of Zen was still preserved. At the hands of these two men, the calligraphic tradition of the temple, a proud heritage going back to the time of the founder, Daitō Kokushi (see cat. no. 26) enjoyed a modest renaissance. Although refinement and strong individuality are characteristic of the works of both Kōgetsu and Takuan, their respective calligraphic styles stand somewhat apart. It is of interest, however, to note that the chief features of each man's style — the powerfully composed characters of Kōgetsu, executed with a rather dry, coarse brush, and the eccentric yet elegant hand of Takuan — are both clearly indebted to the calligraphy of the fifteenth-century master Ikkyū Sōjun (cat. nos. 51, 52, 53) who was also associated with the Daitokuji.

The last branch of Ch'an to reach Japan was the Huang-po (Japanese: Ōbaku) line. Yin-yüan (Japanese: Ingen), who became the first patriarch of this line in Japan, reached Kyūshū in 1654 and moved to Kyoto in the following year. South of the capital, near the village of Uji, he founded the new headquarters, the Mampukuji, where he established the forms, routines and practices current in China at the time. The architecture of the new buildings emulated continental prototypes of the Ming period, and its somewhat baroque, exuberant quality contrasts sharply with the characteristic restraint in traditional Zen architecture. The *sūtras* (which play a more important part in the Ōbaku tradition than in other Zen lines) are chanted in Chinese according to the intonation of Ming times, and much of the religious paraphernalia and routine of the monks still has a strong Chinese flavor. Although the introduction of the Ōbaku line to Japan brought a breath of fresh vitality to Zen, its influence did not spread, and its temples remained essentially exotic enclaves of Chinese culture, isolated from the mainstreams of Japanese thought. It did provide a source of

inspiration for Japanese painters of the *Bunjin* ("Literati") school, however, for these artists looked to contemporary painting in China for their methods of expression. Its influence is also to be seen in a school of the Tea Ceremony where *Sencha*, steeped tea prepared in the Chinese manner, is the chief beverage. The chief artistic contribution of the Ōbaku line is the vigorous calligraphy produced by its monks, men such as Ingen (Chinese: Yin-yüan; d. 1673), the founder (cat. no. 68), and various successors such as Mokuan (Chinese: Mu-an; d. 1684) and Tetsugen (1630-1682) who produced a consistent, rather homogeneous school of writing characterized by fluid, semi-cursive execution of characters.

Despite growing ossification and spiritual apathy, the Zen church produced a number of outstanding individuals during the Edo period, men of strong will and high virtue such as the Rinzai master Bankei (1622-1693), who was highly successful in simplifying the message of Zen and spreading its influence broadly, to high and low alike.

The greatest Zen figure of the Edo period was Hakuin Ekaku (1685-1768; cat. no. 59) the dynamic, zealous innovator who spent most of his life working to revitalize Zen during the eighteenth century. As Bankei had done, he worked tirelessly to spread the message of Zen to the common people and disciples came to him in large numbers from all over the country. Although Hakuin also painted, his calligraphy is his most expressive art form. His characters are written slowly and deliberately, and have a tectonic monumentality which gives them a peculiar strength and impact.

In Japan, Zen has remained a living philosophy up to this day, and even now painters and calligraphers create works of art in the traditions established by the great Zen masters of the Edo period: Hakuin, Sengai (1750-1836), and Ryōkan (1757-1831). These artists, and not their later followers, mark the end of this exhibition, which represents themes and styles of more than a thousand years of Ch'an and Zen art.

Catalogue

1

THE SIX PATRIARCHS OF THE BODHIDHARMA SECT
Artist unknown; 13th century
Mounted as a hanging scroll, ink drawing on
paper, 100.4 x 579 cm.
Kōzanji, Kyoto
Registered Important Cultural Property

Six drawings, sketched on two joined sheets of
paper, illustrate the transmission of the Ch'an
doctrine from Bodhidharma to Hui-nêng. The
scenes can be identified as follows:

BODHIDHARMA, THE FIRST PATRIARCH
(upper right)
 Bodhidharma is seated in a chair and holds a
staff in his left hand. He is represented with
Chinese instead of Indian features, a highly
unusual deviation from what was later to
become a completely stereotyped iconographical
convention (see cat. nos. 7 and 57). The First
Patriarch is surrounded by several of his pupils.
Hui-k'o (traditional dates, 487–593) kneels down
in front of him. Blood gushes forth from the
stump of his left arm, and the knife and the
cut-off arm lie next to him on the ground. This
is a simple, straightforward representation of
Hui-k'o's famous act of self-mutilation when he
cut off his left arm in order to demonstrate
to Bodhidharma his earnest desire to seek
instruction (see cat. no. 55).
 This is the later, canonical version of the story,
which superseded the more prosaic explanation
that Hui-k'o lost his arm in a fight with bandits.
The story also varies in other details, and one of
these minor variations seems to have been
followed here. Hui-k'o is represented in secular
garb and headdress, suggesting that the artist
may have followed a version which did not
describe him as an ordained monk.
 Behind Bodhidharma's chair stand three
figures, two of whom are identified in the
caption as his pupils Tao-fu and the nun Tsung-
ch'ih. The third is probably Tao-yü. These three
disciples were present when Bodhidharma
transmitted the robe to Hui-k'o, thereby
appointing him as his official successor. When
Bodhidharma was ready to leave China, he said
that Tao-fu had acquired the skin, the nun
Tsung-ch'ih the flesh, and Tao-yü the bone,
and that Hui-k'o had penetrated into the
marrow (i.e., the essence) of the doctrine.

1. *The Six Patriarchs of the Bodhidharma Sect,* 13th
century
Facing page: detail showing Bodhidharma and pupils

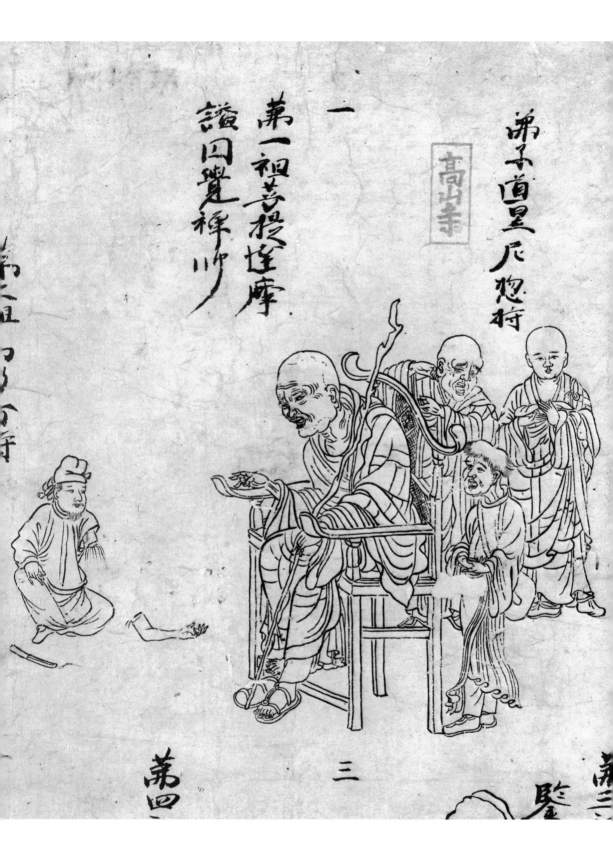

弟子道昱尺悤拘

第一祖菩提達摩
證四覽禪仲川

一

高山寺

三

第四

鑒

HUI-K'O, THE SECOND PATRIARCH (*upper left*)

Hui-k'o, holding the stump of his left arm with his right hand, is shown in the company of his pupil Sêng-ts'an (520-602) and a servant.

SÊNG-TS'AN, THE THIRD PATRIARCH (*middle right*)

Sêng-ts'an is seated on a rock and holds a feather brush in his hand. Waiting upon him is a young man in monk's garb, identified in the caption as the future Fourth Patriarch, Tao-hsin (580-651), who meets his master here for the first time at the age of fourteen. His exact age when he met his Master is not stated elsewhere. To the right are two monks, one holding an incense burner, the other tending a brazier on a small bamboo table.

TAO-HSIN, THE FOURTH PATRIARCH (*middle left*)

Tao-hsin is shown seated in meditation in a bamboo chair. The youth seated on a mat to his right is identified as the future Fifth Patriarch, Hung-jên (601-674), who decided to follow the Path to Enlightenment when he was only seven years old.

HUNG-JÊN, THE FIFTH PATRIARCH (*lower right*)

The Patriarch, seated on a rock, is shown in conversation with a man in secular garb who is kneeling in front of him. This, presumably, is the future Sixth Patriarch at the time when he came to seek instruction from the Master. This scene deviates from the pattern established by the four preceding groups: another pictorial episode has been added, representing the monk Fa-jung (594-657), the founder of a separate branch of Ch'an Buddhism named after Mount Niu-t'ou ("Oxhead") in southwestern Kiang-su.

HUI-NÊNG, THE SIXTH PATRIARCH (*lower left*)

Hui-nêng is shown in conversation with two monks, one of whom is identified as Nan-yüeh Huai-jang (677-744), the founder of the Nan-yüeh branch of the Ch'an sect, one of the two streams of Ch'an Buddhism which originated in the region of Kiang-si.

In the lower left corner is an inscription copied directly from the printed Chinese prototype on which this drawing is based which indicates that the Chinese original was printed in the year 1054. Nothing is known of the original compositional format of this Chinese example. It is more than likely, however, that the copyist rearranged the six scenes from a set of six separate book illustrations or parts of a handscroll, copying them onto two sheets of paper. In the process, the artist may have simplified the original scenes, leaving out much of the paraphernalia which so often crowds Chinese book illustrations of the period.

The drawing bears the seal of the Kōzanji at Toga-no-o near Kyoto. During the lifetime of its founder, Myō-e Shōnin (1173-1232), this temple became an important center of artistic activity where Chinese paintings, drawings, book illustrations, and rubbings were copied. These Japanese copies often served as prototypes for Japanese paintings, and were an important intermediary in the transmission of Chinese iconography and styles of painting to Japan. Among the artists who worked for the Kōzanji were the abbot Genshō (1146- after 1208) of Kōyasan, Myō-e Shōnin's pupil E-nichibō (active first half of thirteenth century), and two lesser known artists by the names of Shunga and Kaneyasu. Although Mochizuki has tried to connect this drawing with E-nichibō, the painter to whom the famous portrait of Myō-e in meditation traditionally is attributed, there does not seem to be any clear stylistic evidence which would justify associating the drawing with any particular monk-copyist (see also cat. no. 19).

Although the provenance of the prototype of this drawing is unclear, there is a possibility that it is based on a copy of a Chinese print which was made by the well-known monk Jōjin (1011-1081), who departed for China in 1072, never to return. The next year, according to his diary, he visited the Ch'uan-fa-yüan at Lo-yang. There he borrowed a set of representations of the Six Patriarchs from the *sūtra* repository; he returned the originals the next day and immediately had his copies sent off to Japan. The only other comparable copy of a Chinese prototype dealing with a similar theme is a set of representations of Ch'an patriarchs, preserved in the Konchi-in. This copy, dated in accordance with A.D. 1154, probably is based on a rubbing of an engraved stone stele, erected at the Wan-shou-yüan in Soochow in 1064.

Myō-e Shōnin, who revived the ancient Avatamsaka (Kegon) sect, was deeply interested in the Chinese origins of his doctrine and is known to personally have copied a set of illustrations of the *Gandavyūha*, the basic text of this sect. It is well known, however, that Myō-e also had a very favorable attitude towards Zen Buddhism. In fact, he is said to have told his pupils to go and seek the advice of Zen priests if they failed to understand some point of Buddhist

doctrine. Myō-e also originated the so-called Daruma Kōshiki, which is a ceremony in honor of Bodhidharma. It is therefore not surprising to find a representation of the Six Patriarchs of the Bodhidharma Sect among the iconographic drawings of the Kōzanji.

REFERENCES:
Hō-un 3 (1932), pp. 46-48 (explanatory text by Mochizuki Shinkō); Kokka, no. 524, pp. 186-187; Takeuchi Shōji, "Rokuso E-nō Zenshi Zusetsu" [On the representations of Hui-nêng, the Sixth Patriarch], Zen Bunka, nos. 27-28 (January 1963); pp. 31-40; Helen B. Chapin, "Three Early Portraits of Bodhidharma," Archives of the Chinese Art Society of America 1 (1945-1946), pp. 66-95.

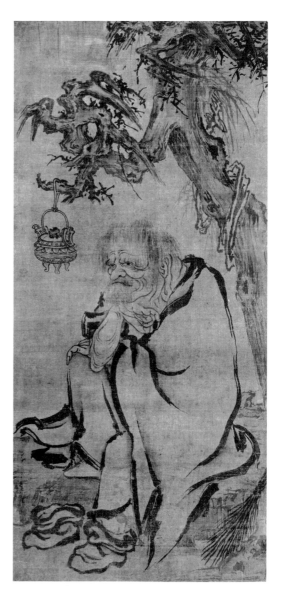

2

THREE ARHATS
Artist unknown; painted in the manner of Kuan-hsiu, ca. 14TH century
Hanging scrolls, ink on silk, each 111.8 x 51.5 cm.
Fujita Museum, Osaka
Registered Important Art Objects

One of the earliest great Chinese artists to emerge from the Ch'an milieu was Kuan-hsiu (832-912), who was as famous for his poetry as he was for his painting. As a child of seven he entered a Ch'an monastery in his native Chin-hua (Chêkiang). From there he wandered to other Ch'an centers in the south, always associating with other monks and men of letters. From 854 to 859 he lived on Mount Hua (Kiangsu), and he subsequently named his collected works *The West Peak Collection* after one of its peaks. For a considerable time he resided in the strongly pro-Buddhist kingdom of Wu-Yüeh, which had its capital at Hang-chou. Later, when he was in Hupei, the political situation grew unfavorable, and he took refuge in the western Chinese state of Shu (Szechwan) where he spent the last twelve years of his life. His great reputation as a painter rests upon his fantastic and grotesque renderings of Lohans (Arhats). Although most of these were painted on temple walls, none of which survived into modern times, there are several sets of paintings of Arhats preserved which are associated with his name.

2. *Arhat reidentified as Shih-tê,* in the style of Kuan-hsiu, ca. 14th century

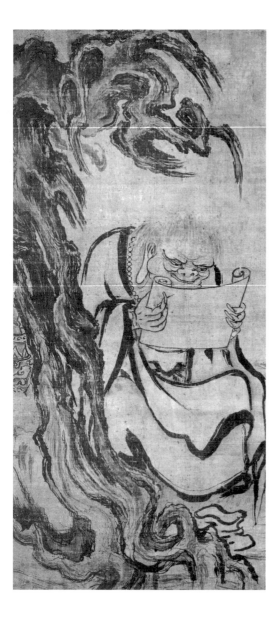 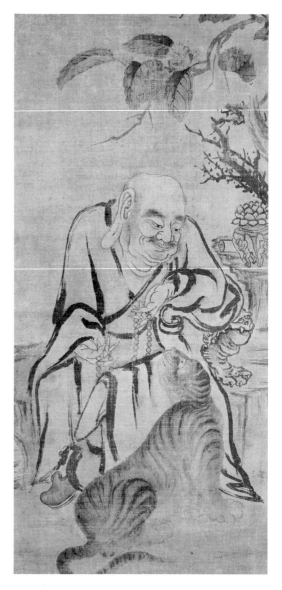

2. *Arhat Panthaka, reidentified as Han-shan*, in the
style of Kuan-hsiu, ca. 14th century

2. *Arhat Bhadra, reidentified as Fêng-kan*, in the style of
Kuan-hsiu, ca. 14th century

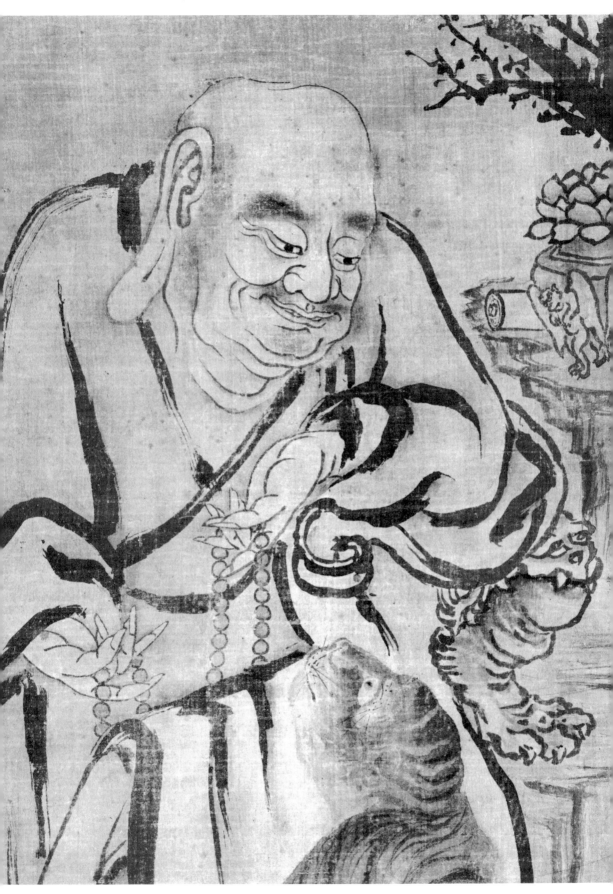

2. *Arhat Bhadra, reidentified as Fêng-kan* (detail)

The *Sixteen Arhats* in the Imperial Household Collection is the most ancient and best documented set, but there are also at least two other closely related, incomplete sets, now dispersed over several collections, which follow a stylistic tradition which is significantly different from that of the Imperial Household set and the well-known rubbings after stone-engravings of Kuan-hsiu's work. These incomplete sets would seem to be somewhat closer in style to the traditional descriptions of Kuan-hsiu's "untrammelled" brush technique. It is nevertheless quite evident that these works are copies, several hands removed from the Kuan-hsiu originals, and that they well may date from as late as the fourteenth century. Their brushwork is rough and simplified. The thin lines of the weird, exotic faces contrast with the thick, heavy contours of the figures and the monk's garb in which they are draped, and the contorted shapes of the gnarled trees in the background enhance the exotic atmosphere of the paintings.

The hanging scrolls from the Fujita Museum belong to this second category of paintings. For a long time they were thought to represent Fêng-kan, Han-shan, and Shih-tê, the eccentric trio of the Kuo-ch'ing-ssŭ (cat. nos. 12 and 14). Several other related paintings all represent Arhats. One of the subjects, the Arhat Nakula, is represented in two virtually identical versions—one in the Nezu Museum and one formerly in the Mutō Collection. This fact suggests that the surviving paintings of this type may represent the remnants of two or more related sets rather than one single group of Sixteen Arhats.

An Arhat who is often shown accompanied by a tiger is Bhadra, and one who is sometimes represented reading a *sūtra* is Panthaka. It appears that three paintings representing Arhats were reidentified here and combined into a triptych representing the famous Ch'an trio, Fêng-kan, Han-shan, and Shih-tê. Shih-tê's identity would appear to have been established by adding his attribute, the broom, to another painting of the same set that originally represented an unidentified Arhat. Thus, the broom in the painting which supposedly represents Shih-tê is probably an addition. This supposition is supported by the fact that a set of copies of Arhat paintings executed by Itō Jakuchū (1713-1800), and now in the Boston Museum, contains a painting either copied from

the Shih-tê in the Fujita Museum or from another representation of the same type. In that painting the broom is missing.

In spite of their derivative nature, these paintings still convey a vivid, if not always accurate impression of Kuan-hsiu's powerful talent and demonstrate how he transformed a group of nondescript, vague figures from the remote past of early Indian Buddhism into weird, exotic apparitions of a great spiritual force.

REFERENCES:
Masterpieces in the Fujita Museum of Art (Osaka, 1954), I, pl. 19; *Seizansō Seishō* (Tokyo, 1939), I, pl. 10; S. Shimada, "Concerning the I-p'in style of painting, pt. 2," *Oriental Art*, n.s. 8 (1962), no. 3, pp. 7-10; Kobayashi Taiichirō, *Zengetsu Daishi no Shōgai to Geijutsu* [The Life and works of the Ch'an Master Ch'an-yüeh] (Tokyo, 1947); Wu Chi-yu, "Le séjour de Kouan-hieou au Houa chan et le titre du recueil de ses poèmes," *Mélanges publiés par l'Institut des Hautes Études Chinoises* 2 (1969), pp. 158-178.

3

TWO PATRIARCHS HARMONIZING THEIR MINDS
In the style of Shih K'o (died after A.D. 975)
Pair of hanging scrolls, ink on paper,
35.3 x 64.3 cm.
Tokyo National Museum
Registered Important Cultural Properties

Shih K'o was born in Ch'êng-tu in the western Chinese province of Szechwan. He studied painting with Chang Nan-pên and was active as an artist in his native city at the time when it served as the capital of the later Shu dynasty (932-965). Although he was known for his Buddhist and Taoist wall paintings, which may have been painted in a more orthodox manner, he also achieved a reputation as an artist who painted in the unconventional, rough, and abbreviated style of the "untrammelled" artists. After the Shu state had been conquered by the Sung dynasty, Shih K'o moved to the Sung capital at Pien-ching (now K'ai-fêng, Honan province). There he received an imperial commission to execute the wall paintings for the Hsiang-kuo-ssŭ, one of the most important

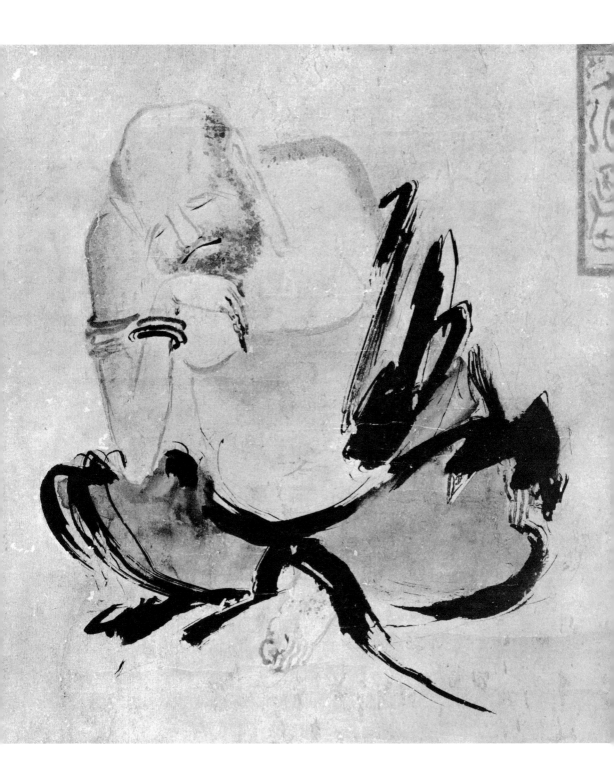

3. *The Patriarch Hui-k'o* (?), in the style of Shih-k'o,
13th-14th century (detail)

Buddhist monasteries at the capital. Although this project established his reputation in the capital and at court, Shih K'o nevertheless for some reason requested to be allowed to return to his native province. He died on his way home. As it is known that the Hsiang-kuo-ssŭ was restored in A.D. 975, we may assume that Shih K'o worked there at about this time. His death must have occurred one or two years later.

This pair of paintings, handed down in the Shōhōji in Kyoto, are the only surviving works which seem to reflect the style of Shih K'o in a reliable manner, even though it is generally thought that the paintings may date from as late as the thirteenth or fourteenth century. They are traditionally known as the *Two Patriarchs Harmonizing Their Minds.* In spite of the fact that this title actually appears on one of the paintings, its correctness is open to some doubt. There can be no question about the identity of the figure who is shown sleeping on the back of a tiger. He must represent the monk Fêng-kan of the Kuo-ch'ing-ssŭ temple on Mount T'ien-t'ai, the companion of Han-shan and Shih-tê (see cat. no. 7). Although this eccentric whose inseparable companion is a tiger is a well-known figure in Ch'an legend and art, he can hardly be grouped with the orthodox patriarchs of the Ch'an sect. The connection between the title and this figure would therefore seem to be tenuous.

Perhaps the title should be interpreted as "The Second Patriarch Harmonizing His Mind" and should be taken as referring only to the other painting of the pair. The phrase "harmonizing the mind" occurs in the biography of the Second Patriarch of the Ch'an sect in *The Record of the Transmission of the Lamp.* According to this story Hui-k'o's behavior and appearance suddenly changed thirty-four years after his famous encounter with Bodhidharma (see cat. nos. 1 and 55). He began to frequent butcher shops and winehouses and to associate with riffraff. When people, puzzled by this strange behavior, would ask him about it, he would say: "I am harmonizing my mind, what concern is it of yours?"

It is quite possible that the painting, which represents a Buddhist monk who has fallen asleep leaning on his right hand, actually illustrates this passage from Hui-k'o's biography. The seemingly careless way in which the monk's garb is draped over his left arm may actually be a deliberate device to camouflage the truncated stump of Hui-k'o's arm. If this is the case, the painting may represent Hui-k'o sleeping off the effects of a visit to a wineshop.

The two paintings may originally have been part of a handscroll. In the process of being separated and remounted, these sections may have been cut out and reduced in size, while at the same time the seals and inscriptions were transposed. The exact interpretation of the inscription on which the title is based had been the subject of much scholarly discussion until 1941, when Tanaka Toyozō proved that the seals, the inscribed date, and the signature cannot be of a tenth-century date. Nevertheless the two works seem to correspond well in their style of painting to the descriptions of Shih K'o's works in literary sources. Their documentary value, in addition to their high artistic quality, is therefore considerable. For even if the paintings should date from as late as the thirteenth or fourteenth century, as some experts believe, they are undoubtedly the oldest extant examples which retain some of the features of the abbreviated, rough style of painting which is characteristic of the artists of the so-called untrammelled class.

In the *Hua-chien* by T'ang Hou, a treatise on painting dating from the Yüan period, it is said that Shih K'o "painted figures with a playful brush" and that he used conventional painting methods "only for the face, hands, and feet; the clothes he did in rough brushwork." This statement would seem to be in perfect accord with the style and manner of these two paintings. Although the anatomical features are drawn in a conventional way with a fine brush, the strokes which the artist used to paint the garments are executed in a rough manner. The irregularity of their shape and the uneven distribution of the ink suggest that the artist may have used some unusual writing instrument, such as a frayed sugar cane, a lotus stem, or a brush made of shredded bamboo.

In spite of their imperfect state of preservation and the spurious character of the seals and the inscriptions, these two paintings are of unique importance for our knowledge of the early stages of Ch'an art in China. They vividly convey to us an impression of the style and the technique of the unconventional, "untrammelled" masters, to whom later generations of Ch'an painters were to turn again and again for inspiration.

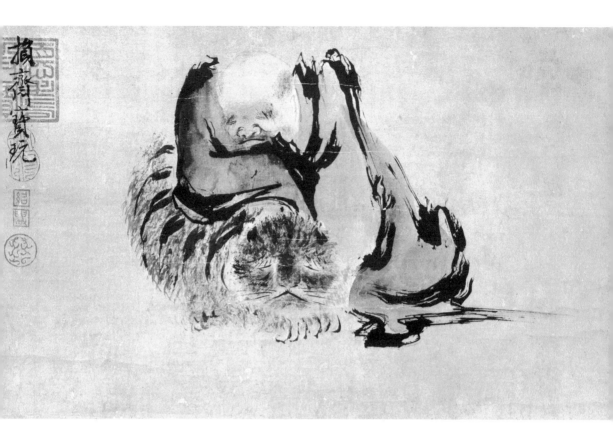

3. *Fêng-kan sleeping on his tiger,* in the style of
Shih-k'o, 13th-14th century

REFERENCES:
S. Shimada, "Concerning the I-p'in Style of Painting," trans. J. Cahill, *Oriental Art*, n.s. 7-10 (1961-1964); Tanaka Toyozō, *Chūgoku Bijutsu no Kenkyū* (Tokyo, 1964) pp. 163-180.

4

YÜN-MEN WÊN-YEN AND HIS TEACHER HSÜEH-FENG I-TS'UN

FA-YEN WÊN-I AND HIS TEACHER LO-HAN KUEI-CH'ÊN

Traditionally attributed to Ma Yüan (ca. 1150-1230)

Pair of hanging scrolls, ink and colors on silk, each 81 x 38.6 cm.

Tenryūji, Kyōto

Registered Important Cultural Properties

This pair of hanging scrolls belongs to the same set as the painting *Tung-shan Crossing a Stream* in the Tokyo National Museum. Originally, the set may have consisted of five paintings, representing the founders of the Five Branches of Ch'an Buddhism.

The painting in the Tokyo National Museum represents Tung-shan (807-869) at the moment when he saw his reflection in the water of a stream and attained Enlightenment.

Although the moment of Enlightenment of the other patriarchs also would have served as picturesque subject matter — Yün-mên for example attained *Satori* when his foot was smashed in the door by his teacher — the artist chose instead to represent these patriarchs in conversation with their respective teachers. The scenes, however, do not offer any obvious clues to the identity of the personages, which is revealed only in an indirect manner by the inscriptions.

FA-YEN WÊN-I AND HIS TEACHER LO-HAN KUEI-CH'ÊN

The poem inscribed at the top of the painting reads as follows:

The Great Earth, mountains, rivers, [all things that] naturally exist,

Are you identical with them or not?

If you understand that all things exist only in the mind,

You will cease to accept [such illusory things as] flowers in the sky and the reflection of the moon in the water.

The first two lines of this verse refer to a conversation between Fa-yen Wên-i (885-958) and his teacher Lo-han Kuei-ch'ên (867-928).

When Fa-yen was first asked the question that is quoted in the poem, he replied: "different," upon which Kuei-ch'ên held up two fingers to him. Wên-i then quickly corrected himself and said: "the same." Whereupon, the teacher repeated his gesture and went off without saying a word, leaving his pupil dumbfounded. We may assume that the older man, standing under the pine tree, is indeed Lo-han Kuei-ch'ên, and that the young monk approaching him with folded hands is Fa-yen.

The poetic inscription on this painting is written in a style which is associated with Lady Yang Mei-tsê, a sister-in-law of the Emperor Sung Ning-tsung (reigned 1194-1224). The seal affixed to the painting at the left of the poem reads: "Treasure of K'un-ning." K'un-ning is the name of the palace of the empresses during Ning-tsung's reign. Like the inscription, the painting is unsigned. It has traditionally been attributed to Ma Yüan. This attribution to the famous Southern Sung artist could be one of long standing, for it is possible that the painting may be identical with one of a set of four "Ch'an encounters" by Ma Yüan, which are mentioned in the catalogue of the shōgunal collection, the *Gyomotsu On-e Mokuroku* (comp. ca. 1500). Several "Ch'an visits" by Ma Yüan are mentioned in Chinese sources, indicating that the association of this type of painting with the master was not restricted to Japan.

Yonezawa, who has studied these paintings most recently (*Kokka*, no. 838), considers it possible that the figures are the work of Ma Yüan himself. He thinks that there is a stylistic discrepancy, however, between the fine lines of the figures and the much bolder strokes of the pine tree. He is therefore inclined to attribute the pine tree to the hand of one of the younger members of the Ma family. Marc Wilson has expressed the opinion that the Tenryūji paintings are by the same hand as the handscroll *A Spring Outing* in the William Rockhill Nelson Gallery of Art in Kansas City, Missouri. This handscroll has also traditionally been attributed to Ma Yüan himself.

大地山河自然
畢竟是同是別
若了萬法唯心
休認空花水月

南山深藏齃鼻
出草長噴毒氣
擬議懣須喪身
唯有韶陽不畏

4. *Fa-yen Wên-i and his teacher Lo-han Kuei-ch'ên*, attr. to Ma Yüan (ca. 1150-1230)

4. *Yün-mên Wên-yen and His Teacher Hsüeh-fêng I-ts'un*, attr. to Ma Yüan (ca. 1150-1230)

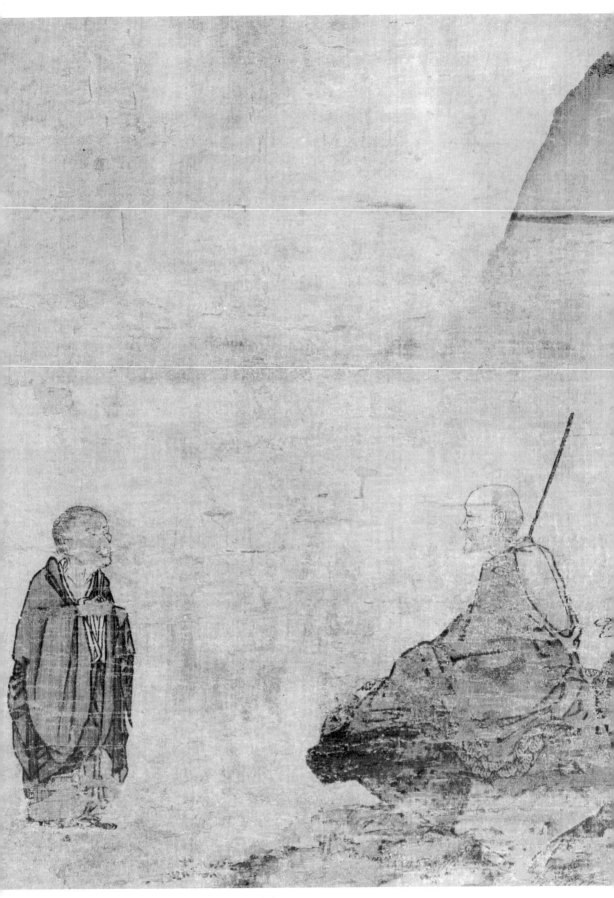

4. *Yün-mên Wên-yen and His Teacher Hsüeh-fêng*
I-ts'un (detail)

Yün-mên Wên-yen and His Teacher Hsüeh-fêng I-ts'un

The painting shows one monk facing another who is seated, and obviously his teacher. The vague contours of a mountain are indicated in the background. The clue to the theme of this painting is provided by the inscribed poem:

Deeply hidden on the southern slope of the
 mountain is a turtlenosed [snake].
Emerging from the grass it puffs out a long
 stream of poisonous vapor.
All the monks talk about how they will lose
 their lives,
And only Shao-yang [i.e., Yün-mên] is not
 afraid.

The "case" to which this poem alludes is the twenty-second *kōan* of the *Green Cliff Record*, the *Pi-yen-lu*:

Hsüeh-fêng instructed his audience saying: "On the southern slope of the mountain lives a turtlenosed [i.e., extremely poisonous] snake. You all should have a good look at it.
 [His pupil] Ch'ang-ch'ing said: "There will be quite a few men in the hall today who are going to lose their lives." A monk reported this remark to Hsüan-hua, who retorted: "It must have been brother Lêng who said that; even though he may be right, I would not have said it." The monk asked: "Reverend, what do you think?" Hsüan-hua replied: "Why should it be the southern slope of the mountain [i.e., in the immediate vicinity of Hsüeh-fêng's residence]?"
 Thereupon Yün-mên threw his staff directly in front of Hsüeh-fêng and made a gesture of fear.

The essential point of this puzzling *kōan* seems to be the difference in reaction between the Master's pupils. Ch'ang-ch'ing merely followed the master's lead, acting as if the snake — nothing more than a figment of Hsüeh-fêng's imagination — were posing a real threat. Hsüan-hua questioned its whereabouts. Yün-mên on the other hand carried the fiction one step further. Acting as if his staff were the snake, he threw it in front of the Master. By this sudden, dramatic gesture, he lent a new, fearsome reality to an imaginary threat.
 The artist seems to have deliberately taken the drama out of the situation, reducing it to its bare essence of a teacher-pupil confrontation. Confusingly, however, it is the senior monk

who holds a staff and whom we must therefore assume to be Hsüeh-fêng I-ts'un (822-908); the younger monk must be Yün-mên Wên-i (864-949).

References:
Bijutsu Kenkyu, no. 3 (explanatory text by Kumagai Nobuo); *Bijutsu Kenkyu*, no. 34 (explanatory text by Watanabe Hajime); D. T. Suzuki, *Essays in Zen Buddhism*, 3rd ser. (Kyōto, 1934), pl. I; *Kokka*, no. 838 (explanatory text by Yonezawa Yoshiho); for a description of the interview between Fa-yen Wên-i and his teacher see Wilhelm Gundert, *Bi-yän-lu* (Munich, 1960), p. 175; for the *kōan* see Gundert, *Bi-yän-lu*, pp. 385-404; for the seal of the K'un-ning Palace see Werner Speiser, "*Ma Lin*," in Zurich, Museum Rietberg, *Eduard von der Heydt zum 70. Geburtstag*, Schriften, no. 2 (Zurich, 1952), pp. 1-12.

5

The Sixth Patriarch Chopping Bamboo
Liang K'ai (active first half of the 13th century)
Hanging scroll, ink on paper, 72.7 x 31.8 cm.
Tokyo National Museum
Registered Important Cultural Property

Little biographical information has been preserved about Liang K'ai, one of the great Ch'an painters of the Southern Sung period. Like his teacher Chia Shih-ku, who was a pupil of the celebrated figure painter Li Kung-lin (died 1106), Liang K'ai became highly skilled in Buddhist and Taoist figure painting. During the Chia-t'ai era (1201-1204) he was appointed Painter in Attendance at the Imperial Academy. However, when he was awarded the Golden Belt, he refused to accept this honor, retired from the Academy, and went to lead a bohemian existence among the Ch'an painters of the monasteries in and around Hang-chou. Judging from the dates of the priests who are known to have written colophons for his paintings, the main period of Liang K'ai's activity appears to have been the first half of the thirteenth century. Unlike Mu-ch'i, the other great Ch'an painter of this period, Liang K'ai does not seem to have incurred unfavorable criticism. His early, more academic manner, as represented in his masterpiece *Śākyamuni Returning from the*

Mountains, conformed to contemporary taste, and knowledge of his later, more cursive style does not seem to have spread beyond the confines of Ch'an circles.

Japanese Zen monks, however, admired his work highly and brought a large number of his paintings back to Japan, including practically all the masterpieces now extant. From references to his works in literary sources, it appears that Liang K'ai painted a variety of traditional Ch'an themes, such as Han-shan, Shih-tê and Pu-tai. None of these themes, however, are as unusual and as specifically Ch'an in character as Liang K'ai's *The Sixth Patriarch Chopping Bamboo* and *The Sixth Patriarch Tearing up a Sūtra* (see cat. no. 6). Both paintings must have been brought to Japan at an early date, for they carry the *Dōyū* seal of the Shōgun Ashikaga Yoshimitsu (1358-1408), the great collector and patron of the arts. They are not mentioned, however, in the catalogue of the shōgunal collections, the *Gyomotsu on-e mokuroku* (comp. ca. 1500). Perhaps they already had been split up by the time this catalogue was compiled. They were handed down separately, in the Sakai and Matsudaira families respectively until recent times.

Liang K'ai's biographers often refer to his "abbreviated" brush technique, a cursory method of execution which is epitomized in his famous *Li Po Chanting a Poem*. In *The Sixth Patriarch Chopping Bamboo*, however, this technique is less apparent and more varied, as it is effectively integrated with the more flamboyant manner of the "untramelled" artists. Liang K'ai has combined this blending of heterogeneous brush styles with the tight pictorial organization which is the hallmark of his academic training. The result is a masterwork of great artistic tension, conveying the artist's penetrating vision of one of the almost legendary figures from the evolutionary period of Ch'an Buddhism.

Perhaps the most puzzling aspect of these two paintings is their subject matter. From such inventories as the *Butsunichi-an kubutsu mokuroku* of the Engakuji in Kamakura (1365), we know that paintings by Ch'an artists representing the third, fourth, fifth, and sixth patriarchs were imported into Japan at an early time. However, in the numerous biographies of the Sixth Patriarch there are no references to any events which could have provided the inspiration for the themes of these two paintings. The

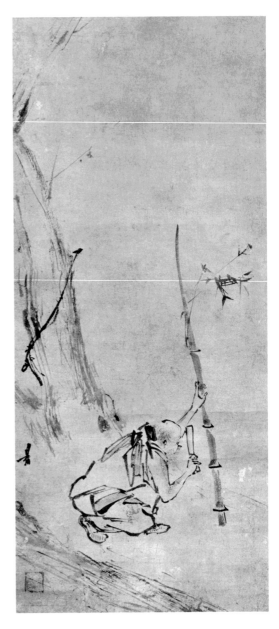

5. *The Sixth Patriarch Chopping Bamboo*, by Liang K'ai (active first half of the 13th century)

traditional explanation of *The Sixth Patriarch Chopping Bamboo* is that Hui-nêng attained *Satori* upon hearing the sound of bamboo being chopped. However, there is no support for this otherwise plausible explanation in the existing texts, although there are several Ch'an paintings which deal with the frequently bizarre circumstances under which a Ch'an adept attained Enlightenment (see cat. nos. 4 and 58). As there is no record of these paintings under their present titles before the end of the sixteenth century, the possibility that they are mistakenly identified should not be dismissed.

REFERENCES:
Institute of Art Research, Tokyo, *Ryōkai* [Liang K'ai] (Kyoto, 1957), pls. 4-5;

6

THE SIXTH PATRIARCH TEARING UP A SŪTRA
Liang K'ai (active first half of the 13th century)
Hanging scroll, ink on paper, 73 x 31.7 cm.
Collection of Mitsui Takanaru, Tokyo

This painting forms a pair with *The Sixth Patriarch Chopping Bamboo* (cat. no. 5). Both paintings were originally in the collection of the Shōgun Ashikaga Yoshimitsu (1358-1408), as is indicated by the *Dōyū* seal of this famous collector. It has occasionally been suggested that this painting might be an early Japanese copy after a lost original by Liang K'ai. However, the marked difference in the two paintings' state of preservation, which Sirén cites as an argument in support of this supposition, could well be due to the fact that the two works became separated at an early date and were handed down in different collections.

In brushwork of great dynamic force, the artist has conjured up a scene which recalls the early days of Ch'an Buddhism, when the "strange words and extraordinary behavior" of the founding fathers of the Ch'an branches still determined the course of the sect. Although stylistically similar to *The Sixth Patriarch Chopping Bamboo*, the brushwork here is even more impetuous, conveying an impression of frenzied ecstasy. The general significance of a patriarch ripping a *sūtra* into shreds is evident, and similar episodes occasionally are described

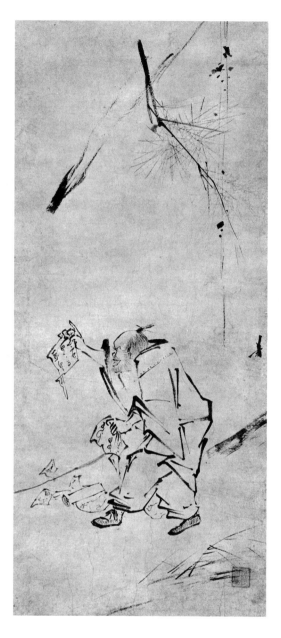

6. *The Sixth Patriarch Tearing up a Sūtra*, by Liang K'ai (active first half of the 13th century)

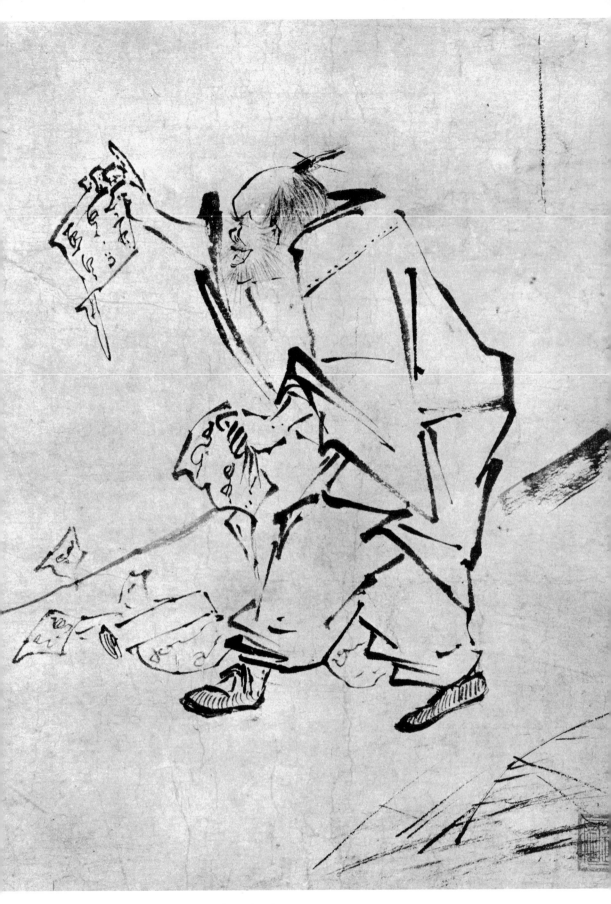

6. *The Sixth Patriarch Tearing up a Sūtra* (detail)

in Ch'an texts. It is known, for example, that the T'ang priest Tê-shan Hsüan-chien (died 865) burned all his *sūtras* after he had attained Enlightenment.

This painting traditionally is identified as a representation of the Sixth Patriarch, Hui-nêng. However, none of the many biographies of this patriarch shed any light on the episode which is depicted here. Yet there is one good reason for connecting this representation with him. In the Ch'an biographies of Hui-nêng, the sect's ideal of independence from scriptural sources is emphasized by a proud and defiant display of the illiteracy of the patriarch. As he was incapable of reading, the stimulus for his initial resolve had to come verbally, and it only occurred when he overheard a monk reciting the *Vajracchedikā-sūtra*. Similarly, the poem which earned him the succession to the patriarchate had to be written on a wall for him by another monk. In the *Platform Sūtra* every opportunity is used to emphasize Hui-nêng's militant illiteracy. His disdain for the written word must have made him an outcast in a society which traditionally revered literary accomplishment. Even though specific references to the dramatic scene in this painting are lacking in Hui-nêng's biographies, it would seem to be in complete accord with the basic attitude and behavior of the Sixth Patriarch.

REFERENCES:
Institute of Art Research, Tokyo, *Ryōkai* [Liang K'ai] (Kyoto, 1957), pls. 6-7; O. Sirén, *Chinese Painting: Leading Masters and Principles* (London, 1956), II, pp. 135-136.

7

BODHIDHARMA, FÊNG-KAN, AND PU-TAI
Center: BODHIDHARMA, artist unknown, colophon by Mieh-wêng Wên-li (1167?-1250?)
Right: FÊNG-KAN, Li Ch'üeh, colophon by Yen-ch'i Kuang-wên (1189-1263)
Left: PU-TAI, Li Ch'üeh, colophon by Yen-ch'i Kuang-wên, (1189-1263)
Hanging scrolls, ink on paper, center: 110.3 x 32.7 cm., right and left: 104.8 x 32.1 cm.
Myōshinji, Kyoto
Registered Important Cultural Properties

Little is known about the Southern Sung painter Li Ch'üeh. His name does not appear at all in early Japanese compilations such as the *Kundai-kan Sōchōki*, but there is a brief entry in the *T'u-hui pao-chien* (vol. 4), compiled by Hsia Wên-yen in 1365, where he is described as a follower of Liang K'ai, along with two other men, Yu Hung and Li Ch'uan, who worked at the Southern Sung Academy of Painting. "Li Ch'üeh studied the sketches of Liang K'ai" according to the entry, but it is not clear whether he did so directly under the master or only worked in his manner. However, comparison with certain works attributed to Liang K'ai, such as the painting representing Han-shan and Shih-tê in the Atami Museum, show a marked similarity of style and brushwork, characterized by the blocking in of general forms in a simple, broad manner, using dry as well as rather fluid brushstrokes and rendering anatomical features with a thin incisive line.

Li Ch'üeh's signature appears in the lower left-hand corner of the Pu-tai painting; the Fêng-kan painting has no signature. It has been suggested that there are minor variations in the brushwork in the two; but since the ink values and the paper are identical and the colophons by the same monk, and since both works are executed in a consistent, distinctive style, it is highly unlikely that they are by different hands.

The Bodhidharma painting is unsigned and generally agreed to be from a different hand than the flanking paintings. An entry in an Edo period guidebook (the *Miyako Rinsen Meisho Zue*) dealing with the Myōshinji attributes it to an obscure painter named Mên Wu-kuan, but this seems to be nothing but a pious traditional assignment (which also attributes the flanking pieces to Li Kung-lin and is not worthy of serious consideration). Nevertheless, the painting has the unconstrained brushwork characteristic of works favored in Ch'an circles, and the identity of the writer of the colophon makes it clear that the painting was produced no later than the end of the first half of the thirteenth century. Sections of paper have been added above and below in order to adjust the height of the painting to the two flanking works, and while there is no evidence to suggest the date when the three paintings were combined into a triptych, the elaborate matched brocade mountings may well go back to the Muromachi period. The colophon was written by a noted

7. *Pu-tai*, by Li Ch'üeh, 13th century

7. *Bodhidharma*, artist unknown, 13th century

7. *Fêng-kan,* by Li Ch'üeh, 13th century

Ch'an monk, Mieh-wêng Wên-li (1167?-1250?), a native of the Hang-chou area, who was a disciple of the founder of the Sung-yüan line, Sung-yüan Ch'ung-yo. Wên-li also used the sobriquet T'ien-mu (which appears in the uppermost seal here) and occasionally signed his name T'ien-mu Ch'iao-chê (the "Firewood Gatherer of Mount T'ien-mu"), ostensibly because his house is thought to have been located at the foot of the mountain. He went into retirement during the middle part of his life at a location close to the Ch'ien-t'ang River in Chêkiang, but he later resumed his activities in the Ch'an church and served as abbot at the Fu-ch'üan-ssŭ and the Ching-tz'ŭ-ssŭ, as well as heading the great monastery on Mount T'ien-t'ung. He seems to have studied the *I-ching* (the "Book of Changes") and to have been very closely associated with Confucian scholars, and it is indicative of the syncretic intellectual currents of the time that the fountainhead of the Neo-Confucian school, Chu Hsi, came to visit him and listened to him lecture on the Dharma. The middle seal, which is shaped like a tripod, has the characters "Mieh-wêng"; the lower one reads "Wên-li." The colophon, which reads from left to right because of the orientation of the figure, reads:

He only muttered tersely "I know not"
How did he understand Chinese when his was a barbarian tongue?
If old Hsiao had had [more] blood under his skin
He would have pursued [Bodhidharma] beyond the flowing sands in search of the Dharma.

This *gāthā* refers to the celebrated meeting between Emperor Wu of Liang, one of the greatest Chinese patrons of Buddhism, and Bodhidharma, who had recently arrived from India. The incident is described in *The Record of the Transmission of the Lamp* (vol. III). According to the account, the Emperor (referred to above as "old Hsiao") first questioned Bodhidharma about how much Buddhist merit would accrue to him for his having erected temples, having *sūtras* copied, and supporting monks. Bodhidharma replied curtly, "none at all" and proceeded to explain to the astonished monarch the reasons for his answer. But the Emperor was unable to comprehend the explanation and tried a new tack: "What is the first principle of the holy doctrine?" "Vast emptiness, and there is nothing holy about it" was the reply. The dis-

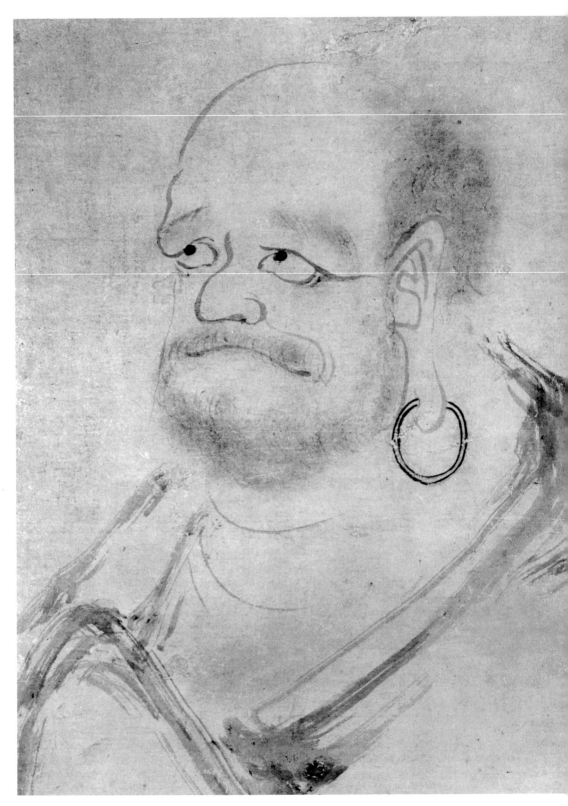

7. *Bodhidharma*, artist unknown, 13th century (detail)

mayed monarch finally asked, "[Well then] who is standing before me?" To which Bodhidharma replied laconically, "I know not." As a result of this unproductive dialogue, Bodhidharma soon departed from the Liang kingdom and went north to the state of Wei, where he spent nine years in "wall-contemplation" at the Shao-lin temple. He is said to eventually have returned to India, and the "flowing sands" refers to the deserts of Central Asia which he had traversed en route.

The colophons on the flanking pieces were written by Yen-ch'i Kuang-wên (1189-1263), a Ch'an priest of the Southern Sung period who began as a disciple of Chê-wêng Ju-yen when he was eighteen and became a distinguished prelate in his later years, serving as abbot at many of the great Ch'an institutions in the Chêkiang area. He was the fortieth abbot at the Ching-tz'ǔ-ssǔ. Perhaps it is more than coincidental that Mieh-wêng Wên-li, who wrote the colophon on the painting of Bodhidharma, served as the thirty-sixth abbot of the temple. Yen-ch'i is said to have come from a Confucian family, and details of his life are included in various Ch'an documents, such as the *Hsü ch'uan-têng-lu*.

Colophons from his hand appear on a small group of Southern Sung paintings: the Li Ch'üeh Pu-tai and Fêng-kan examples; the Mu-ch'i painting of the patriarch Hsien-tzǔ; two works painted by the obscure master Chih-wêng — the representation of the patriarch Hui-nêng in the Ōhara Collection, and the Pu-tai in the Umezawa Collection in Kamakura — and, finally, the anonymous painting in the Tokugawa Reimeikai, which shows Pu-tai seated and which, stylistically, is close to the Chih-wêng paintings. As many as nine seals used by Kuang-wên are known, and these appear in different overlapping combinations of threes in each of the above paintings, with the exception of the Chih-wêng representation of Hui-nêng and the Mu-ch'i work, where they are identical. References to temple names in the signatures make it possible to establish the years in which the colophons were written. The phrase "in residence at the Lêng Ch'uan," appears both on the Chih-wêng painting of Hui-nêng and the Mu-ch'i representation of Hsien-tzǔ. The "Lêng ch'uan" was one of the small buildings in the Ling-yin-ssǔ complex, where Kuang-wên resided during the years 1254 to 1256. Both of the Li Ch'üeh paintings, as well as the Chih-wêng

Pu-tai in the Umezawa Collection, have "in residence on Mount Ching" preceding the signature, a phrase which indicates that the colophons were added during the last years of Li Ch'üeh's life — between 1261 and 1263 — when he lived at the Wan-shou-ssǔ on Mount Ching. Kuang-wên usually substitutes the character *Huang* ("Yellow") for *Kuang* in his signatures. The reason for this is not clear, but the two characters are quite close in sound and form.

Fêng-kan and his tiger are a recurrent motif in Zen painting (see cat. nos. 3 and 29); the colophon reads as follows:

To understand only how to grasp the tiger's head
And not how to manage its tail . . .
Confused old Lü-ch'iu,
The fault was his own.

Lü-ch'iu Yin, is said to have been a prefect in the T'ai-chou area during the T'ang dynasty and traditionally is credited with writing the preface to the *Collected Works of Han-shan*. The incident referred to here deals with his meeting with Han-shan and Shih-tê at the Kuo-ch'ing-ssǔ on Mount T'ien-t'ai. Lü-ch'iu was anxious to find a sage to instruct him, and he asked Fêng-kan whether there were any about. Fêng-kan replied that Mañjuśrī and Samantabhadra resided in the Kuo-ch'ing-ssǔ, and that they were actually Han-shan and Shih-tê, who performed menial tasks in the kitchen there. Lü-ch'iu went to the kitchen to see them and made the proper obeisance, but the two sage-rustics shouted and laughed at him, saying, "Fêng-kan has been gossiping again. You did not recognize Maitreya (Fêng-kan) at sight, what are you doing bowing to us?" This commotion attracted a number of monks, who hurried into the kitchen to observe the strange proceedings. Han-shan and Shih-tê thereupon joined hands and fled from the temple to a retreat in the neighboring mountains. The first two lines of the colophon signify that Lü-ch'iu's religious training and awareness were inadequate, and there may also be an oblique reference to Fêng-kan's tiger. The colophon above the Pu-tai painting reads:

How broadly he ranges, how quickly he runs!
Coming and going, here and there
In front of the jewel-tower are moist traces,
Sudhana has left — is he still recognized?
There, where the grass is thick and green.

Pu-tai, who may have been a historical personage, is said to have lived during the Later Liang dynasty and to have died in 916. He appears as a rotund, unkempt, itinerant sage and is one of the most frequently represented motifs in the compendium of Zen subjects. He had no fixed abode, but wandered about, shouldering a huge sack filled with his paraphernalia. He was thought to be a transformation-body of the Bodhisattva Maitreya, who dwelt in the "jewel-tower" mentioned above, where Sudhana, the chief protagonist of the *Gandavyūha*, visited him during his pilgrimage. Another colophon written by Kuang-wên dealing with Pu-tai appears in the Pu-tai painting by Chih-wêng in the Umezawa Collection. It is identical in content with that on the Li Ch'üeh Pu-tai with the exception of one four-character passage, and the possibility of an additional isolated character.

The calligraphy of Yen-ch'i Kuang-wên has a strong individual quality, a sense of crispness, and a feeling for stylistic niceties, while Mieh-wêng Wên-li's has an eccentric, inept flavor about it. A comparison of the two is instructive, for it demonstrates something of the range of individual variation in rendering characters in the orthodox style practiced by contemporary monks who moved in the same religious circles.

REFERENCES:
Wu Chi-yu, "A Study of Han-shan," *T'oung Pao* 45, (1957), pp. 392-450; Tokyo National Museum, *Sōgen no Kaiga* (1962), nos. 26-27; *Bijutsu Kenkyu*, no. 15, p. 127; *Zendera to Sekitei*, Genshoku Nihon no Bijutsu, vol. 10 (Tokyo, 1967), pl. 91; *Nihon Kokuhō Zenshū Kaisetsu* (Tokyo, 1936), no. 69; Suzuki Daisetz, *Essays in Zen Buddhism*, 2nd ser. (London, 1933), p. 298 ff.; Tayama Hōnan, *Zenrin Bokuseki* (Tokyo, 1955), I, nos. 23, 24, 26; Tayama Hōnan, *Zoku Zenrin Bokuseki* (Tokyo, 1965), no. 9.

8

CALLIGRAPHY PRESENTED TO THE JŌTENJI
Wu-chun Shih-fan (1177-1249)
Hanging scroll, ink on paper, 196.7 x 44.0 cm.
Tōfukuji, Kyoto
Registered Important Cultural Property

Among the many distinguished prelates produced by the Ch'an sect during the Southern Sung period, the name of Wu-chun Shih-fan (1177-1249) is particularly esteemed, not only for his own religious accomplishments and untiring efforts on behalf of the church but also because of his diligence and skill in training disciples. Eager aspirants came from all over China to study under him, and sixteen monks made the long pilgrimage from Japan to seek his guidance. His Chinese disciples included two distinguished priests who later traveled to Japan to transmit the Ch'an doctrine: Wu-hsüeh Tsu-yüan (Mugaku Sogen) (1226-1286) who founded the Engakuji in Kamakura, and Wu-an P'u-ning (Gottan Funei) (1197-1276) who served as the abbot of the Kenchōji. Wu-chun's outstanding Japanese *illuminatus* was Ben'en Enni (Shōichi Kokushi) (1202-1281), the founder of the Tōfukuji in Kyoto. Enni returned to Japan in 1241 after four years of study under Wu-chun He brought with him various memorabilia from the master, including his own certificate of ordination, and two *chinsō*, both in the Tōfukuji —the superb full-length portrait of Wu-chun, which is the finest extant Chinese *chinsō*, and another large half-torso representation. Both bear inscriptions in the master's own hand.

Wu-chun was born in Szechwan, where he entered the priesthood at the age of nineteen. In the following years, he made the standard peripatetic rounds of all the great Ch'an religious centers and received instruction from the most eminent masters of the time, including Sung-yüan Ch'ung-yo, whose line later gained great prominence in Japan. He eventually attained the rank of abbot and served in this capacity at several institutions until 1232 when he was finally elected to head the most revered Ch'an institution of the period, the monastery on Mount Ching, the Wan-shou-ssŭ. In the following year he set out to repair the sprawling temple compound, which had been laid out on a very large scale in the twelfth century, but had fallen into a state of partial ruin. This great project was completed several years later, and Wu-chun was commended by the court and awarded the special title Fo-chien Ch'an-shih ("Mirror of the Buddha, Ch'an Teacher"). In 1242 the great monastery was ravaged by fire, and it was not until seven years later that it was finally restored once again. Following this, Wu-chun moved to a sub-temple, the T'ui-kêng-an ("Retired from Plowing Hermitage"), where

Facing page:
8. *Calligraphy Presented to the Jōtenji,* by Wu-chun Shih-fan (1177-1249)

he lived out his last years. The Japanese often borrowed Chinese temple names for their own institutions, and it is interesting to note that the sub-temple in the Tōfukuji where Shōkai Reiken (see cat. no. 43) lived out his final years, pronounced *Taikō-an* in Japanese, is identical with *T'ui-kêng-an*.

When Enni reached Hakata, he set out to solicit support to found a Zen monastery in the area. He was fortunate enough to receive aid from one of the highest local officials, and in the following year, he founded the Jōtenji. Wu-chun was overjoyed when he heard of his disciple's prodigious activity, and he took up his brush and wrote out a number of calligraphic plaques for the new temple. Some of them were designed to be installed in specific buildings, such as the example in the Sakai Collection in Tsurugaoka, which reads "Sound of the Tide Hall" and which is thought to have been used in the Dharma Hall. Others refer to activities or duties, such as *Zazen* (to "sit in Zen meditation") and *Sanyū* ("Prepare Tea"). The letter which accompanied these pieces of calligraphy is still extant, and is now in the Hatakeyama Collection in Tokyo. In it Wu-chun declares: "I've written the big characters one by one. As your temple is large, I'm concerned that the characters will be too small. So I don't know whether you'll be able to use them or not. But if they are not useable, let me hear from you, and I will certainly write more for you" It is not clear just when or where the exhibition piece was displayed. It has no reference to any building, and may have been hung in whatever place was appropriate on felicitous occassions. It reads "Bestowed at Imperial Order, [the] Jōten Zen temple." Because of the term "Bestowed at Imperial Order," a conventional phrase often used to preface the name of a temple which had received sanction or support from the throne in China, it is possible that the "Jōten Zen temple" is the name of a temple or compound on Mount Ching which still existed during the thirteenth century. The practice of using Chinese temple names for those of the same religious lineage in Japan was certainly common enough to support this supposition. The present manner in which the characters are mounted, in vertical sequence, may not represent the original arrangement. Each character is written on a separate piece of paper, and although the paper is all of the same sort, it is not clear whether Wu-chun originally wrote them on

independent sheets, or whether they might initially have been executed horizontally on a single sheet and separated at some later time. The fact that each has a seal imprint reading "Fumon-in" (the name of a sub-temple in the Tōfukuji), an imprint which appears on all the Wu-chun pieces, indicates that they were probably in separate sheets sometime early in their history. At the bottom left is Wu-chun's seal: "Fo-chien Ch'an-shih."

After founding the Jōtenji in Hakata, Enni seems to have encountered considerable opposition from followers of the Tendai sect in the area, and this appears to be the reason he moved on to Kyoto, where he eventually became the abbot of the Tōfukuji, the largest and most impressive Zen monastery of its time in western Japan. He brought all the calligraphy, chinsō, and other memorabilia received from Wu-chun with him and installed them in the Fumonin.

Four centuries later, during the Edo period, certain of the pieces of calligraphy by Wu-chun passed into secular hands, and many are prized possessions in private museums or collections today. The famous piece in the Sakai Collection once belonged to the tea-master Kobori Enshū, and another, now in the Hakone Museum, belonged to the Tokugawa family. The pieces still preserved in the Tōfukuji usually are displayed on the sixteenth and seventeenth of November every year in commemoration of the death date of the founder, Enni.

Wu-chun's calligraphic style might be compared with the brushwork of Sesshū (see cat. no. 55). Both are vital and direct in their impact, and depend on a strong, unembellished line, devoid of artistic eccentricities. Wu-chun's characters are written in a deliberate, preconceived manner, and are constructed tectonically so that each stroke has its own independent strength, but also interlocks organically with the total composition.

REFERENCES:
Kamakura-jidai, Nihon Bunkashi Taikei, vol. 6 (Tokyo, 1957), pl. 394 (half-torso *chinsō* portrait of Wu-chun Shih-fan); Zaitsu Nagatsugi, *Sho no bi* (Tokyo, 1957), pl. on p. 169; Tokyo National Museum, *Chūgoku Sōgen Bijutsuten Mokuroku* (1961), nos. 395-398; Tokyo National Museum, *Tōyō no Bijutsu* (Kyoto, 1968), pl. 122; Tayama Hōnan, *Zenrin Bokuseki* (Tokyo, 1955), nos. 11-19; idem, *Zoku Zenrin Bokuseki*

(Tokyo, 1965), nos. 14-22; *Shodō Zenshū*, vol. 16 (Tokyo, 1968), nos. 103-104.

9

FANG-CHANG ("THE ABBOT'S QUARTERS")
Chang Chi-chih (1186-1266)
Framed and mounted as a panel, ink on paper, 45.2 x 126 cm.
Tōfukuji, Kyoto
Registered Important Cultural Property

Chang Chi-chih was an official of the Southern Sung dynasty. His career as a mandarin, which initially was furthered by his father's assistance, was not one of particular distinction. He obtained the degree of *chin-shih* (the highest rank in the civil service examination), but never rose to high office. As a calligrapher, however, his fame spread far beyond the borders of his homeland. The Jurchen, who occupied the northern half of China, as well as the Japanese, who heard about him from traveling Zen monks, eagerly sought to acquire specimens of his handwriting.

Chang was a deeply religious Buddhist and copied the *Vajracchedikā-sūtra* as an act of devotion several times during his lifetime. He maintained many contacts with the Buddhist clergy, especially with Ch'an priests. Among his friends he counted the eminent Ch'an priest, Wu-wên Tao-ts'an (died 1271), who seems to have known the painter Mu-ch'i. Several copies of the *Vajracchedikā-sūtra* in Chang's handwriting have survived in Japan, and he is also known for his copies of poems by the T'ang poet Tu Fu, written both in small and large characters.

This fine piece of calligraphy, consisting of the characters *Fang-chang* ("The Abbot's Quarters"), is one of a set of eight examples written with two characters referring to locations in a temple. An incised wooden plaque based on this piece of calligraphy is still in use at the Daitokuji, Kyoto. The words *fang-chang* are an abbreviation for "a room of ten square (*fang*) feet (*chang*)." This expression originally applied to the residence of Vimalakīrti (see cat. no. 64), but was used, from T'ang times on, for the abbot's quarters at a Ch'an temple.

The bold characters, which combine strength with elegance, are characteristic of Chang's robust style which continued the traditions of the Northern Sung schools of Huang T'ing-chien

9. *Fang-chang ("The Abbot's Quarters")*, by Chang
Chi-chih (1186-1266)

and Su Shih. In spite of the close resemblance to other works by Chang's hand, especially the fragment of a poem by Tu Fu in the Chisaku-in, Kyoto, this piece is thought by some to be the work of one of Chang's numerous followers rather than by the great artist himself.

Between the two characters is a seal which reads: "Fumon-in." This is the name of one of the sub-temples of the Tōfukuji (see cat. no. 59). The eight-piece set is believed to have been brought back from China in 1241 by the monk Ben'en (1201-1280), who subsequently founded the Tōfukuji (see cat. no. 59), the temple where these pieces are still preserved. Ben'en was a disciple of Wu-chun Shih-fan (died 1249, see cat. no. 8), one of the most influential Ch'an priests of the Southern Sung period. This may have been the reason why some scholars have attributed these signs to Wu-chun Shih-fan himself.

REFERENCES:
Shodō Zenshū, vol. 16 (Tokyo, 1955), pl. 88; *Daitokuji*, Hihō, vol. 2 (Tokyo, 1968), pl. 237; Tokyo National Museum, *Tōyō no Bijutsu* (Kyoto, 1969), pl. 116.

10

DRAGON AND TIGER
Fa-ch'ang (Mu-ch'i), died between 1269 and 1274
Pair of hanging scrolls, ink with accents in light red on silk, 147.4 x 93.5 cm.
Daitokuji, Kyoto
Registered Important Cultural Properties

The Ch'an monk and painter Fa-ch'ang, better known by his sobriquet Mu-ch'i, was a native of Szechwan. Chinese sources contain no information at all about his activities as a monk and do not mention his Ch'an lineage. All early Japanese sources, however, agree that he was a disciple of the great Ch'an master Wu-chun Shih-fan (died 1249). It appears that Mu-ch'i spent the greater part of his life in Chêkiang, where he is said to have restored the Liu-t'ung-ssū, an old temple on the shore of the scenic West Lake near Hang-chou. Among his friends was the Ch'an monk Wu-wên Tao-ts'an (see cat. no. 9), and his paintings were inscribed with colophons by several of the well-known Ch'an monks of his time.

Although it therefore might seem that his life was spent in the company of kindred spirits in the relative seclusion of Ch'an monasteries, this was not always the case. The *Sung-chai mei-p'u* (1351) tells us that Mu-ch'i became a fugitive from justice after he made derogatory remarks about Prime Minister Chia Ssŭ-tao (1213-1275), and he is said to have gone into hiding in the house of a gentleman named Ch'iu in Yüeh as a consequence. The same source puts the year of his death in the Chih-yüan era (1264-1274). As the *Dragon and Tiger* bears a date corresponding to 1269, the date of Mu-ch'i's death may be narrowed down to between 1269 and 1274.

Chinese sources not only completely ignore Mu-ch'i's religious activities, but have little to say about his talents as a painter. The few remarks made in the standard biographical collections such as the *Hua-chien* (1330) and the *T'u-hui pao-chien* (1365) offer more criticism than praise; they characterize his work as "coarse," "lacking in elegance," and "deficient in the technique of the ancient masters." Chuang Su in his *Hua-chi pu-i* (1298), an almost contemporary source, is the first to blame Mu-ch'i for a lack of refinement, adding that he thinks his work is suitable only for the secluded atmosphere of a temple. Although it is clear that some of these derogatory remarks are simply copied from one text into the next, there seems little doubt that Mu-ch'i was not highly regarded as a painter outside the relatively small coterie of Ch'an monks and their friends.

These friends, however, included Japanese Zen monks, who came to study under the great Ch'an masters of the Southern Sung and Yüan periods. During his lifetime Mu-ch'i had already acquired a great reputation among these visitors from abroad, who took home a very substantial number of his pieces. As practically all paintings by Mu-ch'i which were left in China have been lost, it is due to these Japanese Zen monks that the rather unfavorable reputation of this master can be corrected on the basis of the masterpieces which have been preserved in Japan. In the *Butsunichi-an kubutsu mokuroku,* the inventory of art objects in the Engakuji in Kamakura of 1365, only a few works by his hand are mentioned, including a *Monkey Seated in Zen Meditation.* By about 1500, when the catalogue of the shōgunal collection (*Gyomotsu on-e mokuroku*) was compiled, this collection alone contained dozens of paintings attributed to Mu-ch'i. Many of these were undoubtedly copies, Chinese as well as

Japanese, but the collection also contained such celebrated masterpieces as the *Kuan-yin*, *Monkeys*, and *Crane*, which are now combined as a triptych and preserved in the Daitokuji, Kyoto.

The shōgunal collection at that time contained no less than three pairs of paintings representing the Dragon and Tiger theme. In all likelihood, one of these pairs is that shown here. The catalogue describes them as *waki-e*, i.e., "flanking pictures." This term indicates that the Japanese used them to the right and left of a central icon. According to the *Higashiyamadono Gyomotsu on-kake-e*, an inventory compiled in 1660, a pair of paintings representing a dragon and a tiger, possibly identical with the pair shown here, was used to flank the famous representation of Kuan-yin which is now the central picture of the Daitokuji triptych.

Although triptychs existed in China, where they were used to represent the standard Buddhist trinities, the combining of separate sets of landscapes, animals, or figures with a central image to form a triptych is a practice which evolved very early in Japan and for which there seems to be no Chinese precedent (see cat. no. 7). However, it is in ancient Chinese symbolism of dragons and tigers that we can find a possible explanation for the fact that the Japanese considered such paintings appropriate as "side pictures" for a representation of Kuan-yin or some other iconic subject from the Buddhist pantheon.

The dragon is the first of the *ssŭ-ling*, the Four Supernatural Animals. In the Chinese cosmological system the dragon is identified with *yang*, the Male Principle, and therefore also with spring, rain, the East, and sunrise. The tiger, identified with *yin*, the Female Principle, and therefore in every respect the opposite of the dragon, stands for autumn, wind, the West, and sunset. The Azure Dragon as the antipode of the White Tiger makes his appearance as early as the *I-ching* (the "Book of Changes") and both are frequently represented together with the Phoenix and Tortoise in places such as tombs, which required an exact cosmological orientation. Together, these two pairs of opposites may therefore be considered to symbolize the cosmological principles at work in the universe.

Mu-ch'i was perhaps the first painter to be called "skilled in painting dragons and tigers," and his talent for this subject was recognized even by those who criticized his manner. It is not likely, however, that he was the first artist

to resurrect this ancient theme during the Sung period. He may even have followed an imperial example, for the *Butsunichi-an kubutsu mokuroku* mentions a Dragon and Tiger painted and inscribed by the Sung Emperor Hui-tsung (reigned 1101-1126). It may well be that the revived interest in cosmological speculations and in the *I-ching*, clearly noticeable in the work of such philosophers as Chou Tun-i (1017-1073), made this traditional pair of cosmological adversaries a suitable subject for painting. Incidentally, although a tiger figures prominently in the cycle of anecdotes concerning the Ch'an master Fêng-kan (see cat. no. 7), there is no reason to suppose that the Dragon and Tiger is a typical Ch'an theme.

Of the several paintings in Japanese collections representing the Dragon and Tiger theme and attributed to Mu-ch'i, this pair is the most famous, for it is the only one inscribed and dated by the artist. The signature in the lower right corner of the tiger picture reads: "Executed during the year *chi-ssŭ* of the Hsien-shun period, Mu-ch'i." This year corresponds to 1269 of our era, indicating that it must be a work dating from Mu-ch'i's last years. Both paintings carry a one-line inscription. The two parallel phrases read: "The dragon rises and causes clouds to appear." and "The tiger roars and the wind impetuously blows." The dragon's head is surrounded by undefined, cloudy areas — to some extent the artist's intention, but in part also due to damage to the painting surface. All the traditional marks of the dragon — the bulging eyes, the horns, the long whiskers — are already present. The tiger is seated against a background of windblown bamboo buried in vapors. These scrolls are specimens of Mu-ch'i's late work and do not have the vigor of the Daitokuji triptych, which may have been painted more than twenty-five years earlier. In spite of the soft, sometimes deliberately indistinct brushwork, the subtle gradations in the use of ink for clouds and vapors have created a remote, supernatural atmosphere which is in keeping with a representation of these primordial cosmological symbols.

REFERENCES:
Tanaka Toyozō, *Chūgoku Bijutsu no Kenkyū* (Tokyo, 1964), pp. 243-261; *Allgemeines Lexikon der bildenden Künstler,* s.v. "Mu-ch'i"; Shimada Shūjirō, "Shōsai Baifu teiyō" (bibliographical notes on the *Sung-chai mei-p'u,* in Japanese),

10. *Dragon*, by Mu-ch'i, 1269

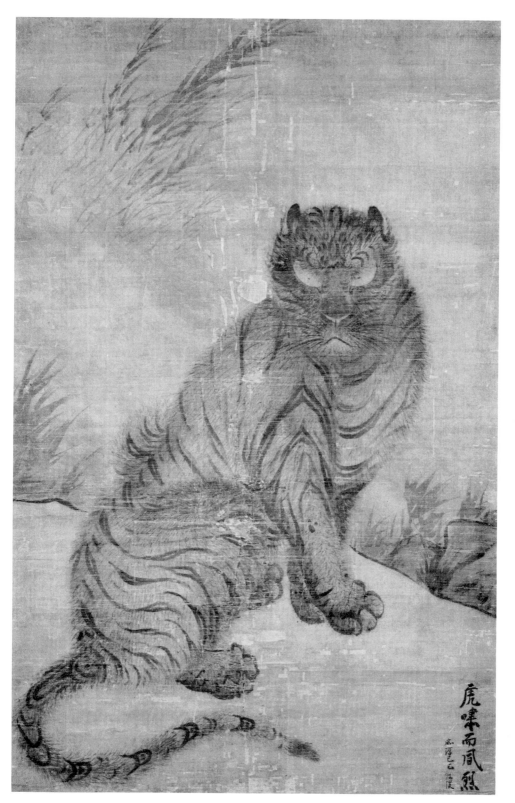

10. *Tiger,* by Mu-ch'i, 1269

虎嘯而風烈

Bunka 20, no. 2, pp. 96-118; Chuang Su, Hua-chi pu-i (Peking: Hsin-hua shu-tien, 1963), ch. 1, p. 6; Kokka, no. 190; Daitokuji, Hihō, vol. 11 (Tokyo, 1968), pls. 25-26; Bijutsu Kenkyu, no. 120, p. 411.

11

SPARROWS AND BAMBOO
Traditionally attributed to Mu-ch'i (died between 1269 and 1274)
Hanging scroll, ink-monochrome on paper, 84.5 x 27.8 cm.
Nezu Art Museum
Registered Important Cultural Property

It is difficult to determine just when the subject Sparrows and Bamboo made its first appearance in Chinese painting. The catalogue of the collection of the Sung Emperor Hui-tsung (the *Hsüan-ho hua-p'u*) lists various works with this title including three by Huang Ch'üan, and two ink-monochrome examples by the famous eleventh-century bamboo specialist Wên T'ung. The subject may thus have been favored not only in the Imperial Art Academy, but also among the literati painters. Sparrows in combination with either bamboo or plum blossoms were a standard theme of the artists in the Southern Sung Academy. Although a considerable number of polychrome representations would seem to have been produced, it is apparent that certain artists continued to treat the theme in ink-monochrome.

The painting in this exhibition has traditionally been attributed to the thirteenth-century master Mu-ch'i, (see cat. no. 10) and has been preserved in Japan since the middle of the Muromachi period. It has been the object of much praise through the centuries by connoisseurs, particularly those associated with the Tea Ceremony, and is known affectionately as the "Wet Sparrows" because the two birds are shown huddled together, dampened by a chill rain. Kobori Enshū mentions a painting of this subject in his *Ganka Meibutsu-ki* (compiled ca. 1658-1661) which may be this work.

The painting has no painter's signature or seal, and the attribution to Mu-ch'i can only be a tentative one, but comparison with accepted works by the master reveals a number of small stylistic and compositional devices which sup-port the claim. If the work is not from the hand of Mu-ch'i, it cannot have been produced by anyone very far removed in time or style from him. Another painting of the same subject is part of a triptych attributed to Mu-ch'i. It and a work depicting Swallows and Willows flank a painting of Fêng-kan. This second example shows four sparrows; three are huddled together on a branch of bamboo and the fourth is flying towards them. The birds are very similar in style to the "Wet Sparrows."

A polychrome painting of Sparrows and Plum Blossoms in the collection of Yamamoto Tatsurō which has traditionally been attributed to the academic painter, Ma Lin, the son of Ma Yüan (see cat. no. 4), provides an interesting comparison with the Nezu piece. The surprising correspondence between the anatomical details and patterns of feathers in the birds in these paintings suggest that the subject was one which could be treated with equal facility either in monochrome or polychrome, and perhaps this explains not only why the subject was treated in both manners from an early time, but also why both traditions continued to flourish in later centuries.

There are at least three paintings of sparrows done by fourteenth-century Japanese Zen monks. Perhaps the most famous is Kaō's fine work in the Yamato Bunka-kan which shows a solitary bird looking up at bamboo, a piece which may once have been paired with one showing three lively birds and plum blossoms. Another example is the badly preserved work by Ue Gukei (see p. 83), which has a colophon by Ten'an Kaigi who died in 1361. The colophon is of particular interest because it likens the two sparrows to two of Śākyamuni's sage disciples, Mahākāśyapa and Maudgalyāyana, and seems to indicate that the painting is to be understood as a *Zenki* theme. It would not be surprising if Ch'an monks had viewed sparrows in some special light. References to the bird appear in treatises on art by Sung literati such as Su Tung-p'o and Wen Yü-k'o and may have been adopted by Ch'an writers.

There can be no doubt that the sparrow had a particular appeal to Zen monks, however, for there are frequent references to the bird in the "Recorded Sayings" of various early masters, and the subject was portrayed frequently in painting of the Muromachi period. Ikkyū's touching tribute to his dead pet sparrow (see cat. no. 52), and the *gāthā* he dedicated to it,

Facing page:
11. *Sparrows and Bamboo*, attr. to Mu-ch'i (13th century)

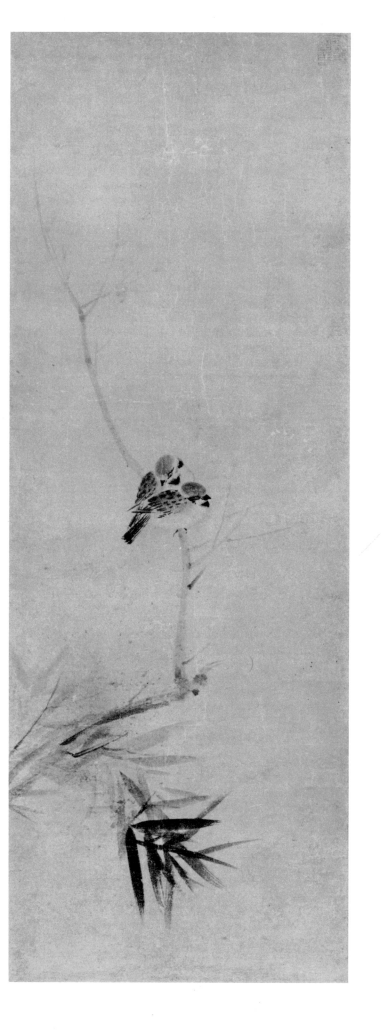

which likened its passing to the final nirvāna of Śākyamuni, is certainly representative of this attitude, as is the appearance of a small vivacious sparrow carved from wood, which sits alertly on the arm of the chair of the famous sculptural image of Bukkō in the Engakuji. Perhaps Zen monks saw a parallel between their ideal of the enlightened individual, freed from the constraints of the world of discrimination and duality, and the vital, spontaneous behavior of the sparrow, direct and uninhibited in its joy of life.

The Nezu painting has two seals which have been the object of much scholarly attention. Both appear on a number of other famous paintings traditionally thought to have been brought to Japan from China. The seal in the upper right-hand corner reads, *Zōge-Shitsu-in*, or perhaps, *Zōka-Shitsu-in* and is known to appear on ten other paintings. It is clearly a collector's seal. The theory that it is Chinese is now generally discounted, and it is thought to be Japanese and to date back to the fifteenth century. Some scholars have suggested that it may have been used by the famous collector Ashikaga Yoshimasa, but there is no evidence to support this claim.

The second seal, in the lower left-hand corner, is shaped like a gourd and has two characters, which read, *Zen-a*. Most scholars agree that the seal is a collector's, perhaps Zen'ami's, a garden designer who was a member of Yoshimasa's coterie. Yonezawa Yoshiho has suggested that the seal may be an artist's and that the works bearing this seal are therefore Japanese copies. His evidence, however, remains inconclusive.

REFERENCES:
"A Tree and Bamboo with Two Sparrows" (in Japanese), *Kokka*, no. 576; Matsushita Takaaki, "Sung Paintings of Birds and Flowers Attributed to Ma Lin," *Yamato Bunka*, no. 13 (March 1954); Tokyo National Museum, *Chinese Arts of the Sung and Yüan Periods* (Tokyo, 1966), pls. 33, 36; Tanaka Ichimatsu and Yonezawa Yoshiho, *Suibokuga*, Genshoku Nihon no Bijutsu, vol. 11 (Tokyo, 1970), pl. 6 (Kaō sparrow and bamboo); Nakamura Tanio, "On a Picture by Gukei entitled 'Bamboos and Sparrows,'" *Kokka*, no. 762; Matsushita *Takaaki, Suibokuga*, Nihon no Bijutsu, no. 13 (Tokyo, 1967), pl. 36 (Kaō sparrows and plum blossoms); Hisamatsu Shinichi, *Zen to Bijutsu* [Zen and fine arts] (Kyoto, 1958), pl. 68 (sparrows and bamboo; one segment of a

triptych traditionally attributed to Mu-ch'i); *Muromachi jidai*, Nihon Bunkashi Taikei, vol. 7, figs. 500 (Zōka-Shitsu-in seal), 503 (Zen'a seal); Yonezawa Yoshiho, "Zen-a in aru Gafu," *Bijutsu-shi*, no. 11; Wakimoto Tokuro, "On the Garden-designer Zen-ami and the Sung and Yüan Paintings with the Collector's Seal 'Zen-a'" (in Japanese), *Bijutsu Kenkyu*, no. 26; Etoh Shun, "Explanations for Kaō paintings of Plum Blossoms and Sparrows and Bamboo and Sparrow" (in Japanese), *Yamato Bunka*, no. 46 (Jan. 1967), pls. 4, 5; Nakamura Tanio, "Gukei's 'Sparrows and Bamboo' Painting and its Date," *Kokka*, no. 762; Hasumi Shigeyasu, "Kaō to Gukei," *Ars Buddhica* 49 (Sept. 1962), pp. 1-16; *Zendera to Sekitei*, Genshoku Nihon no Bijutsu, vol. 10 (Tokyo, 1967), pl. 99 (sculptural *chinsō* of Bukkō Kokushi).

12

HAN-SHAN AND SHIH-TÊ
Traditionally attributed to Yen Hui (second half of the 13th century)
Pair of hanging scrolls, ink and colors on silk, 127 x 41.8 cm.
Tokyo National Museum
Registered Important Cultural Properties

Yen Hui is one of the group of Chinese painters who remained relatively unknown in their native country, but whose fame spread to Japan where they enjoyed a great reputation and where their work exerted a strong influence on native artists. One of the few references to Yen Hui in Chinese sources is found in the *Hua-chi pu-i*, a biographical collection compiled by Chang Su in 1298. According to this treatise, Yen Hui was active towards the end of the Sung period. He specialized in figure painting, especially of demons and deities, and he is reported to have painted landscapes as well. His favorite theme seems to have been Chung K'uei, the Demon Queller. Yen Hui's style is that of a professional painter and he may have worked chiefly on wall paintings in Taoist temples. The *Hua-chi pu-i* indicates, however, that he was highly appreciated by the literati of his time. The finest paintings which bear his seal and which can be attributed to his hand with confidence are the pair of hanging scrolls in Chion-in, Kyoto, representing the immortals Hsia-mo and T'ieh-kuai.

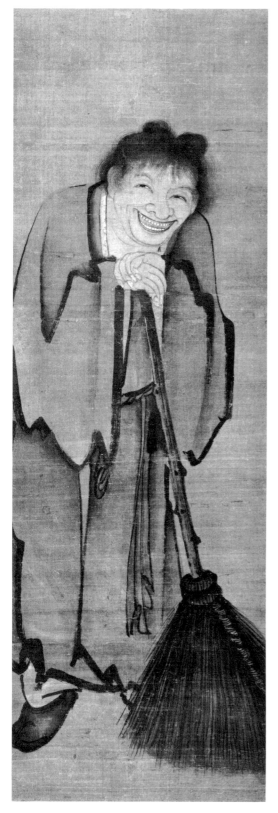

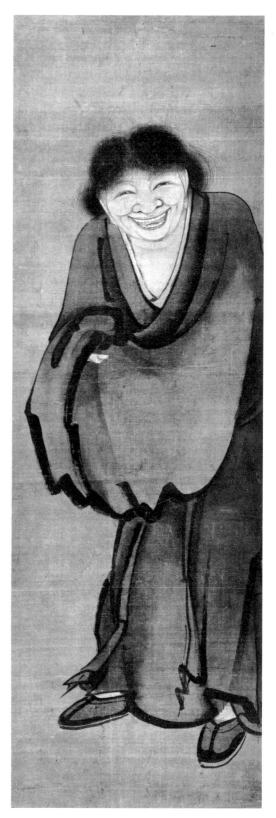

12. *Shih-tê*, attr. to Yen Hui (13th century)

12. *Han-shan*, attr. to Yen Hui (13th century)

The scrolls representing Han-shan and Shih-tê bear neither signature nor seal. Their attribution to Yen Hui, although of long standing, seems difficult to accept if we compare them with the celebrated set of the Chion-in. A touch of green has been applied to Han-shan's shoes and to the sash of Shih-tê's costume. Even though flesh tones are used for the faces, the paintings are essentially monochrome works. In the Chion-in set, there is a greater emphasis on color. The clothes of Han-shan and Shih-tê have been drawn in a bold hand, their shape brought out by a combination of strong, heavy outlines and carefully graduated shadings. However, the brushwork is somewhat less versatile and sensitive than that of the Chion-in set, and the wide grin on the almost identical, rotund faces lacks the spontaneity and the imaginative power of the Hsia-mo and T'ieh-kuai. Although it is possible that the artist modified his style to accord with the theme at hand, it is more likely that this slight exaggeration of the stylistic features of Yen Hui is an indication that these paintings are the work of a pupil or a follower of his style.

Even though their attribution to Yen Hui is thus open to some doubt, these scrolls have been highly esteemed for centuries in Japan. They are mounted in a manner and with brocades of a type which are usually associated with paintings once a part of the shōgunal collection of the Ashikaga period. However, the earliest known reference to them in historical accounts dates from 1580. It notes that Oda Nobunaga presented them to the Ishiyama Honganji at Osaka in an effort to negotiate a peaceful surrender of this fortified temple. In 1664, the famous artist Kano Tanyū (1602-1674) made a copy of the pair. It was not until the late nineteenth century, when the temple was in financial difficulties, that the paintings were sold to the Kawasaki family, where they remained until recent times.

REFERENCES:

Nihon Kokuhō Zenshū, vol. 45 (Tokyo, 1931), cat. no. 895; Matsushita Takaaki, "Genki no Kanzan Jittoku-zu" [The Han-shan and Shih-tê by Yen hui] *Museum*, no. 3 (June 1951), pp. 25-27.

13

THE MONK FROM TAN-HSIA BURNING A WOODEN IMAGE OF THE BUDDHA
Yin-t'o-lo (Indra?) (active second half of the 13th — first half of the 14th century)
Fragment of a handscroll, now mounted as a hanging scroll, ink on paper, 35 x 36.7 cm.
Collection of Ishibashi Kan'ichirō, Tokyo
Registered National Treasure

Of the group of Chinese painters of the Ch'an school whose entire surviving oeuvre has been handed down in Japanese collections, Yin-t'o-lo is the most unusual and enigmatic. Nothing is known about his life, and Chinese biographical works make no mention of his name. From inscriptions on his paintings we can gather only a few, rather puzzling facts. Yin-t'o-lo is probably a sinicized form of the Indian name Indra; for according to one inscription, he was a native of Rājagriha (Rajgir, Bihar), India. Another inscription suggests that he was the abbot of a Ch'an monastery at Pien-liang, the present K'ai-fêng in Honan (northern China). On the other hand, all of the colophons on his paintings were written by Ch'an priests who were active in the south, and authors of some of the earliest Japanese catalogues which mention this master, therefore assumed that he lived in the Hangchou area, where most of the other Ch'an artists were active.

The painting *The Monk from Tan-hsia Burning a Wooden Image of the Buddha* is a section of a handscroll which was cut up into at least five parts after it came to Japan. It is considered the finest work in Yin-t'o-lo's small oeuvre. Each section illustrates a well-known Ch'an anecdote. The story of the monk from Tan-hsia burning a wooden image of the Buddha, an incident in the life of the Ch'an master T'ien-jan Ch'an-shih (738-824), usually referred to as The Monk from Tan-hsia, is told in *The Record of the Transmission of the Lamp*: "Later, when he was staying at the Hui-lin-ssŭ in very cold weather, the Master took a wooden statue of the Buddha and burned it. When someone [in other versions, the abbot] criticized him for doing so, the Master said: 'I burned it in order to get the śarīra [i.e., the ashes of the Buddha, which were venerated as relics].' The man said: 'But how can you get śarīra from an ordinary piece of wood?' The Master replied: 'If it is nothing more than a

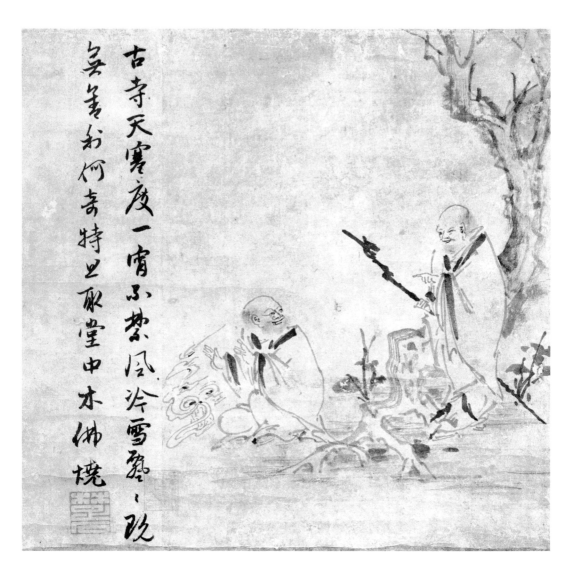

古寺天寒度一宵不禁風泠雪霏霏吸
無筆秋何寺特旦取堂中木佛燒

13. *The Monk from Tan-hsia Burning a Wooden Image of the Buddha*, by Yin-t'o-lo (13th-14th century)

piece of wood, why should you upbraid me [for burning it]?'"

Although no other Chinese example of a representation of this iconoclastic theme has survived, the monk from Tan-hsia seems to have been a popular figure in secular Chinese painting. Several famous artists depicted his visit to the recluse P'ang Yün and his daughter Ling-chao, who is invariably shown carrying a basket in her hand (see cat. no. 17). The great literati painter, Li Kung-lin (died 1106), and the famous Southern Sung painter, Hsia Kuei, are known to have painted this legendary visit.

On a separate piece of paper on the left is a poem written by the Chinese Ch'an priest Ch'u-shih Fan-ch'i (1297-1371):

At an old temple, in cold weather, he spent
the night.
He could not stand the piercing cold of the
whirling wind.
If it has no śarīra, what is there so special
about it?
So he took the wooden Buddha from the hall
and burned it.

The poem bears the poet's seal: *Ch'u-shih*. The other seal is one of the several enigmatic motto-seals for which Yin-t'o-lo was known. It reads: "Children do not know that snowflakes in Heaven are just like willow flowers."

With superb control of the brush, the artist effectively used the contrast of deep black and light gray in bold, expressive strokes. Yin-t'o-lo has captured the spirit of the bizarre incident with the whimsical eye of one who is in sympathy with the iconoclast's point of view. The sardonic grin with which the Monk from Tan-hsia reacts to the remonstrances of the abbot anticipates the incongruous dialogue which the anecdote describes. Perhaps because of the foreign origin of its artist — which may well, for all we know be a Ch'an myth — the painting has, in spite of the typically Chinese brushwork, a slightly outlandish quality. This effect is most evident in pieces which bear inscriptions in the spidery, almost illegible handwriting of the artist. It was this eccentric quality in Yin-t'o-lo's work — so perfectly suited to a Zen context — which fascinated the Japanese. The painter Hasegawa Tōhaku (1539-1610) described Yin-t'o-lo in his *Talks on Painting* as the greatest artist of India and classified him as the equal of

Liang K'ai and Mu-ch'i in China or Mokuan in Japan.

REFERENCES:
Ōgushi Sumio, "Shūseki no san aru Indara-ga" [Paintings by Yin-t'o-lo with eulogies by Ch'u-shih] *Kokka*, no. 583, pp. 193-199; Suzuki Kei, "Shin Kokuhō Indara no Zenki zukan" [Zenki Zu-kan, scroll by Yin-t'o-lo], *Museum*, no. 35 (Feb. 1954), pp. 12-14; O. Sirén, *Chinese Painting: Leading Masters and Principles* (London, 1956), II, p. 146; *Kokuhō*, vol. 5 (Tokyo, 1966), pp. 53-54 and pl. 28.

14

HAN-SHAN AND SHIH-TÊ
Yin-t'o-lo (Indra?) (active second half of the 13th — first half of the 14th century)
Pair of hanging scrolls, ink on silk, each 75.8 x 31.5 cm.
Tokyo National Museum
Registered Important Art Objects

In the small oeuvre of Yin-t'o-lo, about a dozen paintings, the theme of Han-shan and Shih-tê occurs at least five times. Han-shan, the eccentric poet of the Cold Mountain, and his friend Shih-tê, the monk from the kitchen of the Kuo-ch'ing-ssŭ, apparently were much in favor with this enigmatic "Indian" painter.

Han-shan is shown here holding a partially unrolled scroll. Most of the painting is done in tones of light gray, but the outlines of the clothes are indicated in thick, dark strokes of the brush. This is the left-hand painting of the pair, and its inscription reads from left to right:

An empty scroll, one long strip of paper,
Containing all the affairs of men.
Looking at it he seems to be at peace with the
world,
Reciting all of its miraculous ideas.
The waterfall at Stone Bridge splashes the
cold air,
The moth-eyebrow-shaped moon reveals itself
in its true beauty.

The monk of Mount Hua-ting, Tz'ŭ-chiao,
reverently wrote this eulogy.

Nothing is known about the author of this colophon. Mount Hua-ting is the highest peak of the T'ien-t'ai Mountains, famous for the so-called Stone Bridge — a narrow, oblong rock

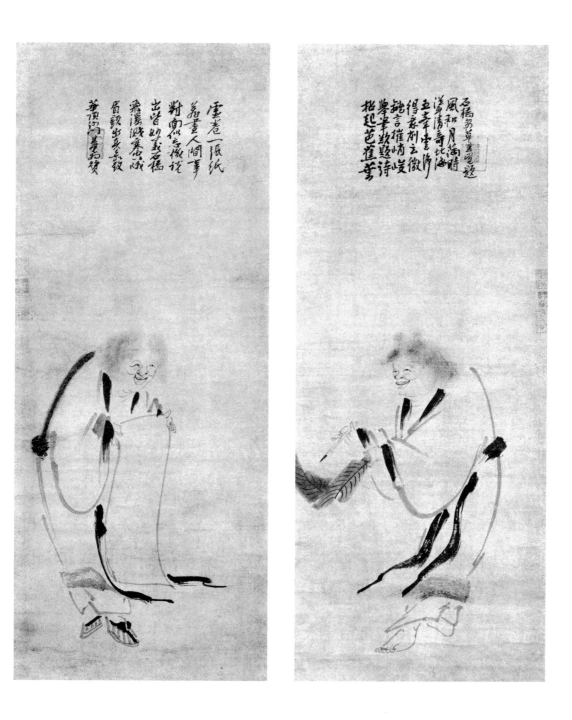

黌頂出真氣機
眉鏡出真氣機
飛溪瀺寒戾
出背妙載名橋
對雨似愛後说
羞畫人間事
雲卷一張纸

拈起芭蕉萼
學章数題詩
魏言權崎嵯
得泰刑立徽
五章雲涂
漢等清奇比海
風和月淘時
名橋努莩蓋覚题

14. *Han-shan,* by Yin-t'o-lo (13th-14th century) 14. *Shih-tê,* by Yin-t'o-lo (13th-14th century)

spanning a waterfall. The "empty scroll, one long strip of paper," is not, as is often taken for granted, a copy of the *Collected Works of Han-shan*, but the *Tao-tê-ching*, the famous Taoist classic. This is clearly indicated in one of Han-shan's poems.

The right-hand painting of the pair shows Han-shan's friend and companion Shih-tê, who is holding a banana leaf on which he is about to write a poem. Shih-tê, though less famous as a poet than his friend, is the alleged author of a few poems in the manner of Han-shan. T'ang eccentrics seem to have been fond of writing their poems on banana leaves, and the "mad monk" Huai-su (725-785) is known to have used this unusual material for his calligraphy. The inscription reads, from left to right, as follows:

He picks up the banana leaf,
And raises the brush to write a poem on it.
Through his unconventional words he over-
 comes the steep and precipitous,
By realizing his wishes he clears away the
 mysterious and infinitesimal.
At the Five Peaks the clouds are pure; they soar
 up in wonderful array.
At full moon, a mild wind blows from the
 Northern Sea.
> Tz'ŭ-chiao of the Thatched Hut at Stone
> Bridge wrote this poem.

Both paintings bear the seal of the artist and of the author of the colophons.

REFERENCES:
Kokka, no. 223; *Shimbi Taikan*, vol. 9, pl. 14.

15

PORTRAIT OF THE CH'AN PRIEST CHUNG-FÊNG
MING-PÊN
Artist unknown; colophon by the sitter, written before 1325
Hanging scroll, ink and colors on silk,
125.2 X 51.9 cm.
Senbutsuji, Kyoto
Registered Important Cultural Property

Chung-fêng Ming-pên (1264-1325) was a native of the Ch'ien-t'ang region in Chêkiang. He was named Chung-fêng (literally: "Middle Peak") after the central peak of Mount T'ien-mu near Hang-chou, an area where he spent many years of his adult life. Strongly disposed towards a life

of meditative seclusion and freedom from administrative responsibilities, he was averse to joining the organized hierarchy of the Ch'an church. When his teacher, Kao-fêng Yüan-miao (1238-1295), died and Ming-pên was put in charge of temple affairs, he found the frequent visits of dignitaries from nearby Hang-chou too much for his patience. Consequently, he left the monastery and for years traveled about the lakes and rivers of the Hang-chou area in a houseboat. Whenever he moored his vessel he would put up a sign reading: "The Abbot," which would attract many followers seeking instruction from him. A popular ballad of this time speaks of Ming-pên as the man who revived the Buddhist Law.

This independent way of life naturally com-manded the respect of the literati of his time. One of them, the famous landscapist Ni Tsan (1301-1374), may well have been inspired by Ming-pên's example when he took to a house-boat to escape the political turmoil of his day. Ming-pên's closest friend was the noted poet Fêng Tzŭ-chên (1257–post-1327) (see cat. no. 16); he also regularly exchanged letters with the great painter and calligrapher Chao Mêng-fu (1254-1322). Ming-pên's fame as a teacher spread to Japan, and many Zen monks traveled to his retreat to become his disciples. In accordance with established Ch'an tradition, each disciple who attained Enlightenment received a portrait of his teacher. The Master would then confirm the pupil's advanced stage of spiritual percep-tion by writing a personal dedication or eulogy (Japanese: *Jisan*) on the picture. As Ming-pên had a considerable number of Japanese pupils, it is not surprising that at least ten portraits of this master have been preserved in Japanese collections. Not all of these, however, were portraits painted during the master's lifetime and inscribed with a personal dedication. Lit-erary sources indicate that the portrait in the Hōunji (Ibaragi Prefecture) was sent to Japan only in 1348 and a portrait in the Museum of Tokyo University of Arts probably dates as late as 1354.

Among the portraits painted during Ming-pên's lifetime, several bear eulogies in the hand-writing of the Master, which is known as "bam-boo leaf" script in Japan, and "willow leaf" in China. The best known of these portraits is the example in the Kōgenji. Ming-pên gave it to the monk Enkei (died 1344), who lived in China from 1306 to 1315. It bears the signature of the

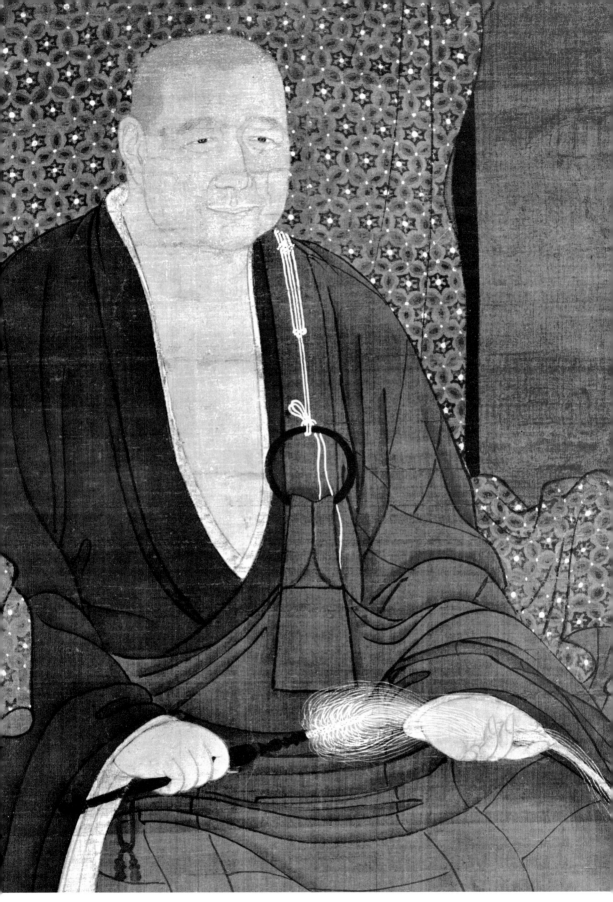

15. *Portrait of the Ch'an Priest Chung-fêng Ming-pên*
(detail)

monk-painter I-an, an artist known only from this work. All the other portraits, although closely resembling the picture by I-an, are anonymous works.

The Senbutsuji portrait exhibited here is not as well known as the Kōgenji portrait and is in an imperfect state of preservation. In style and artistic quality, however, it is very close to the Kōgenji version. The main difference between the two is that the Kōgenji version shows Ming-pên with disheveled hair—a somewhat unusual depiction of a monk whose head is usually shown as shaven. Ming-pên may have followed the example of his teacher Kao-fêng Yüan-miao, who was the only long-haired Ch'an priest of his time. The Senbutsuji version (by contrast) shows Ming-pên with the more conventional closely cropped "chestnut head." The anonymous artist has represented Ming-pên in the traditional seated posture, which seems to have been the standard pose for Ch'an portraits of the period. The sensitive and penetrating treatment of the face however, re-creates admirably the individual features of the monk, capturing the benign intelligence and unconventionality for which Ming-pên was known.

Ming-pên's colophon at the top of the painting is only partly legible. The complete text cannot be reconstructed as it does not seem to occur in the "Recorded Sayings of Ming-pên." It is therefore impossible to establish which of Ming-pên's many pupils was the recipient of this portrait. The cause of the partial effacement of the inscription is explained in an accompanying document which records the circumstances leading to the remounting of this portrait in 1538. According to the document, the portrait belonged at that time to the Genju-an, a building of the Nanzenji in Kyoto. The painting was stored in the library, which was destroyed in a fire. The day after the fire, a monk found this rolled-up scroll among the ashes, and, miraculously, only the outer layers had been scorched. The Genju-an is the temple building where the ashes of Ming-pên's pupil Muin Genkai (died 1358) (see cat. no. 32) are deposited. It is therefore possible that this is the portrait given to Genkai, which he brought home upon his return from China in 1326.

REFERENCES:
Kokka, no. 734 (Senbutsuji version); *Kokka,* no. 318 (Kōgenji version); *Kokka,* no. 683 (Hōunji version).

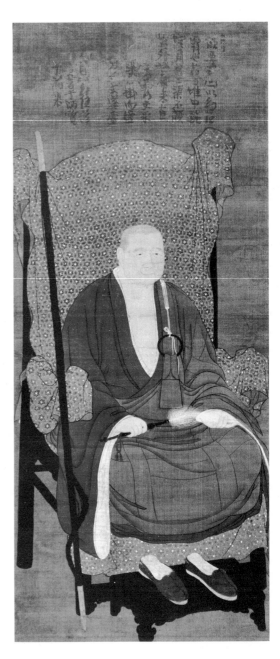

15. *Portrait of the Ch'an Priest Chung-fêng Ming-pên,* before 1325

16

16

Encomium for Hōgyū Kōrin
Fêng Tzŭ-chên (1257–post-1327)
Hanging scroll, ink on paper, 33.4 x 88.7 cm.
Collection of Ueno Yasuyuki, Tokyo

Fêng Tzŭ-chên, a native of Yu-hsien (Hunan province), served as a minor official in the Mongol administration. He was a man of literary talent; his *magnum opus* is a prose poem (*fu*) on the Chü-yung-kuan, a gate in the Great Wall, north of Peking. He was a close friend of the great painter and calligrapher Chao Mêng-fu (1254-1322), and of the Ch'an priest Chung-fêng Ming-pên (1264-1325) (see cat. no. 15). Although the date of his death is not known, a dated poem indicates that he survived both his friends, and that he was still alive in 1327. Fêng-Tzŭ-chên's greatest distinction was not in the field of literature, but in that of calligraphy. He shared this distinction with the Northern Sung calligrapher and art connoisseur Mi Fu (1052-1107) on whose work he is said to have modeled his style. It still retains much of the typical Sung flavor and somewhat resembles the work of Chang Chi-chih (1186-1263), the favorite calligrapher of the Japanese during the previous generation.

Although Fêng's calligraphy did not go unnoticed in China and was appreciated by such eminent arbiters of the arts as Chao Mêng-fu, it was among the Japanese that his work was admired most, and several Zen monks studying in China are known to have asked him for specimens of his calligraphy. Among the surviv-

ing pieces is a poem which he dedicated, undoubtedly at his request, to Muin Genkai (see cat. no. 32).

Hōgyū Kōrin, the Zen monk to whom this calligraphy is dedicated, was a pupil of Shōgun Sentai, the abbot of the Hōkanji in Kyoto. He succeeded Muin Genkai as the thirty-third abbot of the Kenninji. In 1318 he left for China where he stayed for seven years. It was during Hōgyū's residence in China that Fêng Tzŭ-chên's calligraphy was written. It reads in part:

The Japanese monk who calls himself Lin Fang-niu [Japanese: Hōgyū] is a man of agreeable, relaxed disposition, whose thoughts, and intentions are never ill-considered. The plums are now ripening in the Garden of Wu, and the gardenias spread their fragrance at the [Ku] Su Terrace; the verdant fields disappear in the far distance, while the green mountains lie scattered in the panorama before us. Now, Fang-niu has taken the old alms bowl to gather fragrant herbs, and he has made his ragged cassock into a sleeping cloak [i.e., he is leading a life of exemplary frugality]. One day he dismounted and led his horse on the path in Sugar Cane Garden and came to ask me, as of old, for a boat picture. . . .

. . . When he came, I was asleep, holding the bright moon, inhaling another pure breeze; outside the three realms, is there not another paddock?

The text, written in running script of perfect balance and great elegance, is a polished example of expedient prose, written at the request of the recipient. What it lacks in inspiration is largely compensated for by the

refinement of the literary style. Its somewhat
perfunctory character has been expertly hidden
behind a façade of bookish allusions. Evidently,
Fêng was frequently approached for such pieces
of calligraphy, and he acquitted himself of his
task with polite promptness. Hōgyū Kōrin and
Fêng Tzŭ-chên had met before, on which
occasion Hōgyū had brought Fêng a copy of
the "Recorded Sayings" of his teacher, Shōgu
Sentai. Fêng and his friend Chung-fêng
Ming-pên (see cat. no. 15) had been amazed at
the spectacular development of Ch'an Buddhism
in Japan, as was evident from this work by a
Zen priest who had never visited China.

The "boat picture" in the text probably
refers to a picture of a ship setting sail for Japan
—a "farewell picture" for Hōgyū, to com-
memorate his stay in China. Several paintings
of this type, accompanied by inscriptions by
Chinese priests or literati and ranging in date
from the late twelfth to the middle of the
thirteenth century, have been preserved.

REFERENCES:
Tayama Hōnan, *Zenrin Bokuseki* (Tokyo, 1955),
no. 259; *Shodō Zenshū*, vol. 17 (Tokyo, 1956),
pl. 38 (poem for Muin Genkai); *Bijutsu Kenkyu*,
no. 4; *Kokka*, nos. 439, 486 (farewell paintings).

17

THE DISCUSSION BETWEEN MA-TSU TAO-I AND
THE RECLUSE P'ANG
Artist unknown; colophon by Yü-chi Chih-hui
(ca. 1215-1300)
Hanging scroll, ink on silk, 105.6 x 34.8 cm.
Tenneiji, Kyoto

In traditional Ch'an literature there is a
substantial corpus of accounts dealing with
teacher-pupil conversations and confrontations.
One category of this material is known as
"Ch'an meetings" (Chinese: *Ch'an-hui*; Japanese:
Zen-e). Paintings representing these themes
show meetings or conversations between a
Ch'an priest and some well-known person from
the secular world, an official or a recluse. A
personage who participates in several of these
meetings is the recluse P'ang Yün, the father of
Lady Ling-chao, who is often depicted as a girl
carrying a basket (see cat. no. 13).

The subject of this painting is a discussion

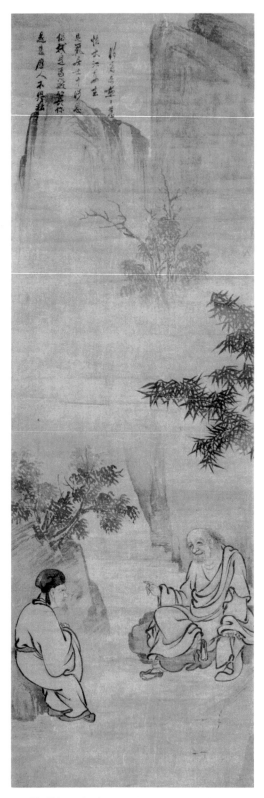

17. *The Discussion between Ma-tsu Tao-i and the
Recluse P'ang*, 13th century

between P'ang Yün and the famous Ch'an monk Ma-tsu Tao-i (709-788). P'ang asked Tao-i: "What sort of man is he who is not the companion of all things?" This question must have been an important one for the recluse, for he had gone earlier to see the Ch'an Master Shih-t'ou Hsi-ch'ien (700-790) to ask him the same question. Shih-t'ou responded by holding his hand over his mouth, and made no reply at all. Ma-tsu, however, replied promptly: "I will give you the answer when you can drink all the water in the West River in one gulp!"

Not to be "the companion of all things" signifies a state of complete non-attachment. Such a state cannot be expressed in words, for an explanation would itself constitute a form of attachment. That is why Shih-t'ou did not reply at all. Ma-tsu, who held the same view, chose to put the insistent recluse off indefinitely.

The painting shows Ma-tsu seated in a relaxed pose, his right leg resting on the rock which he uses as a seat. Pointing pedantically, he delivers his answer to the attentive P'ang Yün whose hands are folded in the reverential position that is characteristic of the listener in these dialogue paintings (see cat. no. 4). The two figures are placed in a setting of steep rocks, with a shrub on one side and a bamboo on the other. A tall mountain rises high above them, its base hidden in mist. In the upper left-hand corner is the following colophon:

What kind of man is he who is tied to nothing
 at all?
I am Ma, the winnow [mouthed],
And you are P'ang, the recluse.
While you contemplate the question,
The water of the Great River continues to
 flow East.

 Yü-chi of the Ching-tz'ŭ-ssŭ

Ma-tsu came from a family of winnow-makers, and therefore was often called "Ma the Winnow." The nickname had a double meaning, for "winnow mouth" is an uncomplimentary reference to the size of Ma-tsu's mouth. In this poem he himself uses the expression, probably to suggest that his mouth was big enough to swallow the river in one gulp.

Yü-chi Chih-hui was the teacher of Ch'ing-cho Chêng-ch'êng (1274-1339) (see cat. no. 27) who came to Japan in 1326. From Chih-hui's signature we know that he was a monk of the Ching-tz'ŭ-ssŭ, but for some unknown reason

his biography was never included in any of the standard compilations. One specimen of his calligraphy bears a date corresponding to 1298 and indicates that he was eighty-four years old. He is reported to have died two years later.

The stiff, heavy lines of the garments and the awkward position of P'ang Yün, who is leaning against, rather than seated on, a rock, suggest that this painting may be the work of an amateur painter who followed the style of Yen Hui (see cat. no. 12). It probably dates from the end of the thirteenth century.

REFERENCES:
Wu-têng hui-yüan, ch. 3; Feng Yu-lan, *A History of Chinese Philosophy*, trans. Derk Bodde (Leiden, 1953), II, pp. 392-393 (the story of P'ang (Yün); Tayama Hōnan, *Zoku Zenrin Bokuseki* (Tokyo, 1965), no. 57 (biographical information on Chih-hui).

18

WINTRY FOREST AND RETURNING WOODSMAN
Artist unknown; colophon by P'ing-shan
Ch'u-lin (1281-1361)
Hanging scroll, ink on silk, 92.3 x 48.9 cm.
Kyoto National Museum

During the thirteenth century the great Ch'an painter Mu-ch'i (see cat. no. 10) and the T'ien-t'ai monk Yü-chien began to produce a new type of landscape painting. Combining rough brushwork with the lavish use of washes, they created poetic, highly evocative landscape scenes in which the solid shapes of mountains and forests are dissolved in mist and vapor. To some extent their method of painting may have been a return to the landscape ideals of the "untrammelled" class of painters, while in other ways they were obviously influenced by the misty landscapes of the calligrapher and collector Mi Fu (1052-1107) and his son Mi Yu-jên (1086-1165). The influence of literati ideas is also noticeable in the fact that they used the general compositional formula of the so-called Eight Views of Hsiao and Hsiang, a set of eight traditional landscape themes based on a popular theme in poetry.

Wintry Forest and Returning Woodsman is a work with an unusual background. For a long period it enjoyed the undeserved reputation of

18. *Wintry Forest and Returning Woodsman,*
14th century

being an authentic work by the famous Yüan master Wang Mêng (ca. 1309-1385), whose spurious seal appears on the painting. A later attribution may have been the cause of the addition of a seal purporting to be that of Mu-ch'i. Although the identity of the artist remains unclear, the style of the painting shows a certain resemblance to works of the Ch'an school. The colophon by a Ch'an monk gives added strength to the supposition that it was painted by a Ch'an artist.

The trees in the foreground, and the contours of the mountains, all done in a somewhat rough brushwork, are more explicit and detailed than the corresponding elements in the works of Yü-chien and Mu-ch'i, and the visual balance, which is typical of the works of these famous masters, has not been achieved. The landscape is nevertheless of considerable interest as an example of the minor works which served as prototypes for Japanese artists such as Gukei (see cat. nos. 35-36). At the top of the painting is the following colophon:

The old road is overgrown with autumn grasses
 and chrysanthemums,
Near the woods the mountain peak rises above
 the smoke of the world.
The old man is all alone, deep in the mountains,
And only a solitary pinetree manifests its youth.
 The Old Man P'ing of the Ching-tz'ŭ-ssŭ

The author of the colophon, the Ch'an monk P'ing-shan Ch'u-lin (1281-1361), was the abbot of the Ching-tz'ŭ-ssŭ during the last years of his life, which suggests that the painting may have been painted about 1360.

REFERENCES:
Kokka, no. 787.

19

WHITE-ROBED KANNON
Artist unknown; first half of the 13th century
Iconographical sketch, mounted as a hanging scroll, ink on paper, 43.1 x 28.8 cm.
Collection of Aimi Shigeichi, Tokyo

The *Gandavyūha*, the principal text of the Avatamsaka (Hua-yen or Kegon) sect, describes at great length the peregrinations of a young man called Sudhana, who in his restless search

for Supreme Enlightenment seeks instruction from more than fifty "Ideal Teachers." One of these *kalyānamitras* is Avalokiteśvara, whom Sudhana visits at Mount Potalaka, the Bodhisattva's residence. According to the text, the Bodhisattva was seated on a rock in the midst of rivulets and lush vegetation. The iconography of the earliest type of Avalokiteśvara — the so-called Water-and-Moon Kuan-yin — was based on this description. Its origins can be traced back to the T'ang period. It is the prototypical parent of such popular, closely related manifestations as the White-Robed Kuan-yin (Sanskrit: Pāndaravāsinī; Japanese: Byaku-e Kannon) and the Weeping Willow Kuan-yin, both of which are shown in similar landscape settings.

The *Lotus Sūtra* spread the cult of Kuan-yin as the Bodhisattva of Infinite Compassion, whose divine power was invoked for deliverance from every sort of peril. As the cult spread, the easternmost island of the Chusan archipelago near Ning-po — in ancient times dedicated to a tutelary goddess of seamen — came to be identified with the residence of Avalokiteśvara and was renamed P'u-t'o-shan, i.e., Potalaka. P'u-t'o-shan became one of China's Holy Mountains and was visited annually by large numbers of pilgrims.

It is not clear when the earliest representations of the White-Robed Kannon were painted. The problem is complicated by the fact that the early nomenclature for the three closely related types was not well differentiated. The earliest known, dated, Chinese example of a White-Robed Kuan-yin is a painting by Li Kung-lin (died 1106), preserved in a stone-engraved reproduction dating from 1132.

In Japan the cult of Byaku-e Kannon seems to have been known as early as the tenth century. This sketch, and another iconographical drawing, now in the Cleveland Museum of Art, are the earliest Japanese representations of this Bodhisattva.

In this iconographical sketch, which is drawn on the back of a fragment of a handwritten *sūtra,* the Bodhisattva is shown in a relaxed posture, seated on a flat-topped rock by a riverside. The large rising moon behind the figure acts as a halo. The cluster of bamboo that is often shown in representations of this form of Avalokiteśvara is repeated here in a symbolic way by two diminutive shoots in a bowl. The dark jagged lines of the rock have been

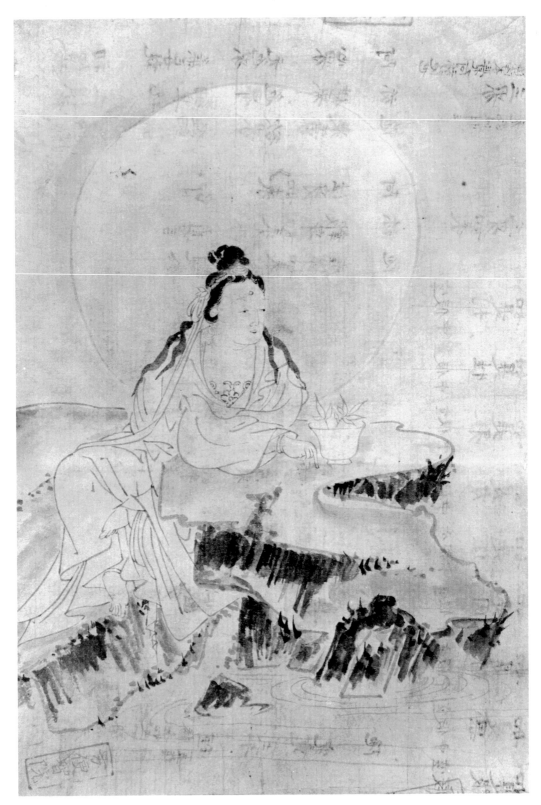

19. *White-Robed Kannon*, 13th century

painted with rough parallel strokes in heavy black ink. They contrast with the soft, flowing lines of the white robe.

The sketch bears the seals of the Hōbenchi-in, one of the buildings of the Kōzanji at Toga-no-o near Kyoto. It was built by Kikai, a pupil of the temple's famous founder, Myō-e Shōnin (1173-1232). During Myō-e's lifetime, the Kōzanji was one of the centers where large collections of iconographic drawings were assembled and copied. Although the names of several monk-painters who were active at the Kōzanji are known (see cat. no. 1), there is insufficient evidence to connect any of them with this drawing. The strongest likelihood is that it was copied during the first half of the thirteenth century after an imported, twelfth-century Chinese prototype.

REFERENCES:
Tō-ei, Sept. 1936, pp. 8-11; Aimi Kōu, *Asuka Sambō Jūyū* (Tokyo, 1962), pl. 2.

20

"RED-ROBED" BODHIDHARMA
Artist unknown; executed ca. 1271;
colophon by Lan-ch'i Tao-lung (1231-1278)
Hanging scroll, ink and colors on silk,
104.8 x 46.4 cm.
Kōgakuji, Yamanashi Prefecture
Registered National Treasure

This superb work is one of the finest Buddhist paintings of the thirteenth century, and the earliest complete full-figure painting of Bodhidharma in existence. It occupies a position of isolated grandeur in the evolution of Zen painting: the artist is unknown, and there is no documentary or art-historical evidence to indicate its iconographical or compositional sources. Yet, it is clear that it represents the flowering of an accomplished artistic tradition of a very high order, one which, in all likelihood, had its roots in China. Stylistically, it shows points of close correspondence with the school of realistic *chinsō* representation that flourished in southern China during the thirteenth century, but there are several important differences that strongly indicate that the work was produced in Japan.

To begin with, the preoccupation with the treatment of minute details in a realistic manner is less apparent here than in the Chinese *chinsō,* and the robes have become an elegant pattern of brushwork which here assumes a vital rhythmic life of its own. (The brushwork is done with "orchid-leaf" strokes.) The red robe, a feature inspired by Bodhidharma's exotic priestly connections with India, is painted in a water-thinned pigment generally unlike the thicker, semi-opaque colors used in Chinese *chinsō,* and the monochrome ink treatment of the rock platform, which consists of intuitively rendered contour lines paralleled by soft, dry, slightly scumbled strokes, relates more closely to traditional Japanese landscape techniques than to Chinese methods. While color is skillfully used in the painting, the overall indebtedness to ink-monochrome techniques is very apparent, as it is in a few early Japanese *chinsō* — among them the famous portrait of Lan-ch'i Tao-lung in the Kenchōji, a work with the closest historical and artistic affiliations with the Bodhidharma painting.

The Kenchōji portrait shows the great abbot — emaciated and advanced in age — in the standard *chinsō* manner. He is seated and is holding a *kyōsaku.* The fluid, attenuated "orchid-leaf" brushstrokes used in the robe are very like those in the Bodhidharma painting; in general, they are straighter, but this is because the abbot's frail and bent body causes the robe to fall vertically. The robust, full-featured patriarch sits erectly, his broad-shouldered figure emanating a strong psychological presence.

Because of the sense of volume and fullness in the figure, it has been suggested that there may have been a sculptural prototype behind the Bodhidharma painting. Although there are no examples of Kamakura period sculpture extant to support this thesis, there are two pieces from the Muromachi period — an image in the Empukuji in Kyoto, and the superb figure in the Darumaji in Nara — which do attest to the evidence of a sculptural tradition which inspired iconographically related representa-tions. In both the Tao-lung and the Bodhidharma portraits, thin, elegant, reddish-brown lines are used with great accuracy to render details of the hands and face, and light colors are sparingly added — off-white for the skin, red for the lips, and touches of white for the fingernails, the eyes, and, in the case of Bodhidharma, the teeth. In short, the stylistic correspondences between

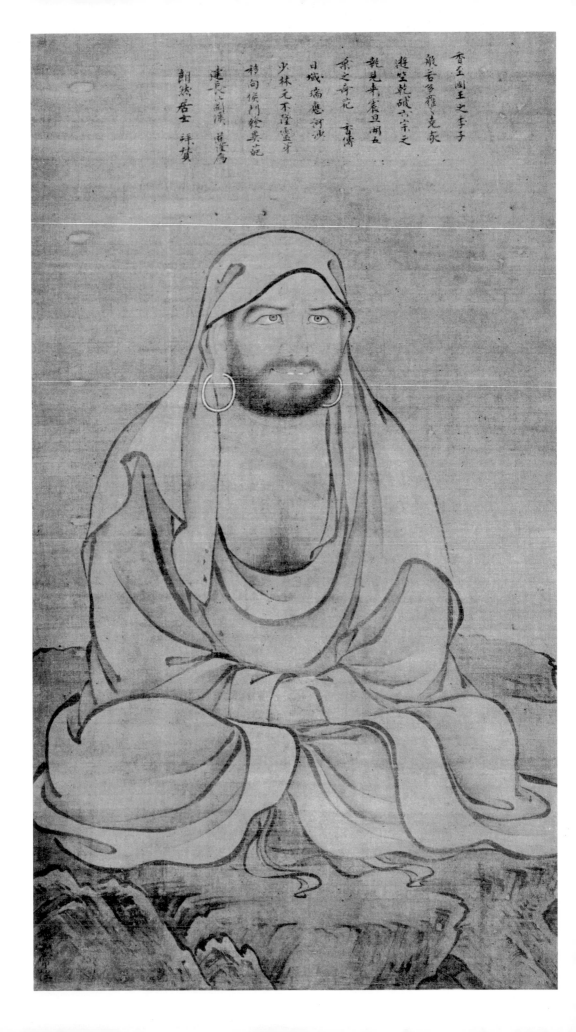

香至國王之季子
般若多羅記克家
遊笠乾竺破六宗之
乾見丰辰旦開五
葉之奇花一香傳
日域瑞應河沙
少林元不隆靈牙
移向侯門發異葩
建忠心流澤德澤廣
朗然居士　禪贊

the two paintings are of such an intimate and pervasive sort that the possibility of their being from the same hand cannot be lightly dismissed.

Further evidence of the relationship between the two paintings is provided by the colophons, both from the hand of Lan-ch'i Tao-lung. Both colophons are dedicated to a mysterious figure named Rōnen-koji, whose identity — despite considerable scholarly speculation — remains unclear. It is presumed that he must have been an influential figure, and the names of the regent Tokiyori and his son Tokimune have both been suggested. Both men were patrons and admirers of Tao-lung, but the colophon of the Kenchōji portrait is dated 1271, eight years after Tokiyori's death. (The Bodhidharma painting is presumed to be roughly contemporary.) Tokimune would only have been twenty, and probably too young to be called by a Buddhist name with the Buddhist lay-suffix koji appended to it. The colophon on the Bodhidharma painting reads:

He was the youngest son of King Hsiang-chih
And follower of Prajñātāra's eminent line.
He studied [the tenets of] the Buddha
Destroying the heretical views of the Six Sects
He came to China, and the strange five-petaled
 flower blossomed
The fragrant doctrine was transmitted on to Japan
The auspicious signs like sands of the river.
The original spiritual sprout of the Shao-lin
 flourished
And transplanted to the noble line abroad,
An extraordinary flower grew.
 Respectfully written for Rōnen-koji,
 Lan-ch'i Tao-lung of the Kenchōji.

Hsiang-chih is first mentioned in *The Record of the Transmission of the Lamp* (compiled 1002) and is thought to have been a kingdom in southern India near what is now Madras, perhaps Kānchī, where a Pallava capital was located in the sixth century. Prajñatara was the Twenty-seventh Patriarch and Bodhidharma's predecessor. The reference to the "five-petaled flower" comes from a quotation traditionally attributed to Bodhidharma (see cat. no. 54), and the Shao-lin is the temple where Bodhidharma spent nine years in "wall-contemplation" (see cat. no. 55).

Although the history of the Bodhidharma portrait is not completely clear, particularly in its early, Chinese phase, one nevertheless can perceive its general evolution through the centuries. The earliest extant portrait of Bodhidharma (cat. no. 1) is derived from a woodblock illustration dated to 1054, and shows the patriarch as a slight, clean-shaven, elderly figure — an image-type repeated in works of the following century. The half-torso type made its appearance by at least the early part of the twelfth century (see cat. no. 7) and may well derive from a different iconographical tradition; it is interesting that Bodhidharma is represented here as a robust figure. His rough beard, prominent nose and eyes, and long earlobes with heavy rings through them must have seemed exotic and Indian to the Chinese. The "Red-Robed" Bodhidharma has these same physical characteristics and also a generous growth of hair on his chest and two prominent front teeth. In both paintings, Bodhidharma's expression is one of alert non-dramatized concentration. The Bodhidharma in the Tokyo National Museum, an ink-monochrome work which is in many ways very similar to the "Red-Robed" Bodhidharma but is about forty years later in date, has the same facial expression. The half-torso Bodhidharma in the Kubō Collection, which has a colophon date of 1326, shows the first signs of a new attitude toward Bodhidharma's expression. The patriarch has a dour, somewhat truculent quality that was to become standard and more exaggerated in later examples (see cat. no. 57).

REFERENCES:
Fujikake Shizuya, "Kōgakuji shozō no Daruma-zu ni tsuite" [On the Bodhidharma painting in the Kōgakuji], *Kokka*, no. 468; Kumagai Nobuo, "Rankei Dōryū-zo ni tsuite" [On the painting of Lan-ch'i Tao-lung], *Bijutsu Kenkyu*, no. 10; Tanaka Ichimatsu, *Nihon Kaigashi Ronshū* (Tokyo, 1968), pp. 169-196, 237-239; Helen B. Chapin, "Three Early Portraits of Bodhidharma," *Archives of the Chinese Art Society of America*, (1945-1946), pp. 66-95; Kidō Chūtarō, *Daruma to sono Shosō* (Tokyo, 1934); Ishida Mosaku, *Bukkyō Bijutsu no Kihon* (Tokyo, 1969), p. 360; *Muromachi*, Sekai Bijutsu Zenshū, vol. 7 (Tokyo, 1962), text figs. 86-87; *Zendera to Sekitei*, Genshoku Nihon no Bijutsu, vol. 10 (Tokyo, 1967), pl. 114.

Facing page:
20. *"Red-Robed" Bodhidharma*, artist unknown, first half of 13th century

十方大調御一切得道

諸聖賢

苦覺妙覺卿云證明

匹来匹向同事加持

次伴祝献

大梵尊天　帝釋尊天

守護正法十八諸天

忉利夜摩匹禅八定

總三十三天諸天仙衆

盡天春列位聖賢

專祈弟子　時宗永狀

帝非火護

宗乘不苑一箭而血逸

不露一鋒而群魔頼息

德仁壽利壽福弥堅秉

慧炬而燭昏衢剖慈心為

眠危乏　諸天臣護

衆聖密扶二六時半吉祥訴

集次巽山門肅静中外安寧

禮信眼崇

21

BUDDHIST HYMN
Lan-ch'i Tao-lung (1212-1278)
Part of a handscroll, now mounted as a hanging
scroll, ink on paper, 32.5 x 95.2 cm.
Tokiwayama Bunko, Kamakura
Important Cultural Property

While the initial introduction of Zen institutions
and tenets into Japan came about through the
efforts of Eisai (1141-1215) and Dōgen (1200-
1235), it was not until after the arrival of the
Ch'an prelate Lan-ch'i Tao-lung in 1246, that the
first full-scale, independent Zen monastery,
closely emulating continental prototypes was
established, and the mainstream of Ch'an
teachings, with all the requisite routine and
ritual, was propagated. Tao-lung was a native
of Szechwan, and began his Buddhist training
as an acolyte at the Ta-tz'ŭ in Ch'êng-tu. He
subsequently went to the Chêkiang area, where
he studied under Wu-chun Shih-fan (1177-
1249) and Pei-chien Chü-chien (died 1246). He
became a direct disciple of Wu-ning Hui-hsing,
a follower of Sung-yüan, and after completing
his studies under this master, moved on to the
famous monastery complex on Mount T'ien-
t'ung. He was thirty-four when he set out for
Japan accompanied by his followers I-wêng and

Lung-chiang. He landed at Hakata, and after
a short period in a temple there, he traveled
to Kyoto, where he resided at the Sen'yūji. He
subsequently was invited to Kamakura by the
regent, Hōjō Tokiyori (1227-1263; regent 1246-
1256), who requested his instruction and
became his enthusiastic supporter. Hōjō
Tokimune, the regent's son who later became
regent himself (1251-1284; regent 1268-1284),
was initiated into the study of Zen by Tao-
lung. This is supposed to have contributed
to Tokimune's *sang froid* at the time of the
Mongol invasion. Tao-lung supervised the
building of the Kenchōji, the first Japanese
monastery where Zen was practiced in
unadulterated Chinese fashion. Its vast com-
plex of buildings took five years to complete,
and Tao-lung became its founder-patriarch and
the fountainhead of his own doctrinal line
there. In 1261, however, he fell into disfavor
with the authorities when some of his disciples
lodged false accusations against him, and he
was banished to Kai province (now Yamanashi
Prefecture). During his exile, he founded
temples in the area and continued to propound
his doctrine diligently. He finally returned to
Kamakura in 1265, and he died at the Kenchōji
in 1278 at the age of sixty-six. He was much
admired by Hōjō Tokimune (see cat. no. 20) in
his later years, and was honored by the Imperial
Court with the posthumous name Daikaku, with

the suffix zenji ("Zen Master"), the first instance in which this title was awarded in Japan.

This piece of calligraphy from the master's hand contains the text of a Buddhist hymn which Lan-ch'i Tao-lung composed himself. Abbots of Zen monasteries often led their monks in chanting such hymns. The text may be translated as follows:

Great Buddhas of the Ten Directions, and all of you holy saints who have attained the Path, all who have attained Undifferentiating and Subtle Perception, we reverently raise our heads and beg you to bear witness.

May those who have attained the Four Fruitions, and those who have attained the Four Stages of Sanctity all favor us with their luminosity and extend to us their blessings.

To the Heaven of Mahābrāhman, to the Heaven of Indra,
To the Eighteen Heavens of the Sphere of Form, where the True Law is protected
To the Trāyastrimśa Heaven, the Yāma Heaven,
To the Four Meditations of the Sphere of Form, the Eight Concentrations of the Spheres of Form and Formlessness,
To all the congregations of saints gathered in the Thirty-three Heavens,
To all saints of all Heavens and Spheres,

we especially pray that our disciple Tokimune may always support the Imperial Throne, and protect, for many years, the doctrine of our sect; that the land within the Four Seas may live in peace and harmony without even one arrow being shot; that the host of demons may bow their heads and desist without so much as a tip of a lance having to be bared.

May we increasingly profit from Virtue and Benevolence; may Longevity and Happiness become ever stronger; may we hold up the torch of intelligence to illuminate the dark road of life; may we open our compassionate hearts to relieve those who are in peril and in want.

May all the Gods assist and protect us, may all the saints closely support us, and may all auspicious events come together and accumulate during the hours of night and day.

Also, we hope that tranquility may reign inside our temple gate; that peace may prevail inside as well as outside; may beneficence and faith be again venerated. . . .

Lan-ch'i Tao-lung has written these characters in a bold, vigorous style that is reminiscent of that of the great calligrapher Chang Chi-chih (1186-1266) (see cat. no. 9). "That the host of demons may bow their heads" supposedly refers to the Mongols, who first threatened to invade Japan in 1274. At that time, the Imperial Court was holding continuous services to pray for the safety of the country, and Lan-ch'i Tao-lung may well have led his priests in chanting invocations such as this hymn.

Two other scrolls of this type have been preserved, one in the Kenchōji, and one in the Ōyama Collection. The wording and content of these hymns are similar to this scroll, and all three are supposed to have once belonged together. The scroll in the Ōyama Collection and the scroll exhibited here—the latter formerly in the Masuda Collection—are known to have been in the same collection as late as the end of the nineteenth century.

REFERENCES:
Tayama Hōnan, *Zenrin Bokuseki* (Tokyo, 1955), no. 58.

22

BODHIDHARMA CROSSING THE YANGTZE ON A REED
Artist unknown; colophon by I-shan I-ning (1247-1317)
Hanging scroll, light colors on silk, 101.6 x 40.8 cm.
Jōdōji, Shizuoka Prefecture.

The origin and identity of Bodhidharma have been the subject of lively debate among scholars for many years, but the lack of reliable early evidence as well as the very nature of Zen literature, with its strong accretic tendency and perennial preoccupation with embellishing the accounts of the founder of Ch'an, make it unlikely that any accurate picture of Bodhidharma as a historical personality will ever emerge.

Two of the many legends concerning Bodhidharma, both clearly apocryphal, tell of his crossing the Yangtze River on a reed and of his meeting, three years after his death, with the monk Sung-yün in Central Asia. An eighth-century elaboration of the latter story relates

that Bodhidharma was carrying one sandal when he met Sung-yün and that his other sandal was subsequently found at the opening of his grave. According to one tradition, he is said to have gone on to India, while another claims that he crossed the sea to Japan. These legends reveal a growing inclination to apotheosize Bodhidharma, to present him as an "heroic" figure capable of miraculous acts.

The earliest extant literary references to Bodhidharma's crossing the Yangtze on a reed do not go back beyond the third quarter of the thirteenth century. The *Wu-chia Chêng-tsung Ts'an* (1254) has this account: "So he broke off a reed, crossed the river, and went on to the Shao-lin temple." But according to a somewhat later source, the *Shih-shih t'ung-chien*, compiled by Pên Chüeh in 1270, "On the 19th, he consequently departed from Liang. He broke off a reed, crossed the river, and hastened north, and on the 23rd he was at the border of Wei." It is of interest that in earlier works such as *The Record of the Transmission of the Lamp* and the *Chêng-tsung-chi* a character meaning "stealthily" is used at the place in the sentence where the two-character phrase "[he] broke off a reed" appears in the later texts. Although this modification may be the result of some misreading (a common enough occurrence in Chinese literary transmission), it is not beyond the realm of possibility that it represents a little selective rewriting. Perhaps the implication that Bodhidharma was guilty of taking French leave after his unproductive meeting with the Emperor Wu of Liang (see cat. no. 7) was not pleasing to later Zen chroniclers anxious to upgrade the founder of the faith.

The theme of Bodhidharma Crossing the Yangtze on a Reed was probably first treated in painting in China during the first half of the thirteenth century. The earliest extant painting of the theme may be a work in the Nanzenji: its colophon, written by Kian Soen (1261-1313), bears the date 1303. The painting in this exhibition is undated, but it has a colophon written by I-shan I-ning (see cat. no. 23), who arrived in Japan in 1299 and died there in 1317, dates which would indicate that the painting may have been executed at about the same time as the Nanzenji piece.

In this painting, Bodhidharma stands lightly in spite of his massive, brawny torso, on two thin sections of reed. He looks back over his left shoulder, perhaps reflecting on the

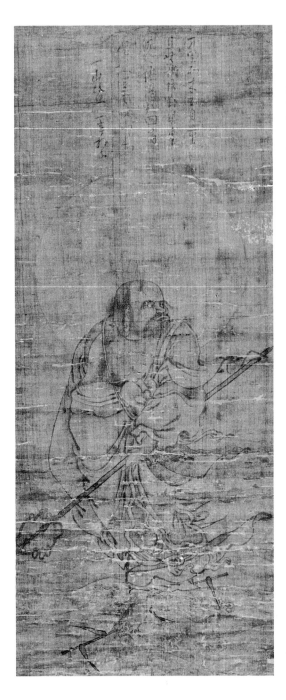

22. *Bodhidharma Crossing the Yangtze on a Reed,* artist unknown, early 14th century
Facing page: detail

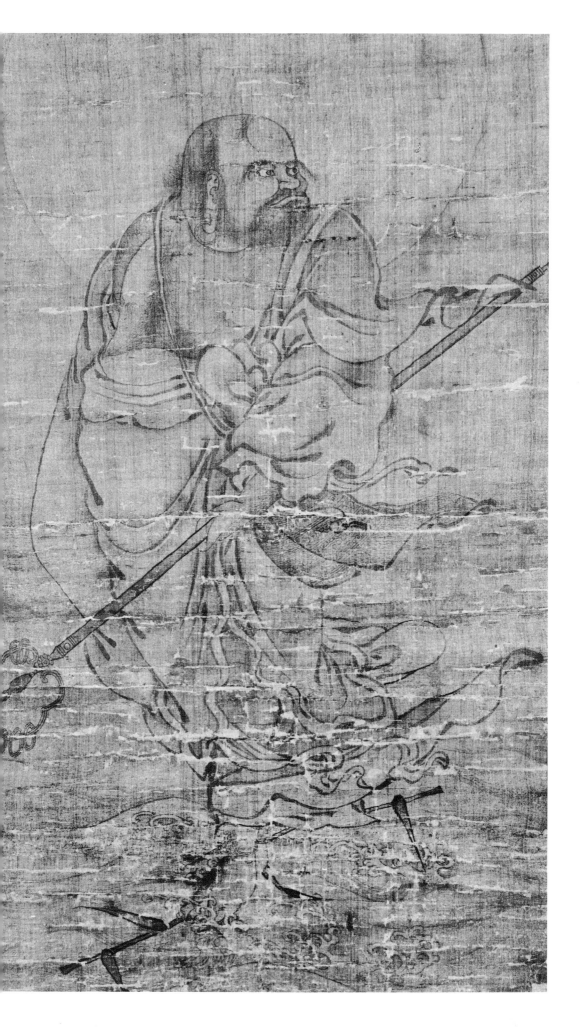

religious myopia of the Emperor of Liang. The entire composition conveys a dynamic feeling of horizontal progress, of the patriarch's smooth, continuous movement over the waves, as his robes stream out to the right; nevertheless, the contrapposto of the figure serves to freeze the action at the height of its drama. This anonymous work is from the hand of a highly accomplished master, whose versatility is apparent not only in the handling of small details but in his ability to coordinate all the elements of the composition into a unified, vital whole. The impressive originality with which Bodhidharma's countenance is rendered and the flowing, spirited treatment of the robes, confident and inspired, are clear evidence of a painter of great talent.

The artistic and iconographical lineage of this piece, like that of the "Red-Robed" Bodhidharma (cat. no. 20) is not easily determined. Both works represent artistic traditions of a very high level, but the lack of material comparable in subject and treatment makes it difficult to place them in a line of development. Although several features of the "Red-Robed" Bodhidharma suggest that it was painted in Japan, certain characteristics of the style and brushwork of the Bodhidharma Crossing the Yangtze on a Reed seem to point to a Chinese origin. An interesting comparison can be made between this work and the famous painting of Śākyamuni Returning from the Mountains by Liang K'ai (see cat. nos. 5, 6), believed to date from the years when the artist was associated with the Imperial Art Academy, during the Chia-t'ai era (1201-1204). This work displays care and calculation in the brushstrokes and preoccupation with detail, characteristics that are in general representative of the artistic canons and taste of the "academic" painters of the Southern Sung Court. Śākyamuni's robe is rendered in a pattern of meticulously interrelated lines; "nail-headed" strokes are utilized to provide accent and dimension, while longer, curved lines give the robe weight and movement. Lifted by a light breeze, the robe flows out to the right. Its borders are rendered by two parallel sinuous lines. These stylistic features, present also in the Bodhidharma painting, again suggest a debt, at least in part, to the Southern Sung "academic" tradition that prevailed about a century earlier. Although the personalities and circumstances of Bodhidharma and Śākyamuni have nothing in common, the treatment of the face in these two paintings is also technically similar: both are finely detailed, and hair, beard, and eyebrows are executed with minute lines, which express perfectly the subject's unkempt appearance. The long, overhanging eyebrows and elongated earlobes are rendered in the same linear manner. The facial configuration of the Bodhidharma somewhat resembles that in the anonymous half-torso representation in the Kubō Collection, which has a colophon date of 1326. In both paintings the noses are short and upturned, and the eyes are focused intently, but the truculent quality that becomes common in later periods (see cat. no. 57, for example) is lacking.

With certain exceptions, such as the fine representation from the early Muromachi period in the Gyokuzōin, which has a colophon by Kozan Ikkyō, the theme of Bodhidharma Crossing the Yangtze on a Reed evidently soon came to be treated by Japanese artists primarily in ink-monochrome. Among the more interesting examples is the ink-monochrome painting by the Shōgun Yoshimochi still preserved in the Horie Collection in Aichi Prefecture.

The colophon is damaged, faded, and partially undecipherable. It refers to Bodhidharma's long trip from India, his cryptic but unproductive meeting with the Emperor of Liang, and to "turning his head," presumably describing the pose shown in the painting.

REFERENCES:
Tanaka Ichimatsu, "Gakurin-san Royō Daruma-zu," Kokka, no. 663; Yonezawa Yoshiho, "The Daruma Crossing the River on a Reed Painting with Colophon by Ching-yu" (in Japanese), Kokka, no. 827; Ishida Mosaku, Bukkyō Bijutsu no Kihon (Tokyo, 1967), p. 360; Muromachi, Sekai Bijutsu Zenshū, vol. 7 (Tokyo, 1962), text fig. 87 (Kubō Daruma); Kidō Chūtarō, Daruma to sono Shosō (Tokyo, 1934); Matsushita Takaaki, Suibokuga, Nihon no Bijutsu, vol. 13 (Tokyo, 1967), pl. 30 (Daruma with colophon by Kozan Ikkyō); Institute of Art Research, Tokyo, Ryōkai [Liang K'ai] (Kyoto, 1957).

23

CALLIGRAPHY: A PASSAGE FROM THE DIAMOND
SŪTRA
I-shan I-ning (1247-1317)
Pair of hanging scrolls, ink on paper,
107.5 x 27 cm.
Collection of Nakamura Yōichirō, Tokyo

Although the Ch'an priests who came to Japan
from the continent during the Southern Sung
and Yüan periods were few in number, their
influence on the progress and development of
the Zen sect in Japan is difficult to exaggerate.
Not only did their presence help to firmly estab-
lish the roots of the sect in Japan but it also
served to stimulate its activities. In a wider
context, it was through their erudition and
industry that knowledge of a comprehensive
range of the superb cultural accomplishments
and traditions of China was disseminated to
eager Japanese students. I-shan I-ning (1247-
1317) was already fifty-two years of age when
he arrived in Japan in 1299 (eighteen years after
Mugaku Sōgen), and in the following years,
until his death, he exercised a particularly
influential role in Zen circles.

I-shan was born in the T'ai-chou area of
Chêkiang province. He began his Buddhist
apprenticeship under Wu-têng Hui-yung and
is said to have studied the doctrines of the T'ien-
tai and Vinaya sects before he finally became a
disciple in the line of Wan-chi Hsing-mi, whose
monastery was on Mount Yü-wang. In the
following years he gained a reputation as a
learned prelate and accordingly rose in the
church hierarchy.

I-shan's journey to Japan was supported by
the Yüan Emperor Ch'êng-tsung, who apparent-
ly felt that, because of the high prestige of the
sect in Japan, a visit by a prominent Ch'an priest
would serve as an initial step in the re-establish-
ment of diplomatic relationships between the
two countries. Almost twenty years had passed
since the last Mongol attempt to invade Japan,
but the memory of this threat was still fresh
among the Japanese, who remained cool toward
any official overtures by the Yüan court. I-shan
had been given the title Ta-shih ("Great
Teacher") and was awarded the high position
of Director of Buddhist Affairs in Chêkiang.
With these impressive credentials he set off on
the voyage to Japan, accompanied by Hsi-chien

Tzŭ-t'an (who was making the trip for the
second time), his nephew and student Shih-
liang Jên-kung, and a large collection of Chinese
books.

They landed at Dazaifu in 1299, but I-shan was
promptly sent off to the geographical obscurity
of the Shuzenji, a temple on the Izu peninsula,
because the Hōjō Regent Sadatoki suspected
him of coming not for diplomatic or religious
purposes, but for the clandestine investigation
of Japan's fortifications and military prepared-
ness. Sadatoki was finally convinced that his
fears were unfounded, however, and realizing
the religious eminence of I-shan, he had the
monk installed as the tenth lineal abbot of the
Kenchōji. I-shan subsequently served as head
of both the Engakuji and Jōchiji in Kamakura,
and during these years he attracted many dis-
ciples, including important members of the
military caste. In 1313 the abbot of the great
Nanzenji monastery in Kyoto died, and I-shan
was asked by the Retired Emperor Go-Uda to
take the position. I-shan declined, explaining
that the ills of old age made him unfit for the
high responsibility, but Go-Uda insisted, and
I-shan reluctantly set out for Kyoto to take up
his duties. With his installation as the third
lineal abbot of the Nanzenji, he worked dili-
gently to spread the influence of the "sudden,"
or Rinzai, branch of Zen, which noticeably
gained momentum as a result, not only in local
ecclesiastical circles but also among the nobility
—a phenomenon of some consequence in the
evolution of Zen in Japan. Go-Uda became a
devoted follower of I-shan's and visited the aged
priest in person when he fell ill during his last
years. I-shan died in 1317 at the age of seventy-
one, and a funerary stūpa was erected for him in
an honored position next to the mausoleum of
the Retired Emperor Kameyama in the Nan-
zenin. On the occasion of the third memorial
service held in commemoration of I-shan's death
at the Nanzenji, Go-Uda added in his own hand
the encomium to the chinsō portrait used in the
ceremony.

Although the reverence bestowed on I-shan
was for his deep knowledge of Zen, his range of
interests extended well beyond purely ecclesi-
astical matters. He was well informed on a
variety of subjects, scholarly as well as popular:
Confucian philosophy, the main currents of
traditional Chinese literature, and popular
genres such as romances, novels, and local
histories. With this broad intellectual back-

ground, he was ideally suited to be a teacher, and many of the most important Japanese monks of the period studied under him, including Musō Soseki, Kokan Shiren, Sesson Yūbai, Tokei, and Kyōdō. He was one of the founders of the Gozan literary movement and played an important role in transmitting the techniques and literary tastes of the Southern Sung period to Japan (in contrast to Jikusen Bonsen, who came to Japan in 1329 and introduced the new literary tendencies of the Yüan period).

I-shan was an accomplished calligrapher, specializing in the "cursive style" of writing. His hand reflects that of the great T'ang practitioners of this style, such as Huai-su ("Mad Monk" of T'ang) of the seventh century and Chang Hsü of the eighth century. These men had established a vigorous prototypical style that was greatly admired by the great Sung calligraphers Su Tung-p'o and Huang T'ing-chien, who were in turn widely emulated in Ch'an circles. I-shan's indebtedness to Huai-su's style is evident in works such as his *Gāthā of the Sixth Patriarch* in the Inui Collection in Kōbe. A certain quality in I-shan's calligraphy, however, distinguishes it from other hands: a tranquil flow, smooth and refined but disciplined and vigorous. I-shan's large characters in the cursive style were already much admired during his lifetime. He had a marked influence on the hand of his student Musō Soseki (see cat. no. 24).

The characteristics of I-shan's style are well represented in these two hanging scrolls, which bear a famous eight-character passage from the *Diamond Sūtra*, a frequent source of textual inspiration for Zen calligraphers. It reads thus: "The Enlightenment of the Dharma rests in no finite place, it is born in the heart." The left-hand scroll bears the signature of I-shan but no date. In the development of I-shan's calligraphic style, these hanging scrolls seem to represent a phase earlier than that of his famous *Snowy Night* composition in the Kenninji and may predate his period of residence at the Nanzenji, which began in 1313.

REFERENCES:
Tayama Hōnan, *Zenrin Bokuseki*, I, no. 59; *Zoku Zenrin Bokuseki*, no. 33; *Shodō Zenshū*, vol. 19 (Tokyo, 1957), pp. 173-174; Nakata Yujirō, *Sho, Nihon no Bijutsu*, suppl. vol. (Tokyo, 1969), pl. 34.

24

CHINSŌ PORTRAIT OF MUSŌ SOSEKI
(ca. 1340-1351)
Mutō Shūi (active first half of 14th century);
colophon by the sitter
Hanging scroll, light colors on silk,
119.4 x 63.9 cm.
Myōchiin, Kyoto
Registered Important Cultural Property

Musō Soseki (1275-1351), an astute man of many talents, was one of the most influential Zen prelates of the early fourteenth century. His extensive endeavors on behalf of his sect are striking in their variety. An active proselytizer, he is credited with attracting multitudes of followers; he even converted priests from other branches of

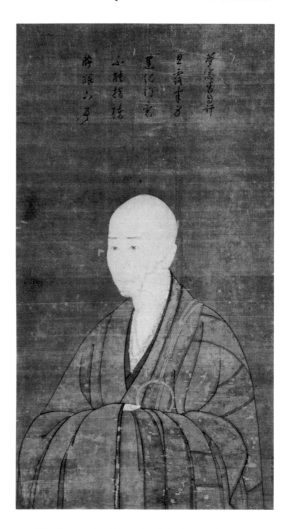

24. *Chinsō Portrait of Musō Soseki* by Mutō Shūi (active first half of 14th century)

Facing page:
23. *Calligraphy: A Passage from the Diamond Sūtra* by I-shan I-ning (1247-1317)

Buddhism. He was especially successful in gaining the confidence of many of the most powerful people of the period, not only in the Bakufu but in court circles as well, and in utilizing these connections to further the interests of the church. That Musō was awarded the title of Kokushi ("National Teacher") by seven successive emperors, three times during his lifetime and four after his death, is an indication of the esteem accorded him by the court.

Musō's close relationship with the leaders of the military class, such as Hōjō Takatoki, and the first shōgun of the Ashikaga line, Takauji, is of particular interest. These men relied on him not only as a kind of spiritual adviser and confidant but also as a negotiator in temporal matters, for they admired him for his discretion. Clearly, Musō also had a gift for persuasion, a talent that could only have been reinforced by his reputation as a learned cleric. His rapport with Takauji seems to have been of a congenial, perhaps even a friendly, nature, and it is easy to understand that Takauji, a rough warrior, somewhat out of place in the sophisticated society of the capital, was pleased when Musō complimented him on his taste and ability in composing verse. Takauji's munificent support of the Zen church enabled Musō to erect a number of temples, including the famous Tenryūji, which later played a vital role in the promotion of trade with Ming China by subsidizing a series of voyages by merchant ships to the mainland. Musō's earliest training had been in Esoteric Buddhism, and the doctrine of the Zen school that developed around him seems to have inclined toward the integration of Esoteric ideas into Zen. This may be, to some extent, the explanation of Musō's success in gaining converts from the nobility, who, for the most part, were traditionally members of the Esoteric sects.

Although Musō's great reputation as a scholar may be partly the result of a partisan attitude of traditional chroniclers toward his accomplishments, it is true that he was an excellent calligrapher. He was also a devoted participant in the Gozan literary movement, a consequence of his association with I-shan I-ning, his teacher, who helped to found the school in Japan (see cat. no. 23). Two of Musō's pupils, Zekkai and Gidō, carried on this tradition, producing some of the best Chinese verse to appear in Japan.

Musō's interest in the layout of gardens and related architectural forms reveals another side of his personality. His name is associated with a number of fine gardens in various regions in Japan, and although some of these attributions may represent nothing more than pious, apocryphal legends, there can be no doubt that he supervised the construction of the superb Tenryūji garden. The garden-architectural complex at the Saihōji is also certainly due in large part to his efforts and provides us with a substantial idea of his refined taste.

This celebrated *chinsō* portrait of Musō is the finest of the eight representations of the master, five executed during his lifetime, the other three posthumously. Here, a high degree of technical proficiency is combined with sympathetic insight in the execution of the features and expression; the personality of this learned and circumspect elderly priest is convincingly portrayed. The artist, Mutō Shūi, was a disciple of Musō's and is presumed on the basis of literary accounts and of stylistic similarities in extant works to have made a number of portraits of him. Through his extended association with the master, Shūi acquired the keen knowledge of Musō's character that permitted the attainment of such quality in Japanese portraiture. An indication of the importance of such portraits in the religio-ceremonial occasions of the period is that when the Shōgun Yoshimitsu was received into the order of monks, he had his head shaved while seated before a portrait of Musō, and he, in turn, obliged a group of nobles and high military officials to follow him in this ritual. Although the seated full-figure portrait was traditionally regarded as the most orthodox form of *chinsō*, a variety of other types evolved as production grew to meet the expanding needs of the proliferating Zen church, and it is thought that Musō was partial to the half-figure portrait because of the number of works still preserved that depict him in this manner. The inscription above this painting, written in Musō's semi-cursive style, seems to justify this conclusion.

The lower extremities from hips to heels cannot
 expound a theme,
So only half a torso is visible within the
 Kenka gate.
 Written by Musō Soseki

Little biographical information is available on Mutō Shūi, although there are several records which mention his paintings. He is known to have executed a *chinsō* of Musō for Mukyoku, Musō's successor as abbot of the Tenryūji, to which Musō added his calligraphy while he was

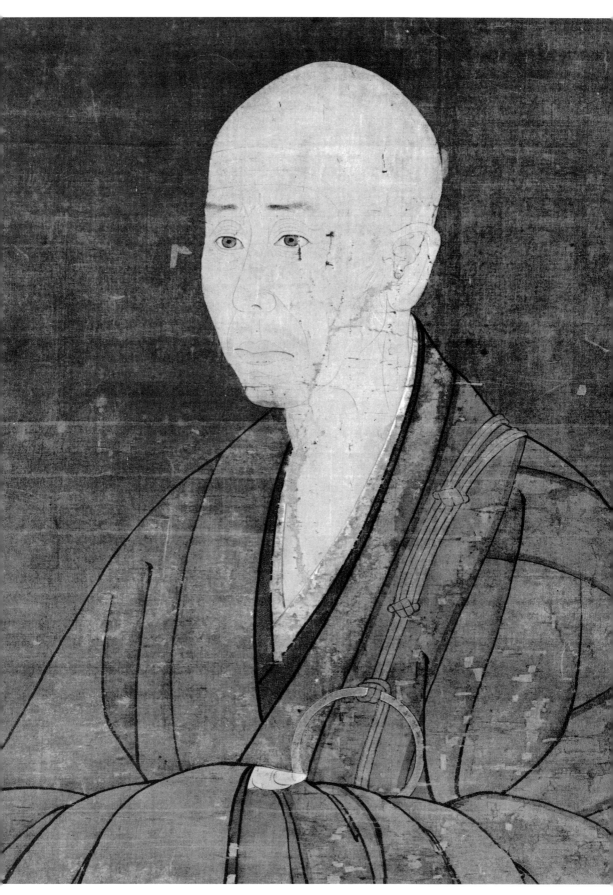

24. *Chinsō Portrait of Musō Soseki* by Mutō Shūi (active
first half of 14th century) (detail)

at the Saihōji in the winter of 1349. Shūi is generally associated with the production of *chinsō*, and the high artistic quality of the Myōchiin portrait lends strength to the argument that this was his specialty. The other subjects he seems to have dealt with are also of great interest, however, for they throw a broader light on the activities of the Zen painter-monk of the period. He is credited with painting a handscroll depicting the Ten Oxherding Stages (see cat. no. 49) that Musō presented to the retired Emperor Kōmyō in 1351. He may also have been responsible for a set of paintings of carp originally executed for the Ruriden ("Lapis Lazuli Hall") of the Saihōji. They were later mounted as hanging scrolls and were apparently much sought after.

In the *Kūge-Nikkoshū*, written by Gidō Shūshin, one of Musō's most famous pupils, there is a brief account of another type of painting executed by Shūi. On the twenty-fifth of February, 1380, Gidō went to visit the Shidōan, a hermitage in the Saihōji, and was surprised to notice that the painting *Hsiung Pên's Visit to Master Liang*, with its calligraphy by Musō, had been removed from the wall. When he inquired about this, he was informed that the painting had been taken down and put away for safe-keeping because of the concern at the temple that some casual visitor might make off with the valuable piece. A work by one of Shūi's pupils had been installed to replace it. The Shidōan ("Pointing to the East Hermitage") had been erected by Musō, and he seems to have personally chosen the theme for Shūi's painting. Although the exact nature of this theme is not clear, it seems from the title to have been of a traditional, anecdotal nature and, according to Watanabe, falls into the *zenkiga* category. A reference in a compilation by Kokan Shiren mentions the completion in 1295 of a poly-chrome painting on a wall in the Nanzenji, depicting the well-known meeting between Li Ao and the priest Yao Shan. The Shidōan painting probably represented a theme of a very similar sort. These two references suggest that Japanese Zen painters were already producing *zenkiga* on their own at an early date. The Myōchiin piece is one of the earliest Japanese *chinsō* portraits with an artist's signature, an indication of the growing specialization and confidence of Zen monks who labored to meet the artistic requirements of their sect.

REFERENCES:
Tokyo National Museum, *Nihon Kobijutsuten Zuroku* (1964), no. 177; *Muromachi*, Sekai Bijutsu Zenshū, vol. 7 (Tokyo, 1964), pl. 7 (Shōkokuji portrait); Tanaka Ichimatsu, "Kenchōji Daikaku Zenji Gazo-kō," in *Nihon Kaigashi Ronshū* (Tokyo, 1968), pp. 169 ff.; Watanabe Hajime, *Higashiyama Suibokuga no Kenkyū* (Tokyo, 1948), pp. 25 ff.; Sawamura Sentarō, "On Shūi, a Painter Priest" (in Japanese), *Kokka*, no. 347; Nara Teishitsu Hakubutsukan, *Nihon Shozōga Zuroku* (Tokyo, 1940), no. 76.

25

CHINSŌ SCULPTURE OF BUTTSŪ ZENSHI
Artist unknown; Kamakura period, ca. mid-14th century
Hinoki with traces of polychromy and lacquer, H. 78.3 cm.
Hokokuji, Ehime Prefecture, Shikoku

Although Zen portraiture of the *chinsō* type has its counterpart in sculpture, there are marked differences between the portraits on silk and in wood. The Japanese *chinsō* paintings were modeled upon Chinese prototypes, but there does not seem to be any indication that Ch'an portrait statuary ever existed in China. If it did, any trace of it has disappeared. That we find no Chinese examples of *chinsō* sculpture in Japan, could also be because it served a somewhat different purpose than the painted portraits. *Chinsō* statues are large and would not have been made for pupils who had attained Enlightenment to carry with them. Japanese *chinsō* sculpture seems to have had a commemorative purpose, and it was usually after the decease of the founder of a monastery that his statue was commissioned. It was then placed in the Founder's Hall, or *Shōdō*, which usually was located next to the Monk's Hall. By his presence in effigy, the founder was thought to ensure the maintenance of the Zen precepts which he had transmitted to his pupils.

It would seem that *chinsō* sculpture, although in many ways similar to painted Zen portraits, may have been inspired by the tradition of founder's-portrait statuary in the orthodox sects. One of the earliest *chinsō* statues is that of

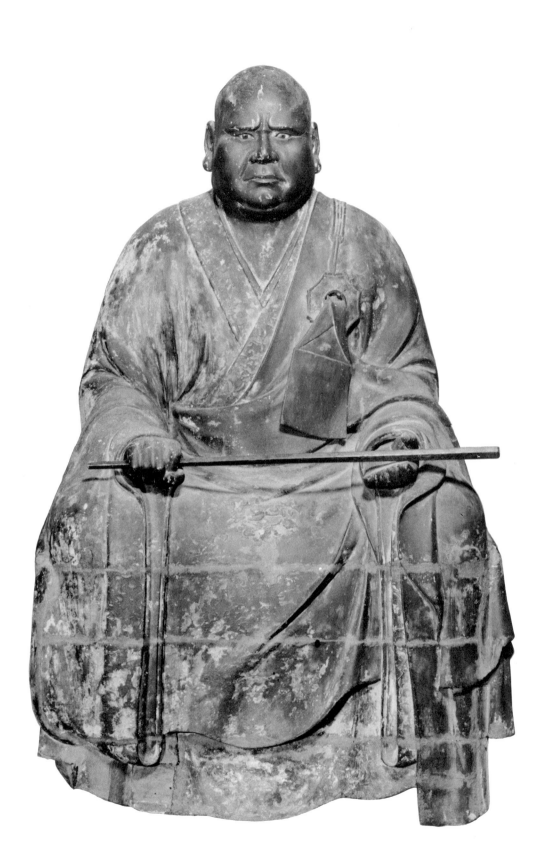

25. *Chinsō Sculpture of Buttsū Zenshi,* artist unknown,
ca. 1350

Hattō Kokushi in the Kōkokuji at Wakayama, which dates from about 1285. The earliest example which can be dated exactly by its inscription is a pair of *chinsō* at the Anrakuji in Nagano which date from 1329.

The monk who is portrayed in this statue is Chikotsu Dai-e (1229-1312), better known by the honorary name Buttsū Zenshi, which he received thirty-three years after his death. Dai-e was born in Ise and was a descendant of the famous warrior Taira Kiyomori (1118-1181), one of the heroes of the Heiji wars. Dai-e entered the priesthood at the monastery on Mount Hiei near Kyoto, where he studied Tendai Buddhism. He later was attracted to Esoteric Buddhism, but Shōichi Kokushi, the founder of the Tōfukuji (see cat. no. 59), converted him to the Zen sect. Most of Dai-e's later life was spent in monasteries in the vicinity of his native Ise, but in 1311, at the age of eighty-three, he was appointed abbot of the Tōfukuji where he died the next year.

In accordance with the traditional formula established for painted *chinsō*, Buttsū Zenshi is shown seated in a chair with a high back, the so-called *kyokuroku*. He is shown in a rigid *en face* position, looking formidably at the spectator. In his right hand, he holds the *kyōsaku* of the Zen instructor. The long sleeves of his habit are draped over the chair in soft, flowing folds. Like most late Kamakura sculpture, this statue is carved in the joint-block (*yosegi*) technique and fitted with glass eyes.

According to the tradition of the Hokokuji, where this fine example of *chinsō* sculpture has been preserved, Buttsū Zenshi is the founder of that temple. There is, however, no evidence that the tradition is historically correct. Another tradition maintains that this statue was brought to the temple from the Tōfukuji in Kyoto. That tradition would seem altogether credible, for a portrait-sculpture of this artistic quality is unlikely to have been carved in the remote area of Shikoku. It probably dates from the middle of the fourteenth century, perhaps from the time when Dai-e received his posthumous title.

REFERENCES:
Kobayashi Takeshi, *Shōzō Chōkoku* (Tokyo, 1969), pp. 187-188.

26

ZEN INSTRUCTIONS (HŌGO) FOR TAIKŌ KOJI
Shūhō Myōchō, (Daitō Kokushi) (1282-1338)
Hanging scrolls, ink on paper, 44 x 196.7 cm.
Collection of Yūki Teiichi, Osaka
Registered Important Cultural Property

Shūhō Myōchō, usually known by his posthumous title Daitō Kokushi, was one of the most influential Zen prelates of the Kamakura period. He was born in Harima (near present-day Osaka), and entered the priesthood at the age of eleven. At first he studied Tendai Buddhism, but in 1301 he went to Kamakura to study Zen. Three years later, when he heard that Nampo Jōmyō (1235-1309), a monk who had studied in China for six years, and who was now residing at Fukuoka, had been summoned to the capital, Kyoto, by Emperor Go-Uda (reigned 1274-1287), he went to Kyoto and became the pupil of this famous monk. He followed his master to the Kenchōji in Kamakura in 1308, and attained Enlightenment.

Nampo acknowledged Shūhō's *Satori* with his official certificate of approval (a document still kept at the Daitokuji) and predicted that Shūhō would need another twenty years of spiritual ripening to complete his experience. Nampo died soon afterwards, and Shūhō returned to Kyoto. Many legends grew up concerning the way he spent the next twenty years, the most common story being that he spent those years living with the outcasts and beggars who slept under the Gojō Bridge in the capital. In fact, however, Shūhō lived for a number of years at a temple in the Higashiyama area near Kyoto, and later built for himself a small study at Murasakino to the northwest of the city. As a result of his fame in court circles he received financial support to expand his hermitage, and in 1316 he was even summoned to court to lecture before the Emperor. Later, after Emperor Go-Daigo had ascended the throne, Shūhō lectured at court once again, and received assistance to expand the small temple at Murasakino into a large Zen monastery which was named Daitokuji, and finished in 1327. Here Shūhō remained for the rest of his life, except for a brief pilgrimage to the temple of his late teacher Nampo at Fukuoka. In 1338, feeling that his life was growing short, he broke his crippled leg, which had always prevented him from as-

26. *Zen Instructions for Taikō koji* by Shūhō Myōchō
(1282-1338)

suming the meditative posture, thus finally enabling himself to sit in proper meditation. Continuing a tradition established in his lineage several generations back in China, he wrote a death verse and passed away. He was awarded the posthumous title of "National Teacher" and named Daitō Kokushi.

As the founder of one of the largest and most important Zen monasteries, and as a colorful personality of great learning and strength of character, Daitō Kokushi has always been held in high respect in the Zen sect. The day of his death is still observed annually in the monastery which he founded. His death verse and blood-stained robe are the objects of worship on that day.

A number of documents which Daitō wrote for his pupils have been preserved. The writing is admired by Zen adepts for its blending of elegance and strength. Some of these documents are Hōgo, (literally, "Words of the Law"), brief texts containing Zen instructions in the form of personal messages addressed to a pupil. Among his Hōgo that are no longer extant but are known from copies, there is one written for the consort of the retired Emperor Hanazono (reigned 1308-1318), who had actively supported Shūhō. It explains the tenets of Zen in simple words. It is evident, however, that Shūhō adjusted the complexity of his instructions to the level of Zen understanding of the individual for whom he wrote such documents. The Hōgo exhibited here is addressed to a layman who had reached an advanced stage of doctrinal understanding, and the document is accordingly couched in abstruse language which defies translation into English by someone less enlightened. The following is a partial translation of the text:

One of the ancient virtuous men said: "If you do not concentrate your thoughts [on Enlightenment], your karma will be the Three Bad Ways [leading to Hell]; if you allow desire to rise even for a moment, you will be chained [to rebirth in this world] for ten thousand kalpas. However, if you will only desist and make desire cease, you will see and hear [the message of the Buddha] and you will understand Enlightenment. Then, a time of peace and happiness will begin"

The retired layman Taikō has come to me to receive the robe and the alms bowl [as a sign of having attained Enlightenment]. He respects the Buddhist precepts and has become a disciple of our Buddha. He requested me to give him a monk's sobriquet, and so I have named him

Shūshō. He also asked me for excerpted Zen instructions, and I jotted down these words in order to accede to his request.

Shūhō Myōchō of the Daitokuji wrote this in the Meigetsuken.

The Meigetsuken is the name of Shūhō's hermitage at the Daitokuji. The identity of Taikō koji is unclear. The style of Shūhō's handwriting and the contents of the document are related to those of two other documents by the master, one written for Sōen Zennin (Nezu Museum), dated in accordance with 1322, and one written for Kaige, dating from about 1331. The Hōgo for Taikō koji was in all probability written sometime between these two dates.

REFERENCES:
Tayama Hōnan, *Zenrin Bokuseki* (Tokyo, 1955), no. 49; *Shodō Zenshū*, vol. 19 (Tokyo, 1957), pls. 48-49 (Kaige document); *Seizansō Seishō*, vol. 2 (Tokyo, 1942), pl. 13 (Sōen Zennin documents); Isshū Miura and Ruth Fuller Sasaki, *Zen Dust* (Kyoto, 1966), pp. 231-234 (biographical information).

27

WINDBLOWN BAMBOO AMONG ROCKS
Artist unknown; colophon by
Ch'ing-cho Chêng-ch'êng (1274-1339)
Hanging scroll, ink on paper, 53 x 29.1 cm.
Nezu Museum, Tokyo

Among the Yüan painters whose names are known only in Japan, T'an Chih-jui was an important figure because of the influence of his work on Japanese painters. Instead of painting the traditional bamboo silhouette in close-up, he favored a more distant view, often placing his tall bamboos in a landscape setting. This method, though certainly not unique in China, became known in Japan chiefly through examples of his work. His name is mentioned in the second class of painters in the *Kundaikan Sōchōki*, and his paintings bear colophons by such distinguished priests as the Chinese I-shan I-ning (see cat. nos. 22 and 23) and the Japanese Shōkei Tsūtetsu (1300-1385), who spent more than thirty years in China.

The anonymous artist of this painting obviously was inspired by the example of T'an Chih-jui. The bamboo has been painted with

石清何似竹之清
却被風清盡力爭
人淨乾坤盈清氣
三清齋向筆端生
端龍山人清拙
　變題

27. *Windblown Bamboo among Rocks,* artist unknown,
early 14th century

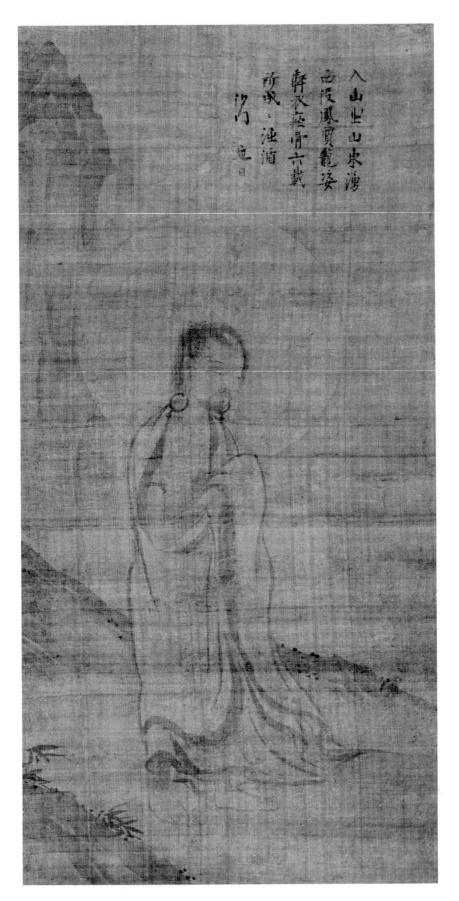

入山出山東坡
白段鳳眸龍姿
軒衣癯骨六載
所成二沌酒

28. *Śākyamuni Returning from the Mountains*, artist
unknown, early 14th century

considerable skill, but the structure of the rock is geologically not very convincing. The manner in which stems of the bamboo are shown through its holes also demonstrates that this early follower of T'an Chih-jui had not yet fully absorbed the methods on which his example was based.

The painting bears a colophon by the prominent Ch'an priest Ch'ing-cho Chêng-ch'êng (Japanese: Seisetsu Seichō); (1274-1339). He was a native of Foochow, who was invited to come to Japan in 1326, and is of special importance for Zen Buddhism because he reformed the monastic rules of the sect in accordance with Chinese traditions.

Old trees, rocks, and bamboo, or according to another tradition, plum trees, rocks, and bamboo, are known as the Three Pure Ones. The colophon verse is a kind of poetic *tour de force* in which the Chinese word for pure appears five times in four lines:

The purity of rocks, how could it resemble the
 purity of bamboo!
Its holes are purified by the wind; they exhaust
 their strength in battle.
Man has Heaven and Earth, reaching to the
 pure vapors.
In the window of the Studio of the Three Pure
 Ones they are born from the tip of my brush.
 Written by the man from Auspicious Dragon
 Mountain, the old man, Seichō.

REFERENCES:
Yamato Bunka, no. 28 (December 1958), pp. 31-33 (biographical information on Seichō).

28

ŚĀKYAMUNI RETURNING FROM THE MOUNTAINS
Artist unknown; colophon by Tung-ming Hui-jih (1272-1340)
Hanging scroll, ink on silk, 72.7 x 36.1 cm.
Chōrakuji, Gumma Prefecture
Registered Important Cultural Property

When the figure of the Historical Buddha, Śākyamuni, was finally resurrected and restored to a position of essential religious importance by the Ch'an sect, it was only after a long period when he had been overshadowed by the popular Boddhisattva cults, and reduced to a bloodless abstraction by the later metaphysics of the Mahāyana. His heroic efforts to attain Enlightenment by his own exertions set an example for the Ch'an adepts, who found inspiration in the story of his life to continue on their own arduous road to *Satori*.

In Ch'an art, this renewed interest in Śākyamuni is reflected in the emergence of several new themes which treat different episodes from his life (cat. no. 53). Judging from the surviving paintings, it would seem that Śākyamuni's return from the mountains was the most popular of these new themes. Its history can be traced back to the Northern Sung period. The Yüan poet Liao Kuan (1270-1342) is known to have written a colophon on a painting of this theme made by the famous literati artist Li Kung-lin (died 1106). Other poems on paintings representing the same subject were written by Lu Po-ta (second half of the twelfth century) and the Jurchen Wan-yen Tao (1172-1232). All these paintings have been lost, making Liang K'ai's famous painting in the Shima Collection the earliest extant work of this type. Liang K'ai's painting probably dates from the first decade of the thirteenth century when he was still a member of the Imperial Academy.

Paintings representing this theme were brought to Japan at an early date. One came from China before 1203, when Chōgen (died 1206), a monk of the Pure Land Sect who is famous for his efforts in rebuilding the Tōdaiji at Nara, returned to Japan from his third and last trip to China. His "Collection of Good Works" (*Sazen-shū*), an inventory of the works of art which he presented to Japanese temples, mentions one *Shussan Shaka*, the Japanese name of the theme. In the Seattle Art Museum is an iconographical sketch, formerly in the Kōzanji, Kyōto (see cat. nos. 1 and 19), which in all probability was copied from an early twelfth-century, Chinese prototype. One of the earliest Japanese paintings of Śākyamuni returning from the mountains bears a eulogy by the monk Hakuun Egyō (1223-1297) and is still preserved in the Tōfukuji. While Liang K'ai's painting was later combined in Japan with two of his landscapes to form a triptych, the Tōfukuji painting was combined with two pictures of plum blossoms.

In spite of the fact that this theme became highly popular in Ch'an-Zen circles, there is no clear evidence of its exact significance. Even the time when it took place has been a matter of discussion among Buddhist scholars. According to the story, Śākyamuni, realizing that asceticism

was not the correct method to achieve his final goal, gave up his fast of six years, and left the mountains. Several paintings of this theme show the Buddha in disheveled clothes and with the emaciated body of a man who has been fasting for six years. Such authoritative descriptions of the life of the Buddha as the *Lalitavistara* describe at considerable length how Śākyamuni was nursed back to health, and how he was given new clothes before he finally went to the Bodhi-tree to attain Supreme Enlightenment. On the other hand, several paintings show him with some of the primary bodily marks of the Buddha, and his head is often given a nimbus. This has led several scholars to believe that the scene represents the Buddha *after* he had attained Enlightenment, and that his return from the mountains should be interpreted as a departure into the world to spread the Law. This interpretation, most recently revived by Dietrich Seckel, is not supported by the details in the story of the life of the Buddha as recounted in the *Lalitavistara* and other canonical works.

The anonymous *suiboku* painting from the Chōrakuji possesses many features characteristic of several of the early versions of this theme. The Buddha is given what must have been considered to be an Indian physiognomy. The protuberance on top of his head (*uṣṇīṣa*) is visible through the curls of his hair. His hands are covered by the monk's garb but appear to be folded together. Dietrich Seckel has convincingly demonstrated that the folded hands symbolize the Buddha's silent possession of the truth. However, in order to avoid the creation of a *mudrā* which would be too specific and would be reminiscent of the symbolic gestures of esoteric Buddhism, the Ch'an and Zen artists consistently used the device of covering the hands with the monk's garb.

In the background, to the left, towers a mountain, partially hidden behind the halo. Sloping lines in front and back of the figure mark the descent from the mountains. The soft, flowing lines of the monk's garb and the subtlety of the ink tones create an air of gentleness rather than one of intense emotion and drama, like that which characterizes the painting by Liang K'ai. A cryptic colophon appears at the top of the painting:

He enters the mountains and returns from the
 mountains.

In the East it flows rapidly, in the West it
 disappears.
He has the bearing of a Phoenix and the manner
 of a Dragon.
He is draped in silk, but emaciated to the bone.
This is what he achieved in six years of
 asceticism:
He became utterly confused [. . .(?)]

 The monk Hui-jih.

The inscription was written by the Chinese Ch'an monk Tung-ming Hui-jih (1272-1340), who reached Japan in 1309 and who taught Sōtō Zen at the Kenchōji and Engakuji in Kamakura.

REFERENCES:
Matsushita Takaaki, *Suibokuga,* Nihon no Bijutsu, vol. 13 (Tokyo, 1967), figs. 33, 34 (Tōfukuji triptych); Dietrich Seckel, "Shâkyamunis Rückkehr aus den Bergen," *Asiatische Studien* 18-19 (Bern, 1965), pp. 35-72.

29

THE FOUR SLEEPERS
Mokuan Reien (active first half of the
14th century)
Hanging scroll, ink on paper, 73 x 32.2 cm.
Maeda Ikutoku Foundation, Tokyo
Registered Important Cultural Property

The priest Mokuan Reien, who was ordained at Kamakura before 1323, went to China about 1327. He lived at several well-known Ch'an monasteries near Ning-po and Hang-chou; he never returned to his homeland and died in China about 1345. It is not known whether he received his training as an artist in Japan or in China, but he achieved great fame in Ch'an circles as a painter in the monochrome style. According to a story which started to circulate among Japanese travelers to China soon after his death, the abbot of the Liu-tung-ssŭ recognized him as a reincarnation of Mu-ch'i, who had lived at that temple sixty years earlier. In recognition of his great skill he is said to have been given Mu-ch'i's seals — perhaps a convenient explanation for the existence of so many Japanese paintings which bear the seals of the great Chinese painter. Only a few of Mokuan's paintings have survived. Since all bear colophons by Chinese priests, we may assume that these works were painted during his stay in China,

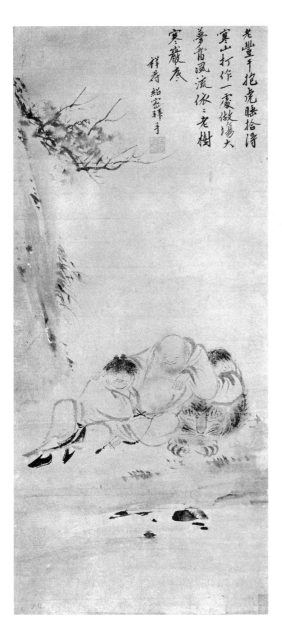

29. *The Four Sleepers* by Mokuan Reien (active first half of 14th century)

and that they were brought back to Japan by other Zen priests.

The Four Sleepers is a theme which shows Fêng-kan and his tiger, and Han-shan and Shih-tê all immersed in deep slumber. It seems to have enjoyed considerable popularity among Ch'an and Zen painters. Fêng-kan sleeping on a tiger, but not accompanied by Han-shan and Shih-tê, appears in a painting after Shih K'o (see cat. no. 3). It is possible that the theme of The Four Sleepers was created by adding the two younger eccentrics. *The Record of the Transmission of the Lamp* (A.D. 1004) is the earliest biographical source in which Fêng-kan is referred to as Han-shan and Shih-tê's elder and mentor and not as their equal. This would seem to suggest that the theme is not older than the eleventh century. Actually, the oldest Chinese example is a monochrome painting in the Tokyo National Museum, inscribed by several Ch'an priests who were active during the fourteenth century. A fifteenth-century Turkish miniature, obviously copied from a Chinese original, is proof of the popularity of the theme far beyond the borders of its country of origin.

Most texts which deal with the story of Han-shan and Shih-tê mention the identification of these two with the Bodhisattvas Mañjuśrī and Samantabhadra. In traditional Buddhist iconography, these two Bodhisattvas often are the attendants flanking an image of the Buddha. By adding Fêng-kan, the Ch'an Buddhists seem to have created a trinity of their own, complete with a *vāhanam*, the traditional mount of a Buddhist deity, in the form of a tiger.

There seems to be no Chinese text which gives us a clue to the meaning of this unusual and appealing theme. In Japan, it is generally interpreted as symbolizing the absolute tranquility of the universe for those who have attained Enlightenment.

The compositional formula which Mokuan adopted was a favorite of several early masters of Japanese monochrome painting. The figures are placed in the center and on one side of them is a steep rock with overhanging shrubbery (cf. cat. no. 44 by Reisai). Mokuan's brushwork has a light touch, and the subtlety as well as the directness which we see in some of Mu-ch'i's works. It reveals a technical skill which justifies his nickname of "Mu-ch'i reborn."

The painting bears a seal of the artist and a colophon reading as follows:

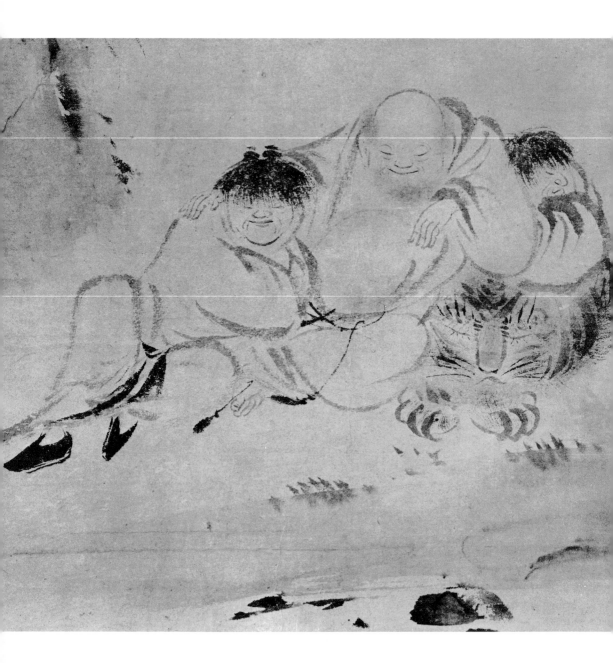

29. *The Four Sleepers* by Mokuan Reien (active first half
of 14th century) (detail)

Old Fêng-kan embraces his tiger and sleeps,
All huddled together with Shih-tê and Han-
 shan
They dream their big dream, which lingers on,
While a frail old tree clings to the bottom of the
 cold precipice.

> Shao-mi of the Hsiang-fu [temple]
> salutes with folded hands.

No biographical details are known about the
writer of the colophon. In addition to the seal
of Shao-mi and a seal of the artist himself, the
painting bears a seal reading: "Seal of Yen
ta-nien, monk of P'i-ling." This suggests that
the painting was in the collection of a Chinese
priest before it came to Japan.

REFERENCES:
Bijutsu Kenkyu, no. 19, pp. 23-24; *Kokka*, no. 779,
pp. 69-70; Watanabe Hajime, *Higashiyama
suibokuga no kenkyū* (Tokyo, 1948), pp. 1-24 and
pl. 3; Oktay Aslanapa, "Türkische Miniatur-
malerei am Hofe Mehmet des Eroberers in
Istanbul," *Ars Orientalis* 1 (1954), p. 83, fig. 43.

30

CALLIGRAPHY: POEM ON THE SUBJECT OF PLUM
BLOSSOMS
Sesson Yūbai (1290-1346)
Hanging scroll, ink on paper with a wax-dyed
imprint of plum blossoms, 99.7 x 34.5 cm.
Hoppo Bunka Museum, Niigata
Registered Important Cultural Property

An important aspect of the expansionist
activities of the Yüan Emperors during the latter
part of the thirteenth century was their deter-
mination to coerce the Japanese into a humiliat-
ing tributary relationship. The failure to achieve
this objective through diplomatic pressure and
intimidation so angered the imperious Mongols
that they determined to use their military power
against the Japanese. Great invasion armadas
were dispatched from Pusan on the southern tip
of Korea on two occasions (1274, 1281), but both
ventures were ill-fated and resulted in serious
losses for the Mongols. In the following years
the official policy of the Yüan Court toward
Japan remained intransigent, and it was not
until the fall of the dynasty that some semblance
of diplomatic congeniality was restored between

30. Calligraphy: Poem on the Subject of Plum Blossoms
by Sesson Yūbai (1290-1346)

the two countries. Despite these political difficulties, however, more than fifty Japanese Zen priests, such as Sesson Yūbai and Jakushitsu Genkō, are known to have traveled to the continent from about the time of the Mongol invasion attempts up until the end of the Kamakura period, while more than ten Chinese Ch'an priests, such as I-shan I-ning (Issan Ichinei) (see cat. no. 23), Ch'ing-cho Chêng-ch'êng (Seisetsu Seichō) (see cat. no. 27), and Ming-chi Ch'u-chün (Minki Soshun) made the long enervating trip to Japan during roughly the same period of time.

Sesson Yūbai (1290-1346) became a student under I-shan I-ning (who had arrived from Yüan China in 1299) at an early age, and he was only seventeen when he set out on the voyage to China in 1307. After his arrival, he spent some time making pilgrimages to famous temples, but eventually he was accepted as a disciple by Shu P'ing-lung at a monastery on Mount Tao-ch'ang in the Chêkiang area. However, as a consequence of the Yüan government's hostile attitude toward Japan, even student-monks like Yūbai were viewed with suspicion, and in 1313, he was accused of being a spy and thrown into a local jail together with his teacher P'ing-lung, who was indicted on the same charge, perhaps because of his association with Yūbai. P'ing-lung died during his confinement, but Yūbai survived, it is said, because of his religious dedication and was released after three years. He went on to Ch'ang-an, but he was taken into custody a second time and again sent off to prison, and it was only after more than a decade of incarceration that he was finally pardoned. His anguish and suffering during these long years are well described in his *Nanyū-shū* and *Minga-shū*. He finally returned to Japan in 1328 after twenty-three years in China, the largest part of this time spent in confinement. While there were many Japanese monks who traveled to Yüan China, no other seems to have suffered an experience comparable to that undergone by the unfortunate Yūbai. Throughout it all, however, his faith seems to have remained unshaken, and when he was about to depart for Japan, the venerable Zen teacher Ku-lin Ch'ing-mou composed a farewell verse for him that contains the following passage:

He escaped death ten thousand times
The Buddhist patriarchs ever foremost in his
 mind

His determination precious as one hundred
 pieces of pure gold

Yūbai was greatly honored in the years following his return from China, and he devoted the later years of his life to serving his sect, acting as abbot at various monasteries, such as the Manjuji in Bungo province and the Manjuji and Kenninji in Kyoto, and founding the Hōunji in Hyōgo.

Yūbai's interest in Chinese literature was stimulated initially by his teacher I-shan I-ning, and he seems to have devoted himself diligently to this subject throughout his life. He is said to have been complimented on his verse by Chinese men of letters, who, perhaps prompted by the traditional ethic of self-denigration, even said that his works were superior to their own. Yūbai, together with his teacher I-ning, are considered the founders of the Gozan ("Five Mountains") literary movement which flourished in Zen monasteries during the fourteenth century. While a few naturalized Chinese priests like I-ning were important sources of direct inspiration during the initial stages of the school, the main creative momentum was provided by Japanese monks like Yūbai and his successors Gidō and Zekkai. (Zekkai also spent a long time in China and is said to have been esteemed there as a poet.) These men focused their attentions chiefly on the production of Chinese literary forms, particularly poetry. Indeed, their reliance on Chinese subjects and compositional structure was so great that the entire movement might be viewed as a kind of provincial school of Chinese literature, and although the difficulties of writing creatively in a foreign language must have been prodigious, some of the most talented Japanese may, on occasion, have equaled their mentors in the quality of their writings.

Yūbai's poem consists of four lines, each with seven characters, a traditional Chinese verse form, and deals with one of the most favored subjects in Chinese and Japanese literature, the plum blossom.

The snowy path is clean and cold
 the butterfly still nowhere to be seen
A subtle fragrance [of plum blossoms]
 carried by the fresh breeze
A single [plum] branch, oblique against a
 country bridge
The [sure] harbinger of spring.

31. *Calligraphy: "Dankei"* by Kokan Shiren (1278-1346)

The characters are executed in an elegant, "running" style that demonstrates Yūbai's accomplished manner with the brush. Examples from Yūbai's hand are very scarce today, but the few pieces still extant provide sufficient evidence to justify his traditional reputation as a gifted calligrapher. One pious account describes a meeting with Chao Mêng-fu, where Yūbai wrote characters in the manner of the T'ang master Li Yung that were so skillfully rendered that even Mêng-fu, one of the most noted masters of his day, was deeply impressed. Although Yūbai studied Mêng-fu's style, his greatest indebtedness seems to be to the Sung master Huang T'ing-chien (1045-1105), whose style was particularly influential in the calligraphy of Zen monks of the Kamakura and early Muromachi periods.

REFERENCES:

Tayama Hōnan, *Zenrin Bokuseki* (Tokyo, 1955), II, no. 62; Tayama Hōnan, *Zoku Zenrin Bokuseki* (Tokyo, 1965), nos. 142, 288.

31

CALLIGRAPHY: "DANKEI"
Kokan Shiren (1278-1346)
Hanging scroll, ink on paper, 34.8 x 105.2 cm.
Collection of Fujii Takaaki, Kyoto

One of the outstanding figures in the Zen church during the late thirteenth to early fourteenth century is Kokan Shiren (1278-1346), a monk noted not only for his eminence in religious matters, but also for his literary and scholarly accomplishments. As a child, he was given the engaging nickname "Monju-dōji" ("Mañjuśrī's child attendant") in recognition of his intellectual promise. He began his religious studies under Tōzan Tanshō of the Tōfukuji when he was only eight, and within two years time he received the tonsure and was ordained. In the following years he studied under various masters at the Tōfukuji and Nanzenji in Kyoto and the Engakuji at Kamakura, devoting himself industriously both to Buddhist scriptures and canonical writings, and to the scholarly pursuit of Chinese literature and thought.

Certain interesting parallels and contrasts may be seen in the careers and activities of Kokan and of his contemporary Sesson Yūbai who died in the same year. Both were prodigies and had the opportunity to study under I-shan I-ning; both became revered dignitaries in the Zen church; and both had a compelling interest in Chinese literature. However, whereas Yūbai went to the continent and immersed himself directly in Chinese culture, Kokan remained in Japan, gaining most of his knowledge of things Chinese from books. Yūbai was able to actually meet and associate with educated Chinese monks and men of letters — perhaps even the great calligrapher, Chao Mêng-fu himself — and to learn composition and calligraphy directly from them, while Kokan's familiarity and reverence for the great continental literary tradition was gained largely through his own bibliophilic enthusiasm.

Both men played significant roles in the Gozan literary movement. Yūbai is especially revered for his skill at verse composition, and some of his poems — particularly examples

in his *Minga-shū*, an anthology compiled while he was in China—are said to equal the best contemporary Chinese examples. Yūbai's work reflects the sentiments and poetic modes of the Yüan period. It is perhaps more spontaneous and genuinely creative than Kokan's, which, in comparison, seems conventional and bookish and is obviously indebted to the Sung period prototypes that he knew from his studies. On the other hand, Kokan's criticism and expository prose in works such as his *Saihoku-shū* represent a high level of scholarly accomplishment and are widely acclaimed. In such works, he reveals a knowledge of considerable breadth, not only about Buddhist literary and canonical tradition and Chinese classical writings, but about Confucian ideas as well.

His most important work is the *Genkō Shaku-sho*, a prodigious compilation in thirty volumes, which deals with the history of Buddhism in Japan over a span of seven hundred years and describes the lives and activities of more than four hundred eminent monks. It is the first comprehensive biographical history of its sort produced in Japan, and is a valuable record of Japanese intellectual history due to Kokan's gift for organizing and evaluating traditional accounts. Kokan's teacher, I-shan, helped him with the compilation, which was completed in 1322 (the second year of the Genkō era). The oldest extant copy is a printed edition based on a copy compiled through the joint efforts of Kokan's pupil Daidō Ichii (see cat. no. 42), Shōkai Reiken (see cat. no. 43), and other priests and handwritten by Daidō. It is owned by the Tōfukuji, and is thought to represent the first printed edition, which was published in 1364.

Kokan Shiren's record of ecclesiastical service is distinguished. He served as abbot at both the Tōfukuji and the Nanzenji, and also founded several smaller temples, such as the Kaizō-in, a sub-temple of the Tōfukuji to which he retired when he was sixty-two.

Dan ("Sandalwood") and *Kei* ("Creek"), the two large characters in this fine specimen of Kokan's calligraphy, form the Buddhist sobriquet given by Kokan to his disciple Shinryō. Because of the Zen sect's emphasis on the master-disciple relationship, the awarding of a sobriquet was a matter of considerable importance. The master wrote the name boldly in his best orthodox style and presented the calligraphic document to the student as evidence of

his acceptance into the master's ecclesiastical line. Dankei Shinryō rose to high rank within the church. He served as the thirty-seventh abbot of the Tōfukuji and established the sub-temple Ryūnin-an. He died in 1374 at the age of seventy-three.

Kokan Shiren's calligraphic style is based on that of the great Sung master Huang T'ing-chien. No other Japanese calligrapher has emulated T'ing-chien's manner with more devotion or success. This is true not only of large characters written in the orthodox style—*Dan Kei*, for example, which has a strong, measured, almost tectonic quality—but also in examples of the "cursive style," such as Kokan's elegant signature to the left, which reads, "written by old man Kokan."

Kokan should be viewed not as an imitator but as the heir to T'ing-chien's underlying attitude toward calligraphic expression. His style is vigorous in its own right, and is characterized by discipline, vitality, and visual eloquence.

REFERENCES:
Shōdō Zenshu (Tokyo, 1962), vol. 20, pp. 167-168; Tayama Hōnan, *Zoku Zenrin Bokuseki* (Tokyo, 1965), nos. 198, 199, 201, 286; Tayama Hōnan, *Zenrin Bokuseki* (Tokyo, 1955), no. 60.

32

MAÑJUŚRĪ SEATED ON A LION
Artist unknown; colophon by Muin Genkai (died 1358)
Hanging scroll, ink and light colors on silk, 91.1 x 39.8 cm.
Collection of Yabumoto Sōgorō, Amagasaki

The incorporation of the Bodhisattva Mañjuśrī and of the White-Robed Kannon (see cat. nos. 19, 33, 35) into the Zen pantheon seem to have been almost contemporaneous. Mañjuśrī, often represented in painting and sculpture holding a copy of the *Prajñāpāramitā-sūtra* in his hand, was regarded as the embodiment of the transcendental wisdom expounded in this *sūtra*. Thus, he came to be identified with the doctrine of universal vacuity (*śūnyatā*) and the non-existence of all beings and things. Such ideas were in basic harmony with the tenets of the Zen sect, and exerted a decisive influence

Facing page:
32. *Mañjuśrī Seated on a Lion*, artist unknown, first half of 14th century

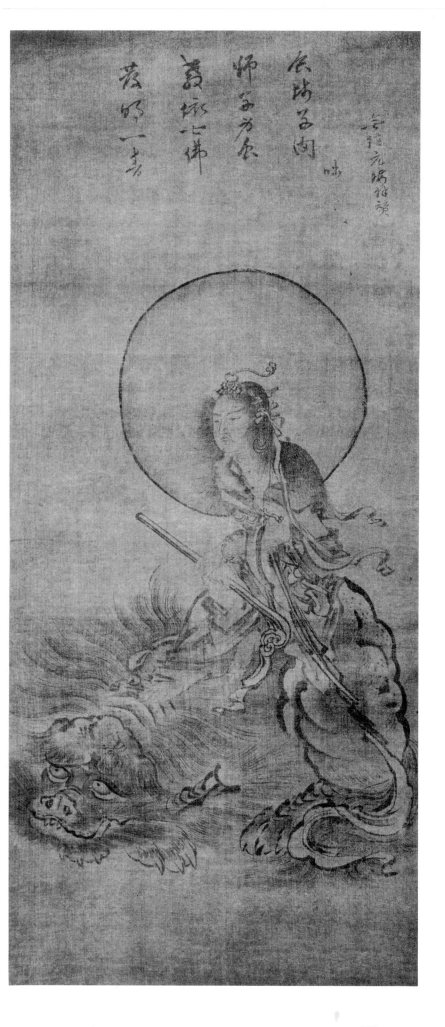

法坊子淘
師子力盡
高林七佛
莊好一書

無準元瑞相讚

咊

on its thought. Moreover, in the *Gandavyūha*, the same source from which the iconography of the Water-and-Moon Kuan-yin and related manifestations derive (cat. no. 19), Mañjuśrī is depicted as one of the most important of the Ideal Teachers, the *Kalyānamitras,* who are able to guide and assist those who are in search of Supreme Enlightenment. The intimate teacher-pupil relationship, which is of fundamental importance in Ch'an and Zen, was in many respects derived from the idea of the Ideal Teacher as he is characterized in the *Gandavyūha.* It was in his role of Ideal Teacher and as the Eternal Teacher, who was believed to have instructed all of the Buddhas of the past, that Mañjuśrī came to be venerated by the Ch'an and Zen Buddhists. Even now, images of Mañjuśrī are often to be found in the *Zendō* or Meditation Hall of Zen monasteries.

The anonymous artist who painted this Mañjuśrī was perhaps a slightly younger contemporary of the famous Mokuan Reien (see cat. no. 29). Here the iconographical details of Mañjuśrī, based on Chinese prototypes, already show many of the characteristics of the later representations of this Bodhisattva which were painted during the middle of the Muromachi period. A representation of the youthful Mañjuśrī by Ryōzen in the Masaki Collection reveals the same type of droll, long-maned lion, comfortably recumbent, its head resting upon its front paws. Mañjuśrī's sash is notable for its length; it trails down and over the hindquarters of the lion.

In his hand Mañjuśrī holds a *ju-i* scepter, an attribute dating back to his famous dialogue with Vimalakīrti (see cat. no. 64). The only iconographical deviation in this picture is the absence of the *sūtra,* which is one of the standard attributes. The verse above the painting reads:

He expounds only one book,
Its doctrine destroys the Seven Buddhas of
 the Past.
In the body of the lion is a worm;
It eats the lion's flesh.
Alas!

 Muin Genkai respectfully wrote this eulogy.

The first two lines of this poem refer to the doctrine of vacuity of the *Prajñāpāramitā-sūtra.* It is here given the negative twist of destroying the Buddhas of the Past, rather than instructing them as Mañjuśrī is said to have done in the *Fang-po-ching.* The last two lines refer to a story in the *Brāhmajāla-sūtra,* according to which

there is a worm that penetrates into the lion's intestines, poisons it, and eats its flesh. In Buddhist terms this parasite symbolizes harmful influences upon the Buddhist Law, threatening it from within.

The author of this whimsical colophon is Muin Genkai (died 1358), who went to study in China under the great Ch'an master Chung-fêng Ming-pên. He may have brought back to Japan the portrait of his teacher which is now in the Senbutsuji (see cat. no. 15). Very few specimens of Genkai's handwriting seem to have survived; this is the only known example of a eulogy from his hand.

Muin Genkai spent a considerable part of his life in Zen temples in Kyūshū. The artist Ryōzen and the monk Kempō Shidon, who wrote colophons on two of Ryōzen's paintings (including one on the *Mañjuśrī* in the Masaki Collection, mentioned above) also were men from Kyūshū. The painting of a branch of plum blossoms (cat. no. 38) was also produced by an artist from this southern island, "The Mad Guest from Kyūshū." These facts suggest that the Chinese *suiboku* styles probably infiltrated Japan through northwest Kyūshū, the first part of Japan to be exposed to influences emanating from China. Moreover, it was there that monks coming from China first set foot ashore. Many of them, either at the instruction of the Japanese authorities (see p. 57) or by their own choice, took up residence in temples on Kyūshū, often in the vicinity of Hakata, their port of disembarkation, before they eventually proceeded on to the capital. The practice must have made the impact of Chinese culture particularly strong in this area. The paucity of paintings which can be attributed to masters from this region, and the lack of sufficient biographical data, make it difficult, however, to reconstruct the characteristics of what may have been a regional school of *suiboku* painting.

REFERENCES:
Sekai Bijutsu Zenshū, vol. 7 (Tokyo, 1962), pl. 4; Tanaka Ichimatsu and Yonezawa Yoshiho, *Suibokuga,* Genshoku Nihon no Bijutsu, vol. 11 (Tokyo, 1970), pl. 20 (Mañjuśrī by Ryōzen).

33

WHITE-ROBED KANNON (BYAKU-E KANNON)
Ryōzen (active ca. mid-14th century)
Hanging scroll, ink on silk, 88.7 x 41 cm.
Myōkōji, Aichi Prefecture
Registered Important Cultural Property

The monk-painter Ryōzen is one of the early *suiboku* artists, who may have come from Kyūshū. He signed several of his paintings "Kaiseijin," i.e., "The Man from West of the Sea." Although this expression has sometimes been interpreted as pointing to China, it is more likely to be a reference to the island of Kyūshū. This White-Robed Kannon and a Mañjuśrī on a Lion in the Masaki Collection both bear colophons by the monk Kempō Shidon of the Nanzenji in Kyoto (died 1361), who was a native of Hakata on the same island. The dates of Ryōzen's activity have not been firmly established. One of the complicating factors is that the connoisseurs of the Edo period mistook Ryōzen for the painters Kaō, Shikan, or Sōnen. The *Honchō Gashi* by Kano Einō (1676) mentions an artist named Ryōzen who painted a set of thirty-two Rakan paintings with inscriptions dated in accordance with 1352. It is somewhat surprising, however, to find him mentioned there both as "Gakō" ("professional artist") and "Hō-in," i.e., a monk of high ecclesiastical rank.

Although this combination of high priestly rank and professional painter is difficult to reconcile, it would help to explain the character of Ryōzen's work. Practically all works which are signed by or attributed to Ryōzen deal with Buddhist subjects. Some of these paintings are in ink-monochrome, and one (the *Mañjuśrī* in the Masaki Collection) is in light colors. Even the *suiboku* paintings show many technical, stylistic, and iconographical points of correspondence with the Buddhist polychrome painting which was produced in the atelier of monk-painters of the Tōfukuji in Kyoto. This correspondence is very close in the case of Ryōzen's *Nyoirin Kannon* (Yamamoto Collection) and a polychrome painting of the same subject in the Daijuji, Okazaki. The latter can be dated in the late thirteenth century; and from an iconographical point of view, Ryōzen's *suiboku* version is practically identical with it. It is of particular interest that it has thin lines, painted in gold, to accent the ink lines of the drapery — a technique which was frequently used by professional Buddhist painters.

The White-Robed Kannon is similar in posture and robe to an iconographical sketch of the subject from the Kōzanji, now in the Cleveland Museum of Art. Ryōzen has taken another ink sketch, which is similar in its simplicity, used it as a prototype, and created a religious icon of great artistic distinction. The white robe is drawn in sharp, precise lines. The halo blots out most of the rocky background, but at the right edge of the painting is a waterfall, which supplies the water which moves in waves against the rocky seat of the Bodhisattva in the foreground. The brushwork and shading are those of a highly skilled artist, but one cannot entirely escape the impression that this work is essentially a translation of an orthodox Buddhist painting into the new *suiboku* idiom.

It is most likely that this White-Robed Kannon dates from the period when Ryōzen was active in Kyoto, and that an iconographical sketch in one of the many temple collections served as prototype. There are at least two other versions of this theme which are either based on the same iconographical drawing or on Ryōzen's painting itself. One of these bears the seal of Reisai (see cat. no. 44); the other is an anonymous painting in the Daitokuji.

Judging from the number of fourteenth-century examples which have been preserved, it would seem that the White-Robed Kannon enjoyed great popularity in Japan at the time. Generally speaking, the paintings of this subject are of two distinct varieties. One is the more formal, orthodox, and professional type of painting, which, in spite of the *suiboku* technique, resembles the polychrome icons. Of this type, Ryōzen's piece is one of the finest examples. While this type often shows Kannon *en face*, the other is less hieratic, and is usually a three-quarter view. In the second type the elaborate headdress is often dispensed with, and the head of the Bodhisattva is covered merely by the white robe. This "informal" type of White-Robed Kannon often is painted in a loose, somewhat amateurish fashion (see, for example, that by Gukei [cat. no. 35]).

The great popularity of the White-Robed Kannon as a theme among professional as well as amateur Zen painters, should perhaps be seen as evidence of the penetration of devotional Buddhist trends into the Zen sect. There are several reasons why the White-Robed Kannon

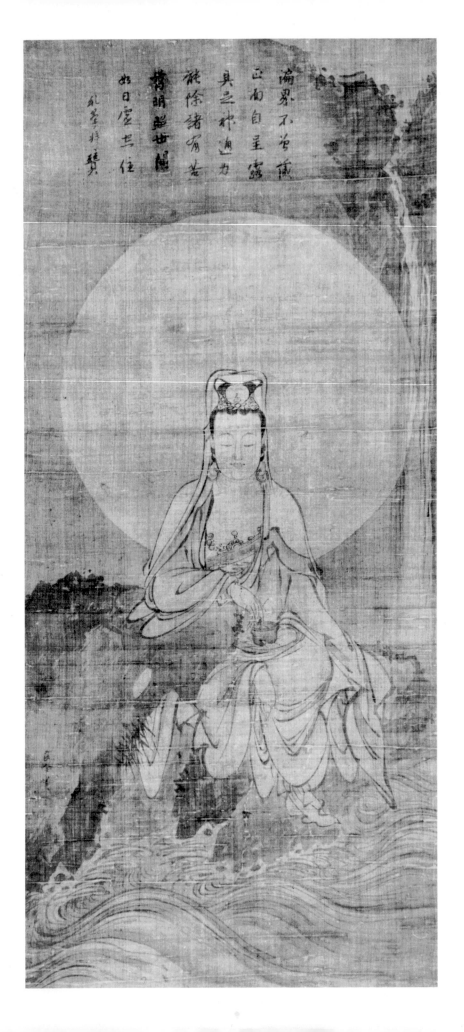

遍界不曾藏
正面目呈露
具足神通力
能除諸有苦
慈眼視世間
好月當空住

龍峯特贊

was singled out by Zen artists as a figure worthy of inclusion in their repertoire. Kannon invariably is shown in a sylvan setting, seated on a rock in the water. Moreover, the simple, unadorned costume of this white-robed deity, in contrast to the profusion of jewelry with which Bodhisattvas are usually bedecked, makes the *Byaku-e Kannon* the most simple, the most "secular" of all Buddhist deities.

At the top of the painting, above the large halo, is an inscription by Kempō Shidon (died 1361). It is not an original eulogy since the last four lines have been borrowed literally from the *gāthās* in praise of Avalokiteśvara in the Samantamukha chapter of the *Lotus Sūtra*:

Never hidden from the Universe,
She manifests her true countenance.
With the strength of her divine power,
She can allay all suffering.
Her splendor illuminates the entire world,
Like the sun dwelling in the void.
 Kempō reverently wrote this eulogy.

The signature of the artist is inscribed on the rock on the left.

REFERENCES:
Matsushita Takaaki, "The portrait of Kannon in white by Ryōzen" (text in Japanese), *Bijutsushi* 12 (1954), pp. 131-133; Tanaka Ichimatsu, *Shūbun kara Sesshū e* (Tokyo, 1969), pl. 14; Matsushita Takaaki, *Suibokuga*, Nihon no Bijutsu, vol. 13 (Tokyo, 1967), figs. 42, 144.

34

HERON
Ryōzen (active ca. mid-14th century)
Hanging scroll, ink on paper, 35.1 x 32 cm.
Anonymous loan
Registered Important Cultural Property

Practically all works attributed to or signed by Ryōzen deal with Buddhist subjects. This painting, representing a white heron, would, therefore, seem to be an exception. It is probable, however, that Zen artists had other than purely secular ideas in mind when they painted birds,

Facing page:
33. *White-Robed Kannon* by Ryōzen, ca. 1350

flowers, or fruit (see cat. nos. 60 and 61).

By leaving the body of the heron almost completely plain, and making it stand out against a background darkened by washes, the artist has applied the same conceptual idea that he used in rendering the white robe of Kannon (see cat. no. 33). This method of painting is very similar to that in the painting of the white goose by Minchō (see cat. no. 42). The beak and legs are accentuated by sharp brushstrokes in black. The painting carries the artist's signature, written through one of his seals.

Ryōzen is also represented in this exhibition by another painting, a White-Robed Kannon (cat. no. 33). Questions relative to the artist's biography are dealt with in that explanation.

REFERENCES:
Higashiyama Suibokugashū, vol. 1 (Tokyo, 1934), pl. 2;

35 & 36

TRIPTYCH: BYAKU-E KANNON FLANKED
BY LANDSCAPES
Ue Gukei (active 1361-1375)
Hanging scrolls, ink on silk, 98.6 x 40.3 cm.
BYAKU-E KANNON
Collection of Yamato Bunkakan, Nara
PAIRED LANDSCAPES
Masuda Collection, Kyoto

It is only in recent years that the identity of Ue Gukei has been established and a fragmentary picture of his style and oeuvre has begun to evolve. Although it is true that art-historical works of the Edo period such as the *Gakō Benran, Honchō Gashi, Koga Bikō,* and *Bengyoku-shū* all list individuals with the name Gukei, there is, unfortunately, no agreement in the brief biographical details given except in the statement that "he was a Zen painter-priest and studied the Sung master Mu-ch'i." Consequently, it is apparent that these descriptions apply not to a single figure, but, rather, to unrelated painters who worked in the ink-monochrome medium. Professor Shimada Shūjirō has discovered, however, several references to Ue Gukei in the *Kūge-shū,* an anthology compiled by Gidō Shūshin (1325-1388), that make it clear that he was a dis-

34. *Heron* by Ryōzen, ca. 1350

ciple of Gidō's distinguished fellow-monk Tes-shū Tokusai (died 1366). Tokusai returned to Japan in 1341 after visiting Yüan China, where he had been given the Buddhist title Yüan-t'ung Ta-shih by the Yüan Emperor. While in China Tokusai took religious training under Ku-lin Ch'ing-mou, who instructed a number of Japanese monks and also taught Hsüeh-ch'uang P'u-ming, a Ch'an painter-monk. Tokusai studied painting under Hsüeh-ch'uang, who was noted for his depiction of orchids, and became an accomplished master in the same genre, as is known from the fine example from his hand in the Gotō Museum.

Ue Gukei's dates are unknown, but the colophon on a painting in the Daijiji (a temple in Kumamoto Prefecture) written by the eighth abbot Ten'an Kaigi, who died in 1361, indicates that he was producing paintings by this time. Other sources of information are two "departure poems" in the Kuge-shū dedicated to Gukei by Gidō Shūshin and written on the occasion of Gukei's departure from Kamakura early in 1375 (after what appears to have been an extended period of residence there); this fourteen-year span conveys some idea of the period of his activity. Gukei used the "studio sobriquet" Gen'an (which might be translated as the "Eidolon Hermitage"), according to the description by Gidō, who also notes that the artist produced different kinds of paintings, ranging from Buddhist patriarchs and Taoist immortals to flowers and landscapes, characterized by an unexplained apparitional or illusory quality, which inspired the name of his studio.

There are at least nine extant works from Gukei's hand, all hanging scrolls painted in ink. They range from orthodox Buddhist subjects (Śākyamuni Flanked by Samantabhadra and Mañjuśrī, in the Manjuji in Kyoto, and Śākyamuni Emerging from the Mountains), to Buddhist deities popular in Zen circles (a Byaku-e ["White-Robed"] Kannon, and a Hotei), to Flower and Bird themes (Sparrows and Bamboo, in the Daijoji, and Grapes, in a private collection, Matsue), to landscapes (a single example in the Tokyo National Museum and the pair in the Masuda Collection). This small but varied corpus of paintings confirms Gidō's statement about the multiplicity of Gukei's subjects. The works themselves, however, reveal that Gukei lacked the versatility necessary to be proficient in all of these divergent themes. Perhaps the weakest of the group is the Śākyamuni triad,

which has a stiff, uninspired quality (probably as a result of the inflexibility imposed by a subject that had to be copied, for iconographical purposes, as literally as possible) that stands in sharp contrast to the fine, tradition-oriented Buddhist representations produced in ink-monochrome by the Zen painter-monk Ryōzen perhaps a decade or two earlier. Other figure paintings, such as the Byaku-e Kannon and Hotei, are more successful, perhaps because they lend themselves more readily to a quicker, less constrained treatment, which was more congenial to Gukei's own artistic inclinations. This is true also of the paintings Sparrows and Bamboo and Grapes and especially of the landscapes, where Gukei displays a confidence and sense of pleasure in execution.

The style of the Masuda landscapes is broad, exuberant, and essentially nonlinear, and details are kept to a minimum. While the compositional elements are piled in a vertical sequence that keeps them close to the picture plane (a method of arrangement whose roots go back at least to the Northern Sung period in China), the generous use of soft, indistinct layers of fog and mist (a feature inherited from the Southern Sung period) serves to tie the composition together and give it a sense of atmospheric depth. This latter feature may be recognized as a characteristic of the landscape manner of Mu-ch'i, but the closest stylistic affiliation of the Masuda landscapes is with the group of works attributed to Yü-chien, the twelfth-century master of the "broken," or "flung," ink technique. In Yü-chien's paintings, landscape components are rendered directly and spontaneously, often with the side of a wet, overloaded brush; details, which are used very sparingly, are painted in a highly abbreviated way. The resulting expression is dramatic and is heightened by an arcane atmospheric tension. Although this style came into vogue in Japan during the latter part of the fifteenth century and was practiced extensively by Sesshū and certain of his followers, the Masuda landscapes demonstrate that it was known in Japan a century earlier.

The single landscape by Gukei in the Tokyo National Museum once formed the right-hand element in a triptych. The other two pieces were destroyed by fire, but the original subjects and disposition are known from a copy and consisted of a flanking landscape to the left and a representation of the Byaku-e Kannon in the center. The Byaku-e Kannon by Gukei recently

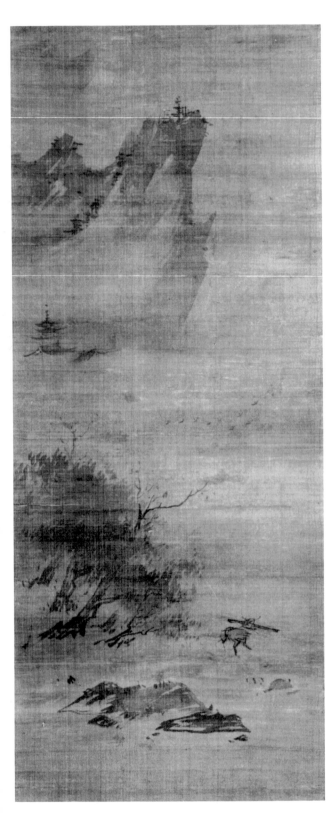
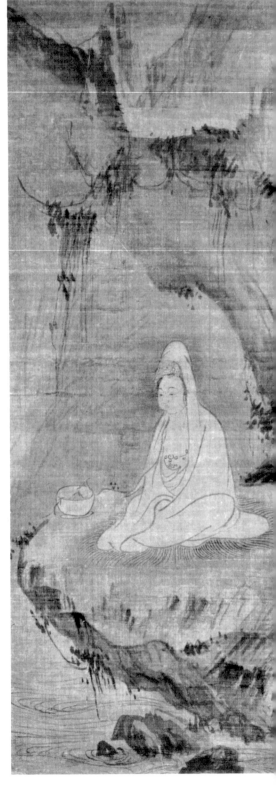

35. & 36. *Triptych: Byaku-e Kannon Flanked by Land-scapes* by Ue Gukei (active 1361-1375)

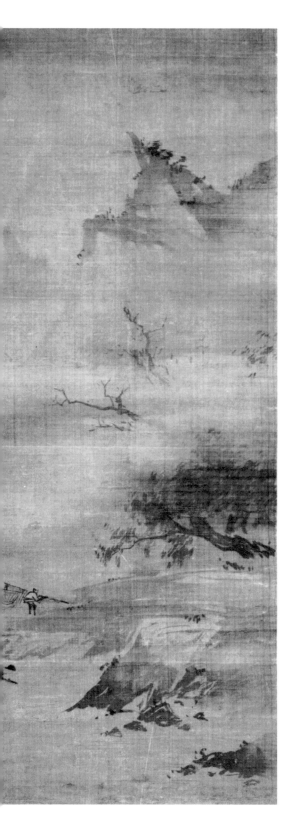

came to light, and Japanese scholars, comparing it with the triptych just mentioned, have determined that it originally formed the center of a triptych, of which the Masuda landscapes are the flanking pieces. This Gukei triptych was originally conceived as a group and in this respect is unusual, for it was common practice in Japan during the late Kamakura and Muromachi periods to combine imported Chinese paintings into triptychs, with a central icon flanked by a pair of works depicting Bird and Flower themes, landscapes, or figures. It is the oldest extant example of this type in Japanese ink-monochrome painting. All three works have the same seals, "Ue" and "Gukei," and are painted on rough silk of the same dimensions.

Ue Gukei belongs to a formative period in the development of ink-monochrome painting in Japan, during which native artists, inspired by the newly imported examples of Sung and Yüan ink paintings, were still struggling to emulate the techniques and conceptions already perfected on the continent. Gukei was preceded, by a decade or two, by Kaō and Mokuan, two of the earliest Japanese practitioners of monochrome painting. He was roughly contemporary with Mutō Shūi and, like him, was a painter-monk whose ecclesiastical function was to produce paintings for the multiple requirements of the Zen church, a role which required treatment of a broad range of subject matter. This role may be said to distinguish Gukei and Shūi from artists like Ryōzen and Minchō, who were associated with the Tōfukuji atelier in Kyoto and stood closer in their subject matter and painterly traditions to the mainstream of Buddhist iconographical painting, which had flourished in the capital for centuries. The tradition of ink-monochrome painting brought to Japan by Zen monks seems to have taken root more readily in Kamakura than in Kyoto. This may be, in part, because the first "pure" Zen monasteries were established at Kamakura, which was geographically distant, rather than at Kyoto, where the sect met with opposition from other entrenched schools of Buddhism, and where the deep-seated cultural traditions tended to inhibit and hybridize Zen institutions. Gukei and Chūan Shinkō (see cat. no. 56) are regarded as the founders of the school that developed at Kamakura and later produced talented men like Shōkei (see cat. no. 57), Sesson, and Koboku. Gukei's paintings are doubtless indebted in the main to Chinese models, but his

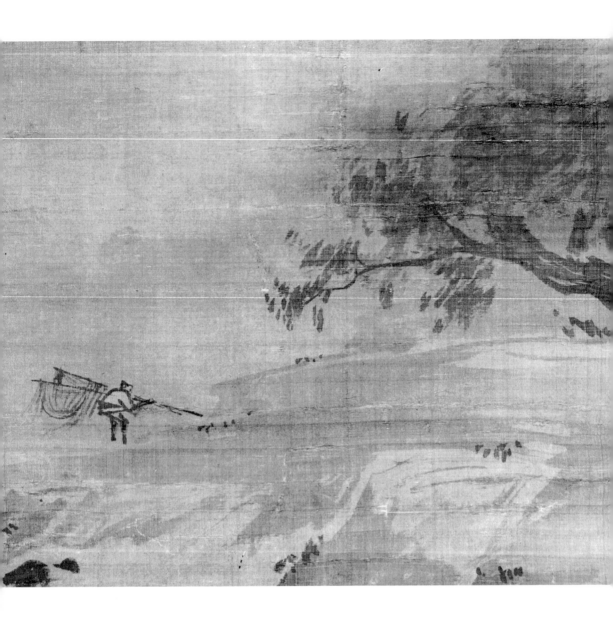

36. *Landscape* by Ue Gukei (active 1361-1375) (detail)

landscape style has a direct, irrepressible quality that is quite personal: it displays the naïveté and enthusiasm of a painter who senses his place in the evolution of a new school of painting.

REFERENCES:

Tanaka Ichimatsu and Yonezawa Yoshiho, *Suibokuga*, Genshoku Nihon no Bijutsu, vol. 11 (Tokyo, 1970); Etoh Shun, "A Byakui Kannon by Ue Gukei," *Yamato Bunka*, no. 34; Nakamura Tanio, "Gukei's Sparrows and Bamboo Painting and its Date," *Kokka*, no. 762; Shimada Shūjirō, "On Two Works by Ue Gukei," *Kokka*, no. 707; Hasumi Shigeyasu, "Kaō and Gukei," *Ars Buddhica* 49; Nakamura Tanio, "'Landscape' and 'Hotei' by Gukei," *Museum*, no. 73; Shimada Shūjirō, "A Painting of Grapes by Gukei Ue," *Kokka*, no. 824.

37

CALLIGRAPHY: A SEVEN-CHARACTER LINE
Sekishitsu Zenkyū (1294-1389)
Hanging scroll, ink on paper, 120.7 x 22.3 cm.
Collection of Takeuchi Zen'ichirō, Tokyo

Sekishitsu Zenkyū (1294-1389) is one of the Zen monks who traveled to China at the end of the Kamakura period and studied there for an extended period of time. He set out from Japan in 1318 and does not seem to have returned until 1326, the same year that the Ch'an monks Chu-hsien Fan-hsien (Jikusen Bonsen, 1294-1348) and Ch'ing-cho Chêng-ch'êng (Seisetsu Seichō, 1274-1339; see cat. no. 27) reached Japan. In China, Zenkyū made the customary pilgrimage to famous monasteries; he visited the Pao-ning-ssŭ, a temple at Chin-ling in Kiangsu, where he became a devout disciple of the venerable Ch'an priest Ku-lin Ch'ing-mou (1262-1329). Ku-lin was an influential teacher in the line of Sung-yüan and produced several out-standing students who spread his doctrine. Zenkyū was well received in ecclesiastical circles in the years after his return to Japan and served as abbot at many temples: the Manjuji and Shōfukuji in Kyūshū, the Chōfukuji, Manjuji, and Tenryūji in Kyoto, and the Engakuji and Kenchōji in Kamakura. He founded the Heirinji in the Musashino area and was instrumental in spreading Ku-lin's doctrine in the surrounding Kantō region. His colleague, Getsurin Dōkō,

37. *Calligraphy: A Seven-Character Line* by Sekishitsu Zenkyū (1294-1389)

who had also been a student of Ku-lin, spread the master's teachings in the region around Kyoto. Zenkyū's long and distinguished career came to an end in 1389 when he died at the age of ninety-five.

Zenkyū is known as an accomplished calligrapher, particularly in the "cursive style." Examples of his hand are preserved in some numbers and justify his reputation for originality. His "cursive style" shows a basic familiarity with the work of the great T'ang masters, Huai-su and Chang Hsü, who specialized in this type of calligraphy, but his characters are less vital and are closer to the derivative form of the T'ang masters' style that was fashionable in Yüan China during Zenkyū's stay on the continent.

This example of his calligraphy is unusual for its period in that it has a long, narrow, vertical format with a single line of seven characters. Although it is known that the Ch'an monk Wu-an P'u-ning (Gottan Funei, 1197-1276) used this format, Zenkyū and his contemporary Jakushitsu Genkō (1290-1367) may be among the first Zen priests to have used it. The line reads: "The immortal knows the mind of antiquity." *T'ung-lao*, the two-character term translated here as "immortal" is a synonym for the more commonly used term *Hsien-shên* (Mathews' *Chinese-English Dictionary*, nos. 2707, 5716) which has its origin in the ancient Taoist concept of the "immortal" or "sylph-man," a class of being who prolonged his existence through Taoist alchemistic and, or, quietistic practices.

REFERENCES:
Tayama Hōnan, *Zoku Zenrin Bokuseki* (Tokyo, 1965), no. 188.

38

PLUM BLOSSOMS
"Kyūshū Kyōkyaku" (active late 14th century)
Hanging scroll, ink on paper, 132 x 36.2 cm.
Masaki Museum, Ōtsu

Bamboo, orchids, and plum, known together as the Three Pure Ones (see cat. no. 27), were a favorite theme of the Chinese literati painters of the Southern Sung and Yüan periods. Their symbolic association with purity of spirit made the plum blossom a suitable topic for poetry as

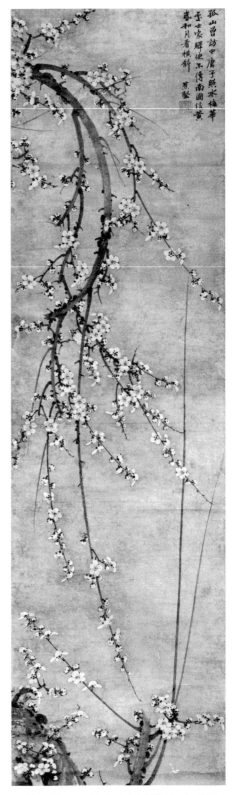

38. *Plum Blossoms* by "Kyūshū Kyōkyaku" (active late 14th century)
Facing page: detail

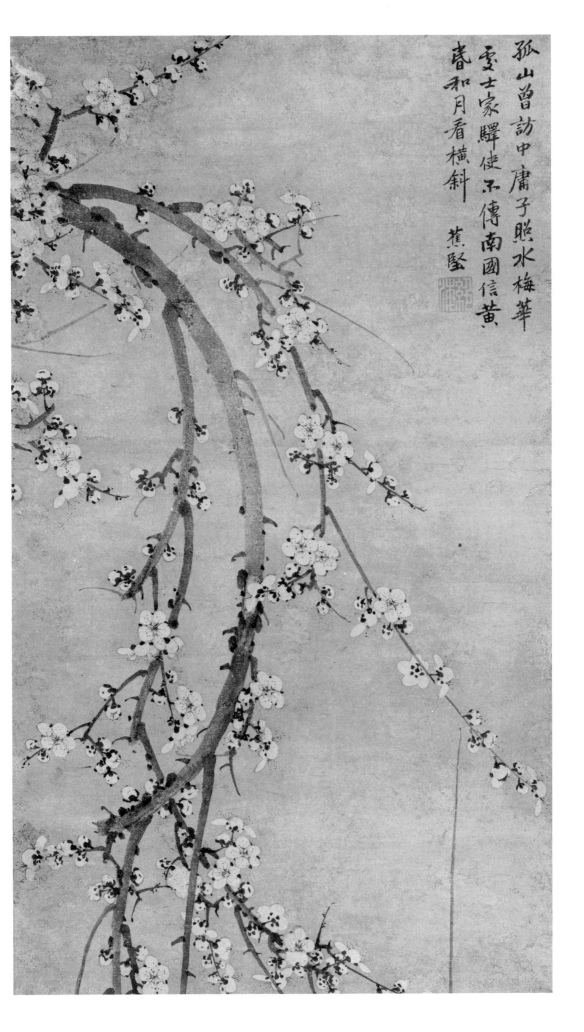

孤山曾訪中庸子貼水梅華
雪士家驛使不傳南國信黃
昏和月看橫斜　蕉堅

well as monochrome painting. Many poems were written in praise of the flower, and the techniques and styles in which blossoming plum branches could be painted were a matter of lengthy discussion in the numerous treatises on plum-blossom-painting which were written during the Southern Sung and Yüan periods.

Given their deep interest in natural beauty and simplicity, it is not surprising that the Ch'an priests soon incorporated the plum blossom into their literary and artistic repertoire. Many of the Chinese priests, whose names one comes across in connection with Ch'an painting, are known to have composed poems on plum blossoms. Among them are such prominent figures as Chung-fêng Ming-pên (see cat. no. 15) and I-shan I-ning (see cat. nos. 22 and 23). The vogue for plum blossoms soon spread to Zen circles in Japan.

This representation of a curving branch of a blossoming plum tree is an early Japanese example. Although it is a rather conventional painting, it differs from slightly earlier examples in that it follows quite faithfully the precepts of the Chinese treatises on painting. In making a crooked branch spread over the entire picture, the artist followed the scheme of composition that the treatises named after the constellation *Pei-tou* (Ursa Major). This method became popular during the Yüan period. The downward movement of the undulating branch dominates the composition. The balance is redressed by the heavy tree trunk in the lower left and by the swift upward thrust of the so-called spirit branch (*ch'i-t'iao*), a branch without any blossoms at all. This "spirit branch" seems to have been first introduced by the Sung artist Yang Pu-chih, who was criticized in later treatises for his repeated use of this innovation. Each intersection of branches has been carefully camouflaged with a blossom.

In the upper right corner is a poem written by the well-known priest-poet and prominent figure in the Gozan literary movement, Zekkai Chūshin (1336-1405).

When one visits Chung-yung-tzŭ at Mount Ku,
The plum blossoms are reflected in the water
 at the hermitage.
Although the courier did not deliver a letter
 from the southern land,
We see the silhouette of branches against the
 moon at dusk.

 Shōken

As is the case with much Gozan poetry, this poem abounds with literary allusions. Mount Ku is the abode of the Sung poet Lin Pu, who spent his life growing plum trees and keeping cranes. He shared these interests with his neighbor, the monk Chih-yen, who is known as Chung-yung-tzŭ. Just as the literary name for bamboo was "this gentleman," the plum blossom became known as "the courier." Phrases containing playful references to couriers therefore frequently occur in poetry on plum blossoms.

Zekkai Chūshin's colophon is included in an anthology of his poems, the *Shōkenkō*. From its context there, it is evident that originally there must have been a pair of plum blossom paintings, each inscribed with a verse. In the *Shōkenkō*, Chūshin adds the following: "The real name of the painter is not clear. I only know that his nickname is 'Kyūshū Kyōkyaku' [i.e., the 'Mad Guest from Kyūshū']. I once met him on the road, carrying his own bedding. Whenever he saw beautiful scenery, he would lie down upon his mat at once and start whistling and singing, and whatever he said would be very strange. I think that he is a person who is good at painting, but who deliberately takes refuge in madness. However, his brushwork is too thin and stiff and does not satisfy people. I have therefore added these poems to allay these shortcomings."

The behavior of this eccentric artist closely resembles that of the eleventh-century artist Chung-jên (Hua-kuang), the first Chinese artist who specialized in the painting of plum blossoms. It is said that he would move his couch under the blossoming plum trees and lie there the whole day humming and chanting. The Mad Guest from Kyūshū obviously took his work seriously, patterning not only his style of painting, but also his behavior, upon that of his Chinese example.

REFERENCES:

O. Sirén, *Chinese Painting: Leading Masters and Principles* (London, 1956), II, p. 156 (on Hua-kuang); *Shōkenkō*, in *Gozan Bungaku Zenshū* (Tokyo, 1936), II, p. 1053; Nakamura Tanio, "Bokubai: Muromachi Suibokuga no Baizu ni tsuite" [Bokubai: On monochrome paintings of plum blossoms of the Muromachi period], *Nihon Bijutsu Kōgei*, no. 340 (Jan. 1967), pp. 38-47.

39. *The Three Doctrines,* attributed to Josetsu, early 15th century

39

THE THREE DOCTRINES
Attributed to Josetsu (active early 15th century)
Hanging scroll, ink on paper, 98.3 x 21.8 cm.
Ryōsokuin, Kyōto
Registered Important Cultural Property

Although Josetsu must have been one of the most brilliant *suiboku* artists of his generation, he was almost entirely overlooked by the chroniclers of his time. Consequently, practically nothing is known about his life. His name appears only once in contemporary records. This is in connection with a project for erecting a stele at the Rokuon-in for the founder of the Shōkokuji, the monk Musō Soseki, sometime between 1414 and 1418. The paintings which can be attributed to his hand with reasonable confidence are all of extraordinary artistic quality. None of them have signatures or seals of the artist, but they are attributed to Josetsu by the authors of colophons which were written either during his lifetime or shortly after his death. A colophon on his painting of The Three Doctrines is the only document which provides valuable biographical information. It tells how Josetsu received his monk's name from Zekkai Chūshin (1336-1405), the great priest-poet of the Gozan literary movement, who lived at the Shōkokuji in Kyoto (see cat. no. 38). The name Josetsu (literally: "clumsy-like") was chosen by Chūshin from the Taoist classic *Tao-tê-ching* (ch. 45): "The greatest skill is like clumsiness" or "the greatest cleverness is like stupidity." We may assume that the two were together at the Shōkokuji at some time before Chūshin's death in 1405.

Of the works attributed to Josetsu, three stand out as closely related works of great artistic distinction. Two of these are shown in this exhibition: *The Three Doctrines* and *Wang Hsi-chih Writing on a Fan* (cat. no. 40). The third is the famous *Catching a Catfish With a Gourd,* a typical Zen allegory which illustrates the difficulty of catching a slippery, elusive catfish, with a smooth, narrow-mouthed gourd. The inscription on this painting states that it was painted in a "new manner" at the request of the *shōgun.* The words "new manner" probably refer to the fact that the artist incorporated a landscape setting into a *zenkiga* for the first time. The picture, which may have served some com-

memorative purpose, bears colophons by thirty-one Zen priests of the period.

The theme of The Three Doctrines represents Sākyamuni, Lao-tzŭ, and Confucius; the alleged founders of Buddhism, Taoism, and Confucianism; and may go back to the Five Dynasties period. Large symposiums, in which the relative merits of the three doctrines were debated, were held under imperial patronage throughout almost the entire time these three doctrines coexisted in China. No Chinese paintings representing this theme seem to have survived, but Chinese catalogues mention several painters of the Five Dynasties and Northern Sung periods to whom such pictures have been attributed. The most famous of these pictures was painted by Ma Yüan (ca. 1150-1230). At the suggestion of the eunuchs at court (who were often anti-Confucian in sentiment), it represented Confucius paying homage to a seated Buddha, with Lao-tzŭ standing to the side. This would seem to indicate that Ma Yüan's *Three Doctrines* reflected the spirit of competition characteristic of the apologists of these three doctrines. The supremacy of one or another of the three sages could be expressed by the juxtaposition and posture of the figures, just as the seating arrangements and other details of protocol at the symposia often were signs of imperial preference.

Although it is evident that competition was a motivation for such paintings it does not seem to have been the only or even the most important one. Throughout Chinese history efforts had been made to harmonize the doctrines of the three schools of thought. Usually, however, such efforts had resulted in reconciling two doctrines at the expense of the third. It was not until the period of the Five Dynasties that the Taoist Ch'ên T'uan (ca. 906-989) proposed a possible way of harmonizing all three. As paintings depicting The Three Doctrines began to appear during the same period, we may assume that at least some of them expressed the union rather than the diversity of the three systems.

The syncretic school of thought, which proclaimed the theory of "Three Doctrines, One Source," had its own specific appeal to the Ch'an school. Taoism, which had contributed so much to Ch'an Buddhism in its formative stage, was looked upon with sympathy by many Ch'an adepts. Furthermore, there was a lively exchange of ideas between Confucianists and Ch'an adepts. During the Southern Sung period this activity created a spiritual climate in which such ideas as "The Three Doctrines Are One" could flourish.

This was especially true in Japan, where Taoism was of little importance, and where Buddhism and Confucianism had been adopted without the historical onus of centuries of strife and competition. The popularity of The Three Religions as a theme in Zen art is an expression of the liberal attitude of the Zen sect, which resolved doctrinal differences on the elevated philosophical level of the non-duality of knowledge.

Josetsu's *Three Doctrines* is a magnificent essay in "abbreviated" brushwork, a technique inherited from the Chinese painter Liang K'ai (cat. nos. 5 and 6). The costume of the wise old man on the left, obviously Confucius, has been summarily indicated in broad strokes of heavy black ink, while the carefree Taoist on the right is dressed in a robe executed in swift, sharp and superbly controlled lines. The faces have been rendered in a fine hand, which meticulously depicts each wrinkle. Between the heads of the two Chinese sages appears the face of Sākyamuni, represented, in accordance with Zen traditions, with a curly beard and the physiognomy of an Indian rather than as a figure of the orthodox Tathāgata type. The technique of drawing has numerous parallels with the *Catching a Catfish With a Gourd* and *Wang Hsi-chih Writing on a Fan*. The principal reason why most modern authorities have hesitated to confirm the attribution of this painting to Josetsu lies in the contents of the colophons, which paradoxically are the basis of the traditional attribution.

The painting is now mounted together with two long colophons. The one directly above it is written by the monk Ryūtō, and dated in accordance with A.D. 1493. The longer inscription at the top of the painting is written by a priest who calls himself "Kanjōsō from Konge" (literally: "Golden Flower"). Konge has been tentatively identified as a name of the Hōunji (Ibaragi Prefecture), a temple founded by Sesson Yūbai (see cat. no. 30), but the identity of the priest remains uncertain. Kanjōsō's inscription, which deals chiefly with the chronology of the three sages, contains the short passage which provides the only clue to Josetsu's name and religious affiliation: "The name of the skilled painter is [Jo]Setsu. The name was given to him by master Kōshō [i.e., Zekkai Chūshin]."

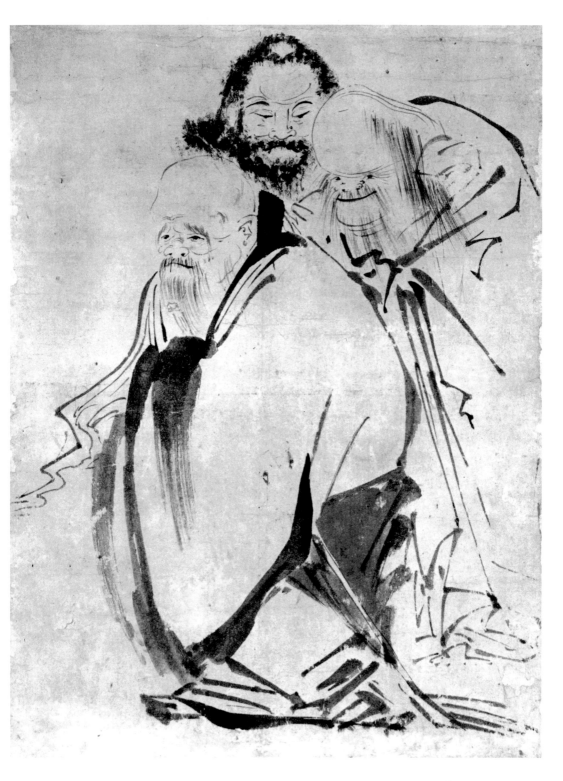

39. *The Three Doctrines,* attributed to Josetsu, early
15th century (detail)

Its meaning derives from 'the greatest skill is like clumsiness.' He painted *The Three Doctrines* in order to clarify the idea that [all three] are One...."

Although the identity of Kanjōsō, obviously a sobriquet, remains uncertain, there is no reason to doubt the authenticity of his colophon. However, it states that it was written on the same piece of paper as the painting itself, whereas they are now separated and rejoined. This is an as yet unsolved discrepancy, which is an important point in determining whether the painting is the original or perhaps a copy of a somewhat later date.

The painting, which remained unknown until its discovery in 1916 by the great scholar Ōmura Seigai, does not seem to date from a period later than the fifteenth century. Theoretically, it could have been painted between 1410 — when Zekkai Chūshin was given the post-humous name of Butchi Kōshō — and 1493, the date of Ryūtō's colophon.

Closely resembling the style of the more firmly established masterworks of Josetsu, *The Three Doctrines* is in every respect their equal as a work of art, and a prime source for the study of this great *suiboku* artist.

REFERENCES:
Kokka, no. 348; Watanabe Hajime, *Higashiyama Suibokuga no Kenkyū* (Tokyo, 1949), pp. 45-78; Nakamura Tanio, *Boku-e no Bi* (Tokyo, 1959), pl. 32.

40

WANG HSI-CHIH WRITING ON A FAN,
Attributed to Josetsu (active early 15th century)
Fan-shaped album leaf, mounted as a hanging scroll, ink and slight colors on paper with mica ground, 98.3 x 21.8 cm.
Agency for Cultural Affairs, Tokyo
Registered Important Cultural Property

This painting, attributed to Josetsu, would seem to be by the same hand as *The Three Doctrines* (cat. no. 39). Biographical details concerning the artist have been dealt with in that explanation.

Wang Hsi-chih Writing on a Fan, although painted by such famous Ch'an artists as Liang K'ai and Josetsu, is strictly speaking not a Zen theme. It illustrates an anecdote about the

40. *Wang Hsi-chih Writing on a Fan,* attributed to Josetsu, early 15th century

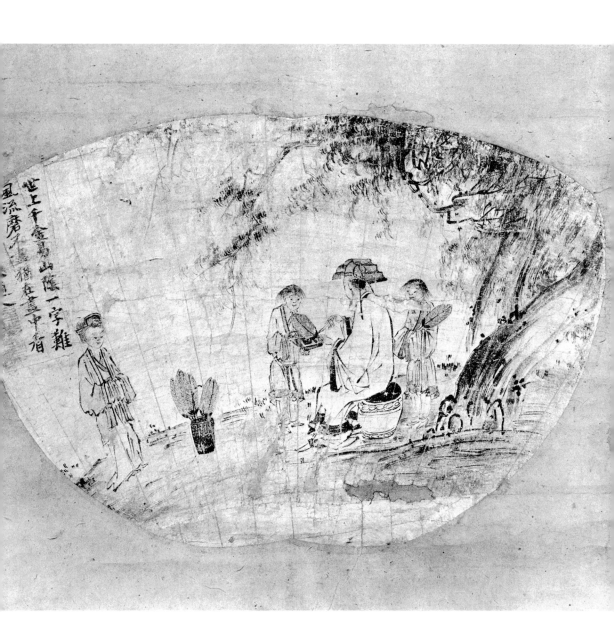

40. *Wang Hsi-chih Writing on a Fan,* attributed to
Josetsu, early 15th century

famous Chinese calligrapher Wang Hsi-chih (321-379). Once, when Wang saw a woman selling bamboo fans, he took them from her and wrote a five-character phrase on each one. The illiterate woman was angry because she thought that Wang had ruined her merchandise. Wang predicted that she would be able to sell all the fans for a good price because of the high market value of his calligraphy. When the woman promptly sold out her stock, she went to Wang and asked him to write phrases on more fans, but he merely laughed and did not respond to her request.

This humorous incident, which illustrates the true gentleman's lack of concern for financial gain, has been painted by Josetsu in a sensitive and delicate manner. Very appropriately, he chose the fan format to illustrate this anecdote. Each detail of the figures is meticulously painted with a fine, pointed brush. Wang Hsi-chih is shown seated on a garden seat under a tree. The tree trunk is painted in the manner of the Ma-Hsia school of the Southern Sung dynasty, but the branches of the tree have been sketchily indicated by closely spaced dabs from a dry brush. Wang is assisted by two child attendants, one of whom holds the ink stone. On the left, the woman is watching the proceedings with apprehension, her hands tucked away in her sleeves, a basket full of fans standing next to her.

Chinese painters may have illustrated this anecdote as early as the Five Dynasties period, (907-960) for there are literary references to a picture of this theme painted by Huang Ch'üan. By far the most famous version, however, was painted by Liang K'ai. It is one of the few paintings by Liang K'ai which has been handed down in Chinese collections. Once part of the Manchu Household Collection and inscribed by the Emperor Ch'ien-lung, it is now in the Ku-kung Museum in Peking. It may be incompletely preserved, for it does not show the woman, who plays an essential part in the story. Both Liang K'ai's and Josetsu's version show Wang Hsi-chih with the same unusual headgear, and in both pictures the calligrapher is assisted by two attendants. This suggests that Josetsu was not inspired merely by reading the anecdote, but that he actually saw some sort of Chinese prototype before he painted this picture.

On the left, written on a separate piece of paper, which has been pasted onto the fan, is a four-line verse by the monk Daigaku Shūsū (1345-1423):

In the world a fan can easily be sold for a thousand cash,
But in Shan-yin [where Wang lived] even one character in his handwriting is difficult to obtain.
His elegant distinction is ineradicable.
It is even visible in this painting.

Daigaku Shūsū was a priest who must have been closely connected with Josetsu. His colophon on the *Catching a Catfish With a Gourd* attributes that painting to Josetsu. Poems from his hand occur on several of the early fifteenth-century *shigajiku* landscapes.

The fan painting is now mounted together with a long inscription by the monk Ishō Tokugan of the Nanzenji, Kyōto (died 1437). He too, contributed a poem to the *Catching a Catfish With a Gourd*, and his handwriting also occurs on a *shigajiku* landscape (cat no. 46). His colophon for the fan painting bears a cyclical date corresponding to A.D. 1430. Tokugan states that the painting was done by Josetsu. In view of Tokugan's association with Josetsu, and the colophon's early date, this attribution carries considerable weight. According to Tokugan the monk Daigaku Shūsū, who owned the fan, was extremely fond of it. Later, presumably after his death in 1423, the fan came into the possession of the monk Shikyō, who was at that time in charge of the *sūtra* repository at the Jishōin. It was Shikyō who had the painting mounted as a *kakemono*.

Wang Hsi-chih Writing on a Fan was handed down in the Jishōin, a temple adjacent to the Shōkokuji, where Josetsu is supposed to have lived. The painting was completely unknown until about thirty-five years ago when it passed into the Moriya Collection.

REFERENCES:
Watanabe Hajime, *Higashiyama Suibokuga no Kenkyū* (Tokyo, 1948), pp. 45-78; Institute of Art Research, Tokyo, *Ryōkai* [Liang K'ai] (Kyoto, 1957), fig. 1; Tanaka Ichimatsu and Yonezawa Yoshiho, *Suibokuga*, Genshoku Nihon no Bijutsu, vol. 11 (Tokyo, 1970), pl. 34.

41

ORCHID, BAMBOO, AND ROCK
Gyokuen Bompō (1349–post-1420)
Hanging scroll, ink on paper, 90.2 x 35.6 cm.
Collection of Fujioka Kaoru, Kyoto

The Chinese orchid has thin, elegant leaves, and its small flowers spread an exquisite fragrance. Originally this flower was associated with modesty and nobility of character, but after the fall of the Sung dynasty this nobility acquired definite political overtones. The painter Chêng Ssǔ-hsiao associated the orchid with loyalty to the *ancien régime* of the Sung and refusal to enter the service of the conquerors, the Mongols. He consistently painted the orchids without portraying the earth from which they grew because, as he claimed, "the conquerors had stolen the land." The orchid thus became the symbol of the ancient Chinese virtue of loyalty to the lost cause of a legitimate but ousted sovereign. During the Yüan period this specific political connotation seems to have gradually faded, and the orchid became an extremely popular theme among the Chinese literati, transcending political differences between those opposed to and those in the service of the Mongols.

The Ch'an monk Hsüeh-ch'uang P'u-ming (died after 1349) was the most popular artist of this theme, and it was said that there were orchids by his hand in every household in Soochow. But Hsia Wên-yen, author of the biographical work on painters *T'u-hui pao-chien* (1365), characterized his paintings as "good only for display in monk's quarters." In the *Kūge Nikkoshū*, the diary of Gidō Shūshin (1325-1388), it is mentioned in passing that Hsüeh-ch'uang had two Japanese pupils, Kō Sekkō and Hō Chōun. There are no known extant works that can be attributed with certainty to these artists, however. Another Japanese artist who specialized in orchid paintings was Tesshū Tokusai (died 1366). It is known that he visited China, and it is possible that he studied with Hsüeh-ch'uang, although there is no evidence for this.

The dates of Gyokuen Bompō, whose *Orchid, Bamboo, and Rock* is shown here, are unknown. An entry in Zuikei Shūhō's diary in 1449 mentions that he chanced upon a document written by Bompō. The document, which is reproduced in the diary, was dated in accordance with 1420 and gave the artist's age as seventy-three. This is the only available source for Bompō's dates. A few facts about his life and career can be established with the help of Gidō Shūshin's diary, in which Bompō is mentioned many times. The earliest reference to him is in 1370. At that time Bompō was a monk at the Tōshōji, a small monastery of the Zen sect at Kamakura. In 1381 Gidō went to Kyoto, and as he refers to Bompō throughout his diary, it may be surmised that the artist also visited the capital.

In view of Bompō's long period of residence in Kamakura, it seems justified to include him among the group of artists associated with this city. Literary references link Bompō with ecclesiastical ranks of increasing importance, and it is known that he served in later years as an abbot of the Nanzenji and that he instructed Ashikaga Yoshimochi in the tenets of Zen. An indication of his importance as a poet is that his signature and poetry appear in a prominent position on many of the most important *shigajiku* landscapes (see cat. no. 46). For example, his name and verse appear on the *Catching a Catfish with a Gourd* by Josetsu (see cat. no. 39) and on the *Studio of the Three Worthy Friends* (see cat. no. 46).

It is not known from whom Bompō learned the technique of orchid painting. The possibility that he modeled his style after Hsüeh-ch'uang, whose paintings had been brought to Japan, should not be excluded. But, whereas Hsüeh-ch'uang's style of painting is strong and powerful, Bompō's orchids have an almost effeminate elegance, much more in keeping with the original connotation of this plant. Several of his paintings of a somewhat similar style and composition have been preserved. The painting in the Asano Collection is especially close to this piece in style and composition.

Damage to the painting has rendered the poem inscribed below by the artist almost unintelligible. It is amusing, in this connection, to note this comment on Bompō made by Gidō Shūshin in his diary in 1370: "His old-style verse is abstruse and rough; he uses many strange characters, which makes his poems frequently undecipherable."

REFERENCES:
Kumagai Nobuo, "Gyokuen Bompō-den" (a biography of Gyokuen Bompō; in Japanese), *Bijutsu Kenkyu*, no. 15; Chu-tsing Li, "The Oberlin *Orchid* and the Problem of P'u-ming,"

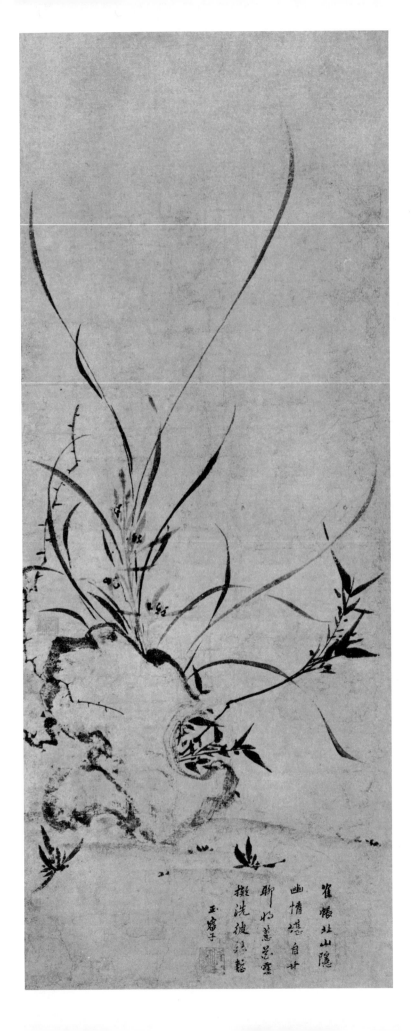

Archives of the Chinese Art Society of America 16 (1962), pp. 49-76; *Sekai Meiga Zenshū*, vol. 20 (Tokyo, 1961), fig. 7 (Asano collection); Yashiro Yukio, *Art Treasures of Japan* (Tokyo, 1960), II, pl. 346; *Kokka*, nos. 690, 768, 634 (other works by Bompō).

42

Portrait of Daidō Ichii (1292 ?-1370)
Attributed to Kichizan Minchō (1350-1431);
colophon by Shōkai Reiken (1315-1396),
dated in accordance with 1394
Hanging scroll, ink on paper, 48.2 x 16.5 cm.
Nara National Museum
Registered Important Cultural Property

Daidō Ichii (Daidō Shingi, 1292 ?-1370) was one of the most respected prelates of the fourteenth century and was renowned for his diligent advocacy of Zen teachings. He was a native of Awaji Island where he spent his early years at the Ankokuji. He studied under Kokan Shiren (see cat. no. 31) and is associated chiefly with the Tōfukuji (see cat. no. 59) where he became the twenty-eighth abbot. Daidō is depicted here as an elderly man sitting peacefully on a boulder atop a stone platform with his staff across his lap. His expression is benign and reassuring. His posture is relaxed which is a departure from the convention of formality in the usual *chinsō* portraits. Everything about his appearance is carefully calculated to engender a sense of trust and intimacy and to make him seem approachable — an objective this painting shares with the *chinsō* portrait of Ikkyū Sōjun (cat. no. 51). The stone steps leading up to the platform are flanked by two spirited creatures, a deer and a goose, who face the aged priest and seem about to ascend the steps. The Buddhist belief in the fundamental importance and unity of all sentient life — a tenet particularly revered in Zen — is expressed here with great artistic insight. There can be no doubt that the concern for all life that permeated Zen thinking provided the basic inspiration for the landscapes and representations of animals, birds, and flowers which are so ubiquitous in Zen art and that it was the cause of the preoccupation with nature in Zen literature (see cat. nos. 30, 52).

Facing page:
41. *Orchid, Bamboo, and Rock* by Gyokuen Bompō (1349-post-1420)

The colophon was written by Shōkai Reiken (1315-1396) (see cat. no. 43) who undoubtedly had known Daidō as both men were ecclesiastical dignitaries at the Tōfukuji. It bears a date of 1394, some twenty-four years after Daidō's death, which indicates that the work is a posthumous representation. It is one of the finest extant examples of Shōkai's calligraphy.

A platform of large and small rocks with a "Diamond Throne"
Heaven and earth, composed alike of only one body
The realms of causality and emotion transcended
The enlightened deer and goose, unfaltering in their trust.
Daidō, the Great Reverend Shingi.
Requested by the Governor of Tanshū, Myōji [Myōchi?]-koji.
1394, early summer [fourth month?], last ten-day period.
Taiko-zuda, age eighty.

To the left of the colophon are three seals which read (top to bottom): "Fukanshi, Reiken, Shōkai." The "Diamond Throne" refers to the Vajrāsana or Bodhimanda, the seat where the Buddha attained Enlightenment; and the "one body" to the universal Buddha-nature. The Governor of Tanshū (Awaji Island in the Inland Sea) is Mitsuharu, the son of Hosokawa Ujiharu (died 1387), who was a disciple of Daidō's and died in 1399.

There is no artist's signature or seal on the painting, but historical evidence and stylistic considerations strongly indicate that it was executed by Kichizan Minchō, the best-known master of the group of artists who flourished at the Tōfukuji during the Muromachi period. Minchō's extant works show that he combined traditional, orthodox forms of polychrome Buddhist painting with the new ink-monochrome techniques that had recently been introduced from China. An ink sketch by Minchō of Shōichi Kokushi, the founder of the Tōfukuji, corresponds very closely in style to the portrait of Daidō; the foliage, rock forms, robes, and countenance are so intimately related that there can be little question about the identity of the artist of the Daidō portrait. The brushwork and certain details in the *Kei-in Shochiku-zu* ("A Studio Facing North by a Stream"), the National Treasure ink-monochrome landscape attributed to Minchō, further justify the attribution of the

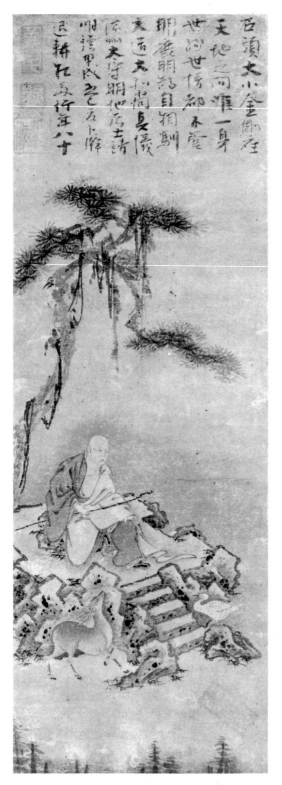

Daidō portrait. Minchō is known to have been a follower of Daidō's and to have respected him with that intensity characteristic of the Zen master-disciple compact. A traditional anecdote tells how Daidō, irritated with Minchō's compulsive preoccupation with painting and disinterest in religious matters, threatened to sever their relationship. Minchō, taken aback by his teacher's attitude, likened his own situation to a discarded "broken straw sandal" (hasōai) with no function, and took this name as one of his painter's sobriquets. According to the story, Daidō finally recognized Minchō's great talent and relented. Minchō was born on Awaji Island where he became a student of Daidō at the Ankokuji, and the fact that the painting is dedicated to the Governor of Awaji, who was also a devout follower of Daidō, adds an interesting historical connection.

Stylistically, the painting demonstrates Minchō's position as a transitional figure between the older, orthodox, iconographically oriented forms of Buddhist art and the new compositional canons and techniques of brushwork which had been recently introduced from China. His preoccupation with crisp, well-defined outline and careful rendition of details is a debt to the past, while his ability to juxtapose areas of monochrome value contrast, as in the superb treatment of the deer and the goose, shows his mastery of one of the new features. The seal in the lower right corner reads, "Komyōin." It may be the name of a sub-temple in the Tōfukuji or of a temple in Bizen province where Daidō resided as a youth.

REFERENCES:

Taki Seiichi, "Minchō-hitsu no Daidō Shingi ni Tsuite" [On the painting of Daidō Shingi by Minchō], Kokka, no. 554; Matsushita Takaaki, Suibokuga, Nihon no Bijutsu, vol. 13 (Tokyo, 1967), pls. 44, 45 (ink sketch of Shōichi Kokushi); Tanaka Ichimatsu and Yonezawa Yoshiho, Suibokuga, Genshoku Nihon no Bijutsu, vol. 11 (Tokyo, 1970), nos. 21, 26 (Konchiin landscape); Kyoto National Museum, Muromachi-jidai Bijutsuten Zuroku [Illustrated catalogue of the exhibition of arts of the Muromachi period] (Kyoto, 1967), no. 30; Tanaka Ichimatsu, Shūbun kara Sesshū e, Nihon no Bijutsu, vol. 12 (Tokyo, 1969).

42. *Portrait of Daidō Ichii,* attributed to Kichizan Minchō (1350-1431)

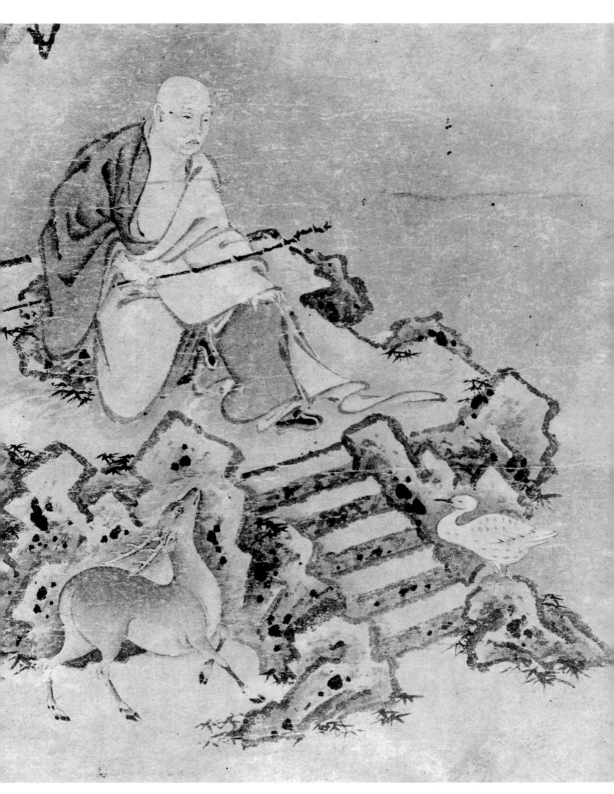

42. *Portrait of Daidō Ichii* (detail)

43

Ippitsu Daruma ("One-stroke" Bodhidharma)
Painting (?) and colophon by Shōkai Reiken
(1315-1396)
Hanging scroll, ink on paper, 65.7 x 32.6 cm.
Umezawa Kinenkan Collection, Tokyo

Shōkai Reiken (1315-1396) was born in the
mountainous Shinshū district in central Japan.
As a youth he studied under Seisetsu Seichō (see
cat. no. 27) at the Kenninji in Kyoto, but he later
became a devoted follower of Kokan Shiren (see
cat. no. 31) whose teachings seem to have had a
strong influence on his thinking. Like Shiren,
he was an industrious student of Chinese litera-
ture and is regarded as an important figure in
the Gozan literary movement. He made the
arduous pilgrimage to the continent in 1343;
he became so engrossed in his religious and
literary activities there that he did not return
to Japan until seven years later. Shiren died
during this period, but he is reputed to have
said in his last instructions that Reiken would
probably become one of the great pillars of the
Doctrine in the future. This statement was pro-
phetic, for the second and third Ashikaga shō-
guns, Yoshiakira (1330-1368) and Yoshimitsu
(1358-1408), became Reiken's devout supporters,
and he served as the head of three of the most
influential Zen institutions in the country, the
great Kyoto monasteries, the Tōfukuji, Ten-
ryūji, and Nanzenji. When he was seventy,
Reiken retired to the Taikō-an, a "hermitage"
sub-temple in the Tōfukuji. The colophon on
this painting was written there when Reiken
was eighty.

My bed is cold when I'm asleep at night
Mulberry-paper cassock, paper mosquito curtain
Following the Dharma, acting as circumstances
 demand
With my hemp-palm chowry, and goosefoot
 staff.

The colophon is signed: "Taikō, age eighty."
To its left are three seals, which read (top to
bottom): "Reiken, Shōkai, Taikō-zuda." The
colophon evokes a vivid image of the austere
life of the Zen monk—a frugal, rigorous exist-
ence in which the common man's comforts were
spurned. The inscription refers to a monk's
cassock made of paper from the bark of the *kōzo*,
a type of mulberry tree. This was a rough,

uncomfortable garment, cold in the winter and
oppressively hot in the summer, whose only
redeeming feature was its cheapness. The paper
mosquito curtain was also inexpensive but was
a somewhat ineffectual substitute for the
standard cloth net. The chowrie, a whisk-like
device usually made of long animal hairs and
designed to keep away insects during medita-
tion, is here fashioned from an appropriately
coarse material, a frayed section of a hemp-
palm. A rude stalk from a goosefoot plant has
been pressed into service as a staff.

There is a direct, systematic quality about
Shōkai's calligraphy. The characters are written
in a consistent, "semi-cursive" style, each one
executed separately in a deliberate, schematized
manner devoid of superfluities. Comparable
qualities are present in the Bodhidharma figure,
which is consequently thought to also be from
Shōkai's hand, and may be intended as a self-
portrait. The dour, bearded countenance which
is rendered with thin, precise lines, stares out
directly at the observer. The cassock is ingen-
iously conceived. It is simplified and schema-
tized to a point of remarkable artistic economy;
yet due to variations in the single, continuous
brushstroke—changes in width, contour,
momentum, and accent—there is paradoxically
a sense of implied volume in the robe and a
feeling of Bodhidharma's presence beneath it.
The robe's concentric quality has inspired the
popular Japanese name for this work, *Guru-
Guru Daruma* ("Round-and-Round
Bodhidharma").

It is difficult to know whether the *"One
Stroke" Bodhidharma* has a prototype or
whether it is simply the isolated product of a
fertile mind. There is frequent mention in Zen
literature of the drawing of circles as symbols
of the nature of the enlightened consciousness,
a practice associated with the early Wei-yang
branch of Ch'an. The priest Yang-shan is said to
have achieved sudden enlightenment through
"the use of circular figures." The practice, which
seems to have developed from Hua-yen
teachings, became codified in the Wei-yang
branch of Ch'an into a set of ninety-seven
circular figures, which were somehow identified
with six generations of patriarchs. The practice
was opposed by other branches of Ch'an and
declined when the Wei-yang sect was absorbed
into the Lin-chi (Rinzai) branch. The round
format that often is used in later Zen art forms
(see, for example, cat. no. 49) may, perhaps,

Facing page:
43. *Ippitsu Daruma* by Shōkai Reiken (?) (1315-1396)

represent the residual influence of the concept of "circular figures."

REFERENCES:
Matsushita Takaaki, *Muromachi Suibokuga* (Tokyo, 1962), I, pl. 13; Umezawa Kinenkan, Tokyo [*Catalogue of special spring exhibition*] (1969), pl. 25; Tayama Hōnan, *Zoku Zenrin Bokuseki* (Tokyo, 1965), no. 241; Heinrich Dumoulin, *A History of Zen Buddhism* (New York, 1963), pp. 107-108 (references to circles, "circular figures," etc.); idem, *The Development of Chinese Zen after the Sixth Patriarch*, trans. and ed. by R. F. Sasaki (New York, 1953), pp. 19-20, 26-28, 68, 69, 70.

44

KANZAN
Reisai (active middle of the 15th century)
Hanging scroll, ink on paper, 83.5 x 35.5 cm.
Daitōkyū Kinen Bunko, Tokyo

Although Reisai was one of Minchō's most gifted pupils, his identity remained obscure until recent times. His work was often confounded with that of his teacher, and the *Honchō Gashi* (compiled ca. 1675) considered his name to be merely a sobriquet for Minchō. Almost nothing is known about his life, and only a few firmly established works by his hand have survived. These include a *Death of the Buddha* painted in 1435. Tanaka Ichimatsu has recently discovered documentary evidence that Reisai visited Korea in 1463, on which occasion he presented a painting of the White-Robed Kannon to King Sejo (reigned 1455-1468) of the Yi dynasty.

This picture of Kanzan (Han-shan) bears Reisai's signature; it is written through a motto seal which reads: "Plant one's feet on solid ground." Reisai has placed Kanzan in the center with a towering cliff on one side, following a standard compositional formula of his time. In spite of the conventional composition, he succeeded in creating a highly original and lively portrait of the famous recluse. He rendered the penetrating chill of the windswept "Cold Cliff" with great virtuosity, evoking the spirit of the poetry which gave birth to the legends of its elusive poet.

REFERENCES:
Bijutsu Kenkyu, no. 87; Watanabe Hajime, *Higashiyama Suibokuga no Kenkyū* (Tokyo, 1949), pp. 237-255; Yukio Yashiro, *Art Treasures of Japan* (Tokyo, 1960), II, pl. 347; Tanaka Ichimatsu, *Shūbun kara Sesshū e* (Tokyo, 1969), p. 59.

45

OX AND HERDSMAN
Sekkyakushi (active early 15th century)
Hanging scroll, ink on paper, 54.8 x 29.6 cm.
Collection of Nakamura Tanio, Tokyo

One of the numerous followers of the great painter Minchō (1352-1431) was an artist who used a seal reading, "Sekkyakushi." Traditional connoisseurs have long mistaken this seal for one of Minchō's own or for one belonging to his well-known pupil Reisai (see cat. no. 44). Several paintings representing monkeys, a *Buddha Attaining Supreme Enlightenment,* and a *White-Robed Kannon* bear the seal of this artist who may have been a monk of the Tōfukuji, Kyoto, but about whose life nothing is certainly known.

In a simple, slightly rough, and unassuming manner, the artist has painted the well-known Zen theme of the ox and its herdsman. Although it is slightly larger in size, this painting is sometimes believed to form a pair with a similar picture representing a man catching an ox, which was discovered about ten years ago. Recently, however, Yonezawa has rejected this idea. If the two paintings belong together, they may well represent the fourth and fifth of the Ten Ox-Herding Stages (see cat. no. 49), the *Catching of the Ox* and the *Herding of the Ox,* respectively.

REFERENCES:
Kokka, no. 58, p. 187; Nakamura Tanio, *Boku-e no Bi* (Tokyo, 1959), pl. 42; Tanaka Ichimatsu *Shūbun kara Sesshū e* (Tokyo, 1969), fig. 37; *Kokka,* no. 802 (description by Yonezawa Yoshiho); *Nihon Bijutsu Kōgei,* no. 379, pp. 98-99.

Facing page:
44. *Kanzan* by Reisai, mid-15th century

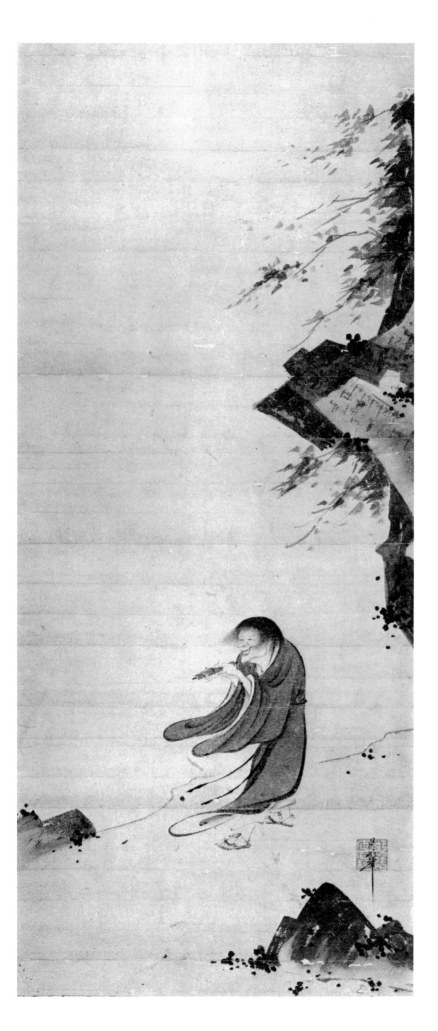

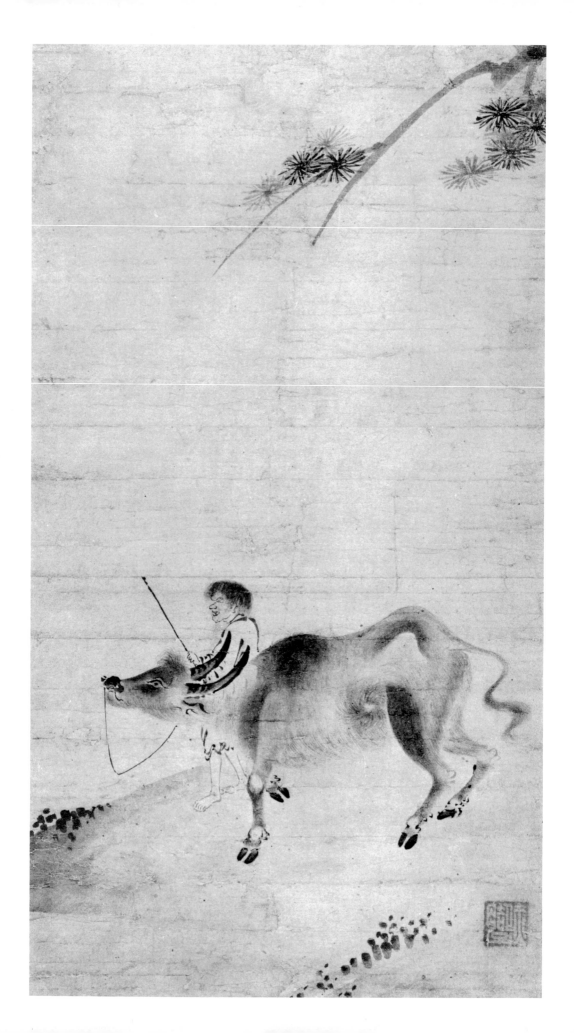

46

LANDSCAPE
Traditionally attributed to Shūbun (active
second quarter of the 15th century)
Hanging scroll, ink on paper, 88.4 x 26.1 cm.
Jishōin, Kyoto

The beginning of the fifteenth century saw the
development of a type of landscape painting
in Japan, which, although obviously indebted
to the styles and techniques of the landscapists
of the Sung and Yüan periods, created a new
poetic atmosphere of seclusion that was expres-
sive of Zen ideals and taste in a typically
Japanese way. Paintings of this type are some-
times called *shosaiga*, ("paintings of [for?] the
study"), probably because a scholar's or Zen
priest's study, hut, or hermitage is shown in
them.

Often the actual picture occupies only the
lower third of the scroll. The remaining space
generally is taken up by many poetic inscrip-
tions. These are usually written by Zen priests
and refer to the theme of the painting. As the
poems and comments were considered equally
important as the painting itself, the genre came
to be known as *shigajiku* ("poetry-painting
hanging scroll").

Among the earliest paintings of this type are
such famous masterpieces as *New Moon Over
the Brushwood Gate* (now in the Fujita Museum,
Osaka), which dates from 1405 and is tradi-
tionally attributed to Josetsu, and *A Studio
Facing North by a Stream* (now in the Konchiin,
Kyoto), which dates from 1413 and is provision-
ally attributed to Minchō. Many of the *shigajiku*
from the first half of the fifteenth century have
been traditionally attributed to Shūbun, the
great monk-landscapist of the Shōkokuji. The
names of many Zen priests appear on these
paintings. When the dates of these men can be
determined, it becomes possible to establish
reliable *termini ad quem* for many of the
paintings.

The landscape shown here carries only a
single poetic inscription. It is by the priest
Tokugan, the author of a colophon on Josetsu's
Wang Hsi-chih Writing on a Fan (cat. no. 40), a
painting which was once part of the collection
of the Jishōin where this landscape is pre-
served. The poem may be tentatively translated
as follows:

Facing page:
45. *Ox and Herdsman* by Sekkyakushi (active early
15th century)

46. *Landscape*, attributed to Shūbun (active second
quarter of 15th century)

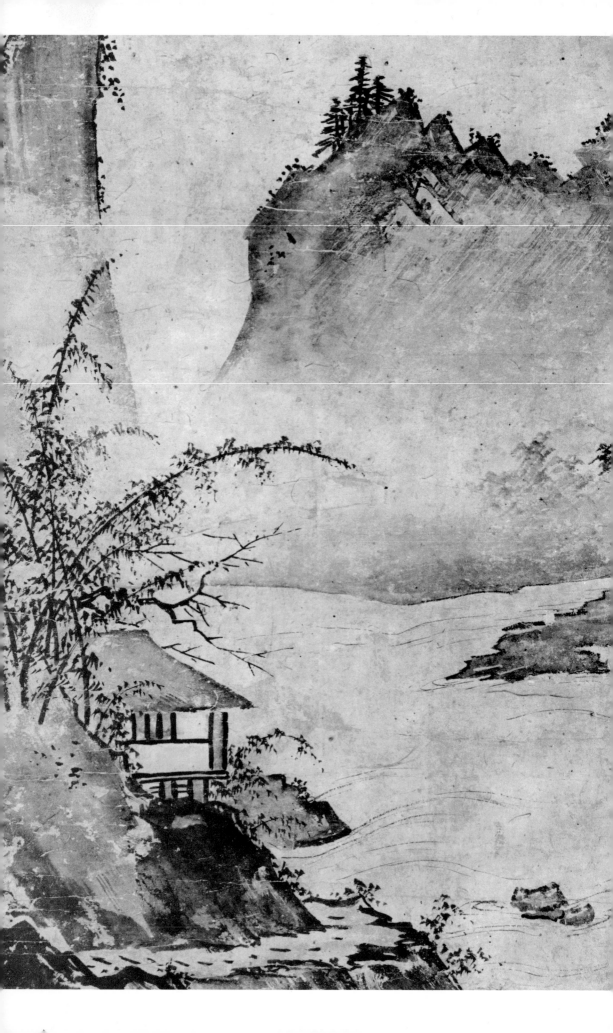

The sheer precipice is covered with verdant
 green; it dominates the rocks on both sides.
The winding balustrade contains the sea; it is
 as if we were looking down upon a lake.
The white seagulls have flown away, far over
 the vast expanse of water.
The plum tree covering the eaves with its
 branches has yet to blossom.

The poem is signed: "the old cassock from
Shōsetsu, Tokugan." The description of the
landscape in the poem seems to accord with the
principal features of the painting: the mountains
in the background, the house with its balcony
on the shore, and the bare branches of the plum
tree. These elements have been combined into
a composition which, like many other works
attributed to Shūbun, shows the strong in-
fluence of the Ma-Hsia School.

The mountains, which block the horizon, take
away the vista which is the hallmark of
Shūbun's other landscapes. There is a lack of
clear structural definition both in the mountains
and the rocks, which have been filled with
rather uninspired textural strokes and washes.
A similar manner of painting can be observed
in the so-called Pavilion of The Three Worthy
Friends (San'ekisai) in the Seikadō Foundation
in Tokyo, a painting whose attribution to
Shūbun is no longer considered certain. The
San'ekisai is dated in accordance with 1418.
Tokugan, the author of the colophon on the
Jishō-in landscape, is known to have died in
1437, a date which seems rather early for the
style of this painting. Tanaka Ichimatsu, how-
ever, is willing to accept an even earlier date.
He tentatively attributes the painting to Shūbun
and suggests that it may have been painted even
before Shūbun went to Korea in 1423.

REFERENCES:
Tanaka Ichimatsu, Shūbun kara Sesshū e, Nihon
no Bijutsu, vol. 12 (Tokyo, 1969), p. 92 (for dis-
cussion of date), fig. 61; Tanaka Ichimatsu and
Yonezawa Yoshiho, Suibokuga, Genshoku Nihon
no Bijutsu, vol. 11 (Tokyo, 1970), fig. 61.

47

THE TEN-THOUSAND-MILE BRIDGE
School of Shūbun (active second quarter of the
15th century); colophon by Kyūen Ryūchin,
dated in accordance with 1467

Facing page:
46. Landscape, attributed to Shūbun (active second
quarter of 15th century) (detail)

Hanging scroll, ink and light colors on silk,
150 x 36 cm.
Seikadō Foundation, Tokyo

Tenshō Shūbun was a priest of the Shōkokuji in
Kyoto, the monastery where such talented in-
dividuals as the poet Zekkai Chūshin (see cat.
no. 38) and the painter Josetsu (see cat. nos. 39
and 40) had lived. It is generally thought that
Shūbun received his instruction in the art of
painting from Josetsu, although evidence
documenting this claim is lacking. In 1423 and
1424, Shūbun took part in a diplomatic mission
to Korea. This voyage and the opportunity it
gave him to become acquainted with the works
of Korean painters probably had a more decisive
importance for his subsequent career as a land-
scape painter than his lessons from Josetsu.
Documentary evidence makes it possible to
trace the career of Shūbun up to 1443. There is
no chronological reference to him after that year,
and the date of his death is unknown. Several
landscapes traditionally attributed to his hand
date from a considerably later time. The works
associated with his hand display a considerable
variety of styles and it has not yet been possible
to establish with confidence which of these were
executed by the famous master himself.

The Ten-Thousand-Mile Bridge is the latest in
date of all the landscapes attributed to Shūbun.
Because of the dated colophon, it has been
assigned to a specific year, 1467. Even though
the date of Shūbun's death has not been firmly
established, however, it is rather unlikely that
he was still alive in 1467. There is good reason,
therefore, to question the original attribution.

The landscape paintings of this period by
Shūbun and his circle of followers were gen-
erally intended to represent Chinese land-
scapes. They were "studio landscapes," made
up of standard components, most of which
ultimately derived from Chinese prototypes.
The texture of rocks and mountains, the types
of trees, and the attempts, with varying suc-
cess, at atmospheric perspective—all had their
origin in Chinese painting of the Sung and
Yüan periods. The Japanese painters gave these
landscapes their own Japanese atmosphere,
and only rarely do these "Chinese" studio land-
scapes represent specific places or views in
China. The Ten-Thousand-Mile Bridge, however,
is an exception in that it represents an effort to
depict a spot in China that the artist himself,
in all likelihood, had never seen.

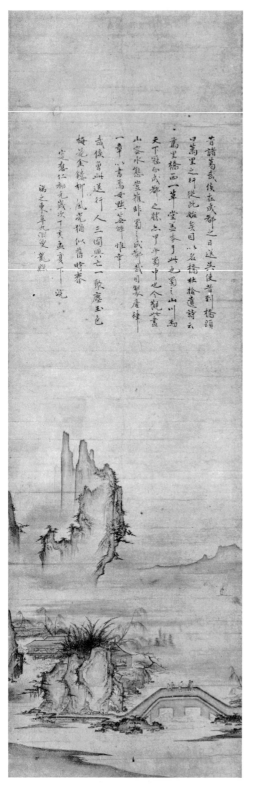

The inscription above the painting explains in detail the historical background of the theme and its connection with the hero of the period of the Three Kingdoms, Chu-ko Liang (181-234). It extols the beauty of this historic landmark:

One day, long ago, when Chu-ko (Liang), Marquis of Wu, was in Ch'êng-tu to see off the emissary of Wu, he said when they reached the bridge, "A ten-thousand-mile journey starts here." That is why the bridge was given this name. A poem by Tu Fu says, "A grass hut stands west of the Ten-Thousand Mile Bridge," and I think that this refers to the same bridge. The mountains and rivers of Shu (i.e., Szechwan) are the finest under heaven, and Ch'êng-tu is the paramount [city] in Shu. Today, on seeing this painting, the shapes of the mountains, and the aspect of the water, [I exclaim,] How could it be anything else but Ch'êng-tu!

Therefore, I composed this stanza of Chinese verse and inscribed it on the painting. If you do not look askance at these words, I will consider it fortunate:

Once the Marquis of Wu came here to see off a traveler.
Of the rise and fall of the Three Kingdoms all that remains is dust.
The jade-colored plum blossoms and the weeping willow like chased gold —
The scene looks just as it did that spring day long ago.

The inscription is signed "Kyūensō Ryūchin" and dated in accordance with 1467.

In 1456 Kyūen became a priest of the Kenninji in Kyoto. During the last years of his life, he made it his daily task to paint a picture of Kannon, with the result that more than 1700 of such pictures had accumulated by the time of his death in 1474. Strangely enough, not one of these paintings seems to have survived. In this colophon, Ryūchin displays his knowledge of Chinese literature. That knowledge, however, was not without its flaws: in fact, Chu-ko Liang accompanies an emissary of Shu, not of Wu. Chu-ko Liang's posthumous title of Marquis of Wu must have led Ryūchin astray.

The most unusual feature of this landscape is the prominent Ten-Thousand-Mile Bridge, made of brick. It is of an awkward, angular shape that can hardly have been based on actual bridge architecture. The structure of the rocks where

47. *The Ten-Thousand-Mile Bridge,* attributed to Shūbun (active second quarter of 15th century)

the bridge meets the shore is curiously repetitive. A bamboo thicket surmounts them. The two houses partially hidden behind the rocks are surrounded by the weeping willows and plum trees referred to in the poem. There is an unusual amount of minute brushwork, even in the treatment of distant objects; the texture strokes of the rocks fail to give them the weight and volume of those in paintings considered to be by the hand of Shūbun. These features would seem to place this landscape outside the main corpus of works generally associated with the master himself and, more feasibly, among those attributed to pupils of his school.

REFERENCES:
Kokka, no. 298; *Bijutsu Kenkyu,* no. 89, p. 183; Watanabe Hajime, *Higashiyama Suibokuga no Kenkyū* (Tokyo, 1948), pp. 90-199.

48

KANZAN AND JITTOKU
Traditionally attributed to Shūbun (active second quarter of the 15th century)
Hanging scroll, ink on paper, 100.4 x 37.6 cm.
Tokyo National Museum
Registered Important Cultural Property

The majority of paintings traditionally attributed to the Zen priest Shūbun (see also cat. no. 47) are landscapes. It was in this genre that this great *suiboku* artist made his most significant contribution to Japanese painting. Of the few figure paintings associated with his name, the most reliable examples reveal a more linear, calligraphic technique than this rendering of Kanzan and Jittoku. The artist has dispensed with outlines, shaping the long-sleeved coats of the figures with bold sweeps and dabs of a wet brush. The hands, feet, and faces have been drawn in fine, sensitive lines, whereas the broom and the hair have been executed in rapid, dry strokes. This technique reveals no close affinity with that in Shūbun's landscape paintings. The traditional attribution to Shūbun should therefore be regarded with caution.

Here the artist has succeeded in recapturing with great skill the spirit of the early legends about these gentle eccentrics and has created one of the most personal interpretations of this theme in Japanese art. Kanzan and Jittoku stand together with their hands clasped, their

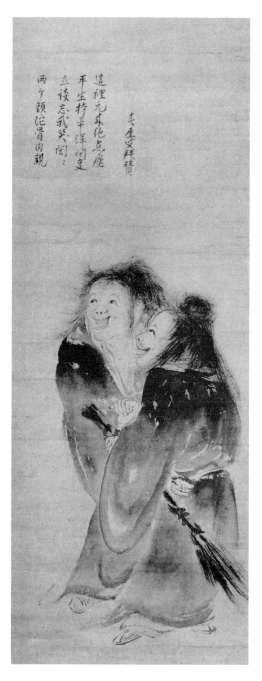

48. *Kanzan and Jittoku,* attributed to Shūbun (active second quarter of 15th century)

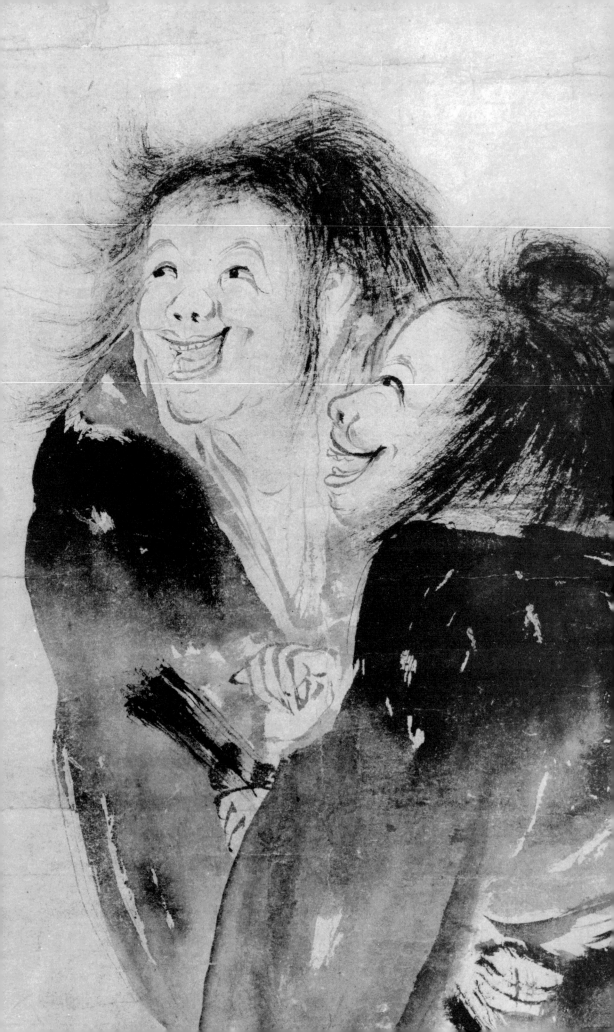

faces expressing the friendly unworldliness that endeared them to the adepts of Zen Buddhism.

Above the painting is a poem which reads, from left to right:

The two recluses are of the same bone and flesh,
They stand talking, oblivious of themselves and
 amiably laughing.
Their entire life they wield the broom to
 muddle up useless things
Where, in the beginning, there was not even
 a speck of dust.
> The old man Shun'oku reverently
> wrote this eulogy.

The priest Shun'oku lived from 1529 to 1611. As he calls himself an "old man," his colophon must date from the end of the sixteenth or the early seventeenth century. The painting, though perhaps not by Shūbun, would seem to be of approximately his period. It appears, therefore, that the poem was added considerably later than the time at which the painting was produced.

REFERENCES:
Kokka, no. 17, p. 106; *Shimbi Taikan*, vol. 10 (Kyoto, 1903), pl. 16; *Tōyō Bijutsu Taikan*, vol. 3 (Tokyo, 1923).

49

THE TEN OXHERDING PICTURES
Traditionally attributed to Shūbun (active second quarter of the 15th century)
Ten round paintings mounted in one handscroll, 32.8 x 186.7 cm.
Shōkokuji, Kyoto

The Ch'an, unlike many other Buddhist sects, did not consider Enlightenment the final result of a gradual development whose every phase could be analyzed and differentiated. Rather, Enlightenment was viewed as an instantaneous revelation not preceded by preliminary stages in which the Truth was revealed step by step. According to Sung accounts, the ancient masters of the T'ang period achieved Enlightenment with a minimum of guidance. In later times, however, when the study of *kōan* had become a standard method of re-creating the circumstances for attaining that ineffable experience, it gradually became evident that there are recognizable degrees in man's ability to grasp the essence of Ch'an truth. In addition, the Ch'an

adepts realized that there are definite degrees of Enlightenment itself, and that the final, absolute awakening is preceded by preliminary stages.

In guiding their pupils, Ch'an masters relied on parables, examples, and symbols. One way of facilitating the process of "seeing into one's own nature to become a Buddha" was by studying a tenfold parable known as *The Ten Oxherding Songs* that explained, allegorically, the different possible degrees of understanding of the Ch'an doctrine. The Ch'an monk- and lay-authors who set down the parable in written form found a precedent in the doctrine of The Five Ranks developed by Tung-shan Liang-chieh (807-869). This philosophical system was symbolically represented by circles with segments ranging from black to pure white. In commentaries, the dialectics of The Five Ranks were expressed in terms of lords and vassals. Although The Five Ranks and *The Ten Oxherding Songs* are not related philosophically, their use of parables and of abstract symbols in black and white are very similar.

In choosing the ox and its herdsman for their parables, the authors of the *Ten Oxherding Songs* followed an ancient Buddhist tradition which can be traced back all the way to India. A Hīnayana *sūtra* on the Herding of Cattle describes eleven ways of tending cows and compares these with the different duties of a Buddhist monk. In Tibet, where the word *glan* can mean both cow and elephant, representations of the mahout and his mount elaborately illustrate a tenfold allegorical story of a comparable genre by Blo-bzan don-yod (16th-17th century).

The "Recorded Sayings" of the great Ch'an masters abound with references to cows and oxen. The *kōan* of Po-chuang Huai-hai (720-814) is well known. It likens the search for Buddhahood to the paradox of looking for an ox while riding on it, and the attainment of this goal to riding home on it. This *kōan* and similar stories must have provided the inspiration for the *Ten Oxherding Songs*.

The earliest of these songs were written in China during the middle of the eleventh century, and the vogue for composing them lasted more than a hundred years. At least a dozen sets of Oxherding Songs seem to have been written. The woodblock prints that illustrated the books in which the songs initially were printed served as a source of inspiration for artists in other media. The songs by the Northern Sung official Yang Chieh, an amateur painter of the "untram-

Facing page:
48. *Kanzan and Jittoku*, traditionally attributed to Shūbun (active second quarter of 15th century)

2 1

4 3

6 5

49. *The Ten Oxherding Pictures,* traditionally attributed
to Shūbun (active second quarter of 15th century),
stages 1-6

8

7

9

49. *The Ten Oxherding Pictures*, traditionally attributed
to Shūbun (active second quarter of 15th century),
stages 7-10

melled" class, provided the inspiration for a huge representation of the parable carved from the living rock at Mount Pao-ting in Szechwan. This is, in all probability, the only Ch'an stone sculpture on a monumental scale.

The earliest songs, which were written by Ch'ing-chu (ca. 1050), have been incompletely preserved. However, there is a complete set composed by the Ch'an master P'u-ming—not to be confused with the monk-painter Hsüeh-chuang who had the same sobriquet—which is almost contemporary with that of Ch'ing-chu. One of the interesting features of P'u-ming's set is that the ox's color changes gradually through the ten stages from pitch-black to snow-white. This feature obviously was borrowed from The Five Ranks.

Of the several sets of Chinese illustrations of the theme, only two seem to have gained wide-spread popularity. In China, the version of P'u-ming was the most popular and continued to be reprinted for several centuries after his death. In Japan, on the other hand, it was the version written and illustrated by Kuo-an (ca. 1150) that was especially admired. Kuo-an's text, where the actual process of attaining Enlightenment is divided into eight stages, in-clined towards the doctrine of "sudden" Enlightenment, whereas P'u-ming's represents the ideas of the so-called "gradual" school of thought, which found many adherents among the Chinese.

Japanese monks brought back copies of Kuo-an's book, which was republished in a number of different editions. One of the earliest may date from about 1325. During the next hundred years as many as five different editions ap-peared, which indicates the widespread popu-larity of the theme. One edition bears a date corresponding to 1419. Painted versions, such as this handscroll, seem to be rare and this is the oldest extant example. The Hoshun'in at the Daitokuji has an example dating from the first half of the seventeenth century.

The set illustrated here was handed down to the present time in the Shōkokuji, the temple where the famous painter Shūbun lived during the second quarter of the fifteenth century. For this reason, it is not surprising that the hand-scroll came to be associated with his name. However there is no evidence to support an attribution to him.

The same temple has a set of mounted inscrip-tions from the hand of Zekkai Chūshin (see cat.

no. 38) that consists of the complete text of Kuo-an's *Ten Oxherding Songs*. In 1395 when Zekkai Chūshin was asked to explain the tenets of Ch'an Buddhism to the Shōgun Ashikaga Yoshi-mitsu, he used Kuo-an's *Ten Oxherding Songs* as a textbook for the lessons. His set of inscriptions is thought to have been written for that import-ant occasion. They have no connection with the set of paintings.

Each section of the *Ten Oxherding Songs* con-sists of an explanatory prose paragraph followed by four lines in verse in which the same ideas are once more expressed. For the sake of brevity, only the prose paragraphs have been translated here, but several complete English translations exist (see *References*).

1) LOOKING FOR THE OX
To begin with, we never really lost him, so what is the use of chasing him and looking for him? The herdsman turned his back on himself and so became estranged from his ox. It moved away into clouds of dust and was lost.

The herdsman's home and mountains recede into the far distance; the mountain paths and roads suddenly become confused. The desire to catch the ox and the fear of losing him burn like fire; doubts assail him about the right course to take.

2) SEEING THE FOOTPRINTS OF THE OX
By relying on the *sūtras* and explaining their meaning, he carefully studies the doctrine and begins to understand the first signs. He realizes that all vessels [of the Law] are made of one metal and that the Ten Thousand Things are composed of the same substance as he himself. But he does not yet distinguish between right and wrong doctrines, between truth and false-hood. He has not yet entered that gate. He has discovered the footprints of the ox, but that dis-covery is, as yet, only tentative.

3) SEEING THE OX
Following the sound [of the mooing of the ox] he enters the gate. He sees what is inside and gets a clear understanding of its nature. His six senses are composed and there is no confusion. This manifests itself in his actions. It is like salt in seawater or glue in paint [invisible, in-divisible, yet omnipresent]. He has only to lift his eyebrows and look up to realize that there is nothing here different from himself.

4) CATCHING THE OX

The ox has been hiding in the wilderness for a long time, but the herdsman finally discovers him near a ditch. He is difficult to catch, however, for the beautiful wilderness still attracts him, and he still keeps longing for the fragrant grasses. His obstinate heart still asserts itself; his unruly nature is still alive. If the herdsman wants to make him submissive, he certainly will have to use the whip.

5) HERDING THE OX

As soon as one idea arises, other thoughts are bound to follow. Through Enlightenment all these thoughts turn into truth, but when there is delusion they all turn into falsehood. These thoughts do not come from our environment, but only from within our own heart. One must keep a firm hold on the nose-cord and not waver.

6) RETURNING HOME ON THE BACK OF THE OX

The battle is over. There is no longer any question of finding or losing the ox. Singing a woodcutter's pastoral song and playing a rustic children's melody on his flute, the herdsman sits sideways on the ox's back. His eyes gaze at the clouds above. When called he will not turn around, when pulled he will not halt.

7) THE OX FORGOTTEN, THE MAN REMAINS

There is but one Dharma, and the ox represents its guiding principle. It illustrates the difference between the hare net [and the hare] and elucidates the distinction between the fish trap [and the fish]. [This experience] is like gold being extracted from ore or like the moon coming out of the clouds: one cold ray of light, or an awe-inspiring sound from beyond the aeons of time.

8) BOTH MAN AND OX FORGOTTEN

All desire has been eliminated; religious thoughts have all become void. There is no use to linger on where the Buddha resides; where no Buddha exists one must quickly pass by. One is no longer attached to either, and even a thousand eyes will find it difficult to detect it. The Hundred Birds bringing flowers in their beaks are nothing more than a farce on real sanctity.

9) RETURNING TO THE FUNDAMENTAL, BACK TO THE SOURCE

Clear and pure from the beginning, without even a speck of dust, he observes the growth and decay of forms, remaining in the immutable attitude of non-activity. He does not identify himself with transitory transformations, so why should he continue the pretense of self-disciplining? The water is blue, the mountains are green. Sitting by himself he observes the ebb and flow, the rhythm of the Universe.

10) ENTERING THE CITY WITH HANDS HANGING DOWN

The Brushwood Gate is firmly closed, and the thousand sages are unaware of his presence. He hides his innermost thoughts, and has turned his back on the well-trod path of the saints of antiquity. Picking up his gourd, he goes to the city; carrying his staff, he returns home. Visiting wineshops and fish stalls, his transforming presence brings Buddhahood to them all.

Even a cursory comparison between the painted handscroll and the woodblock illustrations of a printed edition of Kuo-an's text reveal the painter's close dependence on one of the printed prototypes. As the woodblock illustrations in the different editions of the book differ only in minor details, it does not seem possible, however, to establish which edition served as the artist's model. Adopting the same round format, the artist faithfully followed the basic compositional formulae of each of the ten pictures. The sharp lines in the herdsman's costume and the trees, as well as the elaborate structure of rock formations, are stylistic features derived directly from the woodblock illustrations.

The meaning of the first seven illustrations is evident; the eighth, an empty circle, is a fitting symbol of the Absolute. Ever since the days of Nan-yüeh Huai-jang (677-744), the nature of Enlightened Consciousness had been expressed by this symbol. It was most fitting, therefore, that the entire set of pictures should be given this profoundly symbolic circular shape. The purity of the ninth stage is illustrated by representations of the Three Pure Ones: a rock, plum blossoms, and bamboo (see cat. no. 38).

The meaning of the tenth picture is somewhat obscure, especially because of the uncertain interpretation of the words that literally mean "with hands hanging down." Suzuki has translated them as "with bliss-bestowing hands," and this interpretation has been adopted by other translators. While arms hanging limply are supposed to signify respect, the gesture did not acquire this connotation until Ming times. Older texts suggest that it originally stood for

something closer to the opposite of its later meaning, that it indicated independence, defiance, sometimes even rudeness. It would seem that this is what was meant here: Pu-tai has achieved a stage of Enlightenment where even entering wineshops and fish stalls cannot defile him, and behind the rude remarks he makes lies hidden wisdom. By paying homage to Pu-tai and following his examples, the herdsman reaches his final destination.

REFERENCES:
D.T. Suzuki, *Essays in Zen Buddhism*, 1st ser. (London, 1927), pp. 347-366; Shibayama Zenkei, *Jūgyūzu* (Tokyo, 1954); idem, *Zen Oxherding Pictures* (1967); M. H. Trevor, *The Ox and his Herdsman* (Tokyo, 1969); *Shodō Zenshū*, vol. 20 (Tokyo, 1960), pls. 93-97; Goto Art Museum [*Exhibition Catalogue*], no. 23 (1963), nos. 2, 2A, 7-10.

50

TOSŌ TENJIN (SUGAWARA MICHIZANE IN HIS DEIFIED FORM AS TENJIN CROSSING TO SUNG CHINA)
Artist unknown; colophon by Gukyoku (1363-1452)
Hanging scroll, ink on paper, 97.9 x 30.1 cm.
Collection of Fujii Akira, Nishinomiya

Sugawara Michizane (845-903) was a great statesman who reached high rank in the government and was esteemed in court circles for his unusual poetic talents. Late in his life he was falsely accused by his political rival Fujiwara Tokihira and was banished to Kyūshū. After his tragic death in exile at Dazaifu, he was cleared of the charges that had been leveled against him, but his avenging spirit is supposed to have relentlessly harassed the Fujiwara family who had brought about his misfortune.

Michizane was deified as Kitano Tenjin, God of Poetry, whose principal shrine of worship is the Kitano Temmangu at Kyoto. During the Kamakura period religious veneration of Kitano Tenjin increased, and during the last half of the fourteenth century the cult of Tenjin as God of Poetry spread into the Zen sect, where poetry had become very much in vogue. As a result of a deliberate effort to harmonize this popular cult with the tenets of the Zen sect, there came into being the theme known as Totō Tenjin (Michizane Crossing to T'ang China), or Tosō Tenjin

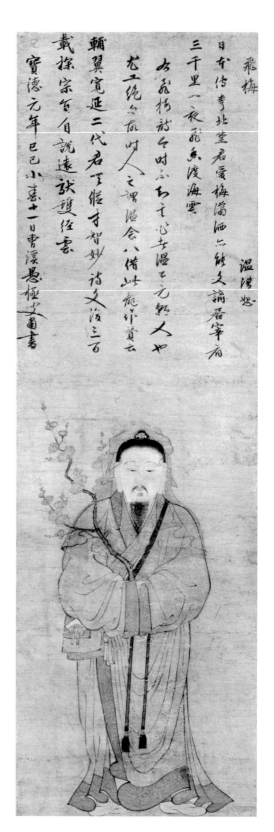

50. *Tosō Tenjin*, artist unknown, first half of 15th century
Facing page: detail

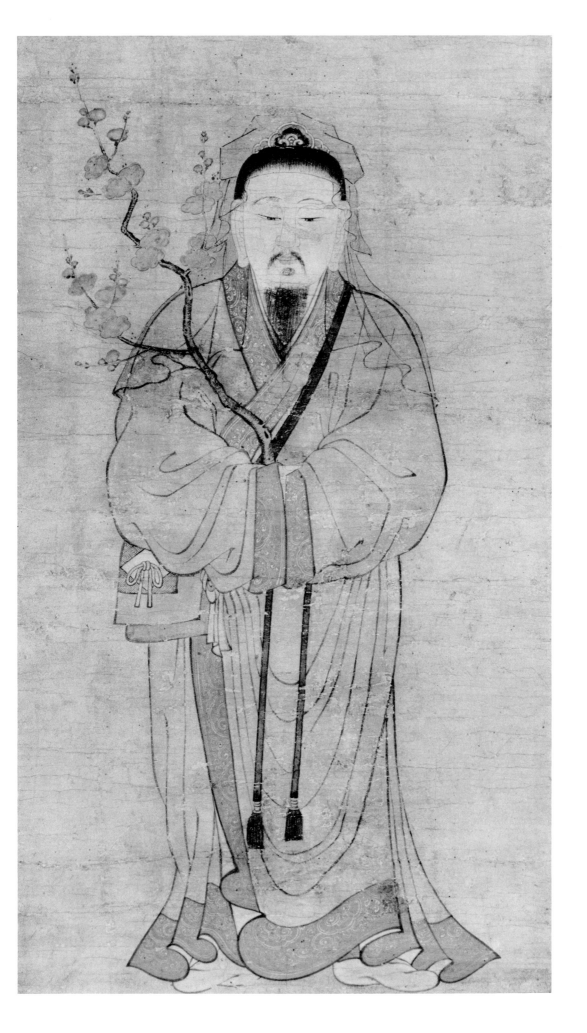

(Michizane Crossing to Sung China). In the Ryōshōki [Record of the two sages] by Fujiwara Nagachika (ca. 1350-1429), written toward the end of the fourteenth century, the following fantastic story is told. When Shōichi Kokushi, founder of the Tōfukuji (see cat. no. 59), returned to Japan after studying for seven years in China with the great Ch'an master Wu-chun Shih-fan (see cat. no. 8), Kitano Tenjin appeared to him and questioned him about the Zen doctrine. That same night Kitano also made his appearance in China at Mount Ching, the residence of Wu-chun Shih-fan. There the deity offered a plum branch to the Ch'an master, who reciprocated by transmitting his doctrine to him.

The Kitano Tenjin cult brought forth a new theme in Ch'an painting. In the many pictures of Totō, or Tosō, Tenjin, the deified poet is shown dressed in a Chinese costume of the Sung period. In his hand he holds a branch of a blossoming plum tree. This is an allusion to his great love for plum blossoms and to the famous story that one of the plum trees in his garden uprooted itself and flew to Kyūshū when he (as Michizane) was exiled there. The representations of Totō, or Tosō, Tenjin bear a striking resemblance to those of the Chinese poet and recluse Lin Pu (ca. 965-1026), who was known for his great love of plum trees and cranes, and it seems likely that the image of Totō, or Tosō, Tenjin was inspired by that of Lin Pu. The many examples dating from the fifteenth century show Totō, or Tosō, Tenjin in a somewhat rigid frontal pose. Profile and three-quarter views appeared at a later date.

The long colophon, dated in accordance with 1449, is written by Gukyoku Reisai (1363-1452), a monk-painter of the Tōfukuji who specialized in paintings of Avalokiteśvara and Mañjuśrī. He quotes a poem entitled "The Flying Plum Tree", which he claims to be the work of an obscure Chinese poet of the Yüan period named Wên Ch'ien-shu. (It is not known whether Wên Ch'ien-shu was actually a Chinese poet, since his name does not seem to have been recorded in any of the traditional reference works). The poem reads as follows:

In Japan the fame of the Lord of Kitano has been transmitted.
He loved plum blossoms; his disposition was open and frank, and he was a skilled man of letters.
Banished, he lived in [Da]zaifu, three thousand leagues away.

In one night the fragrance crossed the sea and the clouds.

Gukyoku, apparently taking pride in the fact that the fame of Tenjin has spread to China, has added a cryptic verse of his own, using the rhymes of the preceding poem.

REFERENCES:
Fujiwara Nagachika, *Ryōshōki* (Tokyo: Gunsho Ruiju, 1898), I, pp. 696-698; Hisao Sugahara, *Hibai Yokō* (Kamakura, 1967), pls. 60-64 (other examples of this theme).

51

CHINSŌ PORTRAIT OF THE PRIEST IKKYŪ SŌJUN
Artist unknown; colophon by Ikkyū Sōjun
(1394-1481)
Hanging scroll, ink on silk, 98.5 x 43.5 cm.
Collection of the Shūon'an, Kyoto Prefecture
Registered Important Cultural Property

By the middle of the Muromachi period, the Zen church, officially sponsored by the military government and widely patronized by people in high places, had begun to show growing signs of religious complacency, and often its prelates evidenced greater interest in aristocratic, worldly concerns than in their responsibilities for spiritual guidance. The strongest, most vociferous opponent of these tendencies during the fifteenth century was Ikkyū Sōjun (1394-1481), who spent the greater part of his long life criticizing, often with vitriolic intensity, the corruption, stupidity, and pretentions of the Zen priesthood. His methods of demonstrating his anger at the growing spiritual debilitation of his sect were often ingenious, though somewhat histrionic, as is illustrated by one familiar incident recounted in his biography the *Ikkyū Oshō Nempu*. Ikkyū is described as taking up a long wooden sword and carrying it conspicuously through the streets of the city of Sakai. Asked by the startled populace the reason for this strange behavior, he replied, "Zen priests nowadays are just like this wooden sword. If it is displayed in a room, it looks like the real thing, but if you unsheath it and take it outside, it turns out to be nothing but a bamboo blade. It's impossible to cut down a man with it, and what's more, I don't think it can be used for anything at all!" His answer seems to have met

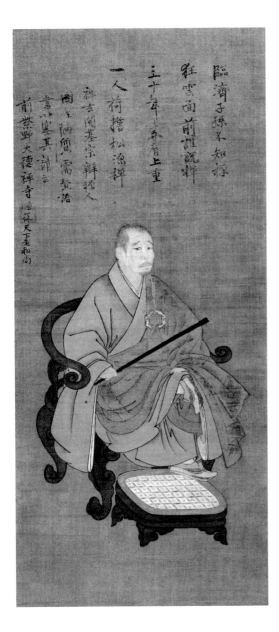

臨済子孫不知禅
往年面前難説禅
三十年來肩上重
一人荷擔松源禅
禅吉関碁宗辞我人
図主阿伯八需頼造
言八鑒其請云
前紫野大徳禅寺
欄依天□老和尚

51. *Chinsō Portrait of the Priest Ikkyū Sōjun,* artist un-
known, ca. 1450-1460

with great approval. Ikkyū's follower Zuiko is
credited with painting his master with an out-
sized wooden sword placed beside his chair.
Several portraits showing Ikkyū in this setting
are still extant. None of them goes back as early
as 1435, the time of the incident, but there are
examples dating from 1447, 1452, and 1453, and
the fact that such portraits were produced for
a number of years suggests a steady demand
for them. They are known by the generic term
shudachi portraits, in reference to the ineffectual
wooden swords used in dramatic performances
or carried by commoners for appearance's sake,
frequently enclosed in garish red scabbards.

Ikkyū is often portrayed in *chinsō* of the
ensō-zō type, that is, a half-torso representation
within a circular framework. Two of his portraits
painted in this manner, together with another
conventional half-torso representation, have
colophons that were apparently added in China.
All three seem to have been sent to China soon
after Ikkyū's death. It is interesting that the colo-
phons were written not by Zen priests but by
Chinese, who seem to have been members of the
literati class from the Hang-chou area; this
suggests that Ikkyū's name may have been
known in secular circles in the region. The
inscriptions praise Ikkyū's exceptional character,
his behavior, and his accomplishments as a
writer of Confucian poetry.

In another category of portrait, Ikkyū is rep-
resented in what might be called a metempsy-
chotic role: he is portrayed as the incarnation of
one of his spiritual patriarchs, the Chinese
priest Hsü-t'ang Chih-yü (Kidō Chigu; 1185-
1269). The reason for this novel form of religious
syncretism appears in the *Ikkyū Oshō Nempu*,
the biography of Ikkyū by Bokusai (Motsurin
Shōtō). According to the account, a man named
Ketsuso bought in Kyoto a rare Chinese por-
trait of the priest Kidō, which was inscribed in
Kidō's own hand. Ketsusō felt that it should be
installed in the Shūon'an (roughly twenty miles
south of Kyoto), but before his departure, the
abbot of the Shūon'an had a dream in which
the esteemed master Ikkyū came to the temple.
The same night Bokusai (who became a student
of Ikkyū's and is credited with painting the
portrait of him now in the Tokyo National
Museum) and the other monks in the Shūon'an
had the same dream. The portrait arrived at the
temple the next morning and was hung upon a
wall. There it was venerated, and everyone
piously exclaimed, "We dreamt of the Master

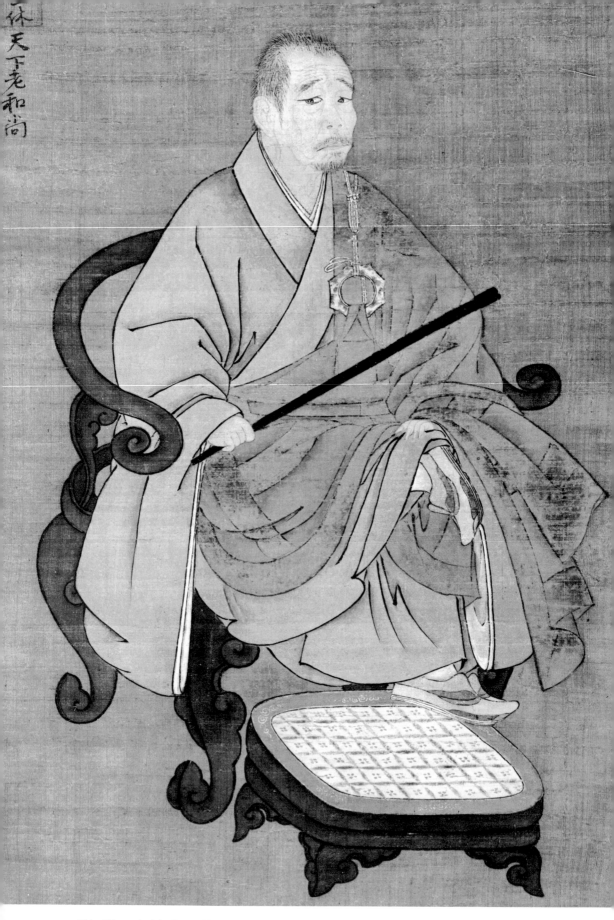

51. *Chinsō Portrait of the Priest Ikkyū Sōjun,* artist un-
known, ca. 1450-1460 (detail)

Ikkyū, and he has become Kidō now that we are awake. Ikkyū is unquestionably the incarnation of Kidō!" Ikkyū himself appears to have acknowledged this belief, for he refers to himself in several inscriptions as "seventh in Kidō's line" (see cat. no. 62), a lineage that indeed has some justification in Zen hagiography. Two examples of this type of portrait are extant. Artistically, neither of them ranks with the finer portraits of Ikkyū, the chief reason being the conflicting iconographic requirements of the subject: the representation of the dynamic personality of a contemporary Zen dignitary with the inclusion of the salient features of a shadowy patriarch of the past, known only from a painting. The result in both cases is a conventionalized, bland image, more interesting in the history of religious ideas than in the development of portraiture.

The Shūon'an portrait of Ikkyū shown here is in the traditional, orthodox *chinsō* manner. His attire is formal and his appearance dignified. He sits erectly in an elegant chair of Chinese origin, equipped with a footstool, and holds one of the usual Zen implements, the *shippei*, a bamboo slat used by the master for striking pupils during meditation sessions. Within this standard format, however, there are certain variations which reveal important aspects of Ikkyū's unconventional character. To begin with, his right foot rests casually atop his left knee, an unusual position that can only represent an intentional departure from proper Zen deportment. The same position may be seen in a *chinsō*, dated 1420, showing Kasō Sōdon (1352-1428), Ikkyū's greatly revered teacher. This painting of Kasō, or one like it, must have provided the model for Ikkyū's pose. Another variant is that Ikkyū's hair is unkempt rather than shaved clean in the prescribed fashion, and he has a rough moustache and beard. These departures from tradition are indicative of Ikkyū's dislike for the pretentions and aristocratic tendencies in the Zen church and demonstrate his desire to be regarded not as a regal, distant dignitary but, rather, as an approachable, fallible human being, sympathetic to the religious needs of all. At the same time, the length of his hair and beard reveals his conception of himself as a protector of the true spiritual concerns of Zen in the manner of Rinzai and Kidō, who also went unshaved.

The realistic treatment of the face is impressive; it displays both the artist's keen sense of observation and his empathy for Ikkyū's personality. In general execution, in quality of line, and in the sitter's fleeting expression, this painting closely resembles the sketch of Ikkyū in the Tokyo National Museum attributed to Bokusai, a disciple of Ikkyū's, who seems to have been very close to the master. (As mentioned earlier, Bokusai was also the author of Ikkyū's biography, *Ikkyū Oshō Nempu*.) Other features that these two works have in common are the colophons, which are essentially the same, and the unusual eyes, which look off to the right, directly at the observer. (This treatment of the eyes, which creates a feeling of intimacy, may have its stylistic prototype in the famous Daitokuji portrait of Daitō, a patriarch revered by Ikkyū, who signs his colophons on occasion "fifth in Daitō's line.") On the basis of these similarities it has been suggested that the sketch attributed to Bokusai served as a preliminary draft for the Shūon'an portrait and that the latter piece may also be the work of Bokusai, but this thesis remains to be proved.

According to Ikkyū's inscription above the painting, the Shūon'an portrait was executed for the Zen layman Shoben, an enterprising merchant who grew rich in the trade with Ming China and contributed financially to the rebuilding of the Daitokuji after the Ōnin wars. No date appears in the inscription, but on comparison with other portraits of Ikkyū that are assigned to the years 1453 and 1457 and show him at apparently about the same period in his life, the Shūon'an portrait seems to represent the priest when he was in his sixties. Ikkyū's forthrightness and his impatience with the spiritual decay of the Zen sect are manifest in his colophon, in which he uses his sobriquet "Kyōun" ("Crazy Cloud"):

The descendants of Lin-chi are ignorant of Zen.
Who dares to expound its teachings in the presence of Kyōun?
For thirty years I have borne the heavy weight;
I alone have shouldered the burden of Sung-yüan's Zen.

REFERENCES:
Yamato Bunka, no. 41 (August 1964) (Special Number Devoted to the Portraits, Autobiographic Writings, and Poetical Works of the Zen Priest Ikkyū); *Nihon Shōzōga Zuroku*, pls. 78, 79, with explanatory text; *Nihon Kobijutsuten Zuroku*, p. 274, pl. 178; Matsushita Takaaki, "Portraits of the Priest Ikkyū," *Museum*, no. 53,

尊林

余飼雀兒盡喜一日忽死...
...

52. *Calligraphy Dedicated to a Dead Sparrow*, by Ikkyū

(August 1955); Donald Keene, "The Portrait of Ikkyū," *Archives of Asian Art* 20 (1966-1967); *Daitokuji,* Hihō, vol. 2 (Tokyo, 1968), pl. 14 (*chinsō* of Sōdon).

52

CALLIGRAPHY DEDICATED TO A DEAD SPARROW: "SONRIN"
Ikkyū Sōjun (1394-1481), dated 1453
Hanging scroll, ink on paper, 78.8 x 24.5 cm.
Hatakeyama Collection, Tokyo

Ikkyū's outspoken condemnation of the religious stagnation of his sect and his disgust with the declining quality and dedication of its priests regularly find expression in his writings and in his unorthodox behavior (see also cat. no. 51). His invective is often bitter, and although there is reason to believe that his fault-finding was largely justified, there is sometimes an almost manic intensity about it, a kind of self-righteous fundamentalism, that reveals a more than resolute, an almost militant aspect of his personality. He emerges as a strong individualist, full of inner conviction and self-confidence, quick to speak his mind. At the same time, however, there is abundant evidence of Ikkyū's concern for the spiritual welfare of his fellow man (as in his diligent efforts to propagate Zen teachings to those of limited education through the use of simplified, popular language) as well as his deep compassion for all life — a fundamental Zen ideal. This compassion is movingly revealed in the content of this piece of calligraphy, written when Ikkyū was sixty-one. He has composed a kind of requiem dedicated to a dead sparrow, which he had named "Sonrin" ("Honored Forest").

I once raised a young sparrow that I loved dearly.
One day it died suddenly, and I felt an intense
 sense of grief.
So I buried it with all the ceremonies proper
 for a man.
At first I had called it Jaku-jisha ("Attendant
 Sparrow"),
But I later changed this to Shaku-jisha
 ("Śākyamuni's Attendant").
Finally, I gave it the Buddhist sobriquet Sonrin
 ("Honored Forest"),

And I attest to this in this *gāthā:*
His bright gold body, sixteen feet long [lying
 between]
The twin sāl trees on the morning of his final
 nirvāna,
Liberated, free of the heretical cycle of samsāra,
Spring of a thousand mountains, ten thousand
 trees, and a hundred flowers.
 1453, eighth month, nineteenth day,
 Kyōunshi Sōjun

Ikkyū here expresses his devotion for the dead sparrow by euphemistically likening its passing to that of the *parinirvāna* (death) of the Buddha, an association that reveals not only Ikkyū's originality but also his fundamental reverence for all sentient beings. In the Zen sect it is traditional practice for a master to honor with an appropriate sobriquet a pupil who has shown excellence in seeking Zen enlightenment. The master writes the sobriquet together with a *gāthā* or brief explanatory passage and confers this on the pupil. Ikkyū has followed this idea here but applied it to a subject outside the priestly fraternity — his pet sparrow. The subject of another, similar piece of calligraphy from his hand is a five-year-old boy, who is also given a Buddhist sobriquet.

Ikkyū's calligraphic style is unique. Although certain features of the styles of his lineal predecessors Kidō and Daitō may be discerned in his calligraphy, these are more likely to have been the result of his keen familiarity with and respect for documents from their hands than of a desire to emulate them. Ikkyū's large characters, like the *Sonrin* here, are written in a straightforward, bold manner and show a preoccupation with the compositional possibilities of the character forms. His ingenuity is apparent in the first two strokes in the upper character, which are intended to suggest two seated sparrows. The smaller characters below, written with greater speed, reveal a fine sense of interrelated continuity and rhythm.

REFERENCES:
Tayama Hōnan, *Zoku Zenrin Bokuseki* (Tokyo, 1965), no. 64.

53

ŚĀKYAMUNI UNDERGOING AUSTERITIES

Attributed to Soga Jasoku (died 1473?); colophon
by Ikkyū Sojūn (1394-1481)
Hanging scroll, light colors and ink on paper,
118.4 x 54.6 cm.
Collection of the Shinjuan, Daitokuji, Kyoto
Registered Important Cultural Property

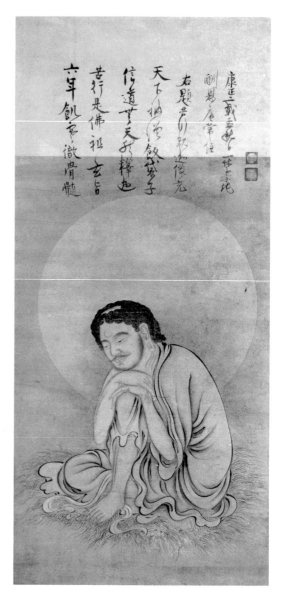

Although *Satori*, the spiritual goal of Zen, is
said to occur suddenly and unexpectedly,
preparation for it requires concerted, rigorous
effort over an extended period of time. Accord-
ing to Zen concepts, it can be achieved only
through the practitioner's own strength and
determination, and all his inherent resources
of self-discipline and introspection must be
brought into action in the quest for this objec-
tive. While this importance of determining
one's own religious progress through personal
strength and resolution is stressed to some
degree by other Mahāyāna sects, it is given the
greatest emphasis in Zen. Long sessions of
assiduous meditation, broken only by short
respites for simple meals, temple duties, or
sleep, and conducted with Spartan disdain for
the extremes of season and temperature, are
part of the Zen devotee's routine. The virtues of
frugality and diligence (see cat. no. 56) are con-
stant preoccupations. These ideals have had a
profound effect on many aspects of Japanese
culture.

According to traditional Buddhist accounts,
Śākyamuni, compelled by a profound desire to
achieve religious awakening, went into a moun-
tain wilderness, where he practiced the most
ennervating forms of self-immolation for six
years. He finally concluded that Enlightenment
must be reached by following a moderate
"middle path" rather than the harsh, self-
abnegating practices of the Indian ascetics, and
he came forth from the mountains (see cat.
no. 28). After restoring his health, he went on
to Bodh Gayā, where he ultimately achieved his
aim while seated in meditation under the
Bodhi-tree.

Śākyamuni is shown here at the end of his
long, harrowing sojourn in the mountains.
Although his wrinkled neck, slim limbs, long
finger and toenails, and beard symbolize his
austerities, he has not been realistically por-

53. *Śākyamuni Undergoing Austerities,* attributed to
Soga Jasoku (died 1473?)
Facing page: detail

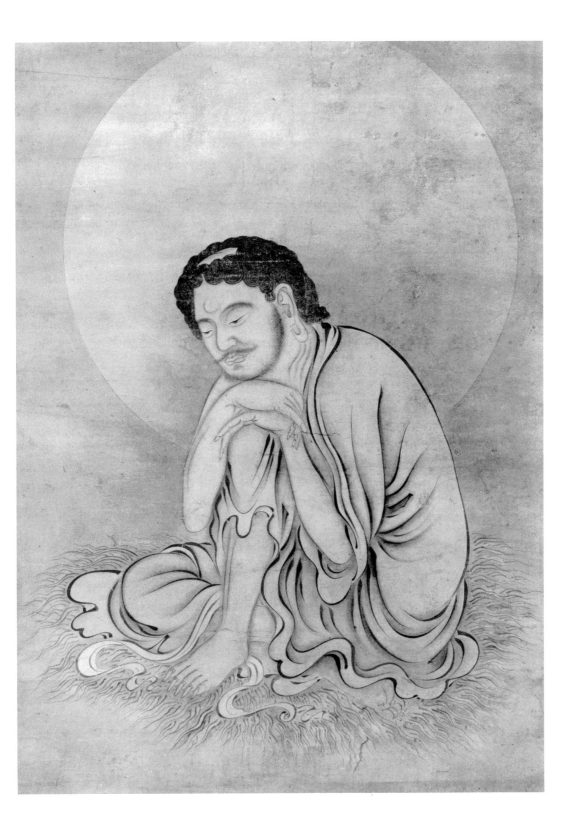

trayed as an emaciated ascetic. Rather, he is represented in an idealized form, that falls conceptually somewhere between the iconic types in the traditional Buddhist figure paintings and the more descriptive, lyrical ink-monochrome portraits. Even though the Buddha disavowed extreme self-denial and preached that salvation could only be attained through more moderate, natural means, it is apparent that themes depicting the hardships encountered in the search for Enlightenment nonetheless had a certain attraction in Zen circles, undoubtedly because they not only were regarded as models for emulation but did indeed reflect the rigors of daily Zen routine. Thus, subjects like the Buddha Undergoing Austerities in the Wilderness, Śākyamuni Leaving the Mountains, Bodhidharma's Nine-Year Vigil Facing the Rock Wall (see cat. no. 55), and depictions of the semi-deified Arhats (see cat. no. 2) came to assume a significant place in Zen art.

Śākyamuni sits on a straw mat, which symbolizes the harsh conditions of the wilderness. His posture suggests relaxed introspection, and although he seems fatigued, he shows nothing of the utter exhaustion one would expect as a result of his six years of fasting and physical and mental hardship. His expression is beatific, suggesting a transcendent state rather than extreme weariness and discouragement at the failure of his long travail.

Although traditional Buddhist literary sources are consistent in their allegation that the Buddha's Enlightenment took place only once (under the Bodhi-tree at Bodh Gayā), it is possible that later syncretic developments in Japanese Buddhism gave rise to the idea that Enlightenment came to the Buddha more than once, and that on one occasion it was as a result of Śākyamuni's solitary vigil in the wilderness. Certain features of this painting might be said to illustrate this idea. The figure of Śākyamuni is shown here with the common iconographic features of *Tathāgata*-hood: the halo, the *ūrnā* on the forehead, and a bald spot in the middle of the scalp representing the *usnīsa*. Furthermore, the beatific expression of the face might be taken as an indication of the realization of *Satori*.

This representation of Śākyamuni is one of several paintings in the Shinjūan and Yōtokuin subtemples of the Daitokuji that are tradition-ally associated with Soga Jasoku, an artist whose identity and oeuvre have yet to be clarified. The consistency of style between these paintings suggests that, if they are not by one hand, they represent the corporate efforts of a small group of artists, perhaps belonging to one atelier, who worked in a remarkably homogeneous manner. The seal "Bokkei" appears on at least two of these paintings. Bokkei's identity is also unclear; he seems to have been closely linked with Jasoku, but whether he was Jasoku's predecessor, as Hasumi Shigeyasu has suggested, has not yet been proved.

Four of the paintings traditionally attributed to Jasoku have colophons by the priest Ikkyū: the *Śākyamuni Undergoing Austerities* (the colophon is dated 1456) shown here; two splendid ink-monochrome portraits, one of Bodhidharma (the colophon is dated 1465), and one of Rinzai (these last three works belong to the Daitokuji); and a portrait of Ikkyū (dated 1452) in the Shōrinji. There is also an unusual monochrome portrait of Ikkyū in the Daitokuji with the seal of Shosen, a painter of the Soga school who is presumed to be a follower of Bokkei. These works provide evidence that the early painters of the Soga school were closely associated with Ikkyū, not only after he went to the Daitokuji in 1473 but also in the preceding years, during his residence at the Shūon'an, some distance south of Kyoto. Ikkyū's colophon for this painting reads as follows:

Six years of hunger, cold penetrated to the
 marrow of his bones
The profound teaching of the Patriarchs was
 asceticism
[But] T'ien-jan and Śākyamuni did not believe
 in this practice
[Today] there are "rice-bag" Zen monks
 everywhere.

> Inscription dedicated to the painting of
> Śākyamuni Undergoing Austerities
> Property of the Shūon'an
> 1456, first month of autumn, Ikkyū Sōjun

There are two seals: "Kokkei" (or possibly "Kunikage"?) and "Ikkyū." The colophon expresses Ikkyū's outlook: he is deferential toward the great figures of the Zen tradition and critical of the behavior of Zen priests of his time (see no. 51). From a historical standpoint, there would seem to be an ideological dilemma inherent in Śākyamuni's renunciation of extreme ascetic

practices and in the later Zen preoccupation with stringent routines, but a distinction might be drawn between the two on the basis of the Zen attitude, which maintains that severity and hardship are necessary aspects of a positive process while pure asceticism is essentially negativistic. Furthermore, in Zen practice austerities generally stop short of self-immolation. The third line of the colophon cannot be interpreted with certainty, but it would seem from the context that T'ien-jan is the monk from Tan-hsia (see no. 13) who was disinclined to bear the cold and burned a wooden image of the Buddha to provide himself with warmth. The pejorative term "rice-bag" refers to monks without ability or religious fervor who, while paying lip service to religious routine, lead essentially unproductive, parasitic lives within the confines of Zen monasteries.

Of the works traditionally attributed to Jasoku those that show the closest stylistic similarities are *Śākyamuni Undergoing Austerities* and the ink-monochrome portraits of Rinzai and Bodhidharma already mentioned. The *Śākyamuni* differs from the other two in that colors have been used: a dark blue in the hair and a very light red in the robe, limbs, and lips. Furthermore, the painting is soft and lyrical in contrast to the more vigorous treatment in the monochromes. Perhaps this difference may be explained on the basis of the varying personalities of the subjects: Rinzai and Bodhidharma are dynamic, intense, while Śākyamuni's beatific appearance is accompanied by an appropriate mood of sanctified introspection.

REFERENCES:
Kugyō Shaka-zu, Nihon Kokuhō Zenshū, no. 10 (Tokyo, 1924), no. 194; "Den Jasoku-hitsu Daruma-zu," *Kokka*, no. 349; Matsushita Takaaki, *Suibokuga*, Nihon no Bijutsu, vol. 13 (Tokyo, 1967), fig. 114; *Daitokuji*, Hihō, vol. 2 (Tokyo, 1968), pls. 12, 58, 59; Ota Sentarō, Matsushita Takaaki, and Tanaka Masao, *Zendera to Sekitei*, Genshoku Nihon no Bijutsu, vol. 10 (Tokyo, 1968), no. 64; Hasumi Shigeyasu, "Bokkei Hyōbu and Dasoku Soga" (in Japanese), *Bukkyō Geijutsu*, no. 43.

54

CALLIGRAPHY WITH DEDICATORY GĀTHĀ: "ICHIGE"
Ōsen Keisan (1429-1493)
Hanging scroll, ink on paper, 32.7 x 49.3 cm.
Collection of Rokuonji, Kyoto

Ōsen Keisan (1429-1493) was one of the outstanding figures in the Gozan literary movement during the fifteenth century. He was the author of several compilations, including an anthology of one hundred poems by famous priests, which is based on the traditional *Hyakunin-isshū* of the Heian period. Keisan was the religious disciple of Donchū Dohō and studied poetry composition under Zuikei Shūhō, a noted master of the period. He achieved a position of considerable distinction in the church hierarchy, serving as abbot at both the Nanzenji and the Shōkokuji, and was one of the high Zen dignitaries who attended the Shōgun Yoshimasa at his deathbed. Following the tradition of the Gozan school, he directed his attentions to scholarly as well as literary pursuits, and he belonged to a coterie of men of letters, including Genryū, Keijō, and Banri, who had their center of activities at the Shōkokuji. Evidence of his contemporary literary esteem is that he was invited to add colophons to scrolls, a fair number of which are still extant.

By the fifteenth century, Zen priests were associating freely with the members of various schools of secular and popular literature, writers of *Renga* ("Linked Verse") and the texts for Noh plays and poets who specialized in the traditional Japanese verse form, the *waka*. These forms of expression, which are strongly native in structure and sentiment, had a marked impact on many Zen monk-writers, some of whom became practitioners in their own right. As a result of this development, the foundation of the Gozan literary movement, which drew its original force and inspiration from Chinese ideas and models, suffered a gradual erosion, and the creative momentum of the school declined. Its adherents gradually increased their interest in philosophy and historical research, and their Chinese verse in general lost its vigor.

These tendencies were paralleled in the calligraphy produced by Zen monks during the period when the boldness and individuality of the Japanese masters of the thirteenth and

fourteenth centuries had been largely replaced by a preoccupation with self-conscious elegance and attention to the refinement of details. These characteristics represent the infiltration into Zen writing of the prevailing Japanese taste in calligraphic expression. It is interesting that the calligraphy of Ikkyū represents one of the strongest reactions against these developments, a determined attempt to reassert the importance of the great hands (such as Daitō) of the Kamakura period.

This accomplished piece of writing by Keisan attests to his awarding of the sobriquet "Ichige" to a disciple named Keijun, whose title "Shoki" indicates that his special duties were that of a clerk or secretary. It reads thus:

Ichige
Secretary Keijun asked me for a sobriquet,
 so I named him Ichige. [I have composed]
 this small *gāthā* in congratulation:
The nebulous becomes clear
People, in new red and mauve
The five petals open of their own accord
Spring fills every corner of the universe.

The inspiration for this *gāthā* is an anonymous ten-character poem, which is customarily taken to refer to the Zen tradition of "sudden," or "spontaneous," Enlightenment. Pious followers of Zen have attributed it to Bodhidharma.

The five petals of one flower open,
and the fruit of itself is ripe.

The "five petals" may be an allusion either to the "five houses" of Ch'an or to the patriarchs who succeeded Bodhidharma. The sobriquet "Ichige" ("One Flower") is made up of two characters in the first line. The tone of Keisan's *gāthā* is one of elation and brightness, in keeping with the auspicious circumstances of the occasion. Keisan's signature reads "Old man Ōsen, formerly of the Nanzenji." It indicates that the piece was executed late in his life, when he was in residence at the Shōkokuji, perhaps about 1490, and that Keijun was one of the lower-ranking monks there.

While Keisan's hand shows a residual influence of the mainstream of Zen calligraphy, which drew its original inspiration from Chinese masters of the Southern Sung period, it also exhibits a tendency toward accommodation with native Japanese calligraphic traditions. Although the writing has vigour, the directness

of earlier Zen calligraphy is superseded by a more calculated, mannered quality; the characters are studied and refined, and there is a strong awareness of detail and of its resolution.

REFERENCES:
Shodō Zenshū, vol. 20 (Tokyo, 1957), no. 103; *Muromachi Jidai Bijutsuten Zuroku* (Kyoto, 1967), no. 144.

55

HUI-K'O SHOWING HIS SEVERED ARM TO BODHIDHARMA
Sesshū Tōyō (1420-1506)
Hanging scroll, dated in accordance with 1496, ink and light colors on paper, 199.9 x 113.6 cm.
Sainenji, Aichi Prefecture
Registered Important Cultural Property

Two of the best-known legends in traditional Ch'an chronicles concern Bodhidharma's nine years of implacable "wall-gazing" at the Shaolin temple and the episode in which Hui-k'o (who was eventually to become the Second Patriarch) severs his left arm to express his sincerity of purpose in seeking Bodhidharma's instruction. These accounts provide instructive examples of the accretive process that is almost invariably at work in the evolution of Ch'an "patriarchal" literature. Pseudo facts embellished by apocryphal embroidery are utilized to give emotional appeal and "authenticity" to the patriarchal characters. The later Ch'an chroniclers were also guilty, of course, of combining legend with historical fact and of writing "history" to their own advantage, although it is only fair to remark that this practice may be observed in the literature of other sects as well. In the case of the Ch'an writers it is particularly understandable because of their constant preoccupation with substantiating the continuity of the patriarchal line.

Although the earliest textual reference to *mien-pi chiu-nien* ("nine years facing the wall") does not appear until the *Wu-chia chêng-tsung ts'an* (compiled in 1254), the biography of Bodhidharma in *The Record of the Transmission of the Lamp* (ca. 1004) contains the following passage: "He stopped at the Shao-lin temple on Mount Sung. [There], facing the wall, he sat down. He remained utterly silent from one day

一華

混沌辟開予人

54. *Calligraphy with Dedicatory Gāthā* by Ōsen Keisan
(1429-1493)

to the next, and no one could fathom his behavior. He was called the wall-gazing Brahman."

Scholarly judgment is divided on the question of whether any of the preserved texts can be relied on as representing an accurate view of Bodhidharma's doctrine. Opinions range from the mildly optimistic, such as that of Daisetz Suzuki, to those that even question the historicity of Bodhidharma himself. A short text entitled *Two Entrances and Four Acts,* which is preserved in Sung chronicles and referred to in the brief biography of Bodhidharma in Tao-hsüan's seventh-century history, may contain a selection of the master's teachings as recorded by one of his pupils. The term *pi-kuan* (literally, "wall-gazing") which appears in the passage just quoted, is mentioned in this text and cryptically commented on. The term refers to a concept involving a form of meditation. It is not to be understood literally, but seems, rather, to allude metaphorically to the ineffable steepness and suddenness of Enlightenment. In later times, the phrase was interpreted literally both in literature and in art. Thus, the story of Bodhidharma sitting in deep meditation while "facing a wall"—one of the most popular and enduring of Ch'an legends—came into being. The final anecdotal elaboration of this tale, now an essential part of Japanese folklore, was that Bodhidharma's arms, legs, and eyelids, atrophied from his long inactivity, disappeared entirely.

In Ch'an and Zen legend the theme of Hui k'o's severing his left arm rivals in importance that of Bodhidharma's nine-year vigil. Other monks, according to Kidō, are also known to have severed their arms in the search for Enlightenment, such as T'ai-kung, a pupil of the Buddhist scholar and writer Ts'ung-mi (780-841). But the story of Hui-k'o became especially famous, and there is even a reference to it in a play by Chikamatsu (1653-1724), the *Battles of Coxinga.* Although Tao-hsüan's *Hsü kao-sêng chuan,* completed in the mid-seventh century, attributes Hui-k'o's loss of limb to an encounter with bandits, later chronicles produced by Ch'an authors flatly reject this explanation and see Hui-k'o's action as the result of his own great bravery and resolve. According to *The Record of the Transmission of the Lamp,* where there is often a strong parochial preoccupation with presenting Ch'an in a favorable light, Hui-k'o (traditional dates 487-593) was an

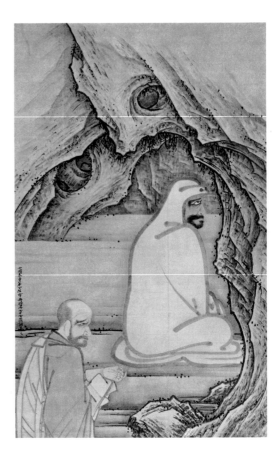

55. *Hui-k'o Showing His Severed Arm to Bodhidharma* by Sesshū Tōyō, 1496
Facing page: detail

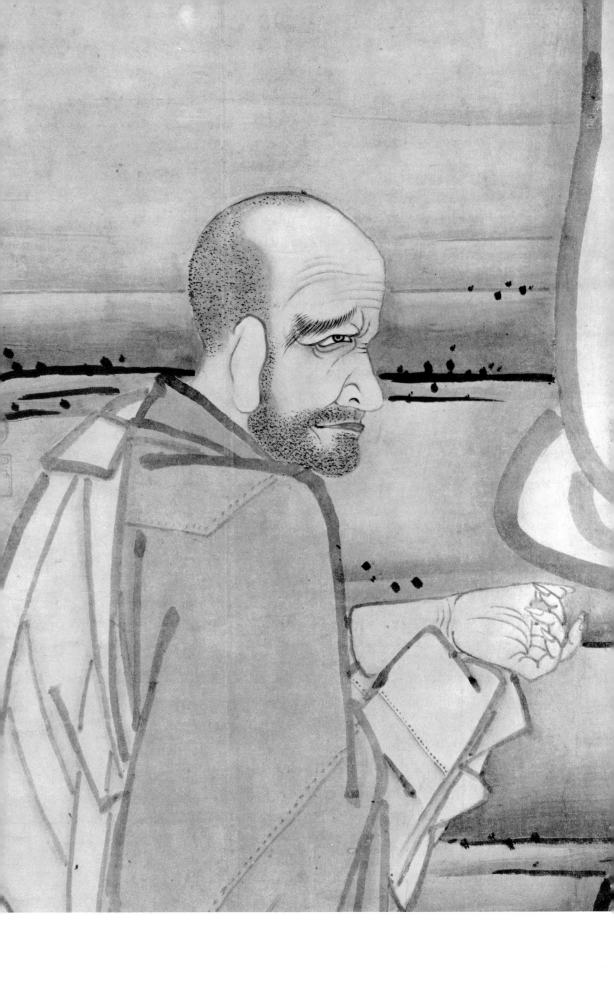

upright, liberal person, who was "fully acquainted with Confucian and Taoist literature but always dissatisfied with their teachings because they appeared to him not quite thoroughgoing" (translation by Suzuki). Having heard of Bodhidharma, Hui-k'o went to the Shao-lin temple to entreat the master to accept him as a pupil. The master, sitting in adamant meditation, ignored him completely. Hui-k'o was determined to show his resolve, however, and finally stationed himself outside the master's place of meditation. It was the dead of winter, but Hui-k'o stood firm through the entire night. By morning he was half-buried in new snow, and Bodhidharma took pity and recognized him. In answer to Hui-k'o's earnest request for instruction, however, the master responded with a brief sermon on the great adversities involved in seeking enlightenment. Hui-k'o, moved deeply by the profundity of Bodhidharma's words, then severed his left arm with his sword and advanced to show it to the meditating master as a sign of his willingness to endure whatever fierce vicissitudes he might encounter, so long as the master accepted him as a follower. Bodhidharma acceded, and after a terse, recondite dialogue with the master, Hui-k'o achieved *Satori*. The events of the interview may have been chronologically telescoped in the narrative and originally occupied a much more extended period of time. Hui-k'o underwent six years of training and became the second Ch'an patriarch, receiving Bodhidharma's robe and his "Seal of Mind". Although Tao-hsüan notes that Bodhidharma also gave Hui-k'o the *Laṅkāvatāra-sūtra* in four volumes, later Ch'an accounts seem to have consciously ignored this statement, probably because of the growing emphasis on ideas such as those expressed in the famous T'ang-period phrase that begins "A special tradition outside the scriptures: no dependence on words or letters" Mount Sung (outside of Lo-yang), site of the Shao-lin temple, had long historical associations with Ch'an. Various Northern Ch'an masters resided there, and it was famous because of royal patronage.

In this painting by Sesshū Tōyō (1420-1506) both subjects are combined into a single composition, which is original in its conception and overwhelming in its impact. Bodhidharma sits in steadfast meditation, facing a wall of jagged rock. His robe, conceived of as an abstract compositional element, is painted with great economy with an even, continuous bounding line, which is intentionally static and inert. Although this line may have been inspired by the brushwork of Minchō (see cat. no. 42), it is unique in its starkness and simplicity; its purpose is not only to emphasize the paradoxical quality of the patriarch—intense spiritual activity without physical motion—but also to express in an antidescriptive, abstract manner the unwavering strength of his determination. The bold, vibrant outlines of the rock are ingeniously juxtaposed with the impassive outlines of the robe, creating an interplay of tension and calm. This is, one might say, a visual *kōan*: the human more adamant than the rock, and the rock, filled with movement that is almost animate.

Two basic compositional schemes are combined in the painting. One might be likened to an archery target, with Bodhidharma's eye at the center, surrounded in concentric sequence by the outlines of the face, the robe, and the successive, gradually expanding contours of the rock wall. The second is a diagonal movement, leading from the lower left to the upper right. This is accomplished not only by the obvious diagonal thrusts of the cave walls behind and below Bodhidharma but also by a sequential arrangement of the compositional elements. Thus, Hui-k'o's profile figure leads to the larger, more abstract, profile figure of Bodhidharma, and this sequence is repeated by their heads and by the concave openings in the rock above. At the same time, the larger composition is resolved by a secondary diagonal counterthrust, achieved through the parallel rock contours above Bodhidharma's head, which lead down the face of the vertical wall, around, and back to Hui-k'o's face. In the concern with two-dimensional effect and sense of overall compositional balance and interlocking structure, this painting has much in common with the works of the modern abstract expressionists.

The painting is also remarkable in its renunciation of any realistic or descriptive devices of a dramatic or emotional nature. Thus, while intense in its concentration, Bodhidharma's countenance lacks the truculence that soon became a distinguishing feature of his portraits (see cat. no. 57), and Hui-k'o's expression seems more impassive than pained. In the hands of a lesser artist, the subject might well have been treated in a gory and exaggerated manner. Depictions of Hui-k'o's sacrifice go back at least

to the eleventh century (see cat. no. 1) and while the theme seems to have remained a part of the traditional Zen repertoire, there is no evidence that it was ever popular.

Precisely when the first representations of Bodhidharma Facing the Wall were executed cannot be determined with accuracy. The passage from *The Record of the Transmission of the Lamp* quoted on page 130 indicates that the literary tradition existed as early as the first years of the eleventh century. Kidō Chūtarō has reproduced a work in the style of Kuan-hsiu (832-912) that appears to be a depiction of the subject, but there is no way of establishing the age of the piece or the authenticity of its lineage. The earliest Japanese example is the fine work by Minchō in the Tōfukuji. There, the figure looks out directly at the observer, so that a wall cannot be shown in front of him. Nevertheless, there can be little doubt that the painting is intended to represent Bodhidharma Facing the Wall. In Ishida's view, the fact that Bodhidharma sits in isolation in a vine-hung cave is sufficient for the identification. It is possible that the Minchō painting served as a general source of inspiration for Sesshū's work. In the treatment of the cave walls there are points of resemblance, such as the distinct contour lines and the textured areas built up with dry, scumbled brushstrokes; there is also similarity in the overhanging vines and in the perspectival angle of recession in the flat, unelaborated cave floor. Paine has remarked on the use of "heavy bounding lines" in the Sesshū painting that were "part of the great achievement of Chō Densu [Minchō]", and, certainly, even though the line used by Sesshū in Bodhidharma's robe is very much his own invention, the strong curvilinear contours appear to owe their conception to the earlier tradition. Minchō's heavy line, which has, however, a flowing grace, also has its stylistic origins in the past — in the brush line of the thirteenth century, like that used in the *"Red-Robed" Bodhidharma* (see cat. no. 20).

Minchō's frontal view of Bodhidharma seems a logical result of his training and experience in painting orthodox Buddhist icons. But Sesshū's treatment of Bodhidharma in profile can only be explained on the basis of his own originality. There is little evidence that he ever produced conventional, orthodox icons, and although he is traditionally thought to have studied at the Shōkokuji under Shūbun, he never became an atelier painter. Rather, he seems to have worked independently, and judging from his extant works, he was less interested in Buddhist themes than in a broad range of subjects that allowed him to give full reign to his artistic inclinations. As is the case with his contemporary Shōkei (see cat. no. 57), Sesshū seems to have been more concerned with art than with religion.

Figures in profile are not unusual in Japanese painting, especially in handscrolls, where they are appropriate for the horizontal sequence of the visual narrative, but in representations of Buddhist subjects they are rare. Although isolated examples exist, the profile seems to have been consistently rejected in Buddhist painting, perhaps because of iconographic considerations. Sesshū's use of the profile here simply represents his pragmatic, independent solution to the compositional problem inherent in the subject: Bodhidharma literally "faces the wall", representing an inexorable confrontation of mind and matter. A half-torso representation of Bodhidharma in profile, traditionally attributed to Mu-ch'i, has been reproduced by Kidō, but the piece has never been authenticated and would seem to have no relevance to Sesshū's painting with the possible exception of one detail: the ear is turned forward in a manner not unlike that of Hui-k'o's.

Sesshū's signature gives his age as seventy-seven, indicating that the painting was executed in 1496. He refers to himself as Sesshū, who received the *dai-ichi-za* ("first seat") at the "Tendō" temple in Hang-chou. The first seat was the place of highest honor in the monks' hall during meditation, and it would appear that Sesshū was the recipient of this honor because of his artistic accomplishments. In 1467 or 1468 he joined an expedition to China. The party landed at Ning-po, and Sesshū made a pilgrimage to the "Tendō" temple, properly named T'ien-t'ung Ching-tê Ch'an-ssŭ, on Mount T'ai-po. This was a famous monastery that ranked as one of the "Five Mountains".

After his return Sesshū occasionally referred in his signatures to the temple and the honor he received there. Sesshū adopted his sobriquet, which is composed of the graphs for *setsu* ("snow") and *shū* ("boat") when he was about forty-three. He is said to have admired a piece of calligraphy on which the phrase was written by the noted Yüan priest Ch'u-shih Fan-chi (see cat. no. 13) and to have chosen it for himself. It seems to have been a popular sobriquet

during the period and was used by a number of other monks.

The calligraphy of Sesshū's signature is executed in a style that conforms very closely with the brushwork and general tenor of the painting: it is deliberate and to the point, brisk but devoid of any unnecessary flourishes. The two seals, which read (from top to bottom) "Sesshū" and "Tōyō" are unique and appear only on this work. According to an inscription that accompanies the painting, it was presented to the Sainenji, at the time of the temple's construction in 1532, by a local *daimyō* Saji Tamesada.

REFERENCES:
Iijima Isamu, "Sesshū Tōyō ni okeru Rakkan-inshō no Kenkyū," *Tōkyō Kokuritsu Hakubutsu-kan Kiyō,* no. 2 (1967); Kumagai Nobuo, "Eka-danpizu," *Kokka,* no. 700; Kyoto National Museum, *Muromachi-jidai Bijutsuten zuroku* (1967), no. 14; Kidō Chūtaro, *Daruma to sono Shosō* (Tokyo, 1934), pp. 203 ff., 210; figs. 3, 4; Suzuki Daisetz, *Essays in Zen Buddhism,* 2d ser. (Kyoto, 1933), pp. 23 ff.; 1st ser. (London, 1927), pp. 163 ff.; Heinrich Dumoulin, *A History of Zen Buddhism* (New York, 1963); Philip Yampolsky, *The Platform Sūtra of the Sixth Patriarch* (New York, 1967), p. 7, n. 10 (Mount Sung), p. 11; Chikamatsu Monzaemon, *Four Major Plays,* trans. Donald Keene (New York, 1961), p. 76; Ishida Mosaku, *Bukkyō Bijutsu no Kihon* (Tokyo, 1967), p. 360 and plate opposite (Tōfukuji *Bodhidharma Facing the Wall*); Robert Treat Paine and Alexander Soper, *The Art and Architecture of Japan* (Baltimore, 1955), p. 54.

56

MENDING CLOTHES IN THE EARLY MORNING SUN
READING A SŪTRA-ASSIGNMENT BY MOONLIGHT
Chūan Shinkō (active ca. mid-15th century)
Pair of hanging scrolls, ink on paper, each
83.9 x 33 cm.
Tokyo National Museum

Chūan Shinkō was a monk-painter who lived at the Kenchōji in Kamakura. Although the dates of his activity as a painter are unclear, the *Koga Bikō* mentions a letter dating from 1452 that Shinkō addressed to the Mishima Shrine near the Izu peninsula. He is supposed to have been

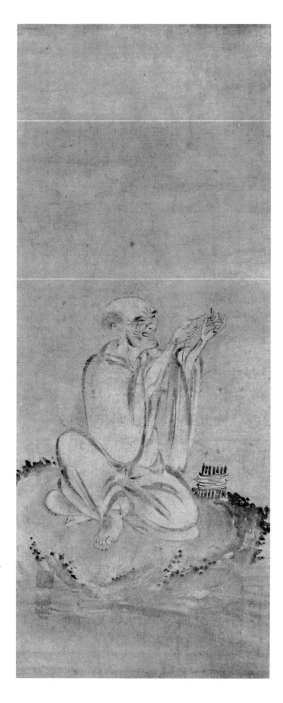

56. *Mending Clothes in the Early Morning Sun* by Chūan Shinkō (active ca. mid–15th century)

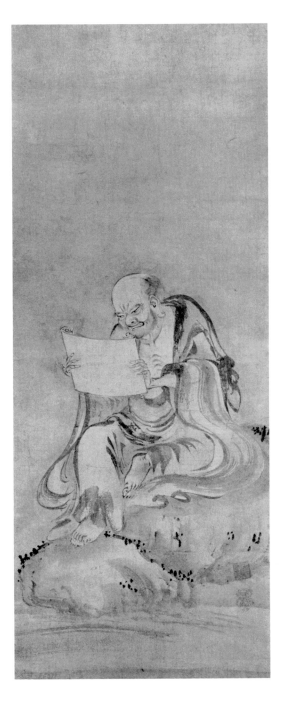

56. *Reading a Sūtra-Assignment by Moonlight*
by Chūan Shinkō (active ca. mid-15th century)

the first teacher of the painter Shōkei (see cat. no. 57), who left for Kyoto in 1478 to study with Geiami. We may assume that Shinkō was active some time between these two dates.

Chūan Shinkō is one of the very few *suiboku* artists of the middle Kamakura period who are known to have lived and worked in Kamakura. Between 1375, when Gukei left, and the middle of the fifteenth century, when Shinkō was active, Kamakura appears to have produced no artists of prominence. It seems doubtful, therefore, that there was a local school of painting with its own character and style in the area during the period.

Practically all of Shinkō's existing works depict typical Zen themes: *The Three Laughers at Tiger Creek, Hotei,* and *Śākyamuni Returning from the Mountains.* Although many monks traveled between Kyoto and Kamakura, and an artist working in Kamakura therefore did not necessarily lead a life of artistic isolation, Chūan Shinkō's style would seem to have retained its own, local flavor. The absence of an established traditional atelier such as that at the Tōfukuji in Kyoto may have been one of the factors responsible for the differences between Kyoto and Kamakura art. The strong influence of Chinese prototypes that is apparent in Shinkō's works can be explained by the presence in Kamakura of a large number of Chinese paintings, which had been brought over from the mainland by traveling monks.

This pair of scrolls shows two monks, one trying to decipher the text he holds in his hands, the other straining his eyes to thread a needle. The paintings illustrate two lines of Chinese verse, the origin and authorship of which are unknown: "In the early morning sun I mend my ragged clothes; / In the moonlight I read my *sūtra* assignment." This poem seems to extol diligence both in intellectual pursuits and in simple, manual tasks. It seems to be analogous to such precepts as that of Po-chang Huai-hai (720-814): "When there's no work for a day, there's no eating for a day." Chinese Ch'an monks of the Sung period were the first to illustrate the theme. The finest example is a pair of paintings by an otherwise unknown artist named Wu-chu-tzŭ, inscribed by the artist and dated in accordance with A.D. 1295 (Reimeikai Foundation, Tokyo). It is obvious that Chūan Shinkō was inspired either by such a Chinese prototype or by an early Japanese copy.

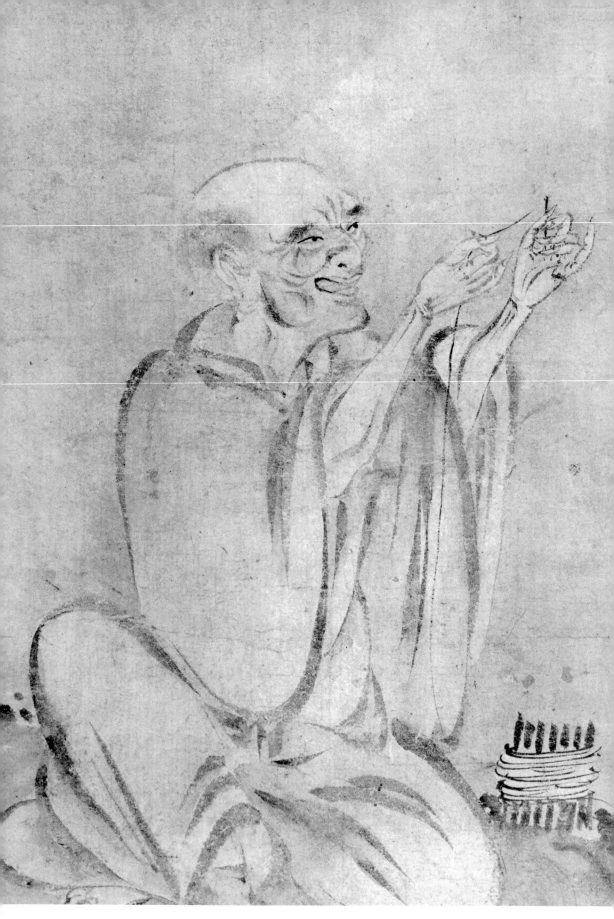

56. *Mending Clothes in the Early Morning Sun* by
Chūan Shinkō (active ca. mid–15th century) (detail)

Chūan Shinkō applied washes to almost the entire surface of the two paintings. By using softly flowing outlines and by toning down the contrasts of black and gray he successfully rendered the subdued effects of shapes and colors in early morning and twilight conditions.

REFERENCES:

Kokka, nos. 77, 264, 797; Matsushita Takaaki, *Muromachi Suibokuga,* no. 87; Asaoka Okisada, *Koga Bikō,* p. 795; Nakamura Tanio, *Shōkei* (Tokyo, 1970), pp. 15-17; Tokyo National Museum, *Sōgen no Kaiga* (Tokyo, 1962), pls. 32-33 (Wu-chu-tzŭ).

57

BODHIDHARMA

Kenkō Shōkei (mid-15th to early 16th century)
Hanging scroll, ink on paper, 93.5 x 46 cm.
Nanzenji, Kyoto
Registered Important Cultural Property

Although Kenkō Shōkei is the most influential and accomplished painter of the Kamakura school of ink-monochrome painting, there is very little reliable biographical information about him. He must have been born about the middle of the fifteenth century, and there is some evidence that he lived into the early years of the sixteenth century. The *Honchō Gashi* notes that he was a monk at the Kenchōji. His title, "shoki," implies that his temple duties were of a clerical nature, and he is commonly referred to as "Kei Shoki" for that reason. The *Honchō Gashi* also notes that he was the son of a painter named Tsuzura from the town of Utsunomiya, but this has not been substantiated. It is generally presumed that Shōkei received his initial artistic training under Chūan Shinkō at the Kenchōji, although there is no clear evidence of this. As none of Shinkō's paintings bear dates or colophons, it is difficult to know precisely when he was active (see cat. no. 56). It is clear that he was Shōkei's predecessor at the Kenchōji, however, and it seems likely that Shinkō was still at the temple when Shōkei first went there. Shōkei left Kamakura and journeyed to Kyoto in 1478, the year after the Ōnin Wars (which had devastated the capital) finally ended. There can be little doubt that Shōkei's pilgrimage was inspired less by religious than by artistic concerns, for he went to study directly

under the noted painter, poet, and critic Geiami (1431-1485) rather than to one of the ateliers in Zen temples. Geiami was one of the select coterie favored by the Shōgun Yoshimasa; he was not only a gifted painter but also an outstanding critic knowledgeable in matters of connoisseurship, and an influential arbiter of the period. Furthermore, he had easy access to the superb paintings in the shōgunal collection and undoubtedly made these available to Shōkei. Shōkei spent about three years under Geiami's tutelage, and the master presented him with one of his own landscapes (a famous work now preserved in the Nezu Museum) upon his departure for Kamakura. The painting has inscriptions by several of the important figures in Geiami's circle—men like Getsuō Shukyō, Rampa Keishi, and Ōsen Keisan. The inscription by Keisan states that Shōkei came to Kyoto in 1478 and became an accomplished painter in only three years of study under Geiami. It goes on to describe how the landscape scroll was given to Shōkei as a parting present by Geiami. The inscription and the circumstances of the gift indicate that the painting probably was meant to serve as an artistic equivalent to the *ingajō,* the certificate of religious accomplishment and lineal authenticity usually presented to outstanding disciples by Zen masters. Geiami was not a Zen priest, but the influence of Zen practices was widespread in secular circles at this time, and he followed Zen precedent in awarding the painting to Shōkei in honor of his artistic progress.

Shōkei returned to Kamakura; his atelier at the Kenchōji flourished and produced a line of painter-monks that included Keison, Keiboku, and Senka. Shōkei's extant work includes the broad range of subject matter characteristic of later, Muromachi ink-monochrome specialists. Some works, such as the Bird and Flower examples, have color added (undoubtedly because of their close stylistic affiliation with Chinese academic prototypes) but Shōkei was clearly most at home in the pure ink medium, and it is there that his versatility and creative power are most apparent. Although he was a Zen priest, only three of his extant works have explicit, orthodox Zen subject matter. The first, a pair of *Zen-e* ("Enlightening Encounters"), depicts the ubiquitous master Wei-shan and the enigmatic meeting between Li Ao and the priest Yao-shan. The Li Ao and Yao-shan is a very skillfully executed copy of the work in the

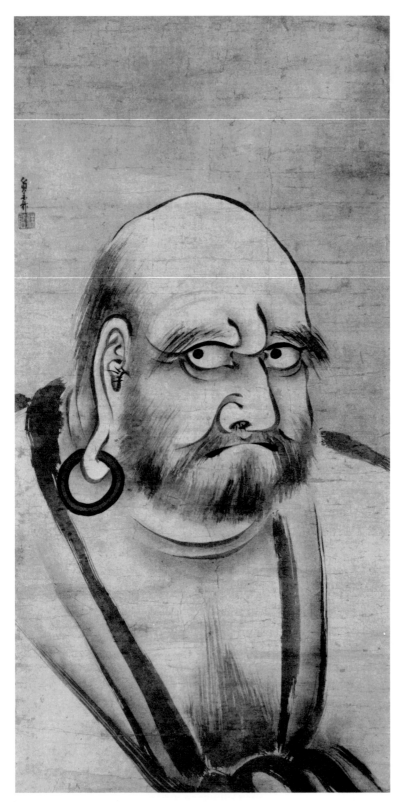

57. *Bodhidharma* by Kenkō Shōkei (active mid–15th to
early 16th century)

Nanzenji by Ma Kung-hsien of the Southern Sung period. The second is this half-torso representation of Bodhidharma. One *chinsō* has also been attributed to Shōkei: the portrait of Kikō in the Kenchōji, which is executed entirely in monochrome. Shōkei's largest and most impressive group of paintings are his landscapes, and this is obviously the area in which he most enjoyed working. His range and choice of subject matter parallels Sesshū's, and the careers of these two great contemporaries show marked similarities. Both were highly dedicated painters whose priestly roles seem almost incidental to their overriding interest in monochrome landscape-painting, the area in which they both achieved their finest expression.

Shōkei's brushwork in the Bodhidharma painting is direct, powerful, facile, and there is a joy and momentum in the interrelated strokes that make an immediate impact on the observer. Early copies of the work in Kamakura temples show that it served as a respected prototype for centuries; this process of emulation established a standard iconographical type known as the "Shōkei-style Bodhidharma." A comparison of Shōkei's Bodhidharma with the Bodhidharma in the Myōshinji (cat. no. 7) clearly reveals that the basic type goes back at least to the early thirteenth century. The Myōshinji example may be the earliest, but it has the appearance of an established hieratic icon. The subject, because of its essential simplicity, readily lends itself to different personal treatments; it is therefore surprising that the details in the two paintings are so similar, since they were executed over three hundred years apart.

The oldest Japanese example of this half-torso three-quarter view of Bodhidharma is the painting in the Kubō Collection with a colophon by Seisetsu Seichō dated 1326. Stylistically, this work fits neatly into chronological sequence—it is somewhat more vigorous in brushwork than the Chinese example, but faithful to it in particulars of countenance and expression. The two finest examples from the middle of the Muromachi period are the Shōkei work, which probably belongs to the first years of the sixteenth century, and the dynamic example by Bokkei that has a colophon by Ikkyū dating it to 1465. The Bokkei work is eccentric and personal whereas the Shōkei follows the long-established iconographical precedent more closely.

REFERENCES:
Nakamura Tanio, *Shōkei*, Tōyō Bijutsu Senshū (Tokyo, 1970); *Sekai Bijutsu Zenshū*, vol. 7, text fig. 87 (Kubo Bodhidharma); Tanaka Ichimatsu and Yonezawa Yoshiho, *Suibokuga*, Genshoku Nihon no Bijutsu, vol. 11 (Tokyo, 1970), pl. 98; *Kamakura no Suibokuga*, Kamakura Kokuhōkan Zuroku, no. 9 (Kamakura, 1954) pl. 9.

58

KENSU AND CHOTŌ
Yōgetsu (active late 15th century)
Pair of hanging scrolls, ink on paper,
90.9 x 33.3 cm.
Tokyo National Museum

Literary sources give conflicting information about the life and background of the monk-painter Yōgetsu. The *Honchō Gashi* by Kano Einō (completed 1676) states that he was a native of Satsuma who lived in the Kasagidera between Kyoto and Nara and who followed the styles of Shūbun and Sesshū. In monochrome painting, he followed the style of Mu-ch'i. The *Gakō Benran* (late 17th century), on the other hand, calls him a monk of the Kenchōji in Kamakura and makes him a pupil of Shōkei (see cat. no. 57). A *suiboku* artist, he painted figures, landscapes, and birds and flowers. The only reliable indication of the date of his activity as an artist is a eulogy written on one of his landscapes by the monk Kesei Ryogen. It bears a date corresponding to A.D. 1486. His only signed work is a Hotei; other works bear only his seal.

Hsien-tzŭ (Japanese: Kensu; "clam") and Chu-t'ou (Japanese: Chotō; "pig's head") are two typical Ch'an characters. Although they were originally in no way related or associated, they are often depicted on scrolls that form a pair. Their association is probably due to the non-vegetarian habits that they share, which set them apart from the regular Buddhist clergy to whom such habits were anathema.

According to a description in the *Wu-têng hui-yüan* by the monk Ta-ch'uan P'u-chi (1179-1253), Hsien-tzŭ is supposed to have been a disciple of Tung-shan Liang-chieh (807-869; see cat. no. 4). He was not a Ch'an monk in the usual sense, however. Dressed in the same rags in summer and winter, he roamed the river-

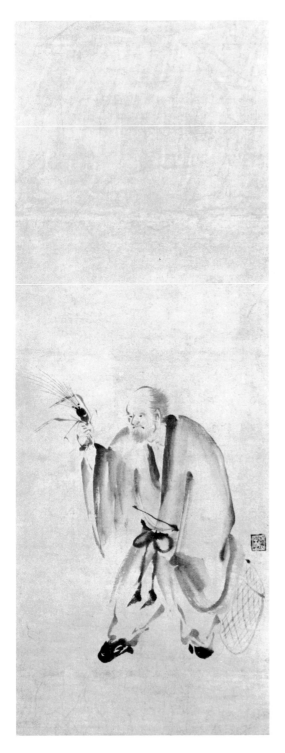

side with his fishing net in search of shrimps and clams, which formed his staple diet. At night he would sleep among the offerings of paper money made to the White Horse Shrine on Eastern Mountain. It was said that he attained Enlightenment while catching shrimp. Although anecdotes depict him as an enlightened being, the story of his *Satori* is not told in the early sources.

The identity of Hsien-tzŭ's companion Chu-t'ou is rather unclear. His name means pig's head and he is usually shown eating a pig's head or holding one in his hands. He is usually said to represent a certain Chih Mêng-hsü who was fond of eating pig and was therefore called "Pig's Head." There is nothing in Chih's biography, however, that could justify his inclusion in the Ch'an pantheon of eccentrics.

There are two other Ch'an stories, which possibly could be relevant to this theme. The first concerns the monk Wên-shu Ssŭ-yeh who started his career as a butcher. One day, on the point of killing yet another pig, he suddenly realized the error of his ways in a flash of revelation. He quit his trade to become a monk and composed the following *gāthā* on the occasion:

Yesterday the heart of a [bloodthirsty] Yaksa,
Today the face of a Bodhisattva.
Between the Bodhisattva and the Yaksa
There is not a shred of difference.

When he went to Master Tao of Wên-shu, who was to become his teacher, the Master asked him: "What did you see when you were about to slaughter that pig? What made you shave your head and depart on a pilgrimage?" Ssŭ-yeh thereupon made a gesture as if he were whetting his knife.

Another possibility is that the representation of "Pig's Head" was inspired by an anecdote from the life of P'an-shan Pao-chi (720-814), a pupil of the great Patriarch Ma-tsu Tao-i (died 788). One day he saw a man in the marketplace enter a butcher's shop to buy meat. He heard him ask: "Please cut me a catty of the finest." The butcher dropped his knife, picked it up again and said: "My dear sir, what do we have here that is not of the finest?" Upon hearing these words Pao-chi suddenly attained Enlightenment.

Although the exact source of the representation of "Pig's Head" is uncertain, it is evident

58. *Kensu* by Yōgetsu (active late 15th century)
Facing page: *Chotō* (detail)

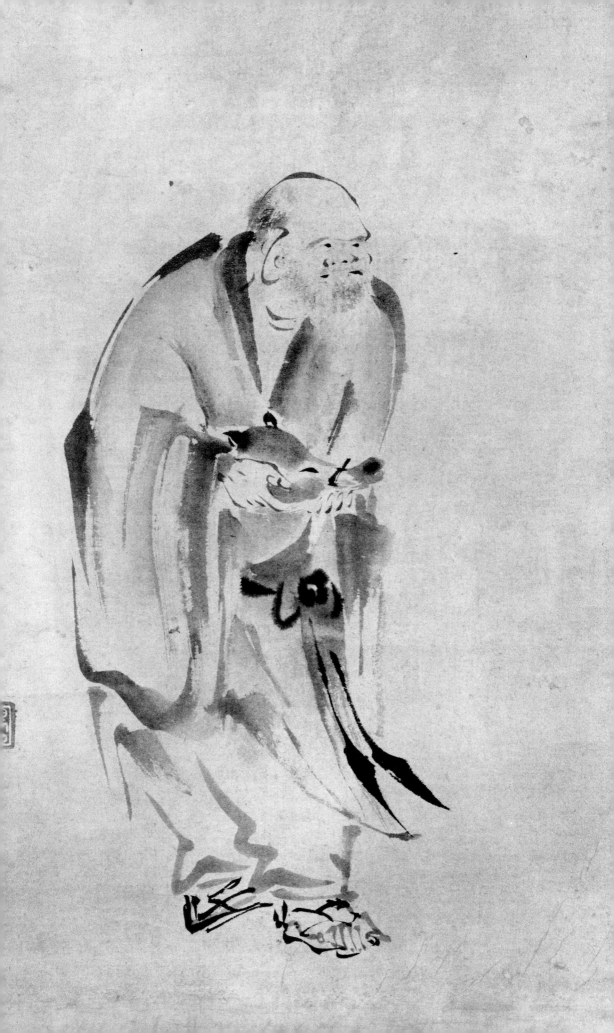

that the two companion themes must have originated among the artists of the Sung period. "Pig's Head" makes his first appearance in a painting attributed to Liang K'ai (formerly in the Masuda Collection). From existing Japanese sketches after Chinese paintings, we know that Liang K'ai must have painted this theme more than once. In this connection it may be of interest to note that Ta-ch'uan P'u-chi, in whose work the story of Hsien-tzŭ is told in great detail, wrote a colophon on one of Liang K'ai's paintings and may well have known the artist personally.

From an artistic point of view, the few surviving early representations of the Hsien-tzŭ theme are the most important. Hsien-tzŭ is shown in a very fine painting by Mu-ch'i (Hinohara Collection) and in an early Japanese *suiboku* painting by Kaō (Tokyo National Museum). Yōgetsu's version of these themes, although painted with great skill and elegance, does not have the lively strength of the earlier works. This may perhaps explain the critical opinion of the author of the *Honchō Gashi,* who describes Yōgetsu's brushwork as coarse and his style as soft and sleek.

REFERENCES:
Kano Einō, *Honchō Gashi* (Nihon Garon Taikan), p. 985; *Kokka,* no. 114 (Masuda Liang K'ai); *Kokka,* no. 213 (Hotei); *Gakō Benran* (Nihon Garon Taikan), p. 1097.

59

THE TŌFUKUJI MONASTERY
Traditionally attributed to Sesshū Tōyō
(1420-1506)
Description above painting by Ryōan Keigo, dated 1505
Hanging scroll, ink on paper, 82.9 x 152.8 cm.
Tōfukuji, Kyoto
Registered Important Cultural Property

Ben'en Enni (1202-1280; later known as Shōichi Kokushi) established the Jōtenji at Hakata in 1242. After a setback in the temple's fortunes because of opposition from Tendai sect followers (see cat. no. 8), he went to Kyoto, where Eisai had founded the first Zen institution, the Kenninji, almost half a century earlier. Soon after his arrival in the capital, Enni was appointed to the abbotship of the Tōfukuji.

In 1236 the Regent Kūjō Michiie, inspired by the great monastery building projects of the past, had begun to construct a compound of very ambitious dimensions along the southern extremity of the Higashiyama, a chain of hills marking the eastern perimeter of Kyoto. He had borrowed one graph from each of the names of the two largest and most powerful temples erected in the eighth-century capital of Nara, the Tōdaiji and Kōfukuji, combined them, and so formed the name of his commodious brainchild, the Tōfukuji. Three years later the main roof beam of the *butsuden* (Buddha hall) was set in place. This was the first structure in the monumental project to take shape, but due to its size and elaborateness it was not completed until 1255. Its gigantic sibling, the *hattō* (Dharma hall), was not finished until 1273.

It was under Enni's supervision that the compound acquired its final form, inspired to some degree perhaps by the sprawling Ch'an monastery on Mount Ching, the Wan-shou-ssǔ, where he had studied under Wu-chun Shih-fan (see cat. no. 8). Although the Tōfukuji may have equalled the largest Chinese monasteries in scale and been similar in layout, it seems less likely that in architectural style it emulated Sung tradition very closely, and it was not until the erection of the Kenchōji in Kamakura (see cat. no. 21) that a true replica of a Ch'an complex was finally realized in Japan.

At the Tōfukuji, as at the Kenninji, certain doctrinal accommodations seem to have been imposed by the older, entrenched Esoteric sects. Thus, both Tendai and Shingon rites were observed there, and portraits of the Eight Patriarchs of the Shingon sect were installed and worshipped. Enni may not have been particularly opposed to such syncretic practices, for he himself had been a Tendai monk and is also known to have introduced Neo-Confucian ideas into Japan. In the decades after Enni's death the monastery met with a series of misfortunes: the soldier's torch took its toll, and various natural disasters, including a severe earthquake, did great damage. It was gradually restored during the fourteenth century, however, and remained for the most part intact until 1881, when it was again badly damaged by fire.

The painting exhibited here shows the Tōfukuji as it appeared about 1500. It is seen from the west, with the Higashiyama hills in the background. Following a long-standing tradition in Buddhist architecture, Zen com-

59. *The Tōfukuji Monastery,* traditionally attributed
to Sesshū Tōyō (1420-1506)

pounds were usually laid out so that they faced south, although there were certain exceptions to this practice. In contrast to the great metropolitan temples erected in earlier times, the most important early Zen compounds (with the exception of those intentionally built in remote places) were erected on the outskirts of either Kyoto or Kamakura, generally on a gentle incline with hills behind them. The selection of this type of terrain for temple sites, which followed continental Ch'an precedent, led to the custom of referring to Zen monasteries as "mountains."

The painting shows the main nucleus of monumental ceremonial structures at the center, surrounded by clusters of sub-temples and subsidiary compounds. The foot of a steep hill appears at the extreme right. This natural obstruction prevents entrance into the temple grounds in the usual manner from the south: instead, one passes first through the *sōmon* (the two-story gate) which faced west, in the middle of a recessed section of the plastered earth wall, turns left, and crosses a flat stone bridge over a lotus pond. The visitor thus comes to the first of the three monumental structures that make up the central nucleus of the monastery, the *sammon* (written either as the "Triple Gate", in reference to the three passages between the columns, or as the "Mountain Gate", in reference to its function as the entrance to the "Mountain" or Zen temple). Behind it, in succession, are the *butsuden* ("Buddha hall") and the *hattō* ("Dharma hall"), massive formal buildings designed for the largest and most imposing ceremonial functions. These three structures (and the *sōmon* in the standard plan) are situated along a rigid central axis and flanked by subsidiary buildings at each side, giving a balance and symmetry to the compound as a whole. To the left of the axis at the Tōfukuji are the *tōsu* ("latrine") and *zendō* ("meditation hall") which balance the *yūshitsu* ("bath") and *kūri* ("storehouse") on the right. This symmetry was further enhanced by a variety of subsidiary structures such as the abbot's quarters, refectory, bell tower, and *sūtra* storehouse. Situated around the periphery of this central compound were the *tatchu* ("sub-temples"). In Zen, as in Ch'an before it, each of the larger monasteries was headed by an abbot, and the most distinguished monks who reached this office were often invited to serve, consecutively, at more than one of the great institutions. It was also general prac-

tice for abbots to serve for rather short periods, usually no more than a few years, at one institution. After retirement, it was common for these men to move to semi-independent "hermitages" or sub-temples, where they could devote the last years of their lives to more purely religious (rather than institutional) activities. In China, the term *tatchu* was used to refer to a complex of buildings built around the graves of one or more of the eminent priests of the temple that included the living quarters of the monks who protected and performed the ceremonial rites for the graves. Such complexes were limited in number at the Chinese temples. In Japan, however, from the late thirteenth century on, the term *tatchu* also came to be used for the residences of retired abbots (which were also known as *ankyo*). During the Muromachi period, *tatchu* proliferated to such an extent that the building of new compounds was prohibited from time to time by the government. Records indicate that there once were one hundred and twenty *tatchu* in the Tōfukuji and one hundred and sixty-five in the Myōshinji. These compounds tended to become independent of the parent monastery, with their own land and resources, and many became the headquarters for doctrinal offshoots based on the special emphasis or teachings of the founder.

Between the mountains to the rear and the *sammon* is a five-storied pagoda. Although medieval Zen monasteries were often graced by this traditional Buddhist structure, it was usually situated some distance from the main buildings, indicating the lack of emphasis given to it in Zen architecture. It is not clear whether the pagoda is part of the Tōfukuji or of a separate temple, perhaps the Sen'yūji, which is located a short distance away. The bridge just left of center is the Tsūten-bashi, first erected by Shun'oku Myōhō in 1380, and rebuilt in 1597 by Hideyoshi. This spot is famous to the present day for the beauty of its maple leaves in the autumn.

Because of its detail and accuracy, this painting is one of the prime sources of information on the disposition and architecture of Zen monasteries during the Muromachi period. It is traditionally attributed to Sesshū (1420-1506) (see cat. no. 55), who may have been associated briefly with the Tōfukuji.

The inscription, written by Ryōan Keigo (died 1514?) is on a separate sheet of paper, and was added to the painting in 1505. It gives a brief factual description of the Tōfukuji, men-

59. *The Tōfukuji Monastery,* traditionally attributed
to Sesshū Tōyō (1420-1506) (detail)

tioning such things as the buildings, the main sculptural images installed there, the personnages associated with the monastery's history, neighboring religious institutions, and subtemples. Keigo was a monk at the Tōfukuji who participated in a diplomatic mission to China in 1511 when he was quite advanced in age, and the noted Neo-Confucian scholar Wang Yangming is said to have honored him by seeing him off when he returned to Japan.

REFERENCES:
Muromachi-jidai, Nihon Bunkashi Taikei, vol. 7 (Tokyo, 1958), pl. 239; Imaeda Aishin, *Zen-shū no Rekishi*, Nihon Rekishi Shunsho, suppl. ser., no. 93 (Tokyo, 1969); Heinrich Dumoulin, *A History of Zen Buddhism* (New York, 1963), pp. 144-148; *Zendera to Sekitei*, Genshoku Nihon no Bijitsu, vol. 10 (Tokyo, 1966); Robert Treat Paine and Alexander Soper, *The Art and Architecture of Japan* (Baltimore, 1955), pp. 239-249; *Nihon Shaji Taikan: Ji-in* (Kyoto, 1935), pp. 424-426 (history of Tōfukuji).

60

A FRESH TURNIP
Artist unknown, late 15th century; colophon by Shumpo Shūki (1409-1496)
Hanging scroll, ink on paper, 36.7 x 54.9 cm.
Jōfukuji, Kyoto

The Chinese monochrome paintings in Japanese collections that are attributed to the great monk-painter Mu-ch'i (see cat. no. 10) include several pieces representing fruit and various kinds of vegetables. While the *Persimmons* and *Horse Chestnut* in the Daitokuji are probably the most familiar of these works, another pair representing a radish and a turnip are also of very high artistic quality. This pair, now in the Imperial Household Collection, once belonged to the Ashikaga Shōguns. Over the centuries, they have been greatly admired, particularly by devotees of the Tea Ceremony who regarded them as ideal paintings to hang in the *toko-no-ma* (painting alcove) during certain ceremonies.

Several Japanese painters, inspired by Mu-ch'i, used his vegetable paintings as models for their own work. Consequently, a number of more or less free copies of Mu-ch'i's *Turnip* are

known to exist, including one by the noted artist Sesson (1504-post-1589). The painting shown here is the work of an as yet unidentified amateur painter whose seal appears in the lower left corner of the scroll. A copy of a famous painting executed in an amateurish fashion does not have stylistic features which give an easy clue to its date. In this case the poem inscribed above the painting fortunately provides a *terminus ad quem*. It was written by Shumpo Shūki, a priest of the Nanzenji in Kyoto, who lived from 1409 to 1496.

The gardener knows that for a well-flavored soup;
The turnip must be pulled up fresh, still full of the aroma of wind and dew.
Its leaves are big as those of the banana tree; its root is large and stout.
And in a single stalk there are two sorts of names.

The cryptic last line may be an allusion to a paradoxical passage in a "song" in the *Green Cliff Record:* "One has many types, but two has no two sorts." However, even if specific Zen ideas are expressed in this last line, one cannot escape the impression that the Zen priests who painted, inscribed, or admired paintings of this type were inclined to associate the turnip with gustatory pleasure rather than meditation. This idea is supported by the first two lines of the poem, which sound like a poetic recipe, and is confirmed by the inscriptions on the *Turnip and Radish* by Mu-ch'i, in which "the guest" is invited to taste them. Instead of expressing profound symbolism, as some authors have assumed, pictures of this type may, by representing ingredients of the simple and frugal fare served in Zen monasteries, merely be a cordial invitation to share the Zen experience.

REFERENCES:
Kokka, nos. 486, 489 (Mu-ch'i's *Turnip* and *Radish*); *Zen Bunka*, no. 53 (June 1969), frontispiece (Sesson).

61

NIGHT HERON
Tan'an Chiden (active late 15th–early 16th century)
Hanging scroll, ink on paper, 32.9 x 49.1 cm.

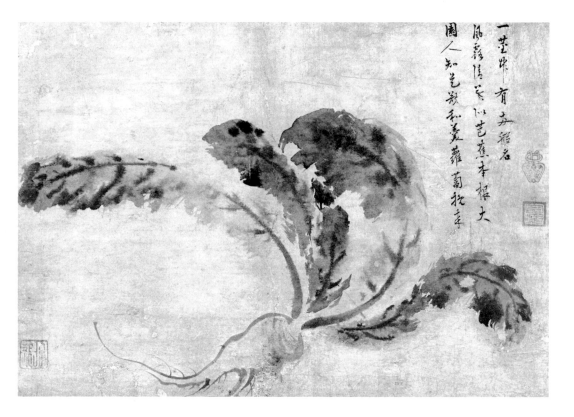

一莖米有母稻名

風穆陽葉似芭蕉本根大

圍人知芭敏和羹蘿蔔托年

60. *A Fresh Turnip,* artist unknown, late 15th century

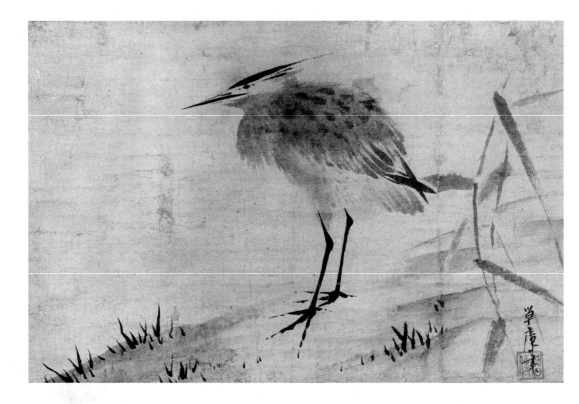

61. *Night Heron,* by Tan'an Chiden (active late 15th–
early 16th century)

Tokyo National Museum
Registered Important Cultural Property

According to the *Tōhaku Gasetsu* ("Talks on
Painting") by the painter Hasegawa Tōhaku
(1539-1610), Tan'an Chiden was the son of an
artisan of Amagasaki (near Osaka). His father
trained him to decorate handicraft, which he
did until the famous painter Sōami (died 1525)
invited him to become his pupil. He died at the
early age of twenty-five or twenty-six after
having caused a scandal because of his homo-
sexual tendencies. His premature death explains
the scarcity of works by his hand.

The Heron was a favorite subject of the early
Japanese *suiboku* artists, and both Mokuan and
Ryōzen (see cat. no. 34) painted birds of this
family. The species represented in Chiden's
painting in the Tokyo National Museum is a
Goisagi or Night Heron (Nycticorax Nycticorax).
The same species is also represented in a paint-
ing by Mokuan, and in another work by Chiden
in the Boston Museum of Fine Arts. The *Tōhaku
Gasetsu* mentions the painting by Mokuan and
its inscription by the Chinese Ch'an monk
Ch'u-shih Fan-ch'i (see cat. no. 13) reading:
"When the water becomes clear, fishes appear."
Although this phrase can be taken as a mere
statement of fact, it is likely that it has a specific
Ch'an connotation. Muddy water becoming
clear might symbolize the disappearance of
delusion, while the swift, unerring movement of
the bird catching his glittering prey could be
compared to the Zen Buddhist's experience of
Sudden Enlightenment.

In this painting, Chiden reveals his great skill
in brush technique and in the use of different
tones of black ink. The bird's beak, plume, and
legs have been drawn in rapid, incisive, black
strokes; whereas the feathers have been dabbed
in wet strokes of varying values of gray. The
shoreline is indicated by a single reed and a few
strands of grass.

REFERENCES:
Bijutsu Kenkyu, no. 16 (1933), pp. 35-38; *Pageant
of Japanese Art* (Tokyo, 1952), II, pl. 61; Nakamura
Tanio, *Boku-e no Bi* (Tokyo, 1959), frontispiece;
Museum of Fine Arts, Boston: Oriental Art
(Boston, 1969), pl. 48; *Tōhaku Gasetsu*, ed.
Minamoto Toyomune (Kyoto, 1964), p. 21, no. 74.

62

THE PATRIARCH RINZAI GIGEN (LIN-CHI
I-HSÜAN; died 867)
Shabaku Gessen (active late 16th century)
Hanging Scroll, ink and colors on silk,
36.5 x 29.1 cm.
Geijutsu Daigaku, Tokyo

From a historical and cultural standpoint, the
most vigorous and influential line of Ch'an-Zen
is the Lin-chi (Japanese: Rinzai) sect founded by
the dynamic monk Lin-chi I-hsüan (Rinzai
Gigen; died 867). This sect was one of the
"Five Houses" in China, and when its vigorous
roots were transplanted to Japan during the
Kamakura period (1185-1333), it not only came
to exercise a dominant role in religious matters,
but also extended its enlightening influence into
other realms of Japanese life so that it eventually
became part of the fabric of Japanese culture.

Rinzai's teachings emphasized the concept of
"sudden" enlightenment, and the methods used
to gain this end stand out in sharp contrast to
the "quietistic" or "intellectualistic" tendencies
which developed in other branches of Zen.
Rinzai himself abominated rationalization and
systematization, and it is one of the ironies of
religious history that bookish Zen clerics of a
later period produced commentaries in which
his "doctrines" are codified. He championed
the visceral, spontaneous Zen experience and is
famous for using the shout *katsu* (Chinese: *ho*)
as an expedient means to assist in the compre-
hension of Reality. (The practice of shouting
was developed by Ma-tsu [see cat. no. 17] and
later advocated by Yün-mên, who used the
exclamation *kuan* [Japanese: *kan*]). Rinzai is also
associated with the use of vigorous blows with
the hand, and this accounts for the determined
manner in which his right hand is clenched in
certain representations.

Although the patriarch is seated here, there is
nothing relaxed about his posture. He is filled
with a latent, volcanic energy and seems on the
brink of some decisive act that will create the
psychological crisis needed to bring one of his
students to an understanding of Zen truth. This
sense of high tension is expressed through his
clenched fist and his resolute, animated counte-
nance, with its trenchant eyes, and half-open
mouth. He seems about to shake the surround-

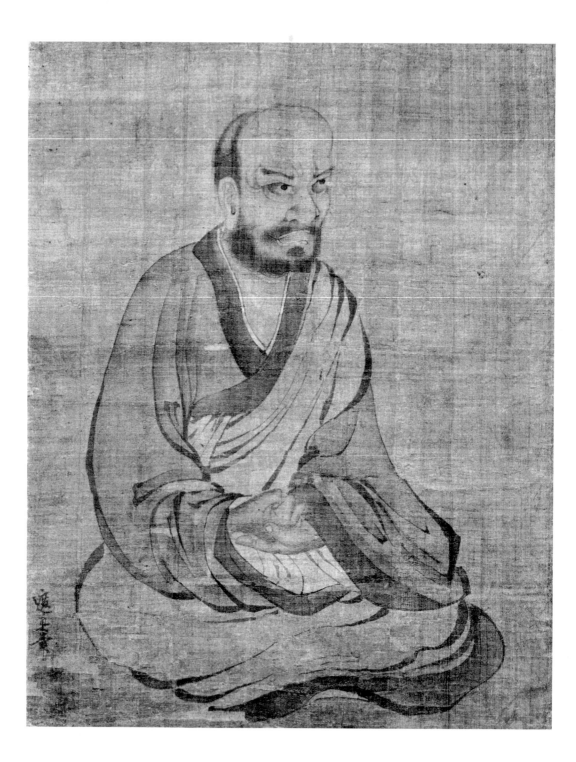

62. *The Patriarch Rinzai Gigen* by Shabaku Gessen
(active late 16th century)

ings with a resounding *katsu*.

In the lower left-hand corner of the painting is the signature of the artist, Shabaku, an obscure painter whose works seem to have been preserved in only two examples: this portrait and a competently rendered painting of birds, plum blossoms, and grass, which bears a round seal reading *Hōzai*, and is reproduced in *Kokka*. Traces of a seal imprint appear below the signature on the Rinzai portrait also, but are unfortunately illegible. There are brief notices dealing with Shabaku in the *Honchō Gashi* and in the *Koga Bikō*. They indicate that he was a monk who used the sobriquet "Gessen", that he "studied the style of Shūbun", and that his brushwork was "vigorous and refined." He is said to have been good at various subjects: figures, landscapes, and birds and flowers, and to have worked in both ink-monochrome and colors. Only one painting is mentioned, a representation of Shōki on horseback, which is likened stylistically to the works of Yamada Dōan (another sixteenth-century painter). Shabaku is said to have been active during the fourth quarter of the sixteenth century.

Shabaku's portrait of Rinzai is a very skillfully executed copy of a subject that was painted at least as early as the third quarter of the fifteenth century. Two early examples exist, both traditionally attributed to the enigmatic master Soga Jasoku (see cat. no. 53) and preserved in subtemples of the Daitokuji. The earliest is probably the superb piece in the Shinjuan, with a colophon written by Ikkyū Sōjun (see cat. nos. 51, 52 and 53). It is not dated, but the signature reads, "seventh in Kidō's line," a term Ikkyū did not begin to use until 1459. While the piece has very faint touches of color, it is essentially an ink-monochrome conception and is executed with great vigor and confidence. The second piece is the left-hand part of a triptych (now in the Yōtokuin) composed of three separate hanging scrolls, with a half-torso representation of Bodhidharma in the center, and a seated version of Tokusan to the right. Tokusan is a fitting complement to Rinzai, for Rinzai's shout and Tokusan's stick are two important features of the vigorous approach to enlightenment characteristic of the Rinzai sect. None of the paintings in the triptych has a colophon or date. The brushwork in the Yōtokuin representation appears more calculated and perhaps less vital than that in the Shinjuan version, and if a choice were to

be made, the latter would have to be called the prototype. The fact that the Shinjuan version has the Ikkyū colophon lends support to this thesis. Hasumi Shigeyasu has pointed out these facts, but his suggestion that the Shinjuan piece is from the hand of Bokkei, while the Yōtokuin triptych was done by Jasoku, interesting though it is, needs further evidence to substantiate it. The Shabaku painting is probably a copy of the Yōtokuin example rather than the Shinjuan version, because the contrasting areas of color and value present in the first two examples do not exist in the last.

REFERENCES:
Hasumi Shigeyasu, "Bokkei Hyobu and Dasoku Soga" (in Japanese) *Bukkyō Geijutsu* 43 (July 1960); "Shabaku-hitsu Kachō-zusetsu" [Paintings of birds, plum blossoms, and grass], *Kokka*, no. 539; Okisada Asaoka, *Koga Bikō* (Tokyo, 1905), I, pp. 332-333; Heinrich Dumoulin, *The Development of Chinese Zen after the Sixth Patriarch in the Light of Mumonkan* (New York, 1953); Heinrich Dumoulin, *A History of Zen Buddhism* (New York, 1963); Tōkyō Geijutsu Daigaku, *Zōhin Zuroku: Kobijutsu*, vol. I, *Kaiga* (Tokyo, 1962); "Jasoku," *Kokka*, no. 77 (Yōtokuin portrait of Rinzai); *Kokka*, no. 136 (Yōtokuin portrait of Tokusan); *Kokka*, no. 349 (Yōtokuin portrait of Bodhidharma); *Daitokuji, Hihō*, vol. 11, pl. 59 (Shinjuan portrait of Rinzai).

63

SHIH-KUNG AND SAN-P'ING
Traditionally attributed to Kano Motonobu (1476-1559)
Hanging scroll, ink and colors on paper, 175 x 90.8 cm.
Tokyo National Museum
Registered Important Cultural Property

This picture is one of a group of twenty-two paintings that once decorated the sliding doors of the abbot's quarters in the Daisen-in, a building which is part of the Daitokuji complex in Kyoto. Some of these paintings depict birds, flowers, trees, and rocks, while others represent Chinese legendary figures such as Hsi-wang-mu and Tung-fang-shuo. Six of the panels, two large and four narrow in format, are typical *zenkiga* and depict famous Zen incidents de-

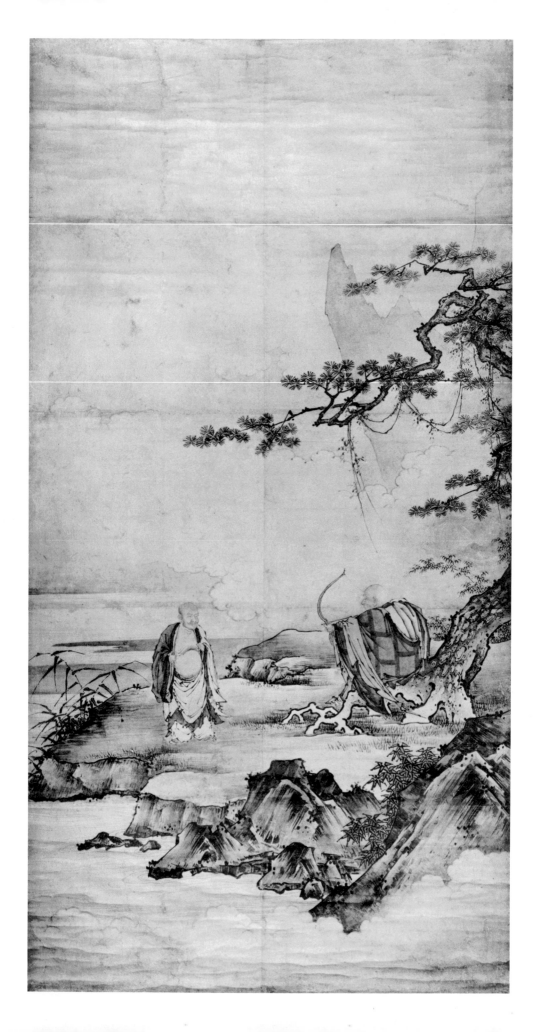

scribed in *The Record of the Transmission of the Lamp* (ca. 1004).

The painting shown here illustrates the confrontation between the Ch'an master Shih-kung Hui-tsang, a disciple of Ma-tsu Tao-i (709-788), and his pupil San-p'ing I-chung. Shih-kung, who had been a hunter before Ma-tsu converted him to Ch'an Buddhism, used to receive his students with his bow bent and an arrow trained at them. When San-p'ing came to see him, Shih-kung shouted, "Watch out for the arrow!" San-p'ing, baring his chest, said to him, "That is the arrow that kills men. Where is the one that brings them back to life?" Shih-kung removed the arrow and twanged the bow-strings three times, whereupon San-p'ing bowed. "For the past thirty years" said Shih-kung, "I have been using this same bow and two arrows, and all I have managed to shoot is one half of a saint." Thereupon he broke his bow and arrow. (*The Record of the Transmission of the Lamp,* ch. 14.) The first time he had broken his bow was when he had been converted by Ma-tsu and had given up hunting deer. The fearless attitude of the novice San-p'ing convinced him that he should give up his bellicose behavior toward his pupils.

This group of paintings has long been attributed to Kano Motonobu (1476-1559). The vague contours of the mountain in the background of *Shih-kung and San-p'ing,* the gnarled pine tree, and the textural strokes on the rock in the foreground clearly point to the continued emulation of the Chinese styles of the Sung and Yüan periods. But Motonobu's superb eclecticism is revealed in his sensitive blending of different styles and of a variety of techniques, in which the *suiboku* and polychrome painting traditions are skillfully combined. By incorporating the polychrome traditions of medieval Japanese handscroll painting into the main current of inherited Chinese styles, which had been handed down by artists such as Josetsu and Sesshū, the early artists of the Kano school laid the foundations for an entirely new style, admirably suited for the decorative purpose for which it was created.

The production of paintings that were both decorative and edifying, such as this set of *zenkiga* made for sliding doors, was not an innovation of the Kano school but can be traced back as far as the late thirteenth century, when a famous Zen meeting was depicted on a wall in the Nanzenji (see p. 62). It is not known whether

Motonobu was the first artist to revive the painting of large-scale *zenkiga.* As he received his formal Zen training from the noted Zen monk Sōkyū, he may indeed have taken this initiative.

The Daisen-in was founded in 1513, and it is likely that the paintings from the abbot's quarters that are attributed to Motonobu date from about that time. About a century later the tradition of decorating the abbot's quarters with *zenki* themes was continued by Hasegawa Tōhaku in several temples. In the Shinjuan, adjacent to the Daisen-in, he painted *fusuma* representing Kensu and Chotō (1601), and a year later he decorated the abbot's quarters of the Tenjuan (Nanzenji) with a set of paintings depicting famous Zen stories. Less permanent and more easily removable sets of paintings of the same type were made on folding screens. A set of twelve such pictures, applied to a pair of six-panel folding screens, are in the Ryōsoku-in, Kyoto. A pair of screens in the collection of Mr. and Mrs. John G. Powers have been identified as the work of Hasegawa Tōhaku's son Sakon. These screens bear inscriptions by the Ch'an priest Takuan (1573-1645) (see cat. no. 66). One of the scenes depicted on them shows Shih-kung and San-p'ing in what is essentially the same juxtaposition and manner as the Daisen-in painting, but without the landscape setting. The Daisen-in panel obviously served as a prototype for Sakon's painting.

REFERENCES:

Kokka, no. 372; *Tokyo National Museum* (Tokyo: Kōdansha, 1966), I, explanation p. 38; Mayuyama Junkichi, *Japanese Art in the West* (Tokyo, 1966), pl. 172; *Zaigai Hihō: Japanese Paintings in Western Collections* (Tokyo, 1966), II, pl. 8 (Hasegawa Sakon); *Nishi Honganji,* Shōhekiga Zenshū (Tokyo, 1969), pp. 97-99 (the Ryōsoku-in screens); *Kokka,* nos. 337, 245 (other paintings of the Daisen-in set); *Nihonga Taisei,* vol. 5 (Tokyo, 1931), pls. 30-31; Daisetz Suzuki, *Essays in Zen Buddhism,* 2d ser. (London, 1933), pp. [95], 166, 178 (Shih-kung and San-p'ing).

Facing page:
63. *Shih-kung and San-p'ing,* attributed to Kano Motonobu (1476-1559)

64

YUIMA KOJI (THE LAYMAN VIMALAKĪRTI)
Tōshun (active early 16th century)
Hanging scroll, ink and slight colors on paper,
111.5 x 55.4 cm.
Umezawa Kinenkan, Tokyo

Little is known about the life of the painter
Tōshun. According to one legend, he was a
young groom whose talent for painting horses
was first discovered by Shūbun. A perhaps more
reliable account of his life is that which is found
in the *Tōhaku Gasetsu* ("Talks on Painting") by
Hasegawa Tōhaku (1539-1610). It claims that
Tōshun was a carpenter's apprentice at the
Daibutsuden ("Great Buddha Hall") of the
Tōdaiji in Nara, where he was discovered by the
great painter Sesshū, who accepted him as a
pupil. The same source records that the paint-
ings on the sliding doors of the Ryūgen-in of the
Daitokuji were executed by Tōshun. As this
temple was built in 1506, these paintings, which
are now lost, would seem to be the earliest
recorded works of the master.

The layman Vimalakīrti (Japanese: Yuima koji)
of Vaiśālī, a contemporary of the Buddha Śākya-
muni and a man of great wisdom and learning
with a superb debating skill, is the hero of the
Vimalakīrti-nirdesa, a Buddhist text which may
be regarded as an early compendium of Mahāy-
āna doctrine. Vimalakīrti's feigned illness, a
device to attract visitors to whom he could
expound his views on the "disease of exist-
ence"; his famous debate with the Bodhisattva
Mañjuśrī; and his silence "like a peal of thunder"
anticipated in many ways the ideas which were
to become popular with the rise of the Ch'an
sect. Although Vimalakīrti was never singled
out for special devotion by one particular sect,
he enjoyed for many centuries a suprasectarian
popularity as the embodiment of secular Bud-
dhist wisdom. Representations of his debate
with Mañjuśrī appear frequently among the
reliefs in Chinese cave temples of the Six
Dynasties period, and portraits of him were
painted throughout the history of Chinese
painting.

In Japan, where sculptural representations of
Yuima koji were carved as early as the beginning
of the Heian period, painted portraits of the sage
seem to have become popular with the rise of
suiboku painting. One of the earliest examples is
the portrait by Bunsei, dated in accordance with

1457, in the Yamato Bunka-kan, Nara. The por-
trait by Tōshun is unusual in that both the fly
whisk and fan, the usual attributes of Vimala-
kīrti, are missing. The bearded sage, whose
hair is tied in a knot and covered with a thin
head cloth which denotes infirmity, has the look
of an invalid. The wrinkles in his face and his
hair and beard are drawn with thin lines; the
folds of his clothes and his head cloth are drawn
in thicker, darker lines. The painting is in-
scribed with the following verse:

The doctrine of non-duality is what he especially
 transmits;
In the city of Vaiśālī he eliminated the causality
 of earthly existence;
This old man shows his sickness, yet he is
 not sick;
With silence like a thunderclap he shakes the
 entire universe.

 Tōki Eikō

Tōki Eikō was a priest of the Kenninji, Kyoto,
who had entered that temple in 1530 and who
died there in 1542. Although the date of his
death gives a *terminus ad quem* for the painting,
it may well have been painted long before the
author of the colophon passed away. In addition
to the signature and seal of Tōki Eikō, the paint-
ing bears two seals by the artist.

REFERENCES:
Matsushita Takaaki, *Suiboku Painting of the
Muromachi Period* (Tokyo, 1960), pl. 54; Tanaka
Ichimatsu, "Tōshun gasetsu," *Kokka*, nos. 888,
890, reprinted in *Nihon Kaigashi Ronshū* (Tokyo,
1966), pp. 383-449.

65

CALLIGRAPHY: "TEA AND RICE"
Kōgetsu Sōkan (1574-1643)
Hanging scroll, ink on paper, 125.4 x 25.9 cm.
Collection of Nemoto Kenzō, Tokyo

Kōgetsu Sōkan was the son of a noted tea master,
Tsuda Sōkyū (died 1591), who served Oda
Nobunaga and Toyotomi Hideyoshi, the most
powerful military figures of the period. Sōkyū
was one of the organizers of the Great Tea
Ceremony held at Hideyoshi's order at the
Kitano shrine in Kyoto in 1587. This was a
gigantic affair that attracted feudal lords from all

Facing page:
64. *Yuima koji (The Layman Vimalakīrti)* by Tōshun
(active early 16th century)

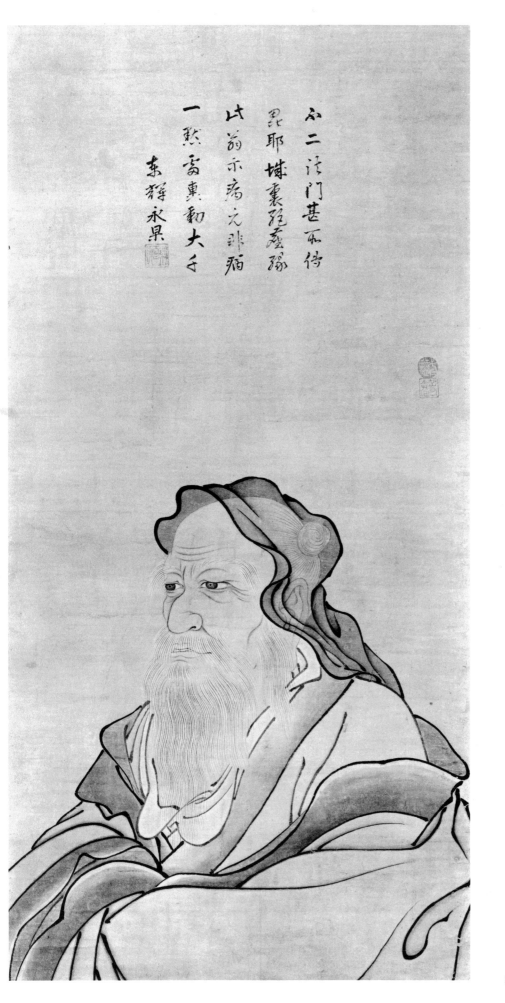

不二法門甚不傳
毘耶堆裏孤庭孫
此翁示疾元非病
一默高東動大千
東郊永昊
[印]

over the country, bringing their prized Tea Ceremony objects such as tea bowls, tea caddies, and other utensils. Kōgetsu thus became familiar with the Tea Ceremony as a child. (Later, at the Daitokuji, one of his fellow students was Kobori Enshū, who became one of the most influential tea masters of his generation.)

After being raised in an atmosphere of aesthetic refinement, Kōgetsu was trained as a Zen monk at the Daitokuji. He became the pupil of Shun'oku Shuon (1529-1611) and a fellow student of Takuan Sōhō (1573-1645) (see cat. no. 66). In 1630 he was invited to Hirado (Kyūshū) by the feudal lord of that region. This was shortly before the uprising at Shimabara, in which thousands of Japanese Christians were slaughtered because of their faith. For a while Kōgetsu was under suspicion of having embraced the foreign religion, but he succeeded in clearing himself of this and returned to the Daitokuji, where he died, at the Ryūkō-in, in 1643.

Calligraphic skills had been highly regarded at the Daitokuji since its founding by Daitō Kokushi (see cat. no. 26). The greatest artist that this tradition produced was Ikkyū Sōjun (1394-1481) (see cat. no. 52), and Takuan Sōhō and Kōgetsu Sōkan were the central figures in the renaissance of this tradition. In contrast to the refined and supple style of Takuan, the work of Kōgetsu is rough and has a strong impact.

The calligraphy reads "When I happen upon tea, I drink tea; when I encounter rice, I eat rice." The motto is an expression of the relaxed and carefree attitude of the enlightened tea devotee who takes life as it comes. It is written in the bold, impulsive manner which is the hallmark of this artist. He allows his thick brush to dry, so that the last characters written with it have a thinner, scratchy appearance, and their basic structure is clearly revealed. They contrast with the solid, pitch-black forms of the characters that were done first, just after the brush had been dipped into the ink.

66

CALLIGRAPHY: "KIKAN"
Takuan Sōhō (1573-1645)
Hanging scroll, ink on paper, 32.8 x 83.5 cm.
Collection of Hosokawa Moritatsu, Tokyo

65. *Calligraphy: "Tea and Rice"* by Kōgetsu Sōkan (1574-1643)

Takuan Sōhō, the son of a *samurai* from Tajima (present-day Hyōgo Prefecture), studied Zen at the Daitokuji under Shun'oku Shuon (1529-1611), who was also the teacher of Kōgetsu (see cat. no. 65) and the tea masters Kobori Enshū and Furuta Oribe. In 1609 Takuan became the abbot of the Daitokuji. Twenty years later, when a conflict broke out over the line of succession at the Daitokuji, he was reprimanded by the Shōgun. Determined to submit a memorial on the matter, he traveled to Edo with Kōgetsu. This rash action was looked upon with disfavor by the Shōgun, and he was banished to Dewa. Three years later he was pardoned and allowed to return to Kyoto. In 1637 his relations with the Bakufu had improved considerably. At the invitation of the Shōgun Tokugawa Iemitsu he went to Edo, where he was allowed to found the Tokaiji at Shinagawa, a suburb of the capital.

Takuan is known as the stern master who initiated Miyamoto Musashi into the secrets of Zen and its mental training for swordsmanship (see cat. no. 67). His name is still a household word in Japan because he invented a practical, simple method of preserving *daikon* (a large, white radish) that is known as *takuanzuke*. Like many other Zen priests of his time, he occasionally painted. His great fame, however, rests upon his calligraphy. He especially liked the horizontal format, writing one or two characters in bold script on the right and adding an explanation or verse in smaller script on the left. The most famous of his works of this type is the calligraphic piece *Dream,* in which the word is followed by a poem. It is Takuan's last work, written as he lay dying, a brush in his hand.

The example shown here with the Zen term *kikan* conforms to the general layout and style of Takuan's *Dream.* The large characters are written in a dynamic running script, whereas the explanation is written in *sōsho* ("cursive" script). The stylistic resemblance of *Kikan* to Takuan's last work, suggests that this piece of calligraphy was executed in the monk's later years.

Kikan (literally, "mechanism") is a technical term used specifically to denote the so-called "interlocking of differentiation." Once the Zen adept has achieved *kensho,* that is, insight into his own real nature, he has passed the first stage of Enlightenment. From there, he has to proceed to a phase in which he must grasp the idea of differentiation. This is done, step by step, through the study of *kōan* that deal especially with this aspect of the Zen truth. Such *kōan* are therefore called *kikan-kōan.* In his explanation Takuan traces the idea of *kikan* to the Chinese Ch'an masters Lung-t'an Ch'ung-hsin and his pupil Tê-shan Hsüan-chien (ca. 781-865).

REFERENCES:
Nihon Bijutsu Kōgei, no. 309 (1964), no. 6, pp. 29-33; *Shodō Zenshū,* vol. 22 (Tokyo, 1959), p. 188; Isshū Miura and Ruth Fuller Sasaki, *Zen Dust* (Kyoto, 1966), pp. 49-51.

66. *Calligraphy: "Kikan"* by Takuan Sōhō (1573-1645)

故六身心忘自性
替与兩手午眠煙
布袋拄杖陸不却
参湁飞宫呼与響

亀山六野袖隨縁子讃

67

SLEEPING HOTEI
Miyamoto Musashi (1582-1645)
Hanging scroll, ink on paper, 101 x 39 cm.
Collection of the Nihon Bijutsu Tōken Hōzon
Kyōkai, Tokyo

Miyamoto Musashi, usually referred to by this painter's sobriquet, Niten, was a swordsman of almost legendary fame. Born in Harima, he was adopted into the Miyamoto family of *samurai* who served the Daimyō Katō Kiyomasa. He developed the two-sword style of fencing (*nitōryū*) and studied Zen Buddhism under Takuan Sōhō (1573-1645), a prominent Zen priest known for his great skill in calligraphy (see cat. no. 66). It was under his influence that Niten began to live up to his maxim of *kenzen itchi* ("Swordsmanship and Zen are One").

As an artist, Niten displayed an amazing versatility. Not only did he distinguish himself as a calligrapher and a painter but he was also a sculptor and forged his own sword guards (*tsuba*). Among the statues attributed to Niten is a wooden image of the sword-bearing Buddhist deity Fudō. Although Niten is known to have occasionally painted in colors, his fame as a painter rests chiefly upon his mono-chrome works. A great admirer of the works of Mu-ch'i and Liang K'ai, Niten adopted the *chien-pi* ("abbreviated brushwork") method for which Liang K'ai was famous. Niten depicted birds of prey such as eagles and shrikes in brushwork as swift and incisive as the strokes of his sword. Whereas these ferocious birds seem to represent the swordsman's facet of his personality, other paintings from his hand express his profound interest in Zen. Of the typical Zen themes painted by Niten representations of Daruma and Hotei are the most common. All of these are in one way or another unusual from an iconographical point of view. For example, in the Matsunaga Collection is a painting which shows Hotei watching a cockfight, supposedly at the moment of his attaining Enlightenment. Niten had adapted and improved upon an earlier Chinese version of the same theme, tradition-ally attributed to Liang K'ai. Another Hotei by Niten shows him in a dancing posture. This version, accompanied by a poem by Hoshina Masayuki (1611-1672), was also inspired by a work attributed to Liang K'ai.

The painting shown here depicts Hotei asleep, his head supported by his hands, his elbows resting upon his sack. The dynamic brushwork and the subtle use of ink tones is closely related to that in the other two Hotei paintings. All three bear the same Niten seal.

At the top, the following eulogy has been inscribed:

He drops body and heart and forgets his own
 nature.
For a while he props up his head with both
 hands, dozing off into a midday nap.
The sack and the staff are set aside.
Engrossed in a dream of the Heavenly Palace,
 no shouting will arouse him.
 Zui-enji, the rustic cassock of
 Kizan, wrote this eulogy.

Kizan is short for Reikizan, a name for the Tenryūji temple in Kyoto. "Rustic cassock" is a polite, self-derogatory term used by Buddhist priests. Zui-enji is the sobriquet of the two hundred and seventh abbot of the Tenryūji, the monk Monrei Shūiku.

REFERENCES:
Kokka, no. 704 (dancing Hotei); Kokka, no. 251 (Hotei watching cockfight); *Nihon Bijutsu Kōgei*, no. 309 (1964); D. T. Suzuki, *Zen and Japanese Culture* (New York, 1959), ch. 5 (Zen and swordsmanship).

68

CALLIGRAPHY: A GĀTHĀ FOR OFFERING INCENSE
Yin-yüan Lung-ch'i (Ingen Ryūki; 1592-1673)
Hanging scroll, ink on paper, 130 x 51 cm.
Mampukuji, Kyoto

When the Manchus conquered China and over-threw the Ming dynasty, many Chinese re-mained loyal to the *ancien régime*. Some pre-ferred going abroad to living under the reign of the new rulers and went to Japan. Among them was the monk I-jan, who, promptly after his arrival in Nagasaki in 1644, was appointed abbot of the Kōfukuji in Nara. He regularly corresponded with the Ch'an monk Yin-yüan Lung-ch'i (1592-1673), abbot of the Wan-fu-ssŭ (a large Ch'an monastery built in 1614 on Mount Huang-po near Foochow, in Fukien Province). Yin-yüan, who had temporarily re-signed from the abbotship when the Ming

Facing page:
67. *Sleeping Hotei* by Miyamoto Musashi (1582-1645)

dynasty fell, responded to the enthusiastic invitations of I-jan and decided that he too would go to Japan. Setting sail from Amoy, he arrived in Nagasaki in the summer of 1654.

Although Yin-yüan received the assistance of the abbot Ryūkei of the Myōshinji, he was on the whole not well received by the Japanese Zen sects. The reason for their reserve lay in the fact that the Japanese schools had long been isolated from developments in China and still retained the austere traditions of Sung and Yüan Ch'an. In China, on the other hand, Ch'an had become exposed during the Ming period to the influence of the devotional Amitabha cult, and certain syncretic developments had taken place. Through the good offices of Ryūkei, Yin-yüan succeeded in gaining the support of the Tokugawa shōgunate as well as of the imperial family. In 1658 he went to Edo and was given audience by the shōgun. At this time he received permission to build his own temple, and the reigning emperor granted him land for this purpose at Uji (near Kyoto).

With the assistance of Chinese artisans, who had come with him from China, Yin-yüan built a large monastery in the architectural style of the late Ming period and named it Mampukuji (the Japanese pronunciation of Wan-fu-ssŭ, the name of his home temple). The Zen sect that he founded was named Ōbaku after Mount Huang-po. Several of Yin-yüan's architectural innovations were later adopted by the Rinzai sect, and some of the monastic rules he had observed in China were incorporated into Zen regulations. On the whole the Chinese atmosphere and new Zen way of living that Yin-yüan created at the Mampukuji were not acceptable to the other Zen sects and consequently did not spread beyond the confines of the Mampukuji and its affiliated temples, which were built later.

The Ōbaku sect created its own type of portraiture and its own, vigorous style of calligraphy, in which the influence of such Ming painters and calligraphers as Tung Ch'i-ch'ang (1555-1636) and Chang Jui-t'u (ca. 1575-post-1642) is blended with that of the Sung prototypes that had been an important source of inspiration for Zen calligraphy throughout its history.

The *gāthā* can be translated as follows:

68. *Calligraphy: A Gāthā for Offering Incense* by Yin-yüan Lung-ch'i (1592-1673)

Suspended in the void, the brightly shining sun
 renews itself each day,
But in the Three Realms only the Buddha mani-
 fests himself.
Auspicious purple clouds descend upon his
 seat, strengthening the manifestation.
With all my heart I take up the incense to offer
 it to the One who is Capable of Humanity.
The Udumbara tree is in bloom, an auspicious
 omen in the garden.
The Bodhimanda, where he attained Enlighten-
 ment, is open; it is Spring outside this world.
Now we mount the stairs of the altar; we bow
 our head to Buddha's feet,
And we move in procession, circumambulating
 the Five Bodies of the Dharmakāya.

In the year Inotori [1669], third day of the first
moon, I mounted the steps of the Main Hall and
offered incense. Written by the thirty-second
generation in line of Lin-chi's succession, the
old monk and founder Yin-yüan.

The Udumbara tree is a legendary tree that
blossoms once every three thousand years to
predict the impending appearance of a Buddha
in the world. The rite of circumambulation and
the expression "the Five Bodies of the
Dharmakāya," are characteristic of the devo-
tional and esoteric accretions in Ch'an Buddhism
during the late Ming period.

REFERENCES:
Shodō Zenshū, vol. 22 (Tokyo, 1959), pp. 174,
193, and pl. 65.

69

CALLIGRAPHY: "BLUE-COUNTENANCED BEARER
OF THE THUNDERBOLT"
Hakuin Ekaku (1686-1769)
Hanging scroll, ink on paper, 133.6 x 39.4 cm.
Collection of Yamamoto Kiyoo, Ashiya

When Hakuin, the son of a *samurai* from Hara,
entered the priesthood at the age of fifteen, the
Zen sect had already fallen into a period of
intellectual stagnation and decline. Hakuin's
entire life as a Zen monk was devoted to a
revitalization of the sect. Although he resided
for some time at the Myōshinji in Kyoto, Hakuin
frequently made extended journeys around the

69. *Calligraphy: "Blue-Countenanced Bearer of the
Thunderbolt" by Hakuin Ekaku (1686-1769)*

country—at first in search of Enlightenment and later to spread the message of Zen among the populace, whose contact with Zen doctrine had been superficial until that time. Hakuin's dramatic personal struggle to attain *Satori*—he suffered from a nervous breakdown after excessive meditation—led him to encourage his students in a patient and humane way. Recognizing the degrees of *Satori*, Hakuin proposed and practiced "post-*Satori*" training, in which the student's initial experience of Enlightenment is gradually deepened and expanded. Instead of relying solely on the classical repertoire of *kōan*, Hakuin created a number of new, original *kōan*. These have never been committed to writing and are still transmitted orally from teacher to pupil.

Hakuin's intellectual creativity is evident from his methods of instruction; his artistic talents found expression in a large oeuvre of painting and calligraphy. Together with the artist Sengai (see cat. no. 70), who continued Zen traditions in painting after Hakuin's death, Hakuin stands out as one of the most original Zen artists of the Edo period. His paintings, often executed in a deliberately inept, primitive-looking brush technique, cover a wide range of classical Zen themes, although he seems to have particularly favored representations of Bodhidharma and the White-robed Kuan-yin. His calligraphy shows great versatility with different types and styles and includes examples of Chinese, Japanese, and *Bonji* (stylized Sanskrit) scripts, written in calligraphic modes which range from "cursive" script to formal *kaisho* characters. During the later years of his life, Hakuin developed a bold style executed in large characters that sometimes resembled the work of his Chinese contemporary Chin Nung (1687-1764). The characters, spaced close together and drawn in strokes of approximately the same width, create an impression of monumental strength. Several scrolls in this bold style have been preserved. They bear the names of Bodhisattvas and deities. The piece of calligraphy illustrated here reads *Shōmen Kongō* ("Blue-Countenanced Bearer of the Thunderbolt"), a terrifying Buddhist deity of the Vajra-Yaksa class.

REFERENCES:
Takeuchi Shōji, *Kinsei no Zenrin Bijutsu*, Nihon no Bijutsu, vol. 47 (Tokyo, 1970), fig. 64.

70

THE DEITY DAIKOKU-TEN
Gibon Sengai (1750-1836)
Hanging scroll, ink on paper, 110 x 35.1 cm.
Idemitsu Art Gallery, Tokyo

Sengai, a farmer's son from Mino (present-day Gifu Prefecture), entered the priesthood at the age of eleven. On his *angya* (pilgrimage in search of a master) when he was nineteen, he met the revered master Gessen Senji and became his pupil. Thirteen years later, after Gessen's death, Sengai set out to travel about the country once again. He finally decided to take up residence at the Shōfukuji at Hakata, the most ancient Zen monastery in Japan. After a distinguished career there, he retired from the abbotship at sixty-two and devoted the rest of his life to propagating Zen through his art.

In the long line of artists who distinguished themselves in the monochrome Zen traditions of painting, Sengai stands out as one of the last great talents. His extensive oeuvre consists in large part of works which deal with traditional Zen themes. His paintings often have a light touch and are permeated with a warm sense of humor. A skilled poet and calligrapher, Sengai added the inscriptions to most of his works himself.

Although he is noted chiefly for his Zen subjects, Sengai is represented here with a painting of Daikoku-ten, the popular Japanese deity who symbolizes the fruits of material wealth and who is one of the Seven Gods of Good Fortune. A distant descendant of the Indian god Mahākāla, his chief attribute is a large bag in which he keeps a hoard of jewels. In his right hand he holds a mallet, the Japanese miner's tool with which he is supposed to extract hidden treasures from the earth. The mallet and the rice-bales on which he stands symbolize Japan's mineral and agricultural wealth. Daikoku-ten is dressed in what was thought to be a Chinese costume. The poem written by Sengai at the top of the painting refers to two stories about jewels:

Daikoku shines bright in the darkness,
Because of his jewels, which no human eye
 has seen.
The Prince of Ch'in [offered] fifteen cities,
The Dragon girl [attained Buddhahood] in
 Three Thousand Worlds [simultaneously].

Facing page:
70. *The Deity Daikoku-ten* by Gibon Sengai (1750-1836)

The third line alludes to the story of the Prince of Ch'in (3rd century B.C.), who offered fifteen cities in exchange for the celebrated jewel of Pien Ho. Pien Ho (8th century B.C.) persisted in offering a supposedly fake jewel to his sovereign and was twice punished for it by the loss of a foot. On his third effort, however, he was successful; his gift was accepted, and its uniqueness finally recognized.

The Dragon girl (*Nāgakanyā*) is a personage who makes her appearance in the *Lotus Sūtra*. After having presented the Buddha with a precious jewel, the eight-year-old girl turned into a man and immediately attained Buddhahood in Three Thousand Worlds of the Universe simultaneously.

By including a Japanese god of Indian origin in a Chinese costume in his repertoire of subjects, Sengai aptly demonstrates the highly syncretic character of his own brand of Zen Buddhism.

71

CALLIGRAPHY: "HEAVEN AND EARTH"
Daigu Ryōkan (1757-1831)
Hanging scroll, ink on paper, 133.7 x 51 cm.
Collection of Akiyama Jun'ichi, Fujiwawa

The monk Ryōkan, sometimes known by the self-deprecating sobriquet Daigu ("Big Fool"), was one of the last proponents of the time-honored Sino-Japanese tradition of eccentric behavior as an expression of artistic individuality. He was a pupil of Kokusen, a monk of the Sōtō sect from the Entsūji at Tamashima. At the age of thirty-nine he went into retirement in his native Echigo, where he soon became famous for his original behavior. His hut at Mount Kugami served as a *pied-à-terre* from which he made extensive journeys throughout the country.

Ryōkan occasionally tried his hand at painting. A simple self-portrait shows his artistic affinity with his more famous contemporary, Hokusai, who shared his liking for a semi-nomadic way of life. Ryōkan's fame, however, rests chiefly upon his poetry and his calligraphy. Living at a time when unconventionality had itself become a firmly established and respected tradition, Ryōkan followed the example of other indi-

vidualists and eccentrics by turning for inspiration to the remote past. His style of writing was modeled upon that of those classical artists with whom he felt a spiritual affinity. Ryōkan studied rubbings and copies of the works of such famous calligraphers as the Chinese Wang Hsi-chih (see cat. no. 40) and the Japanese Ono Dōfū (894-964), a calligrapher who was responsible for the transmission of classical Chinese styles to Japan. Ryōkan's favorite model, however, was the "mad monk" Huai-su (725-785), one of the few early Chinese calligraphers who distinguished himself in what is graphically termed "unrestrained cursive" style (Chinese: *K'uang-ts'ao-shu*). Huai-su, whose impetuous style is traditionally explained as the result of habitual inebriation, may have been the equivalent in calligraphy of the "untrammelled" class of painters, who inspired the pioneer generation of Ch'an painters.

Ryōkan has drawn the two graphs for heaven and earth with the impetuous fervor and complete disregard of classical canons of style which marks the art of the "untrammelled." In two bold swirls of the brush and one final dot, Ryōkan linked together the two characters representing these two cosmic opposites as if they were one large, elongated graph.

REFERENCES:
Bokubi, no. 99 (special Ryōkan issue); *Shodō Zenshū*, vol. 23 (Tokyo, 1958), pp. 30-35, 192.

Facing page:
71. *Calligraphy: "Heaven and Earth"* by Daigu Ryōkan (1757-1831)

Glossary

Chinese and Japanese personal names are given according to the practice of those countries, that is, family name followed by given name. The names of Ch'an and Zen monks are generally composed of two two-character groups: first, the *tao-hao* (Chinese) or *dōgō* (Japanese), a kind of Buddhist sobriquet; and, second, the *fa-hui* (Chinese) or *hōki* (Japanese), the priest's formal appellation. This practice was also followed for a time by the T'ien-t'ai (Japanese: Tendai) and Lü (Japanese: Ritsu) sects, but it became standardized only in Ch'an and Zen. All Chinese proper names ending in *ssŭ* or *an* and Japanese names ending in *ji, in,* or *an* are names of monasteries, temples, or "hermitage" sub-temples.

The terms listed below are Japanese unless otherwise indicated.

Arhat (Sanskrit). An ascetic, or recluse, who has attained Enlightenment through his own efforts. (Chinese: *lohan;* Japanese: *rakan.*)

Bakufu. Literally, tent government. Originally used for the headquarters of an army in the field, the term was later applied to the military governments who were the de facto rulers of Japan during the Kamakura, Muromachi (Ashikaga), and Tokugawa (Edo) periods.

Bokuseki. Ink traces or ink vestiges. Used to refer to the calligraphy of eminent Ch'an and Zen monks.

Chinsō. A formal Ch'an or Zen portrait, either painted or sculptured. The painted portraits constitute one of the most revered forms of Ch'an and Zen art and were traditionally given by a master to his close disciples in recognition of their religious attainment and as tangible evidence of their acceptance in his line.

Daimyō. Feudal lords who controlled local fiefs.

Gāthā (Sanskrit). Buddhist verse.

Gozan. Literally, Five Mountains. Usually mentioned in conjunction with Jissatsu (Ten Monasteries). A hierarchical organization composed of most of the important Zen temples in Japan, patterned after a Chinese prototype.

Gozan Bungaku. The literary movement that flourished during the thirteenth and early fourteenth centuries at the Gozan monasteries.

Hossu. A whisk made usually of badger's hair and fitted with a handle. Although its pragmatic use is to drive off troublesome insects during meditation, it also symbolizes the subjugation of passions or carnal desires.

Kegon. The name of a Mahāyānist sect which considers the *Avatamsaka-sūtra* the fundamental text of Buddhism. (Chinese: Hua-yen.)

Kōan. Literally, public case. A paradox presented in anecdotal or aphoristic form by Ch'an and Zen masters to their disciples as a problem for practice and cogitation. (Chinese: *Kung-an.*) The two most important collections of *kōan* are the Sung period compilations *Pi-yen-lu* (Japanese: *Hekiganroku*) and *Wu-mên-kuan* (Japanese: *Mumonkan*).

Kyōsaku (alternate: *Keisaku*). A long wooden slat used by Zen masters to keep their students alert during meditation.

Mahāyāna (Sanskrit). The Great Vehicle, the second of the three main historic and doctrinal divisions of the Buddhist faith, the first being Hīnayāna (the Small Vehicle), and the third, Esoteric Buddhism.

Satori. Enlightenment.

Shōgun. Generalissimo, the title held by the head of the Bakufu.

Suiboku. Ink-monochrome painting.

Sūtra (Sanskrit). A part of the Buddhist scriptures, purporting to contain the words of the Historical Buddha.

Tathāgata (Sanskrit). An Enlightened Buddha, fully identified with the metaphysical basis of truth and existence; epithet of the Buddha.

Usnīsa (Sanskrit). The protuberance on the Buddha's head symbolizing his transcendent spiritual knowledge.

Index

Names of Chinese monks living in Japan and technical Zen terms current in both countries are included under their Chinese and Japanese pronunciations.